Exploring
MISSOURI'S
LEGACY

Exploring
MISSOURI'S
LEGACY

State Parks and Historic Sites

EDITED BY
Susan Flader

ESSAYS BY
*R. Roger Pryor, John A. Karel,
Charles Callison, and Susan Flader*

PHOTOGRAPHS BY
Oliver Schuchard and Others

University of Missouri Press
Columbia and London

For Missourians Who Care

Copyright © 1992 by
The Curators of the University of Missouri
University of Missouri Press, Columbia, Missouri 65201
Printed and bound in Hong Kong
All rights reserved
5 4 3 2 1 96 95 94 93 92

Library of Congress Cataloging-in-Publication Data

Exploring Missouri's legacy : state parks and historic
 sites / edited by Susan Flader ; essays by R. Roger Pryor
 . . . [et al.] ; photographs by Oliver Schuchard and oth-
 ers.
 p. cm.
 Includes bibliographical references and index.
 ISBN 0-8262-0834-7 (alk. paper)
 1. Parks—Missouri. 2. Historic sites—Mis-
 souri. 3. Missouri—History, Local. 4. Missouri—
 Description and travel—1981–
 I. Flader, Susan. II. Pryor, R. Roger.
 F467.E97 1992
 917.7804′43—dc20 92-6886
 CIP

∞™ This paper meets the requirements of the
American National Standard for Permanence of Paper
for Printed Library Materials, Z39.48, 1984.

Designer: Kristie Lee
Typesetter: Graphic Composition, Inc., and Connell-
 Zeko
Printer and binder: Dai Nippon
Typefaces: Trump and Garth Graphic

The illustrations in the front matter may be identified as
 follows:

[page i] *Three of the rarest textile machines in exis-
 tence—two ring-frame ply twisters and a plain loom
 of 1860 vintage—demonstrate Watkins Woolen Mill's
 fame as America's finest remaining nineteenth-
 century textile factory.* OLIVER SCHUCHARD

[page ii] *The 1.5-billion-year-old granite at the geological
 core of the Ozarks is eroded into fantastic shapes at
 Elephant Rocks State Park.* OLIVER SCHUCHARD

[page v] *Willow-leaved asters and marsh marigolds at
 Pershing State Park offer a taste of a prairie landscape
 once common in north Missouri.* KEN MCCARTY

[page xii] *Morning mists rise from the Meramec, Mis-
 souri's most biologically diverse stream.*
 OLIVER SCHUCHARD

Missouri State Parks
Natural Divisions

Missouri's state parks and historic sites within a matrix of natural divisions. One of the aims of the system is to provide high-quality representation of major characteristics of each of the state's six natural divisions and nineteen sections.

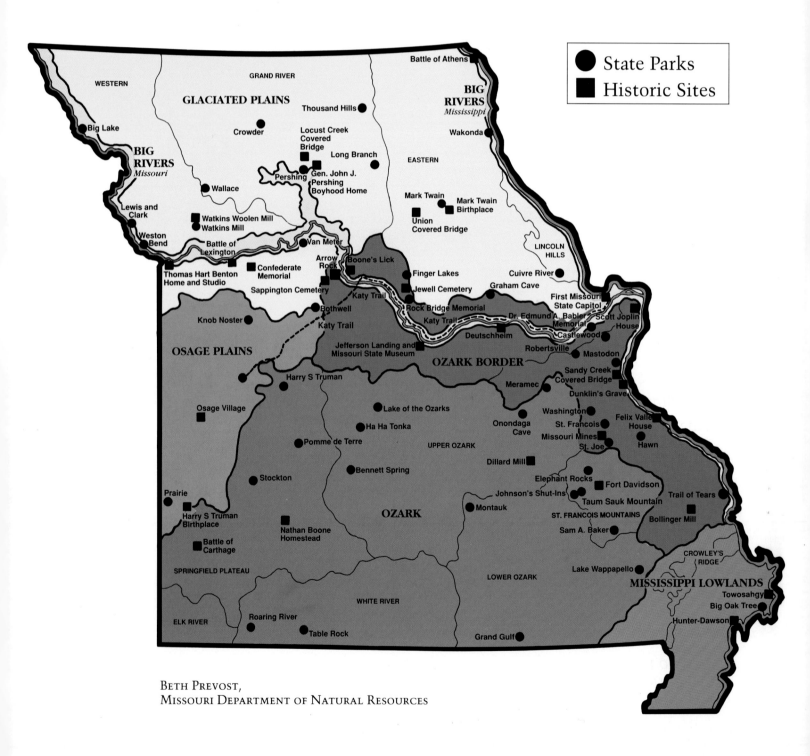

● State Parks
■ Historic Sites

WESTERN

GRAND RIVER

GLACIATED PLAINS

BIG RIVERS
Mississippi

Big Lake

Thousand Hills

Crowder

Locust Creek Covered Bridge

Long Branch

Wakonda

EASTERN

BIG RIVERS
Missouri

Wallace

Pershing Gen. John J. Pershing Boyhood Home

Mark Twain

Mark Twain Birthplace

Lewis and Clark

Watkins Woolen Mill
Watkins Mill

Union Covered Bridge

Weston Bend

Battle of Lexington

Van Meter

Arrow Rock Boone's Lick

LINCOLN HILLS

Thomas Hart Benton Home and Studio

Confederate Memorial

Finger Lakes

Cuivre River

Sappington Cemetery

Jewell Cemetery

Graham Cave

Katy Trail

First Missouri State Capitol

Bothwell

Rock Bridge Memorial

Dr. Edmund A. Babler Memorial

Scott Joplin House

Knob Noster

Katy Trail

Katy Trail

Deutschheim

Castlewood

OSAGE PLAINS

Jefferson Landing and Missouri State Museum

OZARK BORDER

Robertsville

Mastodon

Harry S Truman

Meramec

Sandy Creek Covered Bridge

Osage Village

Lake of the Ozarks

Onondaga Cave

Washington

Dunklin's Grave

St. Francois

Felix Valle House

Ha Ha Tonka

UPPER OZARK

Missouri Mines

Hawn

Pomme de Terre

St. Joe

Bennett Spring

Dillard Mill

Stockton

Elephant Rocks

Fort Davidson

Prairie

Johnson's Shut-Ins

Trail of Tears

Harry S Truman Birthplace

OZARK

Montauk

Taum Sauk Mountain

ST. FRANCOIS MOUNTAINS

Bollinger Mill

Battle of Carthage

Nathan Boone Homestead

Sam A. Baker

CROWLEY'S RIDGE

SPRINGFIELD PLATEAU

Lake Wappapello

Grand Gulf

MISSISSIPPI LOWLANDS

LOWER OZARK

Towosahgy

WHITE RIVER

Big Oak Tree

ELK RIVER

Roaring River

Table Rock

Hunter-Dawson

BETH PREVOST,
MISSOURI DEPARTMENT OF NATURAL RESOURCES

Contents

MISSISSIPPI LOWLANDS

BIG RIVERS

OSAGE PLAINS

GLACIATED PLAINS

Preface

MISSOURI HAS ONE of the finest, most comprehensive systems of state parks and historic sites in the nation. Established in 1917 with the creation of a state park fund and beginning in 1924 with the acquisition of the first park units, the system has grown to more than seventy-five parks and historic sites totaling over a hundred and twenty thousand acres. The system annually records some fifteen million visits—in a state with a population of five million.

The Missouri system of parks and historic sites is a reflection of the remarkable diversity of the state, both natural and cultural, and of its rich historical tradition. Missouri boasts some of the oldest rocks on the continent—the Precambrian igneous knobs of the St. Francois Mountains at the heart of the Ozarks—and some of the geologically youngest landforms—the big rivers and southeastern lowlands shaped by meltwaters of the great continental glaciers that covered the northern third of the state. In between are more caves and springs and clear natural streams than in probably any other state in the nation. The state is located on the border between the tall-grass prairies of the Great Plains and the extensive forests of the eastern woodlands, but it is also at the southern limit of some northern boreal plant species and the northern limit of some southern coastal plain species. All this makes for diversity.

Its commanding position at the junction of the two greatest rivers of the nation, the Mississippi and the Missouri, has given the state a vital role in nearly all the currents of the country's human history. The first archaeologically undisputed contact of man and mastodon in the new world was found in a Missouri state park. Missouri was home to native peoples of both the woodlands and the prairies for more than ten thousand years; elements of the most sophisticated manifestation of native culture north of Mexico, the Mississippian, are found within its borders, as are key sites of the Osage, Missouri, and other historic tribes.

Missouri was a key outpost and vital junction for French fur traders, miners, and farmers in the 1700s, a colony of Spain later that same century, and a magnet for Anglo-American settlers before and especially after the Louisiana Purchase of 1803. The Missouri River was the principal artery to the west for explorers and traders, and towns along its banks served as provisioning points for the great overland trails. With easy access by river, the state attracted a massive immigration from the upper South, complete with slaves. It also attracted large-scale migrations from Germany and the British Isles beginning around 1830, and then, with the advent of railroads, increasing numbers of settlers from non-slave areas of the United States—setting the stage for excruciating conflict during the Civil War. A rich agricultural state, Missouri also developed important mining and industrial activity, especially after the Civil War, but its small towns remained peculiarly vibrant and produced some of the nation's key leaders in war and politics, literature and the arts. And, in the twentieth century, the state became recognized for its outstanding recreational resources, attractive not only to its own citizens but also to visitors from afar.

One of the great strengths of the Missouri park system, like the national park system, has been

the synergy of its combination of historic sites with natural parks. Although many states include some historic sites in their park systems, Missouri is one of relatively few states that have assigned all their state historic sites and parks, as well as outdoor recreation planning and historic preservation, to a single administrative agency—today, the Division of Parks, Recreation, and Historic Preservation in the Department of Natural Resources. The system has functioned within the context of its multiple mission from the beginning, when it was a component of the state's fish and game department, through the period 1937–1974, when it was supervised by a separate Missouri State Park Board, to the present arrangement. That mission, as currently stated, is "to preserve and interpret the finest examples of Missouri's natural landscapes; to preserve and interpret Missouri's cultural landmarks; and to provide healthy and enjoyable outdoor recreation opportunities for all Missourians and visitors to the state."

But the Missouri system of parks and historic sites is a product of more than happy conjunction of diverse natural and cultural resources with good administrative structure and management. Even more important, it is a legacy of people who have cared—cared enough to preserve for their own and future generations the best and most representative examples of their natural and cultural heritage. Behind each of Missouri's parks and historic sites—and behind many other areas that for one reason or another are not part of the system—lies a story of love and dedication and often remarkably effective action or splendid generosity by people who cared enough about their favorite place to secure its preservation. Every state, and the nation as well, has stories like this; but in Missouri, with its strong tradition of skepticism and its determination to hold the reins on government, the role of citizens who care has perforce been exceptionally strong.

Our purpose in this book is to explore each of Missouri's parks and historic sites, and to capture its essence in words and in photographic images. We try to suggest not only what people saw in each park at the time of its establishment, but how the park or site itself and our thinking about it or uses of it may have changed over time. While the essays often describe the types of facilities available at the parks, our focus is primarily on natural and cultural resources and related recreational values, for it is these that have given the units statewide or even national significance and led to their inclusion in the system. It goes without saying that state parks and historic sites would hardly be attracting fifteen million visits a year if they were not providing abundant recreation; but we hope through the stories in this book to expand people's awareness of the full range of recreational opportunities available at these parks, which includes enjoyment and appreciation of natural and cultural features as well as sheer outdoor physical activity.

Beyond our focus on individual units, we seek to convey how the system as a whole reflects the natural and cultural heritage of the state. There are gaps, of course, some of which will surely be filled in the future. But we believe that Missouri comes closer to having a comprehensive system of state parks and historic sites than do most other states. Indeed, it is our hope that at least some readers will read this volume from beginning to end, rather than just dipping in here and there for particular parks or sites, and that they may gain thereby a fuller understanding of the natural and human history of the state, and an appreciation for the vision and dedication of its citizens. We hope also that they will be inspired to visit places they have not yet seen, revisit others with new insights, ponder the particular nature of that which Missourians in the past have elected to preserve, and consider what they and others in the future might seek to add.

Our intention, it should be stated, has not been to produce a guidebook, with detailed maps and locational information, lists of facilities, and addresses, telephone numbers, days and hours, and fees. Much of this information changes from time to time, and it is readily available in any case in brochures and other more timely and portable publications from the parks division or other sources. For the same reasons, we have not ordinarily provided exact figures for park acreages, but rather have rounded them.

This project had its inception nearly a decade ago at a time of crisis for state parks in Missouri, when federal funds that supported many capital improvements during the 1960s and 1970s were suddenly withdrawn and state funds were constricted owing to economic recession. The system was falling into decay and was in danger of dismemberment, with parks being proposed for transfer to another agency and historic sites presumably left hanging out to dry. The authors and editor believed that part of the problem was lack of widespread public understanding of the values at stake in the system as a whole, despite abundant evidence of Missourians' love for their favorite parks and a large reservoir of public goodwill. That love and goodwill were amply demonstrated when Missourians voted in 1984 and again in 1988 for a one-tenth-cent sales tax for state parks

and soil conservation—a stable source of funding that has led in recent years to a genuine renaissance of state parks and historic sites in Missouri. But there is still a limited public understanding of the system as a whole, and of the part that each unit contributes to a much larger and more interesting picture, and it is that need that this book seeks to address.

The project from the beginning has been a cooperative endeavor of the Missouri Parks Association, the Cultural Heritage Center at the University of Missouri-Columbia, and the parks division of the Missouri Department of Natural Resources. The Missouri Parks Association, a statewide citizens organization formed in 1982 in response to the crisis of the park system, initiated the project and has supported it financially and encouraged it throughout. The Cultural Heritage Center, established in 1981 to promote and facilitate multidisciplinary research on the heritage of the state and region, secured a grant from the Weldon Spring Research Fund of the University of Missouri in 1983 to support initial research and to defray travel and other expenses. The parks division of the Department of Natural Resources has encouraged and cooperated with the project throughout, its staff in both field and central office freely providing information and photographs and contributing to review of the manuscript.

Needless to say, the views expressed in this volume, as well as any errors that remain, are the responsibility of the authors and editor. While we have sought to be sensitive to the particular objectives and interpretive themes of individual units of the system and of the system as a whole, we have not hesitated to discuss problems and to offer critiques or judgments where they seemed warranted, sometimes going beyond particular sites to consider issues of regional or statewide interest. We agreed early on not to identify authorship of individual essays, in order to be free to critique, redraft, and expand on the work of our colleagues and thus to speak, insofar as possible, with a common voice.

We begin with a historical account of the evolution of the system in order to provide a context for the essays on the individual parks, many of which reflect the times in which they were established or developed. Missourians' image of their park system and its purposes matured with the years, and the philosophies that guided park development and management matured also. But despite changes in organizational structure and attitudes, there has also been a remarkable degree of continuity that has lent strength and resilience to the system.

The essays on individual units are arranged regionally and chronologically, following a generally accepted classification of the state into six natural divisions with nineteen subdivisions called sections. The natural divisions—Ozarks, Ozark Border, Mississippi Lowlands, Big Rivers, Osage Plains, and Glaciated Plains—are arranged roughly in order of their geologic and historical development; and parks within the divisions and sections are also arranged roughly chronologically—or, in the case of the big rivers with their thousand miles of frontage in the state, by geographic progression up the Mississippi and then the Missouri. An essay at the beginning of each natural division discusses the characteristics of the division and its sections and briefly indicates the principal themes and the logic of the arrangement of individual parks and historic sites.

The scheme is far from perfect, and we have made some compromises. But we believe it is the most sensible one available to us in view of our stated objective to portray Missouri's state parks and historic sites as an integrated system. We rejected out-of-hand an alphabetical arrangement of units as being meaningless to the concept of a system. We also rejected an organization by type of unit—for example, with parks subdivided into natural parks, cave parks, and reservoir parks, and historic sites into Indian, ethnic, Civil War, mills, and the like. We especially resisted any effort to separate the historic sites from the parks because they are, in fact, legally parks and—far more important—there are cultural or historical resources in all of the parks and natural resources in virtually all of the historic sites, as we attempt to demonstrate in the essays. It would have been equally valid to convey the concept of a system through a wholly chronological arrangement—from the 1.5-billion-year-old Elephant Rocks to the studio where Thomas Hart Benton died at his easel in 1975. But it would not have been as practical, because most of the parks exhibit significant features from many different time periods. In addition to the insights afforded by association of parks and historic sites within a meaningful framework, the regional arrangement has the added advantage of grouping essays on units that readers may wish to visit on trips to particular parts of the state.

We hope this book will stimulate some creative thinking about the interrelationships among parks and historic sites and among natural, cultural, and recreational resources and values. We also hope it will renew and inspire in its readers a greater appreciation of the state and its citizens, even as it deepens their understanding of this remarkable Missouri legacy.

Acknowledgments

THIS BOOK HAS BEEN a team effort with an ever-growing and dedicated group of players. We should like to thank especially the board of directors of the Missouri Parks Association, the staff of the University of Missouri Cultural Heritage Center and Department of History, and officials of the Missouri Department of Natural Resources and its Division of Parks, Recreation, and Historic Preservation, who have encouraged and supported the project from its inception.

Our greatest debt is to more than a hundred parks division and Department of Natural Resources employees who viewed this book as another way of expressing their love for the state's parks and historic sites, to which many of them have devoted their entire careers. Tracy Mehan, director of the department, and Wayne Gross, director of the parks division, have offered steadfast support throughout their tenure. Paul Nelson, chief of natural history, and Booker Rucker, chief of historic sites, have served as the principal coordinators of parks division input and devoted untold hours, often during evenings and weekends, to reviewing the manuscript, providing information, suggesting wording, and helping to secure and assess photographs.

Among those who provided photographs, park naturalist Tom Nagel deserves special commendation for his dedication to the project, often going out of his way to get just the right shot at the right time. Nick Decker also provided many images taken during his career as the DNR's principal photographer. Countless other staff members have provided photographs and information and assisted in the review process; among those who made special contributions are James

Baker, Annette Bridges, James Denny, Wanda Doolen, Dan Drees, Stan Fast, Richard Forry, Larry Grantham, Orval Henderson, Blane Heumann, Arne Larsen, Ken McCarty, Ron Mullikin, Erin Renn, Bruce Scheutte, Don Schultehenrich, Bonnie Stepenoff, Eugene Vale, and Gary Walrath. Former park directors who have graciously offered insights and responded to queries include Abner Gwinn, Joseph Jaeger, James Wilson, Fred Lafser, and John Karel.

At the University of Missouri–Columbia, Diane Everman and Dennis Graham assisted with research and Patty Eggleston and Mary Oakes provided clerical support. Staff of the Western Historical Manuscript Collection, the State Historical Society of Missouri, the Missouri State Archives, the Missouri State Library, and the state parks division facilitated research on documentary materials. Among those who supplied information or reviewed certain essays are Thomas Alexander, Jeffrey Ball, Robert Bray, Michael Cassity, Ben Duffield, Cam Fine, Townsend Godsey, Jean Hamilton, Harold Jordahl, James Keefe, David Leuthold, Lynn Morrow, Osmund Overby, Gerald Rowan, Richard Sellars, and William Wallace. Walter Schroeder of the University of Missouri–Columbia, Robert Mohlenbrock of Southern Illinois University–Carbondale, Ney Landrum of the National Association of State Park Directors, and Robin Winks of Yale University read the entire manuscript and offered helpful comments. At the University of Missouri Press, Edward King and Susan Denny guided the project at its inception, while Beverly Jarrett, Jane Lago, Dwight Browne, and Kristie Lee led it along the path to publication.

Financial support during various phases in the

xiv ACKNOWLEDGMENTS

preparation of the manuscript was provided by the three sponsoring institutions, together with a grant from the Weldon Spring Research Fund of the University of Missouri and support of some of the photography and research by the University Research Council. The Watkins Mill Association, a citizen group, pledged the first major support in aid of publication. The Monsanto Fund followed with a generous challenge grant, and that in turn helped to stimulate many other donations that in sum have enabled publication at a price within the means of many Missouri citizens.

Major contributions in response to the challenge have come from Mrs. Edward D. (Pat) Jones, the L-A-D Foundation of Leo A. Drey, and United Van Lines, Inc. Other substantial contributions have come from Boatmen's Bancshares, Inc., Charitable Trust, Boatmen's National Bank of Springfield, Boatmen's Bank of Pulaski County, the Brush and Palette Club of Hermann, Amy and Charles Callison, Cannon General Contrac-tors, Inc., Dolores Flader, Friends of Arrow Rock, Friends of the Scott Joplin House, Jean Tyree Hamilton, Darwin and Axie Hindman, the Jefferson Bank of Missouri, Dean P. Johnson, John A. Karel, the Katy Trail Coalition, Mrs. Whitney E. Kerr, Richard M. Kutta, Ney C. Landrum, Arne C. Larsen, A. James Matson, Missouri Division of the Sons of Confederate Veterans, Missouri Division of the United Daughters of the Confederacy and its Real Granddaughters' Club, John O'Reilly, the Ozark Chapter of the Sierra Club, the Ozark Society, Vernon and Fay Renner, an anonymous fund of the St. Louis Community Foundation, Helen C. Saults (in memory of Dan Saults), William L. Trogdon, P. H. Weiss & Associates, and the Westport Garden Club. Nearly one hundred other individuals, groups, and firms have also helped meet the challenge.

To all of these individuals and organizations we express our deepest gratitude. The manifold contributions to this project are yet another expression of Missourians who care.

The sun rises over the Mississippi at Trail of Tears State Park. NICK DECKER

Evolution of the System

THE CONCEPT OF PUBLIC parks in Missouri gestated for half a century before Gov. Frederick Gardner signed an act of the Missouri General Assembly creating a state park fund on April 9, 1917, and it has continued to evolve for three-quarters of a century since. Yet despite the long and somewhat tortuous history of parks in the state and a multiplicity of attitudes among Missourians, there are remarkable threads of continuity. The result is a system that reflects not only the natural diversity and rich historical currents of the state but, to a rather remarkable extent, the values and dedication of its citizenry and something of their political culture as well.

Origins of Public Parks: Missouri and the Nation

For the origins of the movement for public parks in this country we must look not to the national government or even to the states but to the great cities. New York established its Central Park in the 1850s, and after the Civil War a host of other cities joined in, not least among them St. Louis with Henry Shaw's Tower Grove Park in 1868 and then, in 1874, Forest, O'Fallon, and Carondelet parks. Kansas City, just beginning to grow in the 1860s, did not join the movement for public parks until the end of the century, but then it shot to the front ranks nationally with a visionary yet practical design for parks, boulevards, and residential and commercial districts conceived by landscape architect George Kessler

and realized through a formidable array of civic, political, and entrepreneurial talents. The movement for urban parks was significant in that it drew on and nurtured notions of civic responsibility, planning, and design that would later pay dividends for state parks. George Kessler's successors in park, parkway, and urban planning—S. J. and S. Herbert Hare in Kansas City and Harland Bartholomew in St. Louis and their associates—would make crucial contributions to Missouri's state park system during the 1930s.

The movements for state and, later, national parks had an early tie to the urban movement through the work of Frederick Law Olmsted, principal designer of New York's Central Park, who served as first head of the Yosemite Park Commission after Congress transferred Yosemite Valley to the state of California for protection and management in 1864. Olmsted realized that the prime value of Yosemite was its natural scenery, which the state therefore had an obligation to preserve "as exactly as is possible" and to guard from any constructions that would detract from it. Congress established the world's first national park in the Yellowstone country of Wyoming in 1872, again to protect the fabulous scenery and curiosities of nature from incompatible private exploitation. At the urging of Olmsted and others, New York in 1885 voted to acquire a state reservation at Niagara Falls and to establish a forest preserve on state lands in the Adirondacks. Michigan acquired its first state park, Mackinac Island, in 1885 by transfer from the federal government; Minnesota began acquiring state parks with Birch Coulee, a battleground of the Sioux War, in 1889 and Itasca, at the headwaters of the Mississippi, in 1891; and Massachusetts estab-

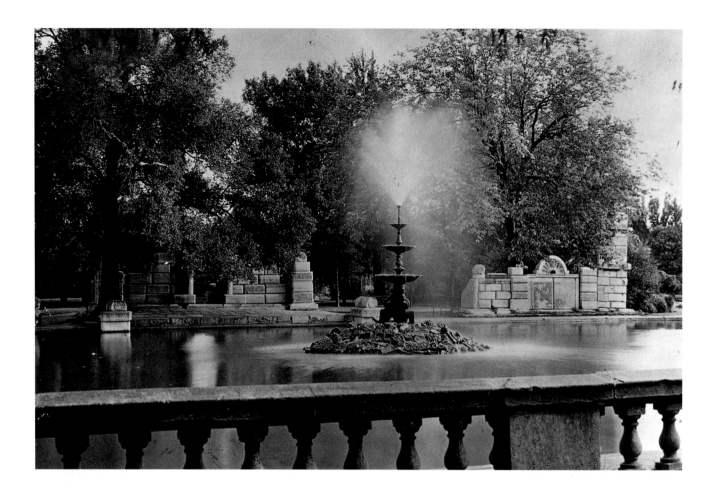

Tower Grove Park, donated to the city of St. Louis by Henry Shaw in 1868, began a tradition of park philanthropy and planning that in the next century would benefit the state park system. The park's fountains, artistic "ruins," pergolas, and other formal design elements from the Victorian era richly merit its designation as a national historic landmark. TOWER GROVE PARK ARCHIVES

lished its Trustees of Public Reservations the same year to begin developing a system of public open spaces.

By the last decade of the nineteenth century and the first decade of the twentieth, the movement for public parks and forests was gaining momentum as part of a progressive era redefinition of the responsibilities of government. Virtually the entire system of western national forests dates from these decades; national parks were established at Yosemite, Mount Rainier, Crater Lake, Mesa Verde, and Glacier; and progressive states such as Wisconsin, Minnesota, California, New York, New Jersey, Maryland, Massachusetts, Pennsylvania, Ohio, and Illinois began or added to their systems of state parks and historic sites.

Missouri also experienced an upwelling of progressive sentiment among its citizenry, character-

ized especially by an emphasis on restraint of special interests and respect for law; but with the state's strong southern tradition of fiscal conservatism and distrust of government, its legislators continued to resist major new governmental programs. Herbert Hadley, a progressive elected in 1908 as the state's first Republican governor since Reconstruction, led well-publicized annual outings on the Current and White rivers in an effort to encourage Missourians' pride in their state and foster their commitment to protecting their resources. But he was thwarted in his efforts to establish state park and forestry programs by the parsimony of the old-line Democratic-controlled legislature, on one occasion failing by only one vote to gain a $160,000 appropriation from the game protection fund to purchase a 5,000-acre park at the fabled Ha Ha Tonka in Camden County.

Before leaving office in 1913, Hadley recommended appointment of a legislative commission to select "some of the natural wonders and beauties" of the state for purchase as parks, and a powerful Ozarkian Democrat, Sen. Carter Buford, won approval for such a commission with himself as chairman. The Buford committee visited and recommended acquisition of sizable parks of

Gov. Herbert Hadley (seated) in a johnboat on the Current River in 1909. The progressive leader led well-publicized float trips on Ozark rivers in an effort to encourage Missourians' pride in their state and foster their commitment to protecting their resources through state parks and other conservation measures. HERBERT HADLEY PAPERS, WESTERN HISTORICAL MANUSCRIPT COLLECTION

Ha Ha Tonka in the 1920s. With its superb concentration of caves, springs, sinkholes, and other karst topographic features and its grandiose castle, Ha Ha Tonka mesmerized Missourians with its potential as a park, perhaps thereby delaying the process of selecting other sites for the state's first parks. Decades later, its castle in ruins, Ha Ha Tonka finally joined the system in 1978. STATE HISTORICAL SOCIETY OF MISSOURI

5,000 acres or more at four sites—the Shut-In Club near Arcadia in Iron County, the Black River near Lesterville in Reynolds County (probably in the vicinity of Johnson's Shut-Ins), Onondaga Cave in Crawford County, and Ha Ha Tonka. But the assembly was still unwilling to appropriate funds, and it would be a half-century or more before most of these prime areas would be secured for state parks.

The movement for state parks in Missouri may have gained impetus from the establishment in 1916 of the National Park Service in the U.S. Department of the Interior, which brought coherence and a sense of mission to the management of the national parks. But even after the Missouri General Assembly in 1917 passed a bill providing that five percent of all fish and game fees be transferred to a special state park fund—the act that is taken as the official establishment of the state park system—it would be seven more years before the state would acquire its first parks. This delay was in part because the money accumulated slowly (after four years there was still less than $40,000 in the fund), but it was probably also because too many people were mesmerized by the lure of Ha Ha Tonka, with its grandiose castle and thirty outbuildings, which was being heavily promoted by real estate interests but was out of reach at an asking price of $300,000. Not until Gov. Arthur Hyde exerted his personal leadership and determination in the early 1920s did a park system begin to materialize.

In his efforts to acquire state parks for Missouri, Governor Hyde must surely have been encouraged by the calling of the first National Conference on State Parks in January 1921 at the invitation of the governor of Iowa. Twenty-eight states were represented, including Missouri, and the enthusiasm generated at this and subsequent conferences spurred the establishment of parks in at least twenty-five states during the 1920s. The movement for state parks was tied closely to that for national parks—in part to relieve the pressure on the national park system for new parks in every state—and also to the movement for better highways, which would connect the parks and open them for tourist development. Formerly an automobile dealer, Governor Hyde enjoyed his greatest successes in molding a modern highway system and a state park system for Missouri.

Realizing that the park fund was growing too slowly to acquire the "chain of parks" he now envisioned, Hyde succeeded in getting the state assembly in 1923 to increase the annual transfer to twenty-five percent of fish and game license fees, instead of only five percent. During his last year in office, 1924, he appointed a new game and

The state regent of the Daughters of the American Revolution, Ethel Massie Withers, showed this glass-lantern slide of the Huston Tavern at Arrow Rock as she traveled the state around 1915 lecturing on Missouri's historic places. The DAR operated a tearoom here and in 1923 encouraged the state to purchase the building, making it Missouri's first state historic site. STATE HISTORICAL SOCIETY OF MISSOURI

fish commissioner, Frank Wielandy, an Izaak Walton League leader from St. Louis who had been a park enthusiast for decades, and the two began canvassing the state—or at least the Ozarks—looking for the best lands to acquire with the $165,000 now in the park fund. Since they wanted five or six parks of 3,000 acres or more, including several of the largest springs, they certainly would not be able to look at highly developed properties like Ha Ha Tonka.

As it happened, the first properties to move toward resolution were small historic sites in which local citizens had long been interested— the old tavern in Arrow Rock and the Mark Twain birthplace cabin in Florida. Like many historic sites that would come into state ownership over the years, each had a citizen support group—the Daughters of the American Revolution and the Mark Twain Memorial Park Association—that secured the site and was willing to make a substantial contribution in the public interest. The 1917 act establishing the park fund had no language defining a park or clarifying its purposes—there would be no such language until 1953—though the fact that the fund originated from game and fish receipts and was administered by the game and fish commissioner naturally led officials to think in terms of lands that could be used to propagate game and fish. The eagerness of citizen groups to promote and support historic sites at the onset of the park program was thus critical to the development of a park system in Missouri that would eventually treat cultural resources on a par with natural resources.

Other than Arrow Rock and Mark Twain, which he happily accepted, the governor and his game and fish commissioner looked solely in the Ozarks for parks, because that is where land was cheap and where recreational and tourist potential seemed greatest. After looking at dozens of properties and turning down many more, Hyde and Wielandy by the end of 1924 had purchased or begun acquisition of six substantial parks in the Ozarks—Big Spring and Round Spring on the Current River, Alley Spring on the Jacks Fork, Bennett Spring on the Niangua, Deer Run near Ellington, and Indian Trail near Salem. Most of these areas had long been identified by their use as recreational sites and by public awe of them as natural wonders, the same kind of awe that led to public pressures for creation of the Adirondack park in New York or the first national park in the Yellowstone country. Together they totaled nearly 24,000 acres and cost about $175,000.

During the next few years a new game and fish commissioner, Keith McCanse, acquired five

more parks—Montauk, Sam A. Baker, Meramec, Chesapeake, and Roaring River, the latter a magnificent 2,550-acre gift from Dr. T. M. Sayman of St. Louis, the first major donation to the system from a private individual. Thus, by 1928 the state had fourteen state parks (including Sequiota, a fish hatchery reclassified as a park) totaling nearly 40,000 acres, acquired at a cost of about $335,000. Of twenty-six states that had created state parks by 1928, only four showed more acreage than Missouri—New York, South Dakota, Minnesota, and Wisconsin; and if state or federal lands reclassified as parks are omitted, Missouri was second only to New York. It was a stunning achievement, especially for a state as conservative as Missouri, an achievement that can only be explained by strong citizen support for saving park areas, unusual gubernatorial leadership, and the availability of splendid park resources at a remarkably low price. Another likely factor was the absence of competition from foresters, since Missouri, unlike most progressive states, had no forestry program whatever as of 1928.

Despite the state's initial success in acquiring a collection of superb parks, park leaders were under no illusion that the state was developing a comprehensive system. Except for Arrow Rock and Mark Twain, all the parks were in the Ozarks, and game and fish officials, cognizant of the source of their funds, were at pains to point out that more than ninety-five percent of park land was being used "strictly for game refuge purposes" and some sixty percent of park expenses were "chargeable directly to game propagation." Public and legislative pressures intensified during the late 1920s and early 1930s to acquire more historical properties and lands north of the Missouri River, but game and fish officials found themselves unable to justify using sportsmen's money for such purchases. In 1932, following years of legislative efforts to force the purchase of parks north of the river, the game and fish department acquired two small areas at Big Lake and Wallace, both of which were developed as fishing sites. The same year, two premier archaeological sites entered the system as gifts— Van Meter, a village site of the Missouri Indians, and Washington, known for its petroglyphs carved by Indians of the Mississippian tradition—but there was no mention whatever of the cultural significance of these sites in news accounts and reports from the game and fish department. Meanwhile, the department felt constrained to demur on an appropriation for a historic site at Fort Osage, dating from the territorial period, on the grounds that it was "not a

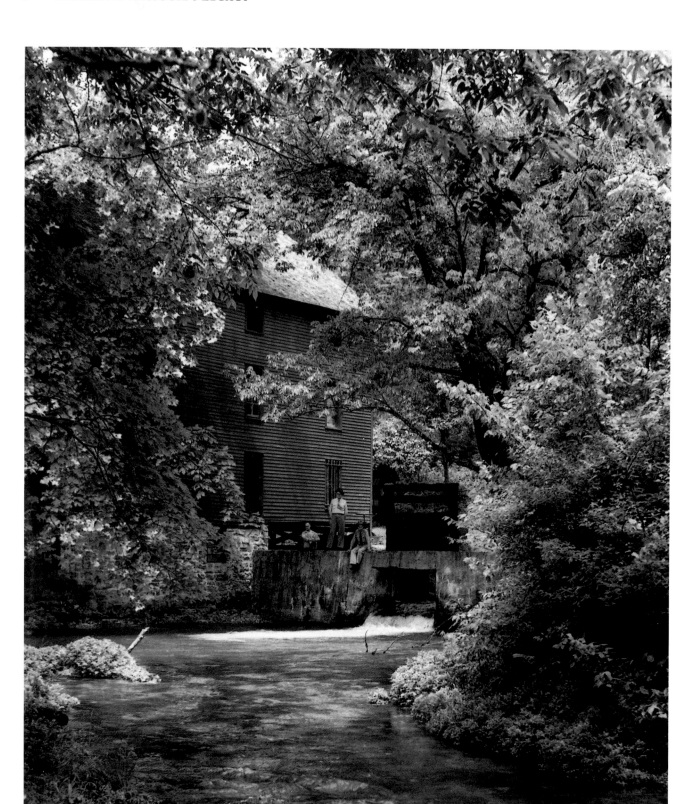

The spring branch and mill at Alley Spring. Gov. Arthur Hyde and other park advocates of the 1920s conceived of the big springs in the Ozarks as jewels on a "chain of parks" connected by modern highways. REX GARY PHOTO, STATE PARK ARCHIVES

wise investment" when considered as a property for the game and fish department.

As fish and game populations in Missouri continued to decline owing to inadequate management and law enforcement, and as departmental revenues fell off during the worst depression in the nation's history, Missouri sportsmen stepped up their efforts, dating back at least to the early 1920s, to take fish and game administration out of politics. By 1932 they were arguing as well against the diversion of license money to parks, as if that were a cause of the decline in harvestable fish and game. (What they wanted was more money for artificial propagation, a technique that leading professionals in the field already knew would not solve the problem.) But once again the assembly failed to take action.

A New Deal for the Parks

If hunters and fishermen viewed parks as the source of their woes, they would have even more cause for concern after the inauguration of Franklin Roosevelt's New Deal in March 1933. For Missouri, with its large acreage of parks ripe for development, was fortuitously poised to take maximum advantage of the Emergency Conservation Work (ECW) programs of the New Deal, and that in turn would mean even more expenditure of time, effort, and money on parks by the game and fish department. Over the next few years thousands of young men in work crews of the Civilian Conservation Corps (CCC), the Works Progress Administration (WPA), and other New Deal programs would literally give shape and definition to the parks, laying out and constructing roads and bridges, entrance gates, hiking and bridle trails, lakes with dams and spillways, swimming beaches, pools, and bathhouses, campgrounds and picnic shelters, group camps, tourist cabins and dining lodges, water and sewage systems, comfort stations, and service centers. By the end of 1936 Game and Fish Commissioner Wilbur Buford, who served as state coordinator for the ECW, reported that more than $25 million in federal funds had been expended in Missouri, a considerable portion of it in state parks.

Virtually every park in the system benefited from the federal programs, and several new parks were added to take advantage of the open moneybags. The most grandiose plans centered on the huge new Lake of the Ozarks, formed after the completion of the Union Electric Power Company's Bagnell Dam on the Osage River in 1931.

Seeing federal dollars in the offing, the company had hired the two leading architectural and planning firms in the state—Harland Bartholomew and Associates of St. Louis and Hare and Hare of Kansas City, known for their urban parks and parkways—to present recommendations for its property around the lake. The consultants recommended three separate state parks totaling 18,000 acres, preservation of large stretches of shoreline, and seventy miles of parkways. When the Missouri State Planning Board was established in late 1933 in response to federal mandates for state-level planning, Bartholomew and Hare were ready to serve as consultants and further their plans for Lake of the Ozarks as a focal point for tourism in the state. By 1934, when the New Deal began a program for federal purchase of submarginal agricultural lands for conservation purposes, including a system of Recreational Demonstration Areas conceived by the National Park Service, Lake of the Ozarks quickly emerged as a likely site. Missouri was second only to Pennsylvania in the number and extent of its demonstration areas, all of which would be developed by the National Park Service but were slated eventually (1946, as it happened) to become state parks: Lake of the Ozarks, at 16,000 acres far and away the largest park in the system; Cuivre River, about 6,000 acres; and Montserrat (later called Knob Noster), 4,000 acres.

Other parks added during the early years of the New Deal included Sugar Lake (later renamed Lewis and Clark), donated by a group of Buchanan County sportsmen, and the Dr. Edmund A. Babler Memorial State Park in St. Louis County. Jacob Babler, who donated the park with his brother Henry, was well connected in St. Louis civic, planning, and political circles, and he clearly intended the park as a unit of the "outer park and parkway system" envisioned by civic leaders since the dawn of the century. He commissioned Harland Bartholomew to design the park and used his political influence to secure not one but two CCC camps and a WPA crew to develop it. Another park heavily promoted at the time by a local park association and other civic groups in northern Missouri, as well as by the state chamber of commerce, was intended as a memorial to a native son, Gen. John J. Pershing, but it had to await resolution of the tension between state parks and game and fish before it too could take advantage of the federal development programs.

More significant even than the sheer quantity of development by the CCC and WPA was the quality. All work was carefully planned in advance and supervised by professional architects,

The young men of the Civilian Conservation Corps in the 1930s gave shape and definition to the parks, carefully crafting more than five hundred structures of rustic stone and wood. Above, the tent camp at Sam A. Baker, with the completed stable in the background (STATE PARK ARCHIVES). *Below, a crew at work on a stone cabin at Big Spring* (NATIONAL ARCHIVES).

landscape architects, foresters, and civil engineers, most of them in the employ of the National Park Service. National Park Service standards and criteria governed the work and even some of the management policies of the parks, which now emphasized "biotic values" in contrast to some of the more manipulative forestry and game propagation practices favored by the game and fish department. Thus, the New Deal not only left a legacy of superb design and expert craftsmanship in rustic wood and stone, most of which still enhances the parks and sets a standard for contemporary development, but it also legitimated management policies for state parks on the model of those for national parks rather than those for game propagation or forestry. As it happened, quite unexpectedly, differences in management philosophies would have an opportunity to incubate over the years in two separate state agencies, one for game, fish, and forestry, the other for parks.

An effort of more than a decade to establish a citizen commission that would insulate the Missouri Game and Fish Department from politics and provide for more professional administration and continuity of policy finally bore fruit in 1936, when a coalition of civic leaders and sportsmen secured passage by statewide initiative petition of a constitutional amendment establishing a four-member bipartisan conservation commission. The amendment, which was to take effect July 1, 1937, gave the commission authority to manage the bird, fish, game, forestry, and wildlife resources of the state, but it was totally silent on the matter of state parks.

Whatever the intentions of the promoters of the amendment, its effect was to force an alternative arrangement for the parks. The general assembly in its 1937 session passed an emergency act to establish a state park board consisting of the governor, the attorney general, and the director of conservation, with the director of conservation to serve also as director of state parks. And, for the first time, the assembly appropriated funds from general revenue for operation and development of the parks. Almost as if to proclaim the removal of the strictures that had guided the use of park fund moneys derived from sportsmen's licenses, the assembly also made specific appropriations for acquisition of the long-sought Pershing Memorial Park, of another park in northern Missouri to commemorate Gen. Enoch Crowder, of a new historic site at Fort Zumwalt, and of additions to Mark Twain and Van Meter. Thus, the year 1937, which saw the sundering of the bonds between game and fish and state parks and the beginning of the long process of extrica-

A lumber company was about to cut down the biggest oak tree in Missouri when it and the eighty-acre remnant of Mississippi swamp forest on which it stood were rescued in 1937 by concerted citizen action. STATE PARK ARCHIVES

tion, also witnessed one of the most successful legislative sessions in the history of the park system. Another park, Big Oak Tree, entered the system on an emergency basis later that year when citizens responded to a lumber company's plans to level the virgin forest surrounding the biggest oak in the state.

It was by no means clear how the new relationship between parks and conservation would work out or even who would manage the parks. The attorney general advised that parks used exclusively for fish and game should be under the jurisdiction of conservation and those used for recreation under the park board, while for those containing both wildlife and recreational resources—virtually all of the parks—the wildlife areas would be controlled by the conservation commission and the recreational areas by the park board. Obviously, there would be problems to sort out.

In retrospect, it appears that the newly elected governor of the state, Lloyd Stark, was supportive of parks and intent on placing them on a firm

management footing. His four appointees to the new conservation commission included two who clearly were park-minded: A. P. Greensfelder, donor of Washington State Park and a member of the state planning board, and former game and fish commissioner Wilbur Buford, who had won the respect of federal officials for his management of the ECW program in the parks. The governor, above all, did not want to do anything to jeopardize continued federal funding of park development. He let it be known that he favored the appointment of a professional with federal experience as conservation (and park) director, and the conservation commission eventually selected I. T. Bode of Iowa, a forester who had served with the U.S. Biological Survey. In order to develop in-house planning capability for parks, as increasingly expected by the National Park Service, Bode and Stark selected an assistant director for parks, E. A. Mayes, who had had experience with both the state and national planning boards, and they hired several other professionals as well. The state planning board prepared a comprehensive state park plan for Missouri during 1938–1939, and Harland Bartholomew and S. Herbert Hare continued to consult on master plans for individual parks. Thus park planning and administration advanced to a new level of professionalism in Missouri—one it would not see again until the 1970s—and federal dollars continued to flow, especially to develop the new parks in northern Missouri.

A review of the 1938 park plan suggests that despite the newfound professional basis of the state park system, modeled on that of the national park system, conceptions of the values of parks were still constrained by present realities. On a map of "lands suitable for recreation," for example, the parks are limited primarily to the scenic, "submarginal" Ozarks, while proposed units termed "recreational areas" (presumably not scenic enough to merit full park status) are scattered elsewhere in the state. The plan briefly mentions the desirability of including in the system distinctive natural features such as native Missouri prairie and important historic sites, but no such sites are identified among the proposed expansions and there is little sense of state parks as a system representing the full spectrum of the state's natural and cultural heritage. Full consciousness of the value of such resources had yet to evolve.

The plan also offers insights on the financing of the system. Nearly $20 million had been invested in the system through 1938, according to the plan: less than $1.5 million by the state ($550,000 in land acquisition and $915,000 in de-

velopment and operation) and the remainder by the federal government. Of fourteen upper midwestern states selected for comparison, Missouri ranked second only to Illinois in the number of park service CCC camps it had been allocated, while it had spent only a third to a fifth as much per capita on parks from state revenues during the 1937–1938 biennium. Missouri, with its superlative scenic resources, its strong tradition of urban parks and park planning, and its unabashed willingness to mine sportsmen's license fees to purchase parklands during a formative period, had managed, with fortuitous federal assistance, to build a remarkable state park system with incredibly little in the way of state funds. The challenge now would be to come up with sufficient funds to maintain and develop that system.

Although the park plan optimistically recommended enhanced state funding, an aggressive program of land acquisition, and stronger and clearer statutory authority for the park board (in a "confidential supplement" it suggested that the current board composed of major state executives was inadvisable and proposed a citizen board), in fact the park system entered a period of severe constraints, retrenchment, and even crisis in the 1940s. It began with the election of 1940, in which a Republican, Forrest Donnell, won the governorship by a hair's breadth against the odds. With a new administration from a different political party, old arrangements were open to question—especially, as it turned out, the relationship between the park board and the conservation commission.

Since 1937, all major policy decisions, acquisitions, and appointments involving state parks had essentially been made out of the governor's office, with some patronage positions given to the attorney general. But day-to-day management during Stark's term was largely by administrators, including E. A. Mayes, whose appointments were split between conservation and parks and who reported to I. T. Bode in his dual capacities as director of conservation and of parks. The two agencies shared the same offices. There was talk of dividing the lands, but it was not done—and, for the most part, technicians in each agency plied their craft on the same lands. Without the management expectations of the National Park Service that came along with the federal funds it supervised, the management of parks and conservation would likely have been even more intermingled and confused than it was.

Under the new Republican administration, beginning in 1941–1942, the central offices, key staff positions, and land-management units of

conservation and parks were formally and physically separated. The conservation commission took over the full salaries of all employees who had been on split appointments, and the park board hired a new chief, Fred W. Pape, former director of Forest Park in St. Louis. I. T. Bode retained his statutory authority as director of parks until a further reorganization in 1953, but he had little role in running the agency. The park board voted to surrender to the conservation commission its jurisdiction over Sequiota and Chesapeake state parks, which had been used primarily as fish hatcheries, and over the 22,000 acres of forests at Deer Run and Indian Trail, which had never been developed for general recreation and had only a few thousand visitors each year. There was discussion about other areas, including Big Lake, Lewis and Clark, Meramec, and Sam Baker, in which the park board authorized the conservation commission to continue certain management activities, but no other parks were transferred. After years of simmering controversy, an agreement in 1980 gave conservation the portion of Meramec east of the river for a state forest while Baker was retained exclusively under parks management. The conservation commission still retains jurisdiction and management of the trout hatcheries in Bennett, Montauk, and Roaring River state parks and has regulatory jurisdiction over the fish and wildlife in other parks, subject to the land management authority of the parks division.

Retrenchment and Redefinition

As the nation became preoccupied with World War II, the parks entered a holding pattern, or worse. Federal work relief programs came to an end, and labor costs suddenly more than doubled, if park workers could be found at any price. The entire professional staff left for the war effort. Personnel funds were nearly exhausted by March 1943, and the park board discussed closing up shop. In the end, the parks continued to operate, but just barely.

The pressing financial crisis of the parks was addressed in part by a provision slipped into the state's proposed new constitution in 1944 by park benefactor Jacob Babler, a Republican delegate to the constitutional convention. It mandated an appropriation from general revenue each year for the next fifteen years of not less than one cent on each $100 of assessed valuation. This would pro-

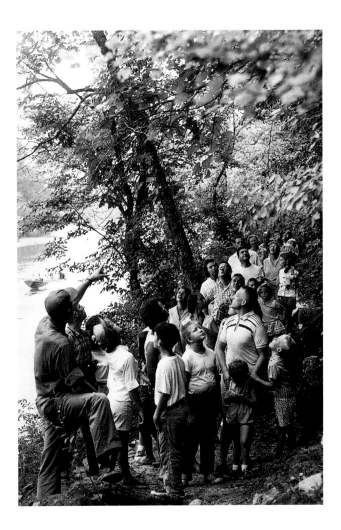

A park naturalist introduces a group of visitors to the wonders of nature. The highly popular naturalist program began in 1937 and continued on a reduced basis even during the war years. HADLEY K. IRWIN PHOTO, STATE PARK ARCHIVES

vide about $400,000 a year, not a princely sum but several times as much as parks had had during the war years. Babler also had a legislative bill introduced to create stronger, clearer statutory authority for the parks, along the lines recommended in the 1938 state park plan, and to establish a new bipartisan citizen park board. Missourians adopted the new constitution with its funding mechanism for parks in February 1945, and in May the general assembly passed Babler's park bill. Babler died on June 1, and on June 4 a new Democratic governor, Phil Donnelly, vetoed the park bill, for technical and—so Republicans charged—political reasons.

The old park board headed by the governor thus continued at the helm. The board hired a new park director, Abner Gwinn, a highway department engineer selected for his ability to deal with the backlog of deferred maintenance.

Gwinn would also have to set up state adminis-
tration for the three former recreation demonstra-
tion areas—Lake of the Ozarks, Cuivre River,
and Knob Noster—which the state was finally
able to accept in 1946 after funds from the new
constitutional appropriation began to flow. Once
people began to sense that there was money, vari-
ous groups appeared before the park board to pro-
mote new parks—Fort Osage, Wilson's Creek,
Battle of Lexington, Sappington Cemetery, Con-
federate Memorial, Battle of Athens, Fort David-
son. Historic sites such as these seemed over the
years to attract more citizen initiative than other
kinds of parks, but the board did not view itself
as having the authority (or the funds) to acquire
such sites, nor was the legislature responsive, so
there were no new parks until 1952. In that year
four new parks entered the system, mostly by do-
nation: Thousand Hills, from the city of Kirks-
ville; Confederate Memorial, transferred by the
legislature; the Pershing boyhood home, pur-
chased through the good offices of the Pershing
Memorial Park Association; and Hawn, a sur-
prise bequest from a country schoolteacher,
Helen Coffer Hawn.

Throughout the postwar years, political
charges continued to swirl around the park
board, particularly regarding the patronage sys-
tem and exorbitant profits made by park conces-
sionaires, and numerous attempts were made to
reform the system. Then, in 1953, a bill similar
to the Babler bill of 1945 passed the assembly
and was signed by the same governor who had ve-
toed the earlier measure, Phil Donnelly, recently
reelected. In addition to setting up a bipartisan
citizen commission of six members with stag-
gered four-year terms, the new act provided a
definition of a park that still forms the basic stat-
utory expression of the mission of the park sys-
tem: a park is "any land, site or object primarily
of recreational value or of cultural value because
of its scenic, historic, prehistoric, archaeologic,
scientific, or other distinctive characteristics or
natural features."

Not only was it now clear that historic sites
were included in the definition of a park, but it
was also clear that the legislators intended the
system to be broadly representative of the dis-
tinctive natural and cultural resources of the
state, much as the national park system is repre-
sentative of the nation. And it was clear that the
criteria of significance for selecting new state
parks related to their distinctive historic or natu-
ral features and the recreational or cultural values
derived from them. This was nothing new; it was
an expression in law of the park philosophy that
had been evolving in the state to that time. But,

just as the 1916 act establishing the national
park system mandated conserving "natural and
historic objects" years before the park service be-
gan acquiring deserts, grasslands, wetlands, and
other nonforested, nonmountainous terrain and
before the service was given major responsibility
for historic sites as a result of federal reorganiza-
tion and passage of the Historic Sites Act of
1935, so too Missouri still had a long way to go
to realize the comprehensive array of natural and
cultural resources implied by its mission state-
ment in the 1953 act.

Under the new citizen commission an array of
new parks entered the system, beginning with
the magnificent Johnson's Shut-Ins in 1955 from
the Desloge Foundation. Later in 1955, Joseph
Jaeger, Jr., a conservation department forester, be-
gan a tenure as park director that would intersect
the administrations of five governors, extending
(with a two-year hiatus in the mid–1960s) until
1973. A dynamic and politically astute adminis-
trator, Jaeger sought, within the limits of avail-
able funds, to shape a more comprehensive sys-
tem and to professionalize its administration.
During the next fifteen years, twenty-six new
parks would enter the system, many of them his-
toric or archaeological sites and nearly all of
them donations, as the park board adopted a pol-
icy of accepting only donated units—and, later,
only donations for which the legislature would
provide specific appropriations for initial develop-
ment—in order to conserve its meager funds for

*State park director Joe Jaeger and University of Mis-
souri archaeologist Carl Chapman examine a newly
constructed shelter over the petroglyphs at Washing-
ton State Park in 1963. By this time, park officials
were making concerted efforts to expand the system's
representation, preservation, and interpretation of
cultural resources.* HADLEY K. IRWIN PHOTO, STATE
PARK ARCHIVES

operations and maintenance. Missouri voters in 1960 overwhelmingly approved a twelve-year extension of the constitutional one-mill appropriation for state parks instituted in 1945, but the funds were decidedly inadequate to support a rapidly growing system.

Citizens of Cape Girardeau County, undoubtedly encouraged by a local park board member, voted a $150,000 bond issue in 1956 to purchase a park on the bluffs of the Mississippi to commemorate the Cherokee Indians' Trail of Tears. A series of reservoir parks were developed on donated leases from the U.S. Army Corps of Engineers—Lake Wappapello and Table Rock in 1957, Pomme de Terre in 1960, and Stockton in 1969—and another water-based park, Wakonda, was donated by the state highway commission in 1960. The United Automobile Workers union donated Harry Truman's birthplace in Lamar in 1957, the Anderson House and Lexington Battlefield Foundation gave Battle of Lexington in 1958, and Boone's Lick came to the state in 1960 as a gift from Russell Clinkscales and Horace Munday. That same year the governor provided money from a special fund left over from the Spanish-American War to purchase the buildings that had housed the first state capitol in St. Charles. In 1964 two parks that are now national historic landmarks entered the system—Watkins Mill, donated by the Watkins Mill Association and the citizens of Clay County, and Graham Cave, donated by Frances Graham Darnell—together with a large park in St. Francois County, donated by local taxpayers and St. Joseph Lead Co.

After the Jefferson County court transferred the grave site of Gov. Daniel Dunklin to the state in 1965, the legislature in 1967 authorized the park board to maintain any grave of a former governor that was not within a perpetual-care cemetery, as well as any covered wooden bridges donated to the state. These provisions resulted in the addition of the Burfordville, Union, Sandy Creek, and Locust Creek bridges to the system in 1967–1968 and, in 1970, the Sappington and Jewell cemeteries. Five other parks entered the system in 1967: Elephant Rocks through a gift by John Stafford Brown; Bollinger Mill from the Cape Girardeau County Historical Society; the Hunter-Dawson home from the city of New Madrid; Rock Bridge from the Rock Bridge Memorial Park Association, supplemented by federal funds; and the Towosahgy archaeological site, also with newly available federal funds. In 1969 Fort Davidson was leased to the state by the U.S. Forest Service, and in 1970 descendants of the Vallé and Rozier families donated the Felix Vallé home in Ste. Genevieve.

The Recreation Boom

The rapid expansion of the Missouri state park system during this period was not at all unusual compared with other states. In fact, the Missouri system expanded less than those of many other states that passed major bond issues or other special funding mechanisms for parks in the early 1960s. Even without any major funding for parks in Missouri, the expansion seemed fully warranted by the surge in attendance, which stood at only about half a million in 1945—down from a million before the war—but exploded to a reported six million visitors by 1960 and over fourteen million in 1970, when a computer projection placed future visitation at more than twenty-three million by 1980. Attendance figures can be notoriously unreliable, particularly in a state like Missouri that does not collect an entrance fee, and the figures from the 1960s, at a time when officials were trying to win greater appropriations for their burgeoning system, are probably especially so. Yet anyone who visited the parks knew that they were popular and could see that they were being overwhelmed.

The dramatic increase in attendance at state parks in Missouri during the postwar years was part of a national surge toward outdoor recreation, spurred no doubt by the ready availability of automobiles and better highways, more leisure time, and other manifestations of what has come to be known as the "consumption society." In response to this phenomenon, the U.S. Congress in 1958 created an Outdoor Recreation Resources Review Commission, which issued a battery of reports and recommendations including a proposal for a federal grants-in-aid program to assist state and local governments in the purchase and development of recreational lands. Congress followed through in 1964 by establishing the Land and Water Conservation Fund (LWCF), which mandated state-level planning, as in the 1930s, but also insisted on one-to-one matching contributions.

The first $700,000 for state parks from the LWCF began flowing in 1966. Included in the first batch of projects, in addition to numerous small items for water, sewer, campground, and picnic area development at existing parks, were acquisition funds for Rock Bridge and Towosahgy. From then through 1990, Missouri would receive more than $68 million through the federal fund, about $17.6 million of which would be allocated to projects in the state parks, with most of the remainder going to local parks. Annual apportionments to Missouri started modestly in the 1960s, increased to a high of nearly $7.5 million by the

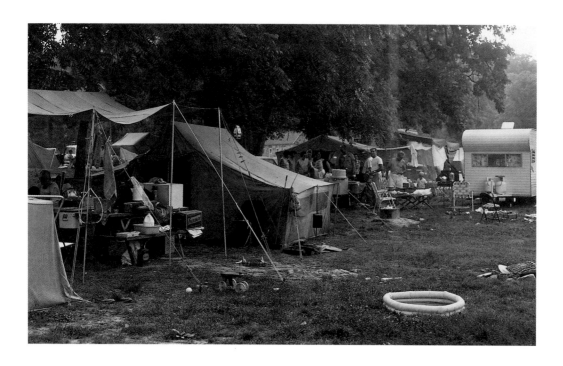

By the late 1960s, the explosion of recreational use in the parks had made campgrounds like this one at Bennett Spring, still without any designated individual spots, greatly overcrowded and in danger of becoming outdoor slums. HADLEY K. IRWIN PHOTO, STATE PARK ARCHIVES

late 1970s (about a third of which went to state parks), dropped to nothing in 1982 during the Reagan administration, and then tailed off to about $500,000 during the second half of the 1980s, with all funds allocated to local parks. The total of about $17.6 million allocated to state parks over the years helped the state to purchase ten new parks and to accept donations of several others that it might not have been able to develop without federal aid. In all, LWCF matching funds helped with acquisition or development projects involving fifty different state parks in Missouri.

The new era of federal aid also had another type of impact. Because it originated from a concern for outdoor recreation and provided so much funding for municipal and other local park systems, where the emphasis was heavily on intensive, facility-based recreation—playing fields, swimming pools, tennis courts, golf courses, fitness programs, and the like—the federal program shifted public attention and professional involvement toward the recreation aspect of the tripartite natural-cultural-recreational mission of the state park system. Acquisition and development funded through LWCF had to be justified in terms of a contribution to public recreation, rather than to resource preservation or cultural interpretation. And most of the newly trained recreation professionals hired for the state park system were products of programs that emphasized facility-based rather than resource-based recreation.

Fortunately for the state's rather vulnerable new ventures into preservation and restoration of historic sites, the federal government during the late 1960s also gave impetus to cultural concerns through the Historic Preservation Act of 1966, which established a National Register of Historic Places and a modest program of matching grants to help states prepare preservation plans, conduct surveys, and assist in preservation of sites. This program, like the outdoor recreation grant program, was administered in Missouri by the state park director, thus providing some possibilities for coordination with park programs.

The pressures of recreational use, severe as they were by the 1960s and 1970s, were more widespread but probably no more intense in the parks than they had been at certain popular getaways like Lincoln Beach, on the lower Meramec River near Castlewood, when this photograph was taken around 1930. Castlewood joined the state park system in 1974 after the federal Land and Water Conservation Fund of 1964 helped states to acquire additional lands for recreation. ST. LOUIS POST-DISPATCH PHOTO, STATE PARK ARCHIVES

The late 1960s and early 1970s were years of heightened interest nationwide in preservation of natural as well as cultural and recreational areas—indeed, *ecology* became a household word by 1970—but there seems to have been relatively little focus on ecological matters at the time with respect to Missouri's state parks, among either the park staff or the citizenry. Environmental attention was focused more on federal agencies and, within the state, on the conservation department, which was engaged in a concerted effort to broaden its mission and public appeal through what would become known as the "design for conservation." Conservation and environmental organizations in Missouri paid little attention to state parks.

Thus, there was scant public objection when, as of January 1, 1970, the park board conveyed three of the original big-spring parks—Alley Spring, Big Spring, and Round Spring—to the National Park Service for management as part of the Ozark National Scenic Riverways. Congress had passed the bill protecting the Current and Jacks Fork rivers in 1964, making them the first federally protected, natural, free-flowing streams in the nation and the model for the National Wild and Scenic Rivers Act of 1968. Some park officials viewed the transfer as a way to get additional federal dollars for recreation development in Missouri, thus freeing state funds for other state parks. It was a point of pride that three state parks were deemed worthy of inclusion in a unit of the National Park Service, but for some park-minded citizens of a later day this loss of three of Missouri's "crown jewels" would be a source of considerable angst.

The pressure of recreational use on the parks seemed almost overwhelming by the early 1970s. Whether or not there were fourteen million visitors annually, as attendance figures indicated, it seemed as if there were and as if the number could only grow. (In fact, the figure dipped to nine million by the mid-1970s, though no one seemed to think there were any fewer people in the parks.) Whatever the numbers, picnic areas, swimming beaches, and campgrounds were bursting at the seams, with campers pitching their tents or parking their vehicles wherever they could find a spot of ground. To reverse the trend toward "outdoor slums," the park board decided to establish strict "carrying capacities" for campgrounds, with clearly marked, designated spaces, and to turn latecomers away if necessary. Then they announced the system's first general user fee—$10 a year per vehicle or $1 per day, effective January 1, 1973—in order to fund a program of park development.

A new governor was inaugurated in January 1973—Christopher Bond, the first Republican since 1940. During his campaign, Bond had let it be known that there would be a new park director if he was elected, and he also challenged the legality of the user fee, which was subsequently rescinded. When Jaeger tendered his resignation as park director, the park board hired James Wilson, a personable young administrator with a degree in marketing who had had considerable experience with urban parks in St. Louis and also had strong Republican credentials.

Wilson was decidedly recreation-minded; he was intent on developing park facilities to make them attractive to people from the cities, and at the same time he wanted to teach people from the cities how to enjoy the parks. He also liked to acquire land, and during his four years at the helm he secured several popular recreational parks—Finger Lakes and St. Joe, former mine lands especially attractive to "dirt bikers"; Castlewood and Bothwell, long famed as recreational retreats for urban visitors; Battle of Athens, acquired initially for its recreation potential; and Harry S Truman, on a corps reservoir. He also added four fine cultural properties to the system, two as a result of strong citizen action: Mastodon through the efforts of the Mastodon Park Committee and Jefferson Landing through the efforts of historic preservationists, along with Dillard Mill, by donated lease from the L-A-D Foundation of Leo A. Drey, and the Thomas Hart Benton home and studio, by purchase after the artist's death.

But Wilson had little opportunity to manage the parks, for he was caught up almost immediately in struggles over reorganization of state government, and then, after the legislature decided to transfer parks to a new super agency, the Department of Natural Resources (DNR), he became the first director of the department effective July 1, 1974. The 1974 reorganization had little to do with parks per se, having been dictated primarily by the need to consolidate agencies for more efficient government, but it had a significant impact on the parks nevertheless. The park board became an adjunct and eventually ceased to exist (a new advisory board was appointed by the governor in 1987). Park personnel fared much better, being grandfathered into the state's merit system, where they received substantially higher salaries—salary levels that for the first time made possible the recruitment of professional career employees for virtually all supervisory positions. As one of five divisions—the division of parks and recreation—of a department concerned largely with regulatory functions involving air and water quality, solid waste, toxic substances, land reclamation, and the like, the parks would on occasion become the unintended victims of controversies not of their making. But the new department also provided opportunities for mutual cooperation and synergism; it was an innovative and exciting place to work in the mid–1970s, and it attracted more than its share of bright young professionals. Among them were three new employees in the planning division—Fred Lafser, John Karel, and Wayne Gross—who would serve as successive directors of the park system, beginning a tradition of appointment from within the agency.

Stewardship of the System

The mission of the department of natural resources, wise stewardship of Missouri's resources, became the touchstone also of the park program under Fred Lafser, an environmental engineer who took over as park director in 1977 during the administration of Gov. Joe Teasdale, a Democrat. Without retreating from the commitment to make the parks accessible for recreational enjoyment, Lafser intended to place new emphasis in planning, interpretation, and management on the value of natural and cultural resources, "with the protection of the integrity of the resource a paramount consideration."

Though preservation of distinctive scenic, historic, archaeological, or scientific features was enshrined in the state park statutes, and the system from the beginning had protected such features, in fact most park staff thought of themselves as managing recreational facilities and people rather than land and resources. The prevailing notion was that land would automatically be preserved if it were protected from destruction by people. To the extent that fish, wildlife, or forest management was required, the experts in the conservation department stood ready. Over the years they did a fair amount of fish stocking, planting of wildlife food plots, and thinning of forests, and they conducted deer and turkey hunts in some of the parks as well. In this respect, Missouri park administration was no different from the early National Park Service, which also had not thought it necessary to have scientific expertise on staff but instead relied on professionals in the Forest Service and other agencies for advice and for resource management. The National Park Service was criticized by scientific groups as early as the 1920s for commodity-oriented management practices inappro-

priate to national parks, and in the 1930s it began some modest park-oriented scientific research, but as late as the 1960s it was taken severely to task in several prestigious reports for failing to restore and maintain ecological integrity in the parks.

It was general awareness of new policies and perspectives nationwide on ecological land management that informed Lafser's efforts to focus more attention on stewardship in Missouri's parks. Following the lead of John Karel, whom he asked to head a new natural history program in the parks division, he initiated an inventory of natural areas in the parks, established a system of wild areas, and developed new management policies geared toward preserving and restoring natural biological communities, including old growth forests and natural grasslands and wetlands. He hired substantial numbers of naturalists, historians, and other resource-minded professionals who could develop management and interpretation appropriate to the mission of the park system. The park division decisively assumed full management responsibility for all park lands and waters, except for the hatcheries in the trout parks, though it continued to cooperate with the conservation department on many matters of mutual concern.

The resource-consciousness of this period was reflected also in park acquisitions, which included the superb karst features of Ha Ha Tonka, added to the system in 1978 after literally seven decades of effort, and the stunning tallgrass prairie landscape of Prairie State Park, negotiated in 1978 and purchased in 1980—with the help of the Land and Water Conservation Fund, like most other parks during this era. Two fine German buildings were donated to the state in 1978 by the Brush and Palette Club of Hermann for Deutschheim State Historic Site, though another state historic site, Fort Zumwalt, was transferred to the city of O'Fallon. Other more recreationally oriented parks that entered negotiation in the late 1970s included Robertsville (purchased in 1979), Weston Bend (1980), Long Branch (1982), and Onondaga (1982), the fabulous show cave identified for its park potential by the Buford commission of 1915, along with Ha Ha Tonka. Three other important properties came into the system in the early 1980s after many years of negotiations: the Scott Joplin house, donated by the Jeff-Vander-Lou neighborhood development corporation in 1983; Grand Gulf, donated in 1984 by Leo Drey's L-A-D Foundation; and Osage Village, purchased in 1984 from the Archaeological Conservancy, which had bought it for the state.

By the time most of these negotiations took place, Lafser had become director of the department of natural resources; after an interim year, natural history coordinator John Karel in 1979 took over as park director. Karel, who would serve for six eventful years under both Democratic and Republican administrations, was committed to continuing the stewardship emphasis, but, with a background in history as well as wildlife ecology, he was determined to bring cultural resources to equal billing with natural and recreational resources and to develop a fully integrated system. As the sixth park director in little over six years during a period of major change, he was especially conscious of the need to forge a sense of unity, professionalism, and pride in the parks among the division's staff by heightening their consciousness of the special mission of the system. Thus, early in his tenure, he worked with the staff to study the history and statutory basis of the system in order to develop the simple statement of the threefold mission of state parks that would guide policy and development from then on: "To preserve and interpret the finest examples of Missouri's natural landscapes; to preserve and interpret Missouri's cultural landmarks; and to provide healthy and enjoyable outdoor recreation opportunities for all Missourians and visitors to the state."

Among other efforts to integrate the elements of the mission and forge a sense of unity, the staff engaged in a conceptual planning process that entailed regular discussions of the character and direction of each of the parks and established priorities for development; this process still continues and, among other advantages, provides an up-to-date five-year plan for each of the units of the system. The division also completed an ambitious natural heritage inventory of the system and launched an equally ambitious survey of CCC and WPA architecture in the parks. The natural heritage inventory led not only to greater staff consciousness of the value of the natural resources in the parks but also to a path-breaking program of ecological restoration. Nine remnant prairies totaling more than 2,200 acres in five parks were burned in 1980 under the direction of park scientists to remove woody growth and encourage regeneration of native grasses and wildflowers, and the program grew with the years.

The survey of New Deal architecture, which would result in the 1984 nomination of eleven historic districts and nearly three hundred and fifty separate structures to the National Register of Historic Places—the most extensive multiple resource nomination in the nation up to that time—was especially effective in heightening the staff's awareness of and pride in cultural re-

sources throughout the system. Prior to the survey, most staff in the parks (as opposed to the historic sites) probably had never even thought of their parks as having cultural resources; after it, these fine New Deal structures and historic structures from other eras took their place in park plans as priority candidates for restoration—most of which has since been completed.

For all the creative leadership and substantial federal funding of the late 1970s, the park system continued to struggle financially. Federal funds went toward acquisition and development, not operation and maintenance. Despite the creative use of donations, the fifty-fifty matching requirement for federal funds meant that at least some state funds had to be used as well. Meanwhile, state funds from general revenue, which provided the main day-to-day support of the system, rarely increased—and, at a time of heavy inflation, actually decreased in real terms. The result was a slowly growing system with a declining base of support. And the situation would get worse before it would get better, reaching a nadir in 1982 when federal funds dried up and recession forced a series of recisions in state support. The $7.7 million park budget for fiscal 1982 was little

more than half what it had been in the late 1970s.

In every legislative session during the early 1980s numerous proposals were introduced to deal with the crisis of the parks. To some legislators and others, an obvious solution was to transfer the parks to the conservation department, where they could be funded out of the one-eighth-cent sales tax the citizens of Missouri had voted in 1976 to fund that department's "design for conservation," which included an ambitious program of land acquisition. To some conservative Missourians who disliked extensive acquisition of land by government, support of the park system seemed a preferable use for the money, while to some conservation officials, who had long thought they could do a better job of manag-

A heightened consciousness of the need to maintain the ecological integrity of the parks led by 1980 to an active program of experimentation in techniques of ecological stewardship that included the use of prescribed fire under the direction of park scientists to restore native grasslands, as here at Prairie State Park. This scruffy, brushy area is now magnificent tallgrass prairie. PAUL W. NELSON

ing the parks, taking on this obligation seemed also to be a way to forestall perennial attempts to repeal the tax. To DNR and park officials, who were just as concerned to preserve the distinctive mission and management philosophy of the parks as they were to solve the fiscal crisis, the apparent willingness of some members of the conservation commission and department to provide for the parks suggested a far preferable solution—transfer of a portion of the tax to parks for their continued management within the department of natural resources. To many citizen groups, including the powerful Conservation Federation of Missouri, which had led the effort to create the conservation commission in 1936 and then to pass the tax in 1976, any proposal to use the conservation tax seemed an intolerable raid on funds the citizens had voted for conservation—but there were differences between and even within groups as to whether the parks would be better off under natural resources or under the conservation department.

Most citizen groups, including the conservation federation, which typically favored the conservation department, and the Sierra Club, which was more environmentally inclined, had simply not focused their attention on state park issues up to that time; although awareness was beginning to spread, many members had little understanding of park resources or the new stewardship program and thus did not think of parks as particularly relevant to their concerns. The parks division had traditionally appealed for its constituency to recreational user groups and local historical and civic associations, most of which related to individual parks more than to the needs of the system as a whole and thus were not much in evidence on the legislative playing fields of the early 1980s.

In the heat of the legislative crisis of 1982, some Missourians began to appreciate the extent to which the park system had been neglected by the existing citizen organizations, and, at the urging of the park director, they determined to rectify the problem by organizing a Missouri Parks Association. The first citizen group devoted solely to the state park system, it would seek to foster public understanding of the values embodied in the parks and historic sites and to serve as a watchdog and support group for the parks division and for the integrity of the system. Swept immediately into the fray, the organization has generally been credited with making a difference for the parks.

Over a period of years of high tension in the conservation fraternity, and through an extraordinary sequence of legislative maneuvers that no one could have predicted, several seemingly unrelated solutions to the funding crisis were developed that left parks by the mid–1980s poised for a remarkable renaissance. In fact, park officials had laid the groundwork for the various solutions in their conceptual planning for the system early in the decade, but even they would not have dared predict the outcome. The first measure to navigate the shoals was a $600 million bond issue for capital improvements known as the Third State Building Fund, which passed the assembly in 1981, was refined in the 1982 session, and then was approved by voters at a special election in June 1982, followed by three years of controversy over specific appropriations from the fund. DNR director Fred Lafser had played a crucial role early on in helping to shape the measure, and the parks division would eventually gain nearly $60 million from this source for the largest building program in the parks since the CCC and WPA of the 1930s.

The second measure, a joint resolution passed by the general assembly in 1983 and narrowly approved by voters in August 1984, after a long campaign led by the Missouri Parks Association and other groups (organized as the Citizens Committee for Soil, Water, and State Parks), provided for a one-tenth-cent sales tax to be split evenly between state parks and soil and water conservation efforts, both administered by the department of natural resources. These funds, which began flowing in July 1985, were expected to provide about $13.5 million per year to relieve the hardpressed operations of the parks as well as to help with capital improvements. The third measure, necessitated when the governor recommended eliminating funding for park personnel from general revenues, involved the successful restoration of more than $6 million in general revenue support by the 1985 assembly. The fiscal 1986 appropriation for parks was far and away the largest in the history of the park system, a stunning $64 million (much of which, admittedly, was intended for multiyear construction projects).

Building for the Future

The challenge of building upon his predecessor's success in putting these funding systems into place by realizing their potential fell to a new park director, Wayne Gross, who was promoted from deputy director in July 1985. With degrees both in recreation and park administration and in public administration, Gross was an excellent manager of people and programs; he

Gov. Christopher Bond discusses the issue of the day with a young activist for the parks and soils sales tax in 1984. L. T. SPENCE PHOTO, ST. LOUIS POST-DISPATCH

sustained excellence that would carry the Missouri system of parks and historic sites to national prominence. In developing their plans for the use of these funds—which would not have been appropriated if legislators had had doubts about the need for them—park officials years earlier had made several strategic choices. Most critical was a decision, inspired perhaps in part by the firestorm of legislative opposition to the conservation department's ambitious program of land acquisition but also by compelling need, to emphasize development of parks currently in the system rather than acquisition of new parks. Although much of the development would be for improvement of basic infrastructure like roads, campgrounds, and water and sewer systems, there was also a conscious decision to emphasize visitor services of a sort that would put out the welcome mat for visitors from afar as well as for old friends. This would be accomplished through handsome, graciously staffed visitor centers with state-of-the-art interpretive exhibitry and special programming to draw visitors into contact with the particular natural and cultural resources of each park. And there was a commitment to restore basic resources, especially the CCC structures and other historic buildings and the ecological integrity of park landscapes.

The challenge for the division's small staff was complicated by the pressing need to show satisfactory results on the ground within a year or two in order to make a case for renewal of the sales tax which, owing to a last-minute amendment in the assembly, was set to expire in only four years. But even as that gargantuan task was undertaken by both office and field staff, park officials and citizen groups repeatedly had to enter the halls of the capitol to defend the hard-won park funds against attempted assaults on what became known as the "park barrel," the trough of riches at which it was supposed anyone with any sort of park-related need could feed.

Local groups and legislators attempted to gain appropriations from park funds for local parks, museums, golf courses, zoos, community centers, swimming pools, and other projects that could not possibly meet the test of statewide significance; most but not all were vetoed by the governor if they survived the legislature. There were also efforts to use park funds for a veterans' memorial (successful) and for tuckpointing the stonework on the state capitol (successfully resisted). And there were determined efforts to tap into the proposed renewal of the sales tax for funds for local parks and cultural institutions, storm sewers, and other endeavors that might well have doomed the measure to defeat at the

was a firm believer in the tripartite mission of the park system, and by all accounts he was evenhanded in advancing it.

The planning, design, and construction of all the new facilities funded by the bond issue and the sales tax, especially coming all at once as they did in the extraordinary fiscal 1986 appropriation, presented a formidable task. Gross's challenge was to spend wisely and to build with a

Funding made available by late 1985 through the parks and soils sales tax and the bond issue supported major refurbishment and development of the parks, like this handsome new visitor center under construction at Watkins Mill. CINDY BROWN

ballot box. Eventually it became necessary for citizen supporters to undertake the arduous task of circulating an initiative petition in order to place a simple renewal of the parks and soils tax before the voters. That effort resulted in November 1988 in an overwhelming two-to-one mandate for a ten-year renewal. Clearly, Missourians loved their parks and approved of the way they were being developed.

After renewal of the sales tax and completion of most of the development funded by the bond issue, it was time for public officials and citizen supporters to examine the system and focus anew on the future. Fortunately, they had for guidance a major study of state parks nationwide published in 1989 by the Conservation Foundation, *State Parks in a New Era.* The report offered a comparative analysis of the growth and development of state park systems, especially in the

period 1955–1985, and examined three major areas of concern common to all of the states: stewardship of natural and cultural resources, innovations in funding, and strategies for tourism and economic development. Missouri had a special place in this study, as its parks and soils tax was featured in the discussion of funding.

The Conservation Foundation report revealed that the total acreage in state park systems had quadrupled between 1955 and 1985—or tripled, if the huge Alaska system is excluded from the calculation. Missouri's park system, by contrast, grew by little more than half in the same period, from about 66,000 acres to 103,000. While only nine states had surpassed Missouri in acreage in 1955 (up from four in 1928), by 1985 twenty-five states had larger state park systems. Missouri had grown more slowly because it had not initiated any major bond issues or other special funding mechanisms when many other states were doing so during the 1960s and 1970s, and, when it finally did gain special funding in the 1980s, it used the money for development rather than expansion. On the other hand, the story on comparative attendance was quite the reverse. In the nation as a whole, state park attendance in 1985

Among the more than fifteen hundred threats to the parks enumerated in a comprehensive study initiated in 1988 is this horror story at Pershing, where heavy sedimentation caused by land clearing and poor agricultural practices in the Locust Creek watershed is smothering floodplain forest and other wetland ecosystems. TOM NAGEL

was three-and-a-half times as great as it had been in 1955, while in Missouri it was nearly five times as great—and by 1990 it would be seven times as great. Visitors were being attracted to Missouri's state parks out of all proportion to acreage—a source of pride to be sure, but also a cause for concern, if the resources that attracted them were to be protected for future generations.

The identification, monitoring, restoration, protection, and interpretation of park resources—collectively termed *stewardship*—came to be recognized by the 1980s as an urgent need of park systems nationwide. The President's Commission on Americans Outdoors, a successor to the Outdoor Recreation Resources Review Commission of a quarter-century earlier, warned in its 1987 report that the condition of the nation's outdoor estate was precarious, owing in part to

"too much use with too little attention" and in part to pervasive long-term threats from outside the system—toxic chemicals, air and water pollution, erosion and sedimentation, unsightly or intrusive development on inholdings or along the boundaries of parks, and the like. The Conservation Foundation report focused on California as a state that had begun to address the problem of stewardship in the early 1980s, but it could have selected Missouri as well. Despite concerted stewardship efforts throughout the decade, however, a study begun in 1988 identified more than fifteen hundred threats to Missouri parks and historic sites—a major agenda for action in the 1990s. When the DNR released the study in 1991 it boldly recommended that ninety thousand acres be added to existing parks to help protect the integrity of their resources.

The pressures of people and other threats on the park system suggested a need to determine not only which parks could be expanded but also what sorts of new parks could be added in order to fill in the gaps in the system's representation of the state and, at the same time, relieve some of the recreational pressure on other areas. With the exception of one highly lauded but controversial park small in acreage but extensive in its reach (the two-hundred-mile-long Katy Trail, purchased and developed with a $2.2 million donation from Edward D. Jones), the period from August 1984, when Missourians approved the parks and soils tax, until halfway through 1990 was the longest time span since the war years of the 1940s without the addition of new parks to the system—and the war period ended with the addition of more than 25,000 acres at once, something unlikely ever to be repeated. The parks division had kept its word, given during the sales-tax campaign of 1984, and spent its money taking care of what it had.

In part at the urging of the Missouri Parks Association, which was acutely conscious of the need to augment the system and wanted to get into a positive mode, instead of devoting so much of its energy to fighting against inappropriate parks being promoted by others, the parks division in the late 1980s began developing a long-range plan for expansion of the system. Among the criteria for selection of new parks, the most important were statewide significance and integrity of the proposed park's resources, but factors such as its contribution to the geographic and thematic balance of the system and its suitability for public interpretation and recreation were also vital.

Among the obvious needs that emerged in the realm of natural history were parks to represent

northern Missouri prairie, northern Missouri forest, Crowley's Ridge in the Mississippi Lowlands, the Elk River section of the Ozarks, the White River glades, and bottomland forest and sloughs along the big rivers. Chronologically and thematically, the most obvious cultural gap in the system was the lack of any site reflecting the French culture or Spanish authority of the eighteenth century. Better representation was needed for the Woodland period and the era of Indian-white contact. And the system was also deficient in sites relating to early white settlement in the interior, many types of economic activity (notably the fur trade, forestry, and various types of manufacturing), and the experiences of women and ethnic groups. Among the areas of greatest recreation need, the plan identified the upper Mississippi and lower Missouri rivers, the Taum Sauk Mountain region, and various rivers not yet represented in the system, such as the Gasconade and the North Fork.

When the department of natural resources requested legislative appropriations for new parks and expansion of existing parks in 1989 and subsequent years, it was greeted with strong support from some members, equally strong resistance from others, and alternative pet projects from yet others. Money was available from the sales tax for modest expansions, but legislators were willing to approve only a fraction of those requested: Taum Sauk Mountain and the Nathan Boone homestead in 1990, and additions to Taum Sauk and Crowder in 1991. They also mandated a new Civil War park at Carthage that was not high priority for acquisition and gave impetus to several other local projects desired by influential members. The citizens' overwhelming 1988 vote for the sales tax and their strong support of the DNR park proposals notwithstanding, the parks were still creatures of politics. Local interests and political whims would continue to influence decisions unless those who took a broader view remained ever vigilant.

As Missourians prepared to celebrate the seventy-fifth anniversary of the founding of the state park system, they could look back on a record of remarkable accomplishment built through never-ending struggle and dedication, and they could look forward to more of the same. To an extraordinary degree, the Missouri system of state parks and historic sites achieves its goal of representing Missouri—both its natural and cultural resources and the values and dedication of its citizenry.

Missourians have built over the years a system of parks and historic sites that reflects the diversity of a remarkably diverse state. While there are

still notable landscape features that are not well represented, the system offers its visitors a lifelong laboratory for study and appreciation of the state's natural heritage. It is perhaps inherently more difficult to reflect the cultural heritage of a state in all its richness because history keeps happening and not all aspects of culture may be embodied in particular sites; but the Missouri system, with its long tradition and its growing commitment to preservation and interpretation of cultural resources in the parks as well as in the historic sites, offers a fine starting point for those who would take the measure of Missouri.

Parks are powerful symbols of a society, a measure of those aspects of their heritage in which people, individually and collectively, have taken pride. Fully two-thirds of the acreage and more than two-thirds of the units in the Missouri system came as gifts. The parks are a legacy of families like the Van Meters and the Grahams, who had long owned land that they and others knew was special; of wealthy individuals like Jacob Babler or Leo Drey or Ted Jones, who realized there were certain resources that *ought* to be the property of the whole people; of individuals of modest means like Helen Hawn or the women of the Mastodon Park Committee, who cared enough to buy or to mount a fund-raising campaign for places they loved; of organizations like the Daughters of the Confederacy or Jeff-Vander-Lou, who wished to honor people they admired; of local citizens, who voted bond issues to make Trail of Tears or Watkins Mill available to all; and of private industries and other units of government who transferred some of their lands to the state for management as parks.

But a park system is more than a collection of individual sites. It involves an image of the system itself and institutions for perpetuating it, including processes for selecting some sites and rejecting others, for funding and developing and maintaining the parks, and for interpreting them and making them accessible to the public. If the history of the Missouri system of state parks and historic sites seems to have been a continuing series of crises and struggles and political gamesmanship, perhaps it is because of the state's political culture—its fundamental conservatism and individualism and distrust of bureaucracy, and above all its love of a good fight. Yet the history of the state park system is also a record of remarkable continuity and sense of mission and strength of tradition, despite frequent reorganizations and battles over ways and means. For that mission and tradition, one must look to the very idea of public parks and of a park system—as worked out in the great urban parks and the na-

tional parks, as developed and perpetuated in the state's own system by a succession of talented park directors and hundreds of dedicated career employees, and as strengthened by the pride that Missourians feel but rarely voice in their state and its heritage.

It is the state's citizens who are ultimately responsible for the park system that represents them and their heritage—citizens acting as individuals, organized in groups, functioning through their elected representatives, and, when necessary, asserting their collective will directly through the initiative process. It is worth recalling that when their own political culture of conservatism and individualism and skepticism has threatened on occasion to strangle their parks, Missourians have found a way to act directly to preserve what they value. The Missouri system of state parks and historic sites is thus above all a legacy of Missourians who care.

Beautiful spring-fed streams are a hallmark of the Ozarks, as here at Ha Ha Tonka State Park, where springwater courses through an old millrace.
Nick Decker

Introduction

THE OZARK HIGHLAND is geologically the oldest region of Missouri and culturally in some ways the least altered. It is also the largest of the natural divisions, embracing forty percent of the state, and ecologically it is the most diverse. Henry Rowe Schoolcraft, who explored the area in the early nineteenth century, exulted in the beauty of the landscape: "The traveller in the interior is often surprised to behold at one view cliffs and prairies, bottoms and barrens, naked hills, heavy forests, rocks, streams, and plains all succeeding each other with rapidity, and mingled with the most pleasing harmony."

At the geologic core of the Ozarks stand the St. Francois Mountains, high rounded knobs of granite and rhyolitic rock formed by volcanic activity some 1.5 billion years ago. These ancient mountains were repeatedly inundated by Paleozoic seas in which the limestones, dolomites, and sandstones of the Ozarks were deposited during hundreds of millions of years. During much of that time, and for more than two hundred million years since the last of the seas drained from the land, the Ozarks have slowly warped upward into a giant dome and just as persistently eroded away, their rivers cutting down through the varied sedimentary layers. The result is a highland of deceptively flat horizons but rugged, dramatic drainages, with successively younger rocks radiating concentrically outward from the ancient core.

Because of the varied rock types, drainage patterns, and topographic features of the Ozarks, and also because the land has been above sea level and unglaciated—and thus available for occupation by plants—for more than two hundred million years, the region boasts the greatest diversity of flora and fauna of any region of the state. Indeed, many scientists regard it as one of the most significant centers of biodiversity on the North American continent. Forest, glade, and savanna dominate a landscape rich in endemic species, plants and animals found nowhere else on earth. Caves, springs, sinkhole ponds, and fens provide smaller, more specialized habitats for yet other species, while ancient drainages in varied rock types also harbor distinctive biotas.

But millennia of ceaseless erosion, especially in the water-soluble rock that covers most of the area, have also left the Ozarks with thin, often stony soils, and the rugged topography has been relatively inhospitable to manipulation for human ends—save for mining of the mineral wealth and the biotic capital of the forests. Thus, although many parts of the Ozarks have been settled nearly as long as other regions of the state, the lifeways there have tended to be at once more precarious and more attuned to natural rhythms, and the Ozarks, though by no means escaping the onslaught of modern civilization, still retain in places a measure of what attracted people there in the first place.

We begin our discussion of Missouri parks and historic sites at the core of the Ozarks in the St. Francois Mountains section of the Ozark natural division, with the weathered pink boulders of Precambrian granite at Elephant Rocks. From there we move to the barren crystalline peaks of Taum Sauk Mountain and the spectacular river-scoured gorges of Johnson's Shut-Ins. The iron-rich igneous knobs in the fertile Arcadia Valley, characteristic features of the St. Francois "knob-and-basin" region, were strategic factors in both the location and the conduct of the crucial Civil War battle of Pilot Knob, commemorated at Fort Davidson State Historic Site. Sam A. Baker State Park, an outlier at the southern boundary of the St. Francois Mountains, combines the elements

typical of the region with its own unique flora and classic park architecture.

From the St. Francois Mountains we move outward to the somewhat younger Ordovician dolomites and limestones with their caves, springs, sinkholes, underground streams, natural bridges, and other features characteristic of the karst topography of most of the remainder of the Ozarks and the Ozark border as well. "Karst" topography is named for the Karst district of the Adriatic coast where the characteristic solutional features produced in water-soluble rocks like limestones and dolomites were first described.

We turn first to the north-flowing streams of the Upper Ozark section. Meramec, named for the scenic and aquatically diverse river that courses several miles along its borders, has more than thirty known caverns and many other karst features, while Onondaga, a short distance upstream, displays Missouri's preeminent individual cave. In the cleft of a dolomitic ledge along Huzzah Creek, a tributary of the Meramec, lies one of the most picturesque gristmills in the Ozarks, Dillard Mill State Historic Site. Farther to the west, near the north-flowing Niangua River, is Bennett Spring, the fourth largest spring in the Ozarks and once the site of a thriving mill community. Down the Niangua is Ha Ha Tonka State Park, which has the greatest concentration of karst features in the state as well as a beautiful orchard-like savanna of open trees and prairie wildflowers. Further to the north, the Osage River's rugged, dissected hills are home to the state's largest park, on the Grand Glaize arm of Missouri's most famous lake, the Lake of the Ozarks.

The Lower Ozark section of the Ozark natural division, like the Upper Ozark section, is part of the Salem Plateau; it is distinguished by high-gradient south-flowing streams that have carved deeply into the otherwise broad, gentle upland plains. Montauk State Park, centered on a series of springs at the headwaters of the Current River, is the only one of the four original big-spring parks in this area remaining in the system, the other three having been transferred to the Ozark National Scenic Riverways. Lake Wappapello State Park, downstream from Sam A. Baker on the St. Francis River, just before it flows into the Mississippi Lowlands, offers an intriguing mix of typical Ozark vegetation with some bottomland species characteristic of the "Swamp Southeast." Farther to the west and just a few miles from the Arkansas line is Missouri's "Little Grand Canyon," now Grand Gulf State Park, formed when a cave system collapsed and pirated a former surface stream, a spectacular instance of the interchange of surface water and groundwater typical of a karst landscape.

If the St. Francois Mountains are the geologic core of the Ozarks, many would say the cultural heart of the region is the White River Hills, where the White River and its tributaries have carved one of the most rugged, sharply dissected landscapes in the state. The most distinctive natural features in the White River section of the Ozark natural division are its dolomite glades and cedar breaks, making it a region of concentrated endemism, with a mixture of southwestern plants and animals among the more typical Ozark species. These Missouri desert balds, as famed in legend as in the annals of science, form the scenic backdrop for one of the state's most popular tourist regions. Roaring River State Park, at the dramatic juncture of the level Springfield Plateau to the north and a sudden descent off an escarpment into the White River Hills, offers a primer in geology and ecology, while Table Rock State Park, on the beautiful White River reservoir of that name, provides a base for exploring cultural facets of the area.

Northwest of the White River Hills is the Springfield Plateau, its younger Mississippian-age bedrocks less highly dissected than those in other parts of the Ozarks and its flora exhibiting an admixture of species from the neighboring prairies of the Osage Plains. While nearly thirty percent of this section was presettlement prairie, much of the remainder was covered in beautiful post-oak flats and natural tree-dotted savanna. The oak groves, containing their own distinctive biota, slowly succumbed to brushland, pasture, and impoverished woods owing to long-term overgrazing and fire suppression. Nathan Boone was attracted to the rolling Springfield Plateau when natural savanna still mantled the land, and now that his homestead is a state historic site the landscape of settlement may be restored. Battle of Carthage, a small historic site at a spring now in the city of Carthage, highlights the strategic importance of the southwestern Ozarks in the Civil War era when it was a no-man's-land between contending forces. Stockton, Pomme de Terre, and Harry S Truman state parks are located on reservoirs on the Springfield Plateau constructed in recent decades by the U.S. Army Corps of Engineers. Pomme de Terre and Truman are models of success in the restoration of oak-hickory savanna by prescribed burning. At the northwestern edge of the region, Truman offers an especially diverse representation of prairie-forest border landscapes and unique flora.

The sixth section of the Ozark natural division, the Elk River Hills in the far southwestern corner of the state, with its distinctive topography and Southwest affinities, is an obvious candidate for a new state park, and officials have identified a fine tract along the Big Sugar Creek to represent this section.

Elephant Rocks State Park

THE PINK GRANITE boulders of Elephant Rocks State Park have captured the imaginations of generations of Missouri children. And climbing, squeezing, and hiding in the labyrinthine maze of fissures and crevasses can be enough to recapture the child in the oldest of the park's visitors. In addition, Elephant Rocks is a veritable geological classroom. Here the visitor can see and touch some of the oldest rocks on the earth's surface. Here one can learn how the hardest rocks remain at the mercy of the elements. And one can contemplate the origin of the "elephants," the Ozarks, or the earth itself.

Geologists tell us that Missouri's red granite is about 1,500,000,000 years old—yes, that's 1.5 billion years. The granite was formed by the slow cooling of molten rock, called magma, as it intruded into the earth's crust. During this slow cooling, vertical and horizontal cracks, called *joints*, developed in the rock. The vertical joints developed in two different directional sets: one set trends toward the northeast, the other toward the northwest. Where the joints crossed each other, the granite separated into a huge stack of oblong blocks—all while still buried beneath the surface and further covered through the eons by layers of rock formed from sediments in ancient seas.

The Ozarks—and the elephants—we know today are the product of uplift and erosion. As the Ozarks warped upward into a gigantic dome and eroded over hundreds of millions of years, the granite blocks were brought closer to the surface. A combination of groundwater and chemical weathering began to decay the rock near the joints and fractures. Corners began to round, like the edges of a melting ice cube, and the spaces between filled with sand and grit, called *grus*. Once the fractured granite was exposed at the surface by further erosion, natural weathering by rainwater, freezing and thawing, and the sun and wind continued rounding the blocks and removing the grus, some of which may still be seen between exposed joints. Even trees and shrubs, growing in the cracks, contribute to the slow disintegration of the ancient granite, one of the hardest rocks known. A measure of the slowness of this process may be seen in the lichens that cover some of the boulders; some lichens require as much as a hundred years to grow an inch. But they can be crushed by human hands and washed away by the next rain, so the elephants no longer sport as many of these elegant timepieces as they once did. As weathering and erosion continue relentlessly over the eons, more of the herd yet buried beneath the surface may be freed.

These pachyderms remain fascinating despite the fact that the geologic explanation puts to rest more fanciful theories of their origin. The elephants were not moved here, either by giants or by glaciers. Glaciers can carry boulders and leave them behind as they retreat—we call them *erratics*—but the glaciers never reached as far south as the St. Francois Mountains. No, the elephants were formed right where they stand—residual boulders resisting the elements. At Elephant Rocks State Park, one can see all the various stages in the formation and weathering of boulders. The largest, which some know as Dumbo, leader of the herd, stands some twenty-seven feet tall and weighs in (by estimate) at 680 tons.

The state park contains several old granite quarries and is surrounded by even more, and the town adjacent to the park is named Graniteville. Local homes and walls and gravestones are often made of the pink Missouri stone. The largest granite quarry, just outside the park, was opened in 1869. It has furnished paving stones for some

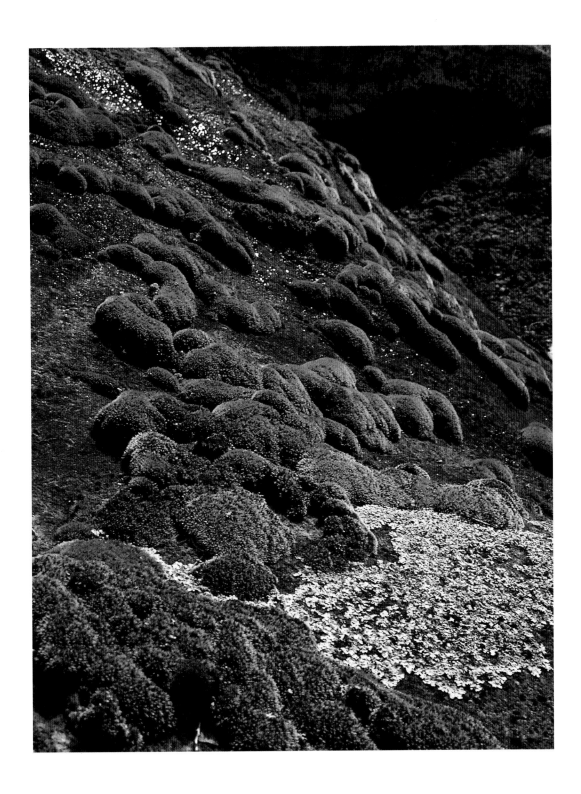

*Mosses and lichens in intricate patterns of greenery
are quilted over the granite, each species attuned to
micro-differences in light and water. They spread
slowly and are easily destroyed.* BLANE HEUMANN

Ancient boulders of pink granite claim the skyline.
OLIVER SCHUCHARD

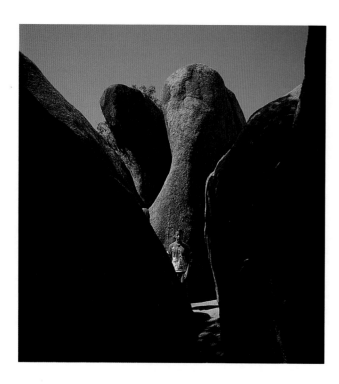

Mingling with the elephants. PAUL NELSON

of St. Louis's streets (still visible in the Laclede's Landing area of the city) and massive blocks for the piers of the Eads Bridge across the Mississippi at St. Louis and for the state capitols of Iowa and Illinois. B. Gratz Brown, who owned one of the quarries and was governor in 1871 when the state's handsome Second Empire style governor's mansion was built in Jefferson City, donated four turned pink granite columns for the portico. Other quarries have furnished stone for major buildings in St. Louis and many other cities in the United States; a monument in Pittsfield, Massachusetts, consists of a single polished column forty-two feet high.

Missourians have been clambering around on the elephant rocks since long before the area became a state park—in fact, since the earliest white settlers and probably the Indians before them. By the 1870s St. Louis artists were producing "views of the elephants," and the beloved old weathered boulders were the inspiration for the lifelike settings developed to house and display the hoofed animals at the St. Louis Zoo, built as a part of the 1904 world's fair. The area was suggested for a state park in 1924, but fourteen years later, when U.S. Secretary of the Interior Harold Ickes came to Missouri in 1938 to dedicate another state park (Babler, near St. Louis), the elephants headed his list of scenic resources that had been lost to commercial interests: "Years ago this state should have set aside the Elephant Rocks, which have now been hammered to pieces." Fortunately, he was not entirely correct, and in 1967 a remnant of the site came into the state park system, fittingly enough through the generosity of a geologist who loved the rocks and appreciated their significance. John Stafford Brown, retired chief geologist for St. Joseph Lead Co., purchased a tract and presented it to the state, and the park officially opened three years later in 1970.

Park division planners have done an excellent job of designing the trails and other necessary improvements so that they have minimal effect on the natural resource. Elephant Rocks State Park was the first park in Missouri to feature a "Braille trail." Opened in 1973, the trail was specially designed to provide access for the visually and physically handicapped. It features a paved surface with gentle grades and guide ropes or railings where necessary. Astroturf patches in the path alert the nonsighted that Braille signs and tactile opportunities are nearby, including a "blindman's buff" play area. Also noteworthy are the picnic tables scattered among the rocks instead of massed in the open; they nearly disappear in the landscape while providing privacy for those using them.

But it is the rocks that beckon, urging the visitor to experience the joy of exploring or to ponder their origins. Here among the ancient boulders of Elephant Rocks State Park one can lose oneself in the weathered maze and imagine that one is in the very core of the Ozarks.

Taum Sauk Mountain State Park

TAUM SAUK MOUNTAIN is the geologic phoenix of the Ozarks, born of volcanic fire 1.5 billion years ago, then rising eons later at the very center of the Ozark dome. If one descends into the core of the Ozarks amid the pink granite boulders at Elephant Rocks, at Taum Sauk one ascends to the apex of the Ozark dome and surveys the world around. Located at the center of the five-thousand-square-mile St. Francois Mountains amid twenty-nine other competing peaks, Taum Sauk is the state's highest point at 1,772 feet above sea level. Nowhere else in Missouri does such a panorama of nature's wild treasures and earthly forces combine.

The first options for Taum Sauk Mountain State Park were acquired in 1990 with funds appropriated by the Missouri General Assembly. But interest in the area has been widespread at least since 1958, when the twenty-four-mile Taum Sauk Trail was dedicated. Since then, more than twenty-five thousand scouts and numerous other hikers have taken the wildest walk in Missouri. Joining a group on the twelve-mile segment from Taum Sauk Mountain to Johnson's Shut-Ins is the best way to take the measure of the park.

The drive to the mountain is not easy, no matter from which quarter of the state one begins, and therein lies our first lesson in geography. The ride is one of constant body-shifting back and forth, side to side, as the car negotiates the frequent hills and curves. The highway threads through the forest, and finding some scenic vantage point from which to see the country is a challenge, with only the rare elevated ridge cleared of trees providing an overlook of the Ozark river valleys. When we can see out, we note a distant horizon made uniformly flat by the succession of deeply dissected ridges and valleys mingled into one. This is the great geologic dome of the Ozark interior, its ancient ocean-deposited limestones, shales, and sandstones lifted upward only to be deeply incised by spring-fed rivers and streams. If one could imagine filling the valleys and hollows with dirt until they were level with each successive ridge, a tabletop landscape would be formed. But the "dirt" has long since been removed, and the drive is tortuous.

Approaching closer to Taum Sauk Mountain from any direction, one begins to see distinctly elevated knobs in the distance: the St. Francois Mountains. As the car ascends a mountain flank, our anticipation heightens as every break in the trees reveals the massiveness of the broad, rounded summits. The road ends at a lookout tower high on the mountain, and we jump out, eager to be free of the car and to explore this vastness afoot.

At the summit, the mountain is flat. While its height is not sufficient to demonstrate life zones at different elevations, its height above the surrounding Ozark plateau teases the atmosphere enough to show subtle but pronounced climatic differences. Records show that the temperature on top of the mountain rarely reaches 90 degrees Fahrenheit. Winter's weather is like that of Kirksville in northeastern Missouri, and local residents often witness the mountaintops capped in snow. Around us, tree limbs lie scattered about the mountain crest, having shattered under the weight of frequent ice storms. Nearly every tree shows the influence of wind and ice breakage and the scars of lightning strikes.

From atop the tower, we can appreciate the im-

posing position Taum Sauk occupies among the other competing domes. To the west of the mountain is Taum Sauk Creek valley. It is into this valley that the trail descends as it takes us into the state park. The valley is Missouri's deepest, measuring one thousand feet from the mountain summit to the mouth of the creek on East Fork Black River some seven miles southwest. But the path doesn't follow the valley all the way, taking us instead to clamber among the peaks. Many a scout with blistered feet and obvious fatigue has yet been able to talk tirelessly about the "treacherous" journey, or the echoing thunder of an ominous storm bouncing from dome to dome, or the ascent on Wildcat and Proffit mountains. What memories, indelibly imprinted on the mind.

As we leave the mountaintop, the trail descends the mountain's west flank onto successive glades of exposed igneous rock, here and there dotted by dwarfed trees and grasses owing to the shallow, droughty soils. Through the veil of a low, foggy cloud cap looms Wildcat Mountain across the valley, its level summit falling short of the highest point by just a few feet. A pair of bald eagles rides fixed on an invisible wave of air on the mountain's south flank.

Everyone stops, then a silence falls over the group. A distant, timeless roar signals that Mina Sauk Falls is near. At the crest of the falls, last night's heavy rains collect in a small stream before cascading tortuously down a series of volcanic rock ledges positioned at right angles across ancient faults and rock fractures. The total drop of the falls is 132 feet, making this Missouri's tallest waterfall. This windswept, pine-crowned igneous cascade stands sentinel at the gate to Taum Sauk valley. Here, young and old alike gaze with wonder at the fortress of igneous mountain domes on each side of the deep valley below. The pink layered rock forming the falls is volcanic ash that spewed forth from some ancient volcano perhaps a billion years ago.

Descending into the forested valley below, the group reaches Taum Sauk Creek, its waters crystal clear and its banks lined with Ozark witch hazel, a shrub that brings forth its sweet-scented red and yellow blossoms in January! Soon thereafter, the trail passes through Devil's Toll Gate, an eight-foot-wide gap in a mass of red and orange igneous rock some thirty feet high. The gate rests along a shut-in pool created by the

Springtime softens the view from an igneous glade across Missouri's deepest valley toward its highest mountains, Taum Sauk (right) and Wildcat. PAUL NELSON

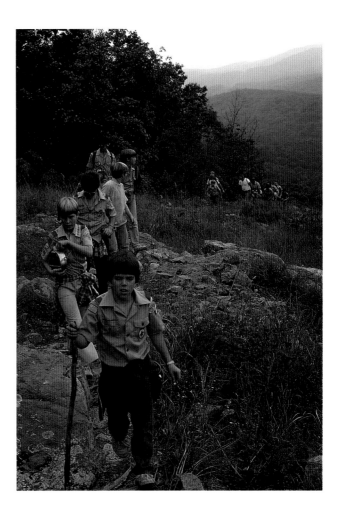

Taum Sauk Mountain is a scouts' paradise, where since 1958 more than twenty-five thousand youths have experienced Missouri's wildest walk, from the mountain to Johnson's Shut-Ins. PAUL NELSON

workings of beaver. This is traditionally the lunch spot.

A climb from our stopping point to open barrens on Weimer Hill to the south provides a spectacular view of Wildcat Mountain and its seemingly pristine blend of rock, barrens, and dwarfed trees. From this vantage point, we can see why this place became a state park. In one view, we see Taum Sauk Mountain, the highest point in Missouri; Mina Sauk Falls, the highest waterfall; Devil's Wall, perhaps evidence of a great collapsed volcanic caldera; and the state's most extensive igneous barrens on Wildcat Mountain across the way. The barrens span a half-mile swatch on the south face of Wildcat and rise nearly five hundred feet above the stream below. A thick mantle of prairie grasses and wildflowers covers the slope, here and there dotted with oaks, pines, and cedars. One of the rarest plants in the country, Mead's milkweed, flowers in mid-May on this glade. Despite their small stature, many

Water cascades down ledges of ancient volcanic rock at Mina Sauk Falls. Marbled veins of pink and dark purple bear witness to molten flows of ash-tuft lava exposed atop the falls. PAUL NELSON

Autumn glory spreads in a panorama from atop Taum Sauk Mountain. KEN MCCARTY

of the twisted, gnarly post oaks and eastern red cedars exceed three hundred years in age. The trees, rocks, grasses, and wildflowers blend harmoniously with the woodlands beyond, punctuated by the abrupt rise of Devil's Wall on the distant mountain crest.

For the adventurous, a hike to the crest of Devil's Wall provides both superlative scenery and a geologic treat. This jagged mile-long rampart around the crest of Wildcat Mountain consists of fused volcanic ash that once poured forth from the earth. Geologists theorize that the tilted positions of Devil's Wall, the rocks at Mina Sauk Falls, and other rock formations in the area suggest they were part of the Taum Sauk Caldera, formed by the collapse of an ancient volcano.

The final leg of the journey is an ascent over the massive Proffit Mountain dome before the trail drops into the East Fork Black River valley and Johnson's Shut-Ins State Park. Atop the broad, high dome grow scattered dwarf blackjack and post oaks. Here and there, oak skeletons dot the grassy lichen-covered volcanic rock, testimony to times when nature failed to maintain the delicate balance between precious rainwater and scorching sunlight.

Eleven hours after beginning the descent from Taum Sauk the group finds its way to the comforts of camp in Johnson's Shut-Ins State Park. Awaiting there, if one is lucky, are hot food,

moleskin for blisters, fresh socks, and a blazing campfire ready for the recapping of the day's adventures on the wildest hike in Missouri.

This park of more than 6,200 acres encompassing Missouri's highest point, tallest waterfall, deepest valley, largest igneous barrens, and other geologic wonders, as well as the state's most popular scout hiking trail, is a tribute to more than twenty local landowners who willingly agreed to part with their property, assuring that generations to come could experience its natural wonders. It includes also a 1,300-acre portion of the splendid Taum Sauk Creek valley and mountain-dome scenery leased to the state by Union Electric Company to expand backcountry hiking.

Taum Sauk Mountain State Park is being managed to preserve its scenery, its backcountry opportunities, and its delicate igneous prairie barrens. Visitors to the mountain summit will be able to see superlative St. Francois Mountain scenery from a new overlook tower. Exhibits will point out prominent features and interpret both the natural and cultural history of the area. Taum Sauk, well known to scouts for more than thirty years, may now become the province of all the people.

Winter brings a hush to the shut-ins.
OLIVER SCHUCHARD

Johnson's Shut-Ins State Park

J OHNSON'S SHUT-INS is probably the best known state park in Missouri. In addition to being perennially popular with visitors, the park in northeastern Reynolds County is widely recognized for its photogenic scenery. Images of swift waters rushing through the chutes and potholes of the shut-ins have graced everything from wall calendars to telephone-book covers.

Located in the St. Francois Mountains at the geologic core of the Ozarks, the park is justly famed for its rocks. Pink granites and porphyries and blue-gray rhyolites offer testimony to an era of primordial volcanism more than a billion years ago. Above the park the East Fork of the Black River flows through a relatively broad valley, the same valley followed by County Route N leading to the park. But as the stream leaves the more easily eroded dolomitic bedrock and meets the tough igneous rocks of the ancient ash and lava flows, the valley becomes narrow and steep-sided. The water has had to fight ceaselessly, laboriously, for every fracture, every weak joint, straining to find the least resistant course to follow. Sometimes it has had to make right-angle changes in direction, creating eddies and crosscurrents, all in an effort to keep flowing onward. The resulting gorges and rock gardens have locally come to be called "shut-ins." There are other shut-ins in the St. Francois Mountains region, but Johnson's, named for nineteenth-century homesteaders (the Johnstons), are the most famous in the state.

This rugged, nearly impenetrable area was once the site of the largest Spanish land grant in Missouri. Sixteen square leagues (nearly one hundred thousand acres) on the forks of Black River were awarded in 1799 to Father James Maxwell, the Irish Catholic priest of French Ste. Genevieve, who intended to rescue indigent Irish Catholics from British tyranny and establish them here under a benign Spanish monarchy. But Spain transferred the land to France, who sold it to the United States, and the Irish settlement never materialized. There is scant evidence of activity in this hardscrabble region until homesteaders trickled in decades later. But the land was still relatively wild, uncut, and inaccessible when it was initially proposed for a state park in 1915.

Most of the park, including the shut-ins and two miles of river frontage, was assembled over the course of seventeen years and donated to the state in 1955 by Joseph Desloge, a St. Louis civic leader and conservationist from a prominent lead-mining family. The family has continued over the years to donate funds for park improvements.

Most visitors to Johnson's Shut-Ins see only a small part of the park—the picnic grounds, the campground, and the shut-ins overlook. The more adventurous jump right in, wading and "swimming" in the shut-ins, climbing on the smooth (and slippery) volcanic rocks, sitting in the swirling waters of the gravel-scoured potholes some say were carved by the Indians as bathtubs—a poor man's Jacuzzi, especially appealing on a hot summer day. But the vast majority of the park's 2,500 acres receive few visitors. Nearly half of this acreage is included in the East Fork Wild Area, generally that part of the park, excluding developments, east of Route N and west of the river. Here in these rugged, wooded hills the visitor can find solitude, a truly endangered resource in today's hectic world.

Johnson's Shut-Ins is a botanical paradise with

over nine hundred recorded species of trees, shrubs, vines, grasses, wildflowers, and ferns, giving this park a special distinction as Missouri's most botanically rich area. Seventeen different natural communities occur here, twenty percent of those that have been identified anywhere in the state. Why this diversity? This question is best answered by exploring the park's several miles of trails, which traverse a variety of rock types, topographic features, aquatic areas, and elevations. Just below the shut-ins, for example, one can find the yellow and the rare red-form of Ozark witch hazel blossoming in January. One of several different small shrubs growing on the gravel washes, the Ozark witch hazel has adapted to the frequent rampaging floods by simply yielding its buoyant, rubbery stems to the forceful torrents. This gravel-wash natural community is part of Johnson's Shut-Ins Natural Area.

A hike into the East Fork Wild Area will take one to igneous rock barrens. Just a moment's pause in this opening in the woods on a sunny

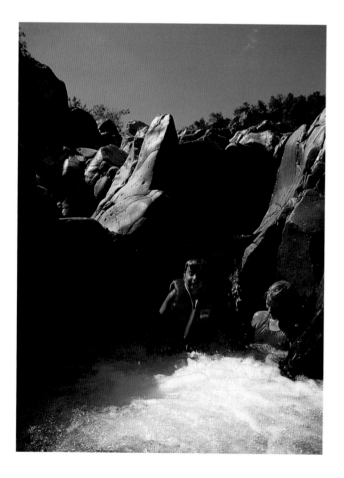

Everyone's favorite Jacuzzi in the heat of summer, these ancient rock bathtubs have been sculpted and scoured by gravel, sand, and rocks swirling in the river's currents. Paul Nelson

winter's day unexpectedly reveals one of summer's harsher elements, now welcome: warmth. In summer's terms, baking heat. Herein lies another key to the park's botanical diversity. Desert-like plants adapted to conserving precious water make this their home. In contrast to the acidic, nutrient-poor soils of the granite, rhyolite, and other igneous rock barrens, just off the trail in the southwest corner of the wild area is the Dolomite Glade Natural Area. This is still a hot, barren, desert-like spot, but the soils overlying the dolomite rock support a host of plant species different from those on the igneous barrens.

In late winter or early spring, a hike to the wild area may reveal blackened hills, scorched by fire. Prescribed burning is conducted by park staff to mimic the natural fires that once shaped the extensive pine woodlands of this region. Without fire, woody thickets and dense leaf litter inhibit the germination of the shortleaf pine and shade out and choke the prairie-savanna wildflowers that grow here.

Upstream in the park campground is yet another unusual community, an eighteen-acre boggy forest designated as the Johnson's Shut-Ins Fen Natural Area. Permanently wet soil fed by cool calcareous groundwater is the key to the fen. Here the coolness simulates the boreal conditions of southern Canada, more common in Missouri during glacial times, which allow plants such as swamp wood betony, bottle gentian, tall sweet william, and blue smooth violet to survive. You can see some of these plants from the main park road, but beware of trampling the rare wildflowers in the boggy fen or sinking in the muck.

The trail to Taum Sauk State Park begins at the main parking lot and heads east up the side of Proffit Mountain through an area called Buzzard Rock Hollow. The valley forest is maturing and has a rich diversity of understory plants, with many orchid species. Found here are the putty root orchid, twayblade orchid, showy orchis, nodding pogonia, coral root orchid, and the rare ladies' tresses (*Spiranthes ovalis*).

In the fall, if you are ambitious, you can return to the wild area and make your way to a high point, nearly 1,200 feet above sea level. From here, and from numerous glades along the way, you can take in the St. Francois Mountains in all their splendor. To the north lie Goggins and High Top mountains, and beyond them are Bell and Lindsey mountains within the Bell Mountain Wilderness, part of the Mark Twain National Forest. Immediately to the south is Lee Mountain, while along the eastern edge of the park is the ancient hulk of Proffit Mountain. The flattop appearance of Proffit is the result of its use as a

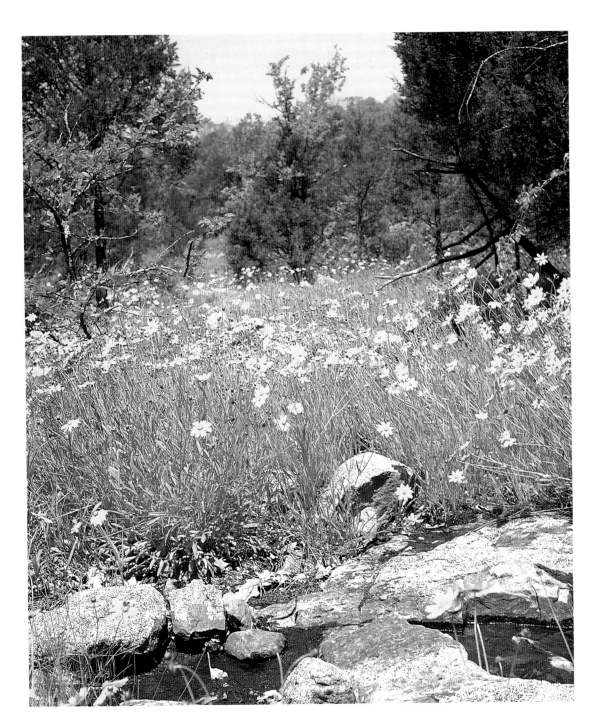

Tickseed coreopsis brightens a rhyolite glade in late spring. Rainwater drains quickly from the nearly solid exposures of bedrock, producing a dry environment for a host of specially adapted species.
PAUL NELSON

reservoir in an electric utility's innovative pump-storage scheme to conserve energy for use in periods of peak demand. Even with the technological scalping of Proffit, the view from the park is striking.

Johnson's Shut-Ins, after being loved nearly to death some years ago, was closed down entirely for a time and redesigned as a controlled-access park. Now the park is limited to one hundred cars, and when the limit is reached—usually only on certain weekends and holidays between Memorial Day and Labor Day—other vehicles must wait to enter until someone leaves. The result is a higher-quality recreational experience and reduced impact on the park's resources. If you should find a line when you arrive, there are other beautiful parks in the vicinity. And you may be encouraged to return to experience the wonders of this fabulous park at other seasons.

Fort Davidson State Historic Site

IN THE SHADOWS OF the granite knobs of the St. Francois Mountains, near Pilot Knob in the Arcadia Valley, lie the time-gentled remains of Fort Davidson. Standing on the grass-covered, tree-shaded slopes of what were once dry-moated walls, it is difficult to comprehend the carnage that took place here and down along Knob Creek on the afternoon of September 27, 1864. The Battle of Pilot Knob was one of the bloodiest actions in the Civil War in Missouri. It also marked the beginning of the end for the Confederate forces under Maj. Gen. Sterling Price.

Lack of discipline, lack of arms, horses, and even shoes conspired with geography against Price and his army. The onetime Missouri governor had entered Missouri from Arkansas on September 19 with a force of about twelve thousand men, including some three thousand Arkansas conscripts and deserters pressed into service. Thousands of his troops were barefoot, and fully one-quarter of the complement was without arms. Price planned to march his three divisions north to take the federal arsenal at St. Louis, a much-needed prize for the failing Southern cause, and then install the Confederate governor-in-exile in Jefferson City, rallying Missourians to his side as he progressed through the state. From a broader Confederate perspective, the intent of the campaign was to tie up federal troops in the West in order to relieve the desperate situation in the East, and in this Price probably succeeded, though at a terrible cost.

After reaching Fredericktown, having encountered little resistance, Price and his staff debated moving on directly to St. Louis—or turning west to seize the Union fortification at Pilot Knob.

Afraid to leave this enemy fort on his flank, Price made the fateful decision to assault the stronghold twenty-two miles to the west. On September 26, he sent one division northwest to cut the railroad to Pilot Knob, but Brig. Gen. Thomas Ewing, Jr. (a brother-in-law of William Tecumseh Sherman) and a small detachment of infantry reinforcements had reached Fort Davidson by train before noon that very day. This was the same Thomas Ewing who had provoked the passionate hatred of Missouri Southerners by his issuance of the infamous "Order No. 11," which forced the depopulation and despoliation of several heavily pro-Southern counties along the Kansas border in western Missouri.

Fort Davidson, with its hexagonal nine-foot earthen walls and moat, had been built the previous year by federal forces. It guarded the Ironton gap between Shepherd Mountain on the west and Pilot Knob on the east, and marked the terminus of the Iron Mountain Railroad, which hauled the abundant minerals of the St. Francois Mountains region north to St. Louis. An approaching army would have to pass through hundreds of yards of open ground to reach the walls of the fort. Still, the fort was vulnerable to artillery attack from either of the flanking knobs, planned forts on the knobs never having been built.

Ewing had about 1,400 men with whom to hold his position. He also possessed formidable artillery and plenty of ammunition. Shortly after his arrival at the fort, he sent two companies through the gap to patrol the road to Fredericktown. They quickly engaged the rebels' advance troops along the Stouts Creek shut-ins just east of Ironton. Skirmishes continued around the Iron County courthouse and back up the gap toward

Autumn leaves and evening shadows soften the earth-works of Fort Davidson, the target of a frontal assault in one of the shortest, most devastating battles of the Civil War. NICK DECKER

the fort. Price gave Ewing an opportunity to surrender early on September 27; when Ewing refused, he launched a frontal assault on the Union forces. The bloody assault was short, some say only twenty minutes, but the casualties quickly mounted to from five hundred to a thousand, mainly among Confederates attempting to storm the fort.

Having learned a bitter, costly lesson in this ill-advised frontal attack, Price decided to bombard the fort with cannons from Shepherd Mountain the next day. But at two o'clock on the morning of the twenty-eighth, a loud explosion roused the rebel forces. At daybreak they found the fort empty with a giant smoldering hole in the center—all that was left of the Union powder magazine. During a drizzly, dark night, with the wheels of their cannons and wagons muffled, the federal troops had sneaked right through the disorganized rebel lines. When the squad he left behind blew the powder magazine, Ewing was already miles away. Outraged, Price sent a division after the fleeing federal forces, but Ewing managed to fight his way safely to Leasburg after several days.

With many of his best troops lost and the rest in disarray, Price abandoned his plans to attack St. Louis. He turned, instead, to a secondary prize, Jefferson City, only to be turned away by a newly reinforced Union garrison. From there, Price continued westward, pursued by Union forces; he suffered major defeats on October 23 at Westport (the biggest battle west of the Mississippi) and two days later at Mine Creek, Kansas, before retreating into Arkansas, all hope for "redeeming" Missouri now shattered.

The site of the debacle at Pilot Knob that doomed the realization of Price's dream was purchased in 1905 by the Pilot Knob Memorial Association, an organization of Civil War veterans who hoped to encourage federal preservation of the battlefield. Even though General Ewing's son was a principal player in this endeavor, broad support for creating a national battlefield was apparently not forthcoming. In 1938–1939, Ewing and his wife, still hoping the site would someday become a national park, donated it to the U.S. Forest Service, which was acquiring land in the vicinity. State park planners apparently prepared a master plan for the site as a cooperative endeavor, but the park board was not interested in taking it over at the time, and there was little development save a small pull-off with a historical marker.

The modern reawakening of the site began with cannon fire and a rousing speech on the occasion of the centennial of the battle, in 1964, and in 1969 the Forest Service transferred a two-acre tract containing the fort to the park board for management. Renewal of the ten-year permit in 1980 led to increased staff interest in making a trip to this fascinating site a more meaningful experience for visitors. In 1987 the state obtained title to the entire fifteen acres originally purchased in 1905 for the memorial through a complicated exchange transaction, and in 1990 an adjacent nineteen-acre city park was added as well. This expanded landholding allowed for the construction of a nicely landscaped driveway and parking area and a new visitor center.

A visit to Fort Davidson today should begin in the visitor center, equipped with an audiovisual program and a fiber-optic battle map as well as other exhibits and artifacts. Featured is a Confederate six-pounder cannon that had been dragged to the top of Shepherd Mountain only to be hit by uncannily accurate Union cannon fire from the fort before it could be brought into action. The building of subtle classical design is located at the edge of the site to minimize its impact, while still providing a formal and dignified entry to the battlefield.

The approach to the fort itself is over a pleasant walking path across the ground that was once contested so fiercely. From the path toward the fort, the strategic nature of the narrow notch in the mountains becomes apparent. The mass of Shepherd Mountain looms ahead, blocking the horizon, while the jagged-toothed, mined-out summit of Pilot Knob rears up behind. When Cyrus Peterson, in his book about the battle, referred to Fort Davidson as the "Thermopylae of the West," he spoke not only in classical allusion but with some considerable accuracy.

The sharp-edged reality of armed conflict to the contrary, the fort today evidences a curious softness, the result of years of weathering and the healing miracle of grass covering the entire earthwork. Early morning and late afternoon visits are most rewarding, when the low angle of the sun's rays heightens the relief of the remaining features. Then the moat lies in shadow while the tops of the walls, where the parapets once stood, are still bathed in sunlight, bringing forth the clear outline of the once-embattled hexagon. Even the earthen platforms for the thirty-two-pounder siege guns at the corners become visible in the slanting rays. The deep shadow marking the crater in the center of the fort convinces one of the magnitude of the blast that startled the resting Confederates during that rainy night following the afternoon's carnage.

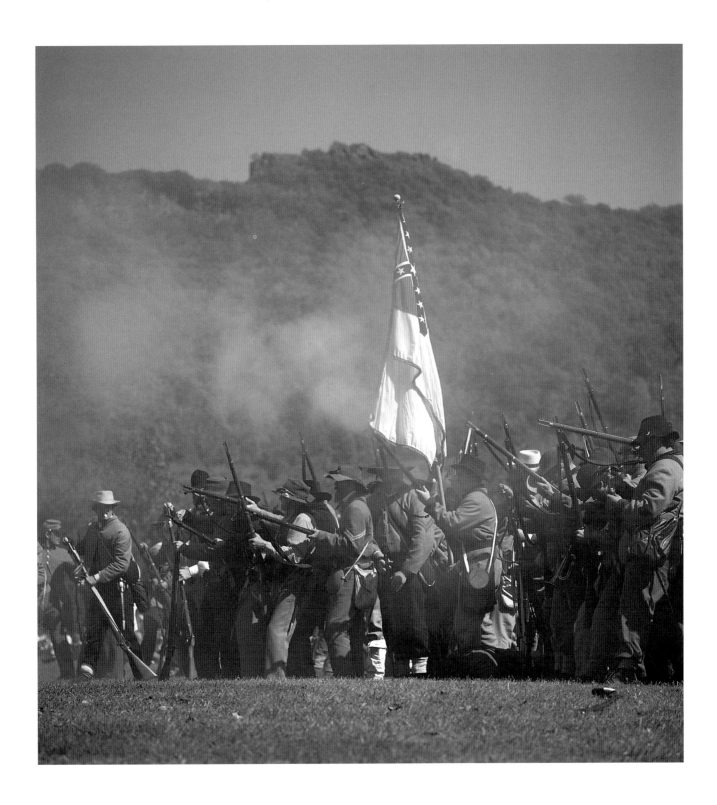

Extending from the fort's south wall was a rifle pit, really a trench some two hundred yards long and deep enough for men to walk in and fire from. Now it is visible only from the air, as a faint shadow in the green grass, reaching out from the fort and stretching south toward Shepherd Mountain in the distance. In it still repose the remains of several hundred Southern soldiers,

Pilot Knob looms behind rebel troops storming the fort in a modern battle reenactment. NICK DECKER

resting forever on the battlefield where they made the ultimate sacrifice for their cherished beliefs on that warm fall afternoon in Missouri, September 27, 1864.

*Morning mist floats along the steep north flank of
Mudlick Mountain above Big Creek in the heart of
Sam A. Baker State Park.* TOM NAGEL

Sam A. Baker State Park

AT THE SOUTHERN FLANK of the St. Francois Mountains, Sam A. Baker State Park offers visitors the freedom to wander at will in spacious, undeveloped lands, to savor old-time park hospitality in the rustic comfort of what is probably Missouri's most "classic" state park, to enjoy the refreshing tingle of a clear Ozark mountain stream, and to top out on the blue granitic hulk of Mudlick Mountain. Because Mudlick stands alone, separated from the concentration of domes surrounding Taum Sauk to the north, one can look out on virtually the entire panorama of the St. Francois Mountains. And looking back to the south and east one scans across the deeply dissected tabletop hills of the Ozark border to the abrupt escarpment that drops off into the Mississippi Lowlands beyond.

Life was hard in rural Wayne County where Sam A. Baker was born, grew up, and later taught school. The hard work of firing a furnace to pay for his board at the state teachers college in Cape Girardeau undoubtedly fired his determination to succeed. After working his way up from teacher to principal to superintendent, he became state superintendent of public schools and then, in 1924, was elected governor of Missouri. It was during his term that many of the "first-generation" state parks were acquired, not least the forested, mountainous area of canyons, shut-ins, and rushing streams in Wayne County, not far from the village of Patterson where the governor was born. Baker himself encouraged friends and relatives to sell or donate their land to the state, beginning in 1926, and the first 4,000 acres cost the state only $23,000. The park later grew to more than 5,000 acres.

Sam A. Baker State Park stands out in bold re-lief, encompassing all of Mudlick Mountain and the valleys on both sides. On the east the park fronts for about two miles on the St. Francois River and for about five miles on its tributary Big Creek. Huge boulders of Precambrian Mudlick dellenite, locally called blue granite, litter the hillsides and tumble into the canyons. The waters of the creeks rush and swirl around them, polishing them to a beautiful sheen. A reporter describing the remote new park in 1927 wrote, "It would seem that nature has endeavored to hide her grandest scenes."

Because the park was established under the old Missouri Game and Fish Commissioner, a large portion of the mountainous area was set aside as a big-game refuge. Here, standing fields of grain enhanced efforts to increase the state's decimated deer herd, and a state turkey farm was established to help restore a virtually extinct wilderness species. In talking about the park and the wildlife when he was a boy, Governor Baker made it clear that he wished "to make available for this and future generations something that was commonplace to the youth of forty years ago." Today, deer and wild turkey have returned to their former abundance, both inside the park and in the surrounding area, and the park no longer requires the previous artificial measures for their propagation. Jointly managed for decades by the conservation department and the park board, Baker since 1981 has been entirely in park hands.

The resources that make Sam A. Baker Missouri's most classic state park are cultural as well as natural. The first major construction came during Franklin Roosevelt's New Deal when the park became the site of Civilian Conservation Corps camp #5, set up in June 1933 in the valley

The entire park of the 1930s has been designated a national historic district, owing to the quality and integrity of its CCC workmanship: (clockwise from top) the "Black Lodge," built of local blue dellenite (TOM NAGEL), *tourist cabin* (PAUL W. NELSON), *trail shelter* (TOM NAGEL).

Backpackers relax along Big Creek. WANDA DOOLEN

near the present-day visitor center. By 1935, CCC enrollees had built barracks, installed telephone and water lines, laid out trails, planted trees, combated fires, and built a number of well-crafted rustic structures, including bridges, cabins, barbecue pits, restrooms, trail shelters, a gatekeeper's house, a stable, and part of a timber and blue granite dining lodge. After the CCC company pulled out in October 1935, Works Progress Administration workers completed many construction projects, including the lodge.

Most of these handsome, sturdy, Depression-era structures continue to function in the park today. Indeed, they set the tone for the whole place. Many have already been restored, and others will be. The dining lodge, formerly known as the "Black Lodge" because of the dark appearance of the blue dellenite stone, is a truly arresting structure, as is the stable, with its three-story octagonal tower and two projecting wings, now converted to an interpretive center. Mudlick fire tower, a distinctive CCC-era landmark, is still used to spot smoke in the region's heavily timbered hills. Owing to the integrity of the pre-

served CCC-WPA workmanship and the limited extent of other intrusions, the entire 4,860 acres of the 1930s park has been designated the Sam A. Baker State Park Historic District on the National Register of Historic Places—the only park whose entire area is a historic district.

One of the best ways to enjoy Sam Baker is to hike the trail that begins across from the dining lodge. We descend first to the floodplain of Big Creek, hugging the base of Mudlick Mountain. On our right are the majestic sweet gums, syca-mores, shumard oaks, and cottonwoods of a southeast Ozark terrace forest; on our left, the rich vegetation of the shaded mountain base. We pass several steep rocky draws where huge purple and bluish boulders of the Mudlick dellenite are jumbled like a giant's toy blocks. In the spring these draws are alive with the rush of clear waters cascading over glistening rocks, moisten-ing scattered patches of moss into puffy emerald cushions. These cool, moist cushions provide the rare and colorful four-toed salamander with ideal shelter beneath which to breed and deposit its eggs. Also in spring, the lower slopes of Mudlick display the lovely yellowwood tree, its luxuriant yellow-green compound leaves draped with fra-grant pealike white blossoms. Baker is one of the

few places in Missouri where this Appalachian species grows in its natural habitat.

Soon the trail turns left up a slope and begins a series of switchbacks across a bulging shoulder of the mountain. As we climb, the forest soil gradually becomes thinner, rockier, drier. Then we cross several small glade openings filled with sun-loving grasses and flowers. From the openings, we look back and see the valleys of Big Creek and, farther off, the St. Francois River. Reentering the oaks and hickories, we emerge suddenly at the brow of a point and discover a small stone cabin that seems to have grown right out of the mountainside. Its dellenite walls and floor, wood-shingle roof, and sturdy rock fireplaces all welcome us after our steep climb up the trail. It is actually a three-sided shelter, and as we sit resting under the eave on the raised lip of the stone floor, we notice that there is an open ledge not far in front of us. A few steps closer and we are drenched in a spectacular panorama of the wild canyon of Big Creek, looking upstream toward the cliff-lined narrows and across at the pine-strewn slopes on the opposite bank. Our shelter is one in a series of three strung out along the trail in an arc across the flank of Mudlick. Each is a joy. For a really special experience, you might arrange to camp overnight in one of them during the winter backpacking season.

This area is all part of the 4,180-acre Mudlick Mountain Wild Area, one of the largest wilderness preserves in the state park system, and a third of it, part of which we have just traversed, is a state-designated natural area. The twelve-mile Mudlick Trail, now a national recreation trail, contours around the mountain, with a spur to the fire tower at the top. Near the top of the mountain on its westerly flank are gnarled, stunted, weather-sculpted white oaks, many exceeding two hundred years of age and showing signs of the violent winds, lightning strikes, and heavy ice storms that pummel the mountain crest. Amazingly, most of the trees survive, providing numerous hollow trunks that serve as nature's hotels for a variety of birds, mammals, reptiles, and invertebrate fauna.

On the south ridge of the mountain, the trail leads through an area ravaged by a tornado in 1984. Hundreds of centuries-old oaks and hickories were toppled. In human terms, perhaps a catastrophe. In nature's terms, though, just part of a never-ending sequence of earth events. This event was unique, however, in that university researchers have carefully monitored and collected data to study how plants and animals have responded. For example, within two years a profusion of flowering dogwood burst into bloom owing to the great increase in sunlight. The fallen trees and newly sprouted thickets supplied habitat for dozens of species. Equally valuable, park visitors can see and learn about this great storm and its aftermath in wilderness terms. Here we have a natural event, recorded in time, which has affected a wilderness landscape. Like the volcanic explosion on Mount St. Helens or the great Yellowstone fires of 1988, the Mudlick blowdown at Sam A. Baker State Park offers scientists and park visitors alike an opportunity to witness, study, and appreciate nature's regenerative processes.

Meramec State Park

ONE OF FOUR STATE PARKS along the Meramec River—Onondaga Cave, Robertsville, and Castlewood being the others—Meramec State Park is one of the oldest, best known, and most popular of Missouri's parks. At nearly 6,800 acres it is also one of the largest. That the park is named for the river that flows through it and along eight miles of its borders is most fitting, for the Meramec River is the dominant natural influence over the park's varied features and it was also the centerpiece of a bitter public controversy resolved in favor of the free-flowing stream, the most biologically diverse in the Midwest.

A new visitor center for the park, dedicated in June 1989, provides an outstanding introduction to the park and the river. It is both educational and fun, with a nice mix of exhibits and activities for visitors of all ages and interests. Especially popular are the large aquariums that display the amazing variety of aquatic life in the river—from huge catfish to eels to foot-long salamanders—with a clarity and closeness that one otherwise might not experience. Large murals and complex dioramas present the broad sweep of history, both human and natural, in the Meramec River valley.

The visitor will find there is much to see and do at Meramec: too much to be accomplished in only a few visits. One way to enjoy the park is by river. The river has an undeserved reputation as being treacherous, probably because of accidental drownings on the lower, deeper sections near St. Louis. But the Meramec is as safe a river to float as any other Ozark stream. If you launch your boat up at Sappington Bridge and take out down at Cane Bottom, you can see much of the park in a good day's float. Or you can break the trip down into two more leisurely day floats. Consider the uppermost float:

As you drift downstream, you will see Hamilton Creek coming in from the right. A bit more than a mile up this creek are the ruins of the old Hamilton Iron Furnace, not far from Hamilton Spring. The ironworks, one of many in the Meramec basin, was built in 1873 and was soon followed by a town that grew in size to some one hundred and fifty persons in the late 1880s. Ironworks are dependent upon the vagaries of the economy, and this one died young. It remains an intriguing site to visit, with the brick crucible still visible in the fantastic stone furnace and with the sites of several auxiliary structures still visible as well. The walking trail has interpretive signs identifying the features.

After you pass the mouth of Hamilton Creek, a massive dolomite cliff rises on the right bank. And in that cliff looms one of Missouri's most impressive cave openings—Green's Cave. It is well worth a stop. Actually, Meramec State Park could well be called the "cave park," with more than three dozen known caves within its boundaries—more than any other park in the nation. Several of the wild caves have been gated to protect endangered species of bats. But Green's Cave is one wild cave that invites exploration—at least near the entrance.

At this point, the river makes a large bend to the left and then back to the right, what geologists call an entrenched meander. Such bends say a lot about the natural history of Meramec State Park. Rivers on flat or relatively flat terrain tend to meander, whereas rivers in rough terrain tend to follow a straighter course. Most of the rivers of

*A grotto dissolved from porous dolomite, one of more
than three dozen known caves in Meramec Park,
beckons canoeists. Earth's natural plumbing system
of caves, springs, and interconnected underground
streams provides a constant supply of calcium-rich
water, helping to make the Meramec Missouri's most
biologically diverse stream.* NICK DECKER

the Ozarks were originally formed when the area was a broad plateau, so they meandered back and forth. As the region slowly became elevated over millions of years, the rivers—meanders and all—cut their way into the dolomitic bedrock, thus "entrenching" themselves.

This is a good place to witness the hydrologic power of the Meramec. On the outside bend of the meander, the water is relentlessly working on the bank, wearing away soil and rock. Large sycamores that have been undercut wait to tumble into the stream with the next flood. On the inside bend, the opposite is occurring. Silt and chert gravel are being deposited, often forming large bars with willows and other plants anchoring the new alluvial land. You cannot see it, but the river actually flows in a corkscrew motion as it rounds the bend. The rugged landscape of this state park owes its character to the persistent force of the Meramec River over the eons.

Down a little further, you float past what was to have been the site of the Meramec Park Dam. This controversial federal water project was effectively killed in 1978 when the public voted "NO" by a margin of two to one in a regional, twelve-county referendum. Respecting the citizenry's disfavor, elected officials moved to deauthorize the project several years later. In fact, all of the state park land you have just floated by had originally been purchased for the proposed lake by the U.S. Army Corps of Engineers. Several thousand acres of the land were transferred to the state for the park, along with a scenic easement (what Ozarkers call a "setback") of six hundred feet on each side of the river when other lands were returned to private ownership through public auction.

Many factors figured into the dam's demise, but one is worthy of mention here: caves. In addition to all of the known caves in the park area—those where happenstance and erosion have provided entrances large enough for people—countless caves probably exist with no surface entry. Critics of the dam tried to point out the cavernous nature of the hills that the earthen dam would have abutted, but army engineers insisted that with enough concrete grout any "solution cavity" could be sealed. Drilling accidentally confirmed a major cavern in one hillside, a cavern with chambers fifty feet high in places. That would have been a lot of concrete! Today, that pristine cave—Moore's Cave, which can only be entered by rope through a hundred-foot shaft—is protected as part of the state park. For further protection, it is closed to the public.

Meramec State Park had its beginning in 1927 when the state fish and game commission started acquiring land along the river near the site of the old mining town of Reedsville. The area had been mined for lead by Indians and then by early settlers, both French and American, and it also produced iron and copper. Some ten thousand people in two thousand cars reportedly attended the dedication in 1928, and Meramec, with its ready accessibility from St. Louis, quickly became the state's most popular park. Many of the early facilities in the park were built by the Civilian Conservation Corps (CCC) in the 1930s. Most of these structures—including the dining lodge, cabins, and river shelter—have been restored and are still in service. The vintage lodge offers good food and a fine view of the river. Many new facilities such as the park store, the Hickory Ridge conference center, and the visitor center were designed to carry on the CCC's heritage of handsome craftsmanship.

Down near the riverside campground is the entrance to Fisher Cave, one of Missouri's oldest "show" caves. State park naturalists conduct

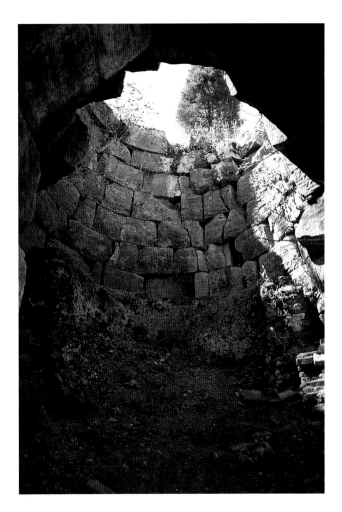

The Hamilton iron furnace stands in mute testimony to a once-thriving industry. TOM NAGEL

guided tours of its subterranean splendor from April through October. The cave features many speleothems (rock forms) and troglobites (cave creatures). Fisher Cave figured importantly in the 1950s studies of J. Harlan Bretz when the prominent geologist was developing his theory of speleogenesis, or cave origin.

Wildlife abounds in the park, and an early morning float can be a photographer's dream. September is often the best month to be on the river. Typically, skies are sunny, both air and water temperatures are mild, and the river is clear and uncrowded. In mid-September the peak of the hummingbird migration usually coincides with the peak blooming of the cardinal flower. This common riverside plant is so sought after by hummingbirds that you will rarely watch for five minutes before a hummer shows up to feed. While waiting for hummingbirds you will have a good chance of also seeing ospreys, mink, or river otters.

Even at midday on a summer weekend the rich diversity of the Meramec can be experienced by putting on snorkeling goggles and submerging into the clear waters. With over one hundred species of fish and numerous species of turtles, salamanders, crawfish, and mussels it is easy to see why the Meramec is Missouri's Amazon of aquatic life.

Back from the river is a vast expanse of mature forest also protected in the park. On east- or north-facing slopes the forest often reaches an impressive size and density. Here in early May a healthy population of the exquisite yellow lady's slipper orchid flourishes. On the south sides of several ridges the forest is occasionally broken by thin-soiled rocky glades. In mid-April Indian paintbrush erupts from these glades to embellish them in red. A second peak of color occurs in early June as the long, lavender ray flowers of purple coneflower blossoms unfold. One of the best places in the park to experience the harmonious blend of glades and majestic trees is the 460-acre Meramec Upland Forest Natural Area. This area presents one of Missouri's finest examples of the forest community that typically grows on well-drained cherty soil formed from dolomite rock.

Although the woods and the caves provide an

Turtle meets girl in a watery wonderland.
WILLIAM ROSTON

A park naturalist captures children's attention at an evening program in the amphitheater. DAN DREES

extra measure of enjoyment for an outing at Meramec State Park, it is ultimately the river that defines not only the experience but the park. The park, like one of the river's own meanders, has come nearly full circle, from its beginnings as a modest attempt to preserve and make the riverine environs available to the public, through the speculative fevers of dam construction and flatwater lake boosterism, to its return to the real heart of the matter: the Meramec. It is the value of the river itself that has prevailed.

Onondaga Cave State Park

I F MERAMEC STATE PARK has the greatest number of caves, Onondaga some twenty miles upstream may claim the preeminent cave. With more than five thousand known caves, some two dozen of them developed for the public, and perhaps as many yet to be discovered, Missouri has a solid claim to the title *The Cave State*. And Onondaga is widely recognized as the crown jewel in Missouri's underground treasure chest. For more than seventy-five years before its recent acquisition by the state, Onondaga Cave has been one of the major public attractions in the Midwest.

More than a geologic curiosity is preserved at Onondaga Cave State Park. Here is a memorial to a disappearing style of roadside showmanship that is peculiarly American. It is impossible to separate Onondaga Cave, the natural phenomenon, from Onondaga Cave, the showplace of a twentieth-century-vintage frontier-style capitalism. The two are intertwined in their recent history. Although the colorful cave forms are the results of millions of years of geologic history, the human story of the cave is every bit as colorful. Appreciation of this state park is greatly magnified by a knowledge of both.

At least nineteen caves are located in this 1,300-acre park that fronts on the Meramec River near Leasburg. Two are well known, Onondaga and Cathedral, and both have long histories of commercial operation as show caves. They occur in separate forested ridges divided by two small but steep valleys and a third ridge with nearly three hundred feet of relief. The geologic story of these caves is not unlike that of many others in the state.

In prehistoric times much of what is now Mis-souri was inundated by a series of shallow, warm seas. Over millions of years organic material—shells and exoskeletons from a whole host of aquatic plants and animals—was deposited as layer upon layer of sediments. Millennia passed, and these deposits became the limestones and dolomites of the Ozark plateau. Even though the bedrock was no longer covered by Paleozoic seas, the sedimentary layers provided pathways for groundwater, which had become mildly acidic from percolating through decayed organic material on the surface. Along cracks and within the horizontal seams separating the sedimentary layers, the water slowly dissolved away the calcareous material, forming larger cracks and, finally, tunnels and chambers.

While this subsurface rock was being dissolved by groundwater, surface runoff began to cut valleys forming the Ozarks we know today. As the valleys deepened, the water table dropped, and some of the water-filled tunnels were drained. As air replaced water in the passages, they became what we know as caves—like Onondaga and Cathedral. The mouths of the caves are the points where valley streams have cut across the passages, opening them to the world aboveground. But the work of water was not done. Streams within the caves continued to erode both stone and clay fill, enlarging the cave passages and finally emerging as springs at the cave mouths. And water carrying dissolved minerals from the ground could seep into the caves, frequently depositing carbonate rock forms known technically as speleothems, or more familiarly as stalactites and stalagmites. It is the color and variety of these dripstones and flowstones that lend a decorator's touch to the caves' interiors. Cave forma-

The "lily pads" have formed drop by drop over the eons. EUGENE VALE

tion is an almost magical process: water dissolves and erodes the rock, forming the caves, and water can eventually fill the cave back up with redeposited stone.

No one really knows when the first explorers entered the spring exit of Onondaga Cave, but the entrance area was host to several mills during the latter half of the nineteenth century. It is known that in 1886 three men—Charles Christopher, John P. Eaton, and Miles Horine—began exploring what was then called Davis Cave, after William Davis who owned and operated a mill at the spring. A few years earlier, Davis had built a dam to create a millpond at the cave's entrance. The ponding forced Eaton and his friends to use a johnboat to gain entrance. Later, Eaton and Christopher acquired several hundred acres north of the Davis property, land under which much of their beautiful discovery was located. Plans were made to mine the cave onyx from the plentiful formations, but lack of mining expertise and funds forced them to sell their holdings to other parties after the turn of the century.

One of those parties was a St. Louis man, George Bothe, who formed a mining company to remove and market cave onyx. But a number of factors, including a glutted market, led Bothe to look for some other way to exploit his underground treasure. He chose to advertise the cave as an attraction for fairgoers to the 1904 Louisiana Purchase Exposition in St. Louis. Thousands of visitors rode the Frisco Railroad to the little town of Leasburg where they were met by surreys or wagons for the five-mile trip to the cave. The success of the cave as a fair attraction convinced Bothe to keep it open for public viewing. He acquired the mill property from William Davis's widow, and he promoted the cave in the railroad literature. A naming contest settled the cave's title as Onondaga, meaning "spirit of the hills" (the name of a tribe of the Iroquois), and the grand opening occurred in 1908.

Two years after the official opening, Bothe sold the cave to a niece, and in 1913 Robert Bradford arrived to manage the commercial venture. Bradford eventually purchased the cave and formed a development company, issuing stock to finance improvements to the property. Bradford was a railroad stockholder, but when rail traffic began to decline, he started using highway advertising, a technique that his successors would develop into a fine art.

Onondaga Cave has been the center of several controversies, the most fascinating of which began in the early 1930s. Actually, the stage for this chapter had been set back in 1902 when John Eaton sold 240 acres near the cave to Eugene Be-

noist. As it was later learned, much of Onondaga Cave ran under this acreage. Dr. William Mook held a lease to Benoist's property, and in 1931 he undertook to commercialize his part of the cave as Missouri Caverns, utilizing a different entrance.

A cave war erupted! The dividing line between Onondaga Cave and Missouri Caverns was designated underground by a barbed-wire fence—actually several fences, since Bradford and Mook could not even agree on just where the line should be. Bradford sued, claiming the other half of the cave by adverse possession. The case went all the way to the Missouri Supreme Court, which decided in Dr. Mook's favor in May of 1935. But Mook was not around to enjoy his victory, as he had died unexpectedly about six months earlier. Still, cave guides from the competing owners would stage rock fights at the fence just beyond the Twins, two large stalagmites in the Onondaga section. And, aboveground, roadside hucksters attempted to divert unsuspecting tourists from the rival attractions.

At this point, a hospital entered the controversy and eventually became the instrument for reuniting the bisected cavern. Dr. Mook had willed his interest in Missouri Caverns to Barnard Hospital in St. Louis. While Mook's brother Robert continued to run Missouri Caverns, he soon found himself in a struggle with the hospital over division of the profits. Lawsuits were filed, but neither party was satisfied. Mook quit, and the hospital closed the doors of the "Rock House" entrance to the cave. Ironically, Robert Bradford, who been left nearly broke by his own lawsuits against Missouri Caverns, now turned to Barnard Hospital for a loan of $10,000 to make improvements, in exchange for an option to buy Onondaga. In 1945 Bradford's widow urged the hospital to exercise its option.

Charles Rice of St. Louis leased both parts of the cave from the hospital and formed the Crawford County Caverns Company to run the facility. When Rice died in 1949, the cave was sold to Lyman Riley and Lester B. Dill. Under their leadership, Onondaga reached its apogee in the 1950s and 1960s as a nationally known show cave. Dill became sole owner in the late 1960s, and his remarkable personality has left its indelible mark on Onondaga Cave and Missouri's tourism industry. Dill had an Ozark wit and a legendary gift for telling tall tales. He always told what he called the "Ozark truth"—something between the honest truth and a bald-faced lie—like the time he promoted a 102-year-old Oklahoman named J. Frank Dalton as the real, still-living Jesse James. That 1950 stunt brought national attention to his

Eastern red cedars, some over six hundred years old, have weathered the ages on Vilander Bluff.
EUGENE VALE

caves. He coupled his P. T. Barnum–style show-manship with a measure of respect for the natu-ral integrity of the cave. And his stubborn resist-ance to the Army Corps of Engineers helped save the cave and much of the surrounding Meramec River valley from permanent flooding.

Lester Dill eventually became known as "America's #1 Caveman," but he always referred to himself as a "caveologist." He had started ex-ploring caves as a young boy, giving torchlit tours of Fisher Cave in Meramec State Park, where his father, Thomas Benton Dill, was a former land-owner and the first superintendent. In 1933, Dill bought the old Saltpeter Cave near Stanton and turned it into Meramec Caverns, set in what he called La Jolla Natural Park. Dill took Robert Bradford's idea of highway advertising and set a standard for cleverness and saturation rarely equaled on the nation's highways. Billboards and painted barns heralded "See Jesse James' Hide-out—Meramec Caverns" and "Visit Onondaga

Cave, Daniel Boone's Discovery." He was instru-mental in founding the National 66 Association to promote tourist attractions along old Route 66, dubbed the "Main Street of America."

Dill's influence spread to other commercial caves. He supported a state law requiring safety inspections for all show caves. He was not afraid to go to court and did so several times, fighting highway beautification laws over his billboards, fighting the National Park Service over the con-fusion brought about by his "natural" park, fight-ing the army engineers over the Meramec dam.

Before his death in 1980, Lester Dill had al-ready begun talks on turning Onondaga Cave into a state park. With the cooperation of the Dill estate, the Nature Conservancy, and the Missouri legislature, Dill's desire to preserve Onondaga for future generations was at last realized with the dedication of Onondaga Cave State Park in 1982.

The following year, another 380 acres down-stream from the park, including the largest, high-est dolomitic bluff on the Meramec, were added to the park courtesy of the army engineers as a result of the deauthorization of the Meramec Dam. Many a canoeist is awed by the hulking

magnesium-stained cliff face of Vilander Bluff with its projecting overhangs looming above. Along its rocky, broken slopes and atop the two-hundred-and-fifty-foot cliff, eastern red cedars grow in timeless fashion. Some exceed six hundred years in age. Dislodged skeletons of these ancient trees lie scattered here and there at the base of the cliff, their extremely slow decay allowing dendrologists to study the effects of bluff weathering on the trees. Beware. Here below the cliff is no place to camp. Cross sections of the base of these deceased cedars show their tree rings interrupted an average of every six years by scarring wounds. The cause? Falling rocks.

Shortly after acquiring Onondaga, park division scientists worked closely with the concessionaire and park staff to develop a cave stewardship plan. The plan insured that the public would continue to enjoy the cave while its delicate biota and fragile geologic treasures were preserved. For decades, countless thousands of visitors had caused physical damage to natural features and cave organisms—not maliciously but through insensitivity and lack of knowledge. New corrosion-resistant metal railings were installed along walkways; new lighting circuits with low-intensity lights reduced the unwelcome green algae that covered areas around the old lights. The Missouri Speleological Society and other groups of cavers volunteered to remove trash and debris brought into the cave through the decades, thus reducing chemical contamination to groundwater that had interfered with the cave-formation process. The practice of tossing coins into the pools in the unique lily-pad room was prohibited; cave guides were trained to explain how this activity had disrupted the delicate chemical process that formed the "lily pads." Smoking was prohibited to eliminate air pollutants harmful to cave life. Old air shafts once used for transporting gravel into the cave were sealed and airtight entry doors installed to restore natural air currents, humidity, and temperature in order to prevent drying of the cave. Visitors are instructed to remain on pathways and not touch or remove cave forms; the natural oils on human skin can stain pearly white onyx, and

it takes a hundred years for a "soda-straw" to grow one inch.

Missouri celebrated 1990 as the "Year of the Cave," when its 5,000th cave was officially recorded. Gov. John Ashcroft proclaimed Missouri *The Cave State* and urged that Missourians become aware of the fascinating mysteries and wonders underground. This proclamation aptly coincided with the dedication of a handsome new visitor center at the entrance to Onondaga Cave, which contains elaborate exhibits interpreting Missouri's underground wonderland.

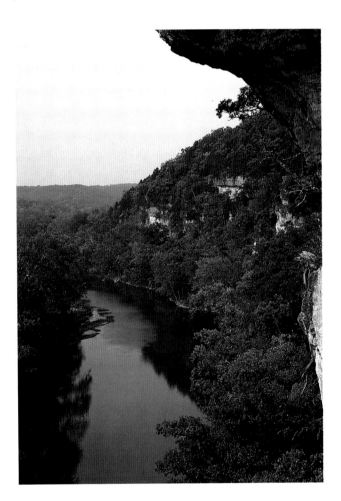

The hulking overhang of two-hundred-and-seventy-foot-high Vilander Bluff is awesome whether viewed from above, below, or across the way. DAN DREES

Dillard Mill State Historic Site

NESTLED AMONG THE OZARK hills along a rocky stretch of Huzzah Creek is one of the state's most picturesque gristmills. Dillard Mill was added to the state park system through a donated lease from the L-A-D Foundation, a private land preservation organization, in 1975. The parks division undertook a massive overhaul of the mill's mechanical systems, and today the machinery is in good working order. Visitors delight in the creaks and moans as the turbine begins to spin, belts move, and the mill inches its way slowly back to life.

The present mill was built about 1904 by Emil Mischke, a German-Polish immigrant. He and his sister and partner, Mary, operated the mill together from 1908 until 1917, when Mary sold her interest to Emil. In 1927, Emil, at age sixty-seven, sent for a mail-order bride. Anna Pressler, from Los Angeles, never became accustomed to the rugged Ozarks and in 1930 persuaded Emil to sell the mill and move to California. Mary Mischke continued to live in Dillard until her death in 1944; she is buried in the old Dillard cemetery, located within the historic site.

Lester E. Klemme and his wife, Virginia, purchased the mill and adjacent land in 1930. Klemme continued to operate the mill off and on, although by the mid–1930s it was producing more cattle feed than flour. Taking advantage of the scenic beauty of their Ozark location, the Klemmes began operation of Klemme's Old Mill Lodge for city folks who wanted to get away from it all. Following an unsuccessful attempt to get in on the health-food fad in the 1950s, Klemme closed down operation of the mill for good around 1956. In 1962, following the death of his wife, he closed the Old Mill Lodge.

Sometime later the state park board became interested in acquiring the mill. The plan was for the U.S. Forest Service to buy the entire Klemme tract for the surrounding national forest and lease the mill to the state to operate as a historic site. But the forest service appropriation fell through, so in 1974 the L-A-D Foundation of St. Louis forest owner and environmentalist Leo Drey stepped in to save the day.

Reflections of the mill's barn-red metal siding shimmering in the clear waters of the ponded Huzzah Creek are a frequent temptation to photographer and artist alike. The setting of the mill is extraordinary. There are two millponds, one upstream and one downstream, separated by a narrow outcrop of rugged dolomite that continues to the east and south as a pine-covered bluff. As the bluff peters out, the small tributary Crooked Creek enters the Huzzah. At one time the Huzzah Creek wound around past where the miller's house is located and formed a large oxbow or gooseneck. Eventually, the erosive work of the water breached the rocky ledge and the Huzzah took a shortcut down a beautiful waterfall, the same route it used during many a flash flood. Local popular accounts attribute the cleft in the dolomite "wall" to a lightening bolt. But it is a classic case of a cutoff of an entrenched meander, leaving an isolated "lost hill" where the mill now stands.

Regardless of the rock gap's origin, it presented an obvious site for a small dam and water-powered mill. The millrace, where the sluice gate is located, was cut into the bedrock. The present-day mill was preceded by a mill built just north and below today's location. The first mill is credited as having been built by Francis Wisdom, who

*Reflections of Dillard Mill's metal siding shimmer in
the ponded Huzzah Creek.* OLIVER SCHUCHARD

Dillard is the only mill left in the Missouri Ozarks with all of its original machinery intact and in operating condition. NICK DECKER

owned the property from 1853 to 1869. In 1881 Joseph Dillard Cottrell and James Cottrell purchased the mill property. Joseph Dillard ran the mill, while James opened a store just to the north. The local economy took an upswing with the 1880 opening of the Sligo iron furnace in nearby Dent County. In 1887 the first post office was established near the mill, and thus was born the small town of Dillard—named for the owner of the mill, Joseph Dillard Cottrell. In 1890 the Cottrells sold the mill to Andrew Jackson Mincher and his son Jesse. The Minchers added a stave mill and lumberyard, but in 1895 the old mill burned. By this time the Sligo and Eastern Railroad had a rail line a mile north of Dillard, and migration to this new location began. The

new Dillard prospered for many years until the Sligo Furnace Company closed in 1921. One of the Sligo workers, Emil Mischke, continued to live in Dillard operating his new mill, which leads us back to the beginning of our tale about this beautiful mill on Huzzah Creek.

Today the 132-acre Dillard Mill State Historic Site offers a fully operational mill and a mill store, which visitors can tour for a nominal fee. The site also offers a day-use picnic area and a mile-and-a-half hiking trail.

Dillard Mill stands as a reminder of a not-so-bygone era, when man and nature cooperated to produce one of man's needs. Of the more than nine hundred mills that dotted Missouri's landscape at the turn of the century, the sites of only about one hundred and fifty are known today. Many of the mill buildings are but skeletal remains, some are used as houses or other businesses, but all hark back to a quieter, simpler time. Along with the other mills preserved in the state park system, Dillard Mill is a real treasure.

Bennett Spring State Park

PPROACHING FROM HIGHWAY 64 west of Lebanon you wind down an entrance road past several private cottages and a tackle shop, then emerge suddenly into the pleasant valley of Bennett Spring. Across a meadow-like slope you see, a hundred and fifty yards or so on your left, the tree-lined racing stream, almost always host to attentive figures garbed in waders and other accoutrements of the devout angler. They stroke the waters lovingly with their lines and, with rods extended, twitch the tips from time to time—homage to the sacred trout.

Wooded hills rise steeply on either side. On your right you pass a sandstone-buttressed interpretive center, nestled into the oak-timbered hillside. The road curves and you cross over the stream on a graceful bridge of concrete and native stone, a now-historic structure built in 1934 by the Civilian Conservation Corps. Upstream to your left is a low dam, successor to earlier mill-dams, usually lined with anglers—at season's opening and on pleasant weekends literally shoulder to shoulder.

To their left are the brown buildings of a fish hatchery where *Salmo gairdneri*, the rainbow trout, is artificially spawned. The hatchlings are rotated by age groups in a network of rearing ponds, artificially fed, and some grown to "lunker" size before being released into the stream for enticement by the lures of the anglers.

Over the bridge, you enter the village-like heart of the state park. The lodge, containing a restaurant and meeting room, is another architectural gem from CCC days, its decorative chandeliers featuring a trout motif. In the park store, the concessionaire sells tackle and other supplies to visitors and rents cabins and canoes for use on the nearby Niangua River; offices for the park superintendent and aides are in one end of the building. Past these buildings, one road winds around the hill to stone cabins of recent construction and renovated ones built in the CCC years. The main park road extends downstream along the riffles and pools of the spring branch, recrosses it via a low bridge near the point where it empties into the Niangua River, then goes back up the hill and rejoins the main highway. Along this route through the park you will also pass a swimming pool, campsites with electric hookups, and, up a spur road, campgrounds for those less-mechanized vacationers, some of whom may even use tents.

Without spending a thoughtful hour or two studying the old photographs, maps, and artifacts in the interpretive center, the casual visitor is unlikely to learn and could scarcely imagine how this inviting and heavily used park evolved from a little mill town that faded away as a commercial center when big companies in Minneapolis and Kansas City began producing and distributing flour and other cereal products more cheaply, and when the automobile and improved roads led residents of the area into Lebanon or Buffalo to do their shopping. The great spring has been a constant in the history of the area, the rainbow trout was a catalyst for change, and the same automobile and good roads enabled increasing thousands to come to the little valley for recreation.

This was once country of the Osage Indians and earlier native peoples. An Osage legend, as reported by Samuel Bradford, explains how the great spring was created when the sins of arrogant

Trout fishermen have been casting their lines beneath the triple-arched bridge at Bennett since it was built by the CCC in 1937. NICK DECKER

warriors so offended Wah'Kon-Tah, the Great Mystery Force, that he caused the earth to heave and shake, toppling trees from the slopes: "As the earth's convulsion ceased, the Indians arose from the ground to behold the ruin about them. The stream which white men call Spring Creek had ceased its flowing and while the warriors watched, the quiet pool became a boiling spring as the stream of tears flowed from the eye of the Sacred One."

The Indians had already been pushed out when, about 1837, an early settler named James Brice arrived with his wife and their two young daughters. Brice, originally from Virginia, recognized an economic opportunity in the strong and steady flow from the spring. He secured his first deed from the federal government for 121 acres in Dallas County on December 11, 1846—a parcel including the spring and part of the spring branch. In later purchases from the government and from a neighbor, Brice increased his holdings to 427 acres straddling the Dallas-Laclede county line.

Even before obtaining his first land patent, Brice erected a gristmill, probably exercising his "squatter's rights." Peter Bennett and his son soon established a rival mill near the confluence with the Niangua, setting off a feud that was finally bridged by marriage. Both mills were swept away by flood in 1852. Brice rebuilt, but died a year later, bequeathing his land and mill to his daughter Anna and her husband, John Clanton, who had become Brice's business partner. Clanton died four years later, leaving all the property to Anna, who later married Peter Bennett, Jr., thus merging the two families.

In those days the spring was known as Brice Spring, and the town that grew by the mill was called Brice. What happened to the Brice-Clanton mill is unclear, but during the Civil War, according to old newspaper files, Peter Bennett, Jr., constructed a larger mill closer to the town of Brice. This one endured until 1895, operated after Peter died by his son William. In 1895 it burned to the ground in what was rumored to have been an act of arson growing out of a neighborhood quarrel. The last in the historic succession of mills at Brice was built in 1899 by the local Atchley family under lease from the Bennetts. It was during the period from about 1900 until the Great Depression, according to regional historians, that Brice enjoyed its greatest prosperity. In addition to farmers who came to get their grain milled and to shop in the general store, tourists began to arrive in buggies and later in Model T's and Model A's to stay at the Brice Inn and enjoy fishing and relaxing in the scenic little valley.

The popular name of the spring had long since changed from Brice to Bennett; but until its demise after it was bought by the state to become a state park, the town was called Brice. In its heyday, Brice had not only the mill but a hotel and a store, both owned and operated by the Bennetts, a blacksmith shop, a church, perhaps a second general store, and miscellaneous small structures. The last mill ceased making flour and cornmeal some time in the 1920s but remained in partial operation to grind food for fish and to generate electricity until it too was destroyed by fire in 1944.

The church still stands on one acre given to it by the Bennetts in 1917, still an active place of worship for the community. It was veneered with orange-brown sandstone in 1940 to blend with the CCC-built structures, and a second building that doubles as parsonage and Sunday school is painted park-brown. Except in the interpretive center, little attention is given to the fascinating history of the little mill town that finally gave way to the state park. There are no markers at the sites of old mills or at places where the dams, perhaps as many as six, at various times diverted water to power the mills, although submerged log footings and the embankments of some of the dams can still be discerned.

By 1900, the focus of the area had already begun to shift toward recreation. Early mill customers waiting for service idled away time fishing in the spring branch. Trout were introduced around the turn of the century. The *Laclede County Sentinel* reported in January 1900 that the state fish commissioner "stopped by" and released 40,000 "mountain trout." The stock apparently came from a federal fish hatchery at Neosho, Missouri. Although unrecorded, there were probably other releases of trout before Charles Furrow, a dentist and fishing enthusiast from Tulsa, Oklahoma, leased a site from the Bennetts and built a fish hatchery in 1924. Again, the hatchery at Neosho provided 50,000 rainbow trout eggs for Furrow's new hatchery troughs and placed another 50,000 brook trout eggs from Wisconsin into the stream.

Bennett Spring was one of the first parks acquired by State Game and Fish Commissioner Frank H. Wielandy with funds set aside under a legislative act from hunting and fishing license revenues. The initial acquisitions included 8.5 acres from Josephine Bennett Smith in 1924 and 565 acres in 1925 from William Sherman Bennett, who had added to the acres that his parents inherited from James Brice.

When the state acquired the Bennett land, it also bought Dr. Furrow's hatchery. Since then the hatchery has been enlarged, modernized, and op-

A scuba diver explores the eerie depths of Bennett Spring. Divers can descend eighty-five feet to a constricted passage where powerful currents tumble chert gravel into finely polished stone jewelry.
GARY HALEY

An "eye of the microscope" bubble in the interpretive center reveals the microcosmic universe of a cold-water spring. Algae, cyclops, seed shrimps, scuds, and water mites are among the unique life-forms found here and are important to the health of the spring branch. NICK DECKER

erated by the state, until 1936 by the game and fish department and after that by the successor agency, the department of conservation. The department licenses the anglers; sets limits, seasons, and fishing hours; and enforces the regulations. The daily release of catchable trout is based on the number of trout tags sold, so anglers are always assured of a well-stocked stream. All other facilities and operations in the park are administered by the parks division of the department of natural resources.

Little improvement had taken place in the new state park until a CCC company composed of nearly two hundred out-of-work veterans of World War I arrived on the scene in November 1933. During the next four years, according to a CCC yearbook, the vets built "an $8,000 dam, a $13,000 bridge, a $14,000 dining lodge, and six beautiful cabins, a store and post office building, shelter houses, roads and trails." They also renovated the Atchley mill, enlarged the fish hatchery, built a custodian's residence, a garage for park vehicles, and a stonemasonry latrine, and installed rustic trailside benches. In addition, they razed and carted away the now dilapidated and deserted buildings of the old town of Brice. Most of the CCC structures still grace the park, now restored to their original architectural integrity.

After the initial acquisitions in 1924–1925, the state continued to pick up adjacent tracts as they became available, and by early 1988 the total stood at just over 1,400 acres. This included the Bennett Spring Savanna, located several miles south of the park, an outstanding natural feature leased to the state by the Nature Conservancy in 1984 and managed by prescribed burning.

Then a breakthrough: in purchases from three willing sellers the parks division added 1,660 acres of wild and hilly land that include most of the watershed of Spring Hollow, one of two tributary drainages that contribute to the occasional devastating floods on Bennett Spring Branch. Some of the new land is recovering from spotty timbering, clearing, and abuse as unsuccessful cattle rangeland, but, with help from park staff, the integrity of this Ozark landscape will be restored. Acquired primarily to provide watershed protection for the spring and park, the new land more than doubles the opportunities for hiking and adds significant natural history features, including several shallow caves used for shelter by native Americans and more recent huntsmen, a spring-fed pond, and remnants of good-quality glades and savannas. The outstanding natural feature is a tunnel one hundred yards long that was carved through the dolomite strata by the stream over geologic ages. Approached from either end it appears to be the mouth of a large cave. In fact, it is a cave, one that has been cut off by a deeper valley at each end. Because the tunnel curves, from either end one cannot see through to the other end. Inside, the tunnel is forty to fifty feet wide in places with a ceiling up to sixteen feet high. Even during the driest times of the year, spring-fed pools within the tunnel are populated by small fish and other aquatic organisms.

To appreciate the natural history of this won-

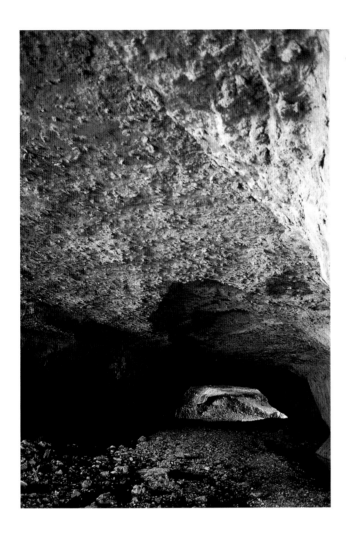

Light reflects from the "upstream" end of the three-hundred-foot-long Bennett tunnel created by the partial collapse of an ancient cave. TOM NAGEL

drous spring park, the best place to start, as with the human history, is in the interpretive center. Visitors are fascinated by the powerful surge that issues mysteriously from the earth. Does the cold water come from Lake Michigan? Why doesn't it freeze? The state-of-the-art exhibits answer these and many other questions, as well as open the senses to many unimagined wonders of a cold-water spring.

An "eye of the microscope" exhibit presents an illuminated plastic bubble that simulates a tiny drop of springwater with its microcosmic underwater universe. Invisible to the human eye but beneath the foot of every angler wading in the stream is a fascinating array of brilliantly colored water mites, daphnias, and other creatures that drift among colonies of algae. Some of these tiny creatures are found nowhere else in the world but at Bennett.

Another exhibit profiles the depths of the

spring, which have been explored by qualified scuba divers who have descended more than one hundred feet into its cavelike passage, entering a large chamber that often contains trout and giant lobster-like crayfish. Through a narrow cleft at the base of a dolomite wall enters a torrential spring flow, its passage unexplored because the current is too swift. Here, nature performs her own polishing of rock jewelry, "tumbling" small pieces of chert that have sifted down to the rim of the upward-rushing currents; the result is smoothly rounded stones, several of which are on display.

No, the cold water does not come from Lake Michigan. But the water from a lawn sprinkler or a septic tank soaking into the ground may eventually find its way through the spring. Exhibits explain how the fractured layers of soluble limestone and dolomite in the region's natural plumbing system capture surface water from at least a thirty-mile radius to the east and south. An understanding of this process has led citizens of nearby Lebanon, represented by their chamber of commerce, to recognize protection of the area's water quality as their number one priority in order to ensure the continued health of the park and, by extension, the economic health of the region.

The great spring at Bennett, fourth largest in Missouri, gushes unchangingly, year in and year out, averaging a hundred million gallons daily, its temperature holding steady at fifty-six to fifty-seven degrees Fahrenheit, cool enough for trout. Its one-and-a-half-mile course to the Niangua has been altered in places, by damming for mill purposes, by dredging by the fisheries managers to create deep holes for trout, and by both natural and man-induced changes in streamside and emergent vegetation. But the overall impression remains one of naturalness. Certain stream segments are left as natural riffle zones to preserve the aquatic plants and animals native to the cold-water stream. The concrete rearing races for trout, straight and geometric, are of course highly artificial, although the swarms of rainbows, all swimming in place against the constant current, are fascinating even to the non-angling visitor.

Anglers and their families predominate among the nearly one million park visitors recorded at Bennett Spring annually—more than one hundred and eighty thousand daily fishing tags were sold in 1989—but many others come to use the dining lodge, cabins, and campgrounds and to relax on the hiking trails and in the scenic and historic setting. Everyone who comes, though, senses that Bennett is here because of the spring. And so are the trout.

Ha Ha Tonka State Park

NEARLY SEVENTY YEARS passed before Ha Ha Tonka, recommended by Gov. Herbert S. Hadley in 1909 to become Missouri's first state park, was finally acquired by the state. Years earlier, in 1903, a Missouri representative had promoted the area as a national forest. And in 1915, a special committee of the state legislature, appointed to investigate sites for potential state parks, recommended Ha Ha Tonka as its first choice. Many attempts at state purchase were made during subsequent years, all to no avail. The property changed hands frequently, with each new owner failing to realize initial expectations. As one St. Louis realtor and conservationist pointed out, the tract seemed cursed. But in 1978 the curse was broken, and Ha Ha Tonka became Missouri's sixty-first state park.

And what a state park it is. Ha Ha Tonka contains Missouri's most outstanding examples of karst topography, that honeycomb of tunnels, caverns, springs, sinkholes, and other solutional features in limestone named for the Karst Mountains of Yugoslavia but characteristic also of the limestone-laden Ozarks. The park is mantled in oak-shaded grasslands known as savanna—oak orchards, some call them—once one of Missouri's most widespread natural communities but now among the most rare. And it offers the storybook ruins of a castle for good measure.

No other state park has a more fascinating, if convoluted, history. Indians, early explorers, frontiersmen, outlaws, turn-of-the-century capitalists, and twentieth-century real estate speculators are all part of the tract's history and folklore. What attracted all this attention and why was Ha Ha Tonka heralded as the first of Missouri's "seven beauty spots" in 1929? The answer is simple: this is one of the most scenic and fascinating areas in the entire state. It is an open-air textbook for the earth scientist. Thomas R. Beveridge tells us why:

> The Hahatonka area is a classic example of collapse structures in a karst area and the close kinship of the common karst features is no better demonstrated in any other area of Missouri. Where collapse has not spread ruin, there are cave systems; where the cave system is filled with water and breached by surface erosion, there is a major spring. Where a cave system has collapsed *en toto*, there are chasms and sinkholes as well as the tumbled ruins of collapse rock. Where the collapse has been incomplete, a natural bridge is preserved. Steep bluffs mark the remaining walls of a collapsed cave system.

Much has been written about the area over the years, including an early description of what is probably Ha Ha Tonka in an April 17, 1805, letter from Meriwether Lewis to Thomas Jefferson. The first widespread discussion for a general readership was a published account by Col. R. G. Scott in an 1898 issue of *Carter's Monthly*. But for true Missouri hyperbole, consider the praise lavished on Ha Ha Tonka by Dr. Walter Williams, founder of the journalism school at the University of Missouri, who would later undertake the naming of Missouri's seven scenic wonders. Having visited the area many times beginning in the 1870s, he wrote that it contained "more natural curiosities than in any other similar share of the

Castle ruins highlight the skyline above the spring branch at Ha Ha Tonka. TOM NAGEL

earth's surface" and chastised Missourians for their unawareness:

> If Hahatonka were on a railroad it would have thousands of visitors where now it has one. Here is a cave more wonderful than Mammoth Cave, a spring surpassing in size any in the State, a natural bridge superior to the famous Virginia Natural Bridge. The ignorance of Missourians regarding the natural wonders of their State is shown when reference is made to Hahatonka and other places of less attractiveness. The existence of these is scarcely known, and yet Missourians will wander off to the distant sections of the country to see caves, waterfalls, lakes and mountains far inferior in beauty.

With so much natural beauty, it is little wonder that Indians of the Osage and other tribes frequented the area. It remained Osage territory until the early nineteenth century, when the Indians ceded most of their lands to the government. Early visitors putatively included Daniel and Nathan Boone, who spent two winters (1801 and 1802) trapping beaver along the Niangua River, and Lieutenant James B. Wilkinson of the Pike Expedition, who described it in his official report. It is also generally believed that a band of counterfeiters, the infamous "Bank of Niangua," used the area in the 1830s and that the gang's leader, Garland, built a gristmill on the spring branch.

High on a bluff overlooking the Niangua arm of Lake of the Ozarks are the ruins of a sixty-room mansion and other associated structures. Giving the park the look and mood of a back lot for the filming of a gothic romance, these ruins represent what is probably the most intriguing episode in Ha Ha Tonka's fascinating history. They also represent the origin of the supposed "curse."

Robert M. Snyder, a wealthy businessman from Kansas City, first visited the site in 1903 on a hunting trip. Snyder had been tipped off by the proprietor of a hotel in Lebanon, Missouri, who owned part of the tract. Immediately captivated, he set out to acquire some sixty different tracts of land. He envisioned a private retreat with a huge, European-style castle. With native stone quarried on the site and stonemasons from Scotland, the 85-by-115-foot structure began taking shape in 1905. In addition, an 80-foot-high water tower was constructed, and greenhouses and stables were designed and begun. Snyder apparently planned to spare no expense, as everything about the project was on a grand scale.

But in 1906 tragedy struck when Snyder was killed in an automobile accident. All work at Ha Ha Tonka ceased, and the fate of the property was in doubt. A group of St. Louis investors almost bought the unfinished property for $156,000. Eventually, Snyder's sons finished the castle, though not to the sumptuous specifications their father had envisioned. Still, it was a luxurious white elephant, and they tried repeatedly to unload it on the state—for $160,000, $200,000, $300,000, always more than the state could afford. Using the mansion as a summer home, the Snyder family sued Union Electric when Bagnell Dam, completed in 1931, backed the Lake of the Ozarks up the spring branch. The Snyders settled out of court for $200,000. As the years passed, they used the home less and less, finally leasing the castle as a summer hotel. Tragedy struck again in 1942 when the wooden shingles on the roof of this supposedly fireproof building caught fire and the entire interior was gutted. The crumbling stone walls have maintained a lonely vigil ever since.

After the fire, the property changed hands several times, with each new owner planning to cash in by commercializing the tract's natural wonders. Various groups tried unsuccessfully to purchase the land as a park or refuge or scout camp. Each succeeding owner did little with the property except cause the price to rise. Meanwhile, the area was prey to trespassers, and many of the structures were vandalized. Shortly before the state acquired the land, the water tower was burned. But in 1978, with a grant from the federal Land and Water Conservation Fund and a sizable tax write-off donation from the current owner, the James T. Barnes Investment Company of Detroit, Ha Ha Tonka (now valued at nearly $2 million) finally became a state park.

Governor Hadley's effort to secure a $160,000 appropriation for the park in 1911 had failed by one vote; having cleared the Missouri Senate, the measure died in the House. Other governors failed as well, including Frederick Gardner in 1921 and Phil M. Donnelly in 1947. So Gov. Joseph Teasdale had every right to be proud of his announcement in December of 1978 that the state had finally acquired the fabled Ha Ha Tonka—and for just about the same cost in state funds as the failed appropriation of 1911.

Since the site was acquired by the state in 1978, it has become apparent that its fabled scenic grandeur and the saga of the castle, however appealing both remain to the public, are not the park's only claims to significance. Mantling the rugged karst topography are natural oak orchards and glades now protected in the Ha Ha Tonka Savanna Natural Area, a thousand-acre reserve boasting the finest and largest savanna in the park system. A short walk on a self-guiding trail

Yellow coneflowers grace Lodge Glade, part of Ha Ha Tonka Savanna Natural Area. Nick Decker

immerses one in a prairie-flower-carpeted oak wonderland representative of the western Ozarks in presettlement times.

The special character of this landscape is owing to repeated natural or Indian-set fires. For centuries, periodic fire shaped a mosaic of post oaks, white oaks, blackjack oaks, and hickories into a harmonious intermingling of open glades, widely spaced individual trees, or, on north slopes protected in topographic "fire shadows," open woodland. The post oaks, and to a lesser degree other oaks, have evolved bark thick enough to protect their trunks from fire, while their limbs sprawl just out of harm's way. Beneath the oaks flourish prairie plants—tall grasses such as big bluestem, Indian grass, and little bluestem, and myriads of prairie wildflowers, sometimes as many as two hundred species on a single acre.

Animal life on the fire-dependent savanna

landscape is equally diverse. Prior to white settlement, the once-extensive savanna zone stretching along the eastern plains from Texas to Wisconsin was home to many species that are today associated with brushy thickets and the woodland edges of fields. The eastern bluebird (Missouri's state bird), cardinal, pileated woodpecker, prairie warbler, screech owl, and many other species prefer these open natural orchards to denser forests. Tree hollows, created by insects, bacteria, and fungi that enter trees scarred by fire, for thousands of years provided refuge for nearly a hundred species of cavity-nesting vertebrates. Flying squirrels, gray and red squirrels, raccoons, opossums, broad-headed skinks, chip-

At nearly a thousand acres, Ha Ha Tonka Savanna Natural Area is the state's largest representation of the now-rare savanna landscape that once covered perhaps a third or more of the state. Botanists have recorded more than two hundred and fifty species of native wildflowers in this "prairie in the shade," now restored and maintained by carefully planned prescribed burns. TOM NAGEL

munks, and certain bats are plentiful in the savanna.

The savanna is in large part a cultural landscape. For thousands of years Indians used fire presumably for practical reasons: to make hunting better, to promote berry and fruit production, and to prevent acorn weevils from destroying acorns, so precious as food for Indians and animals alike. After white settlement, savannas were largely eliminated owing to agricultural conversion and, later, specific efforts at fire control. But in this rough region of the Ozarks a tradition of woods burning persisted despite the best efforts of conservation officials to stamp it out, thus unintentionally preserving vestiges of a savanna community. Since 1984, park staff have worked closely with conservation officials to educate local citizens about the role and use of prescribed burning in the park. Careful interpretation and patience have paid off in gaining public support for management efforts aimed at restoring a biologically unique and valuable component of Missouri's presettlement heritage.

In addition to its continuing savanna stewardship program, the parks division has imbedded three-quarters of a million dollars in the highly

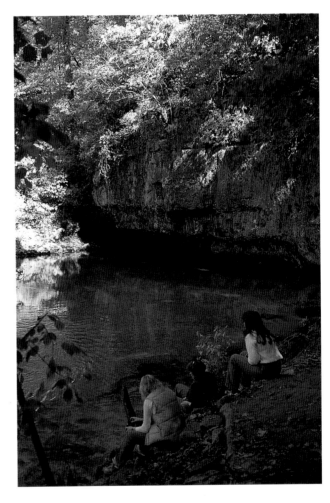

The storied ruins of the old castle would melt away to rubble within decades if not for stabilization utilizing a sophisticated "post-tensioning" method being tested here on the stable. SUSAN FLADER

Hikers pause in contemplation of Ha Ha Tonka spring. Nowhere else in the state is there such a variety of karst landscape features—a spring, sinkholes, a chasm, a "pirated" stream, a natural bridge, and numerous caves—in as concentrated an area as at Ha Ha Tonka. TOM NAGEL

professional but virtually invisible stabilization of the castle ruins so beloved by visitors. Without the sophisticated "post-tensioning" technique utilizing steel plates and reinforcing rods (bonded several feet deep into the bedrock with epoxy cement) as tension devices to compress the stone walls, it would only have been a matter of years before the castle was reduced to a pile of rubble. Considering the extent to which park designers and estate planners in the nineteenth century went to deliberately create false ruins in the landscape, as at Tower Grove Park in St. Louis or the Biddle estate, Andalusia, outside Philadelphia, it is perhaps not surprising that Missourians should want to preserve those real ones so spectacularly situated at Ha Ha Tonka.

Even the park's karst features have come in for their share of protection, in this case through a series of boardwalks and stairs to give visitors better access to the springs and cliffs and castle without causing damage by climbing the scarps. One can now descend into River Cave or climb from the spring to the castle on wooden steps. The boardwalk going up over the cliff at the spring is a truly amazing sight—145 steps to the top.

Even without campgrounds, restaurants, or an interpretive center—one is planned—the 2,700-acre Ha Ha Tonka is a remarkably popular park, with visitation that more than doubled from 110,000 in 1985 to over 260,000 in 1990. The wonderland that is Ha Ha Tonka will not disappoint.

*Fishermen cast their lines into the morning mist at
Public Beach No. 1.* OLIVER SCHUCHARD

Lake of the Ozarks State Park

MISSOURI'S LARGEST and most varied state park is an inheritance from the Great Depression. The farm economy was collapsing even before the historic stock market crash in 1929, the event often cited as triggering the economic decline that prostrated not only America but most of the industrialized world. Swept into the presidency by an unhappy electorate in 1932, the pragmatic and innovative Franklin D. Roosevelt quickly launched a series of programs aimed at relieving unemployment and widespread human distress.

Some of these New Deal programs were designed to relieve problems in rural America. Crop and livestock prices had collapsed, small-town banks were going broke, and mortgage foreclosures had turned thousands of once landowning farmers, the descendants of proud homesteaders, into impoverished renters or unemployed wanderers. Roosevelt and his advisers were sensitive to problems of farmers and of land misuse. One of their programs was to buy up tracts of land in areas where the terrain and the soil—steep, rocky, and thin—made them submarginal for agriculture. The farmers were to be moved to better lands or into different occupations, the acquired lands turned into primitive parks or public recreation areas.

In 1933, as part of the National Industrial Recovery Act, a system of "recreational demonstration areas" was authorized to test the feasibility of converting submarginal farmlands near large population centers into outdoor recreation areas suitable for transfer later to the states or to other political subdivisions. By 1939 there were forty-six such areas in twenty-four states, including three in Missouri, all managed by the National Park Service. Beginning in 1942—in Missouri, 1946—they were conveyed to the states.

In addition to this one, assembled around the Grand Glaize Arm of the Lake of the Ozarks, the others were Cuivre River State Park in Lincoln County and Knob Noster State Park in Johnson County. While this area wasn't as close to either St. Louis or Kansas City as were the other two, one special feature surely attracted the New Deal planners to this region in hilly Miller and Camden counties as they were thinking about recreation. It was the lake itself, formed in 1931 as the Union Electric Company of St. Louis completed construction of Bagnell Dam on the Osage River, the largest hydroelectric impoundment in the Midwest.

The new dam backed water up the meandered main stem of the Osage and its many tributaries that descended through precipitous little valleys, creating a reservoir of 55,342 surface acres with some 1,150 miles of shoreline. Grand Glaize Creek was one of the more scenic tributaries, and it had already been identified as a potential park site by planners working for Union Electric. Fifteen linear miles of the creek and eighty-five miles of shoreline were to be encompassed within the federal recreation area. Thus it could have charming lake vistas, swimming beaches, facilities for boating and fishing as well as camping and picnicking, and miles of trails for nature lovers and seekers of solitude. Lake of the Ozarks State Park has all of these within its 17,200 acres—far and away the largest park in the system.

Union Electric, empowered with a license from the Federal Power Commission, had gone about aggressively in the late 1920s buying up all the

The symphony of the seasons at Lake of the Ozarks: flowering dogwoods welcome the spring (OLIVER SCHUCHARD); *Rocky Top Glade celebrates the summer* (TOM NAGEL); *sugar maples herald the fall* (NICK DECKER); *and a wintry camp in Patterson Hollow* (NICK DECKER).

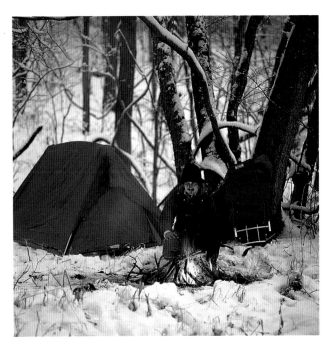

land needed for its new reservoir. It acquired most of it in fee, some by condemnation, but took only "flowage easements" in some cases where only a small part of a farm would be inundated at the lake's highest level. Thus while the federal agencies were purchasing other lands in the planned recreation area, they also negotiated with Union Electric for its previously acquired lands in the Grand Glaize area. The company's land records show that the transfers to the federal government took place from 1935 to 1937, mostly at a nominal price since this was at the depth of the depression and submarginal farmland wasn't worth much for any purpose. Union Electric was required by federal regulations anyway to divest itself of lands not actually needed for operation of its hydroelectric project. Future fortunes were to be made in resort, commercial, and home development around the lakeshores, but not by Union Electric.

Although the utility company could condemn land and did, the federal agencies chose not to exercise the power of eminent domain. Despite the economic straits of the era, a few landowners chose to hang on to their property. Thus, there remain today a number of "inholdings" within the park boundaries, some of which pose management problems.

Group camps constructed in the 1930s by the Civilian Conservation Corps are a distinction and attraction shared with the other two former federal recreation areas and several other parks. Perhaps because it is the largest, Lake of the Ozarks has the most—named Camp Red Bud, Camp Pin Oak, Camp Hawthorn, Camp Clover Point, and Camp Rising Sun; another, Camp Pe-He-T'se, has now been dismantled. The camps are heavily utilized in warm weather months by Girl Scouts, Boy Scouts, Future Farmers, 4-H clubs, and a variety of other youth and adult organizations. Red Bud, the smallest, can accommodate groups as small as twenty or as large as forty-four. Rising Sun can take as many as two hundred persons.

Pin Oak, long known as the Girl Scout Camp, features primitive cabins in the woods, tastefully spaced along the shoreline so the young campers can go to sleep listening to the night music—owls, whippoorwills, and the lapping lake waters—and not to sleepless voices in a neighboring cabin. It was restored to its original CCC integrity in 1989, but with modernized dining and bathing facilities. Renovation of Clover Point, often used by adult groups such as the Audubon Society of Missouri, was completed in the early 1980s by the Young Adult Conservation

Corps (YACC), a federal program reminiscent of the CCC. Since 1982, Camp Hawthorne has been used to house low-security prisoners, who are employed in a variety of maintenance tasks in the park through an arrangement with the state department of corrections.

The park is a treasure trove for social and architectural historians of the twentieth century; in fact, some old log buildings that were salvaged by the CCC date from the nineteenth century. Other new ones were carefully crafted to match closely the older structures. The park and its main road, Highway 134, have been designated a historic district on the National Register of Historic Places in recognition of the prime examples of CCC-era hewn-log construction, the beautiful rustic bridges, and the extensive network of CCC-built stone ditch-dams that provide erosion control and add to the charm of the beautifully designed road. All of Camp Pin Oak and the central area of Camp Hawthorne are separate historic districts on the national register. Many other CCC-built structures in the park—such as the park office, the log naturalist headquarters, and features associated with Public Beach No. 1—also appear on the register.

As a water-based park, Lake of the Ozarks offers excellent opportunities for swimming and boating. The several swimming beaches include the longtime favorite Public Beach No. 1. The park operates an extremely popular boat-launch service at Grand Glaize Beach that provides access to miles of undeveloped shoreline. Public access is an important factor, given that most of the lake's shoreline is privately owned.

Away from the waters of the reservoir the landscape is largely the dry upland forest that charac-

A park naturalist thrills his charges with a harmless king snake. MIKE SKINNER AND TOM NAGEL

terizes the northwestern part of the Missouri Ozarks. Species of oak predominate, but sometimes in April, when the oaks are just budding, an understory of flowering dogwood and wild plum contributes a breathtaking beauty. A visitor who takes the trails finds fascinating natural diversity in numerous small glades (more than twenty have been counted in the park), a couple of savanna areas now maintained by controlled burning, sundry calcareous wet meadows and fens, dolomite bluffs reaching down to the lake, and marshes, spring-fed or in the shallow fringes of the impounded water. Each terrain supports its characteristic community of wildflowers, grasses, or sedges and other plant and animal life.

The fauna, naturally, is also diverse. Aside from offering glimpses of white-tailed deer or the stealthy wild turkey, this park is noteworthy among birders for migrating hawks in the fall. In winter, bald eagles are easily seen soaring over the secluded coves. And, standing three feet high, the great blue heron accents primordial misty lakeshores early in the morning. One of Missouri's most secretive creatures is a harmless, beautifully colored scarlet snake, rarely more than twelve inches long, which comes out only at night to feed on small rodents, lizards, or snake eggs.

The longest of the park's hiking trails winds through the 1,275-acre Patterson Hollow Wild Area. The area was set aside, a park brochure says, to give visitors "a chance for solitude in a wilderness setting." A similar area for riders is available via an equestrian trail serviced from stables operated by a concessionaire.

At the eastern end of the park is an unusual, probably inappropriate, feature for a state park, the Lee C. Fine Memorial Airport. It is a reminder of the days of grandiose planning in the 1960s when federal dollars flowed freely for regional economic development and park officials envisioned a $5 million convention center and luxury resort at which the governor could host his colleagues at the national governors' conference. The jetport that was to trigger an "economic explosion" in the lake region was built, but legislators turned thumbs down on the convention center and the state proved unable to attract private investors to build a resort on park land. The concessionaire-operated commercial terminal serves the resort area around the Lake of the Ozarks, as well as offering an unusual opportunity for "fly-in" camping and park recreation. It was named in honor of a popular official who died of a heart attack in 1966 in his second year as director of state parks.

The visitor center at Ozark Caverns is situated near a restored fen and a spring-fed brook near the entrance to the caverns. An old house once stood on gravel fill at the cave entrance, but when house and fill were removed, revitalizing the natural groundwater seepage, more than a hundred and twenty plant species appeared, their once-buried seeds germinating after forty years. PAUL NELSON

Ozark Caverns and Coakley Hollow

The natural attractions of Lake of the Ozarks State Park were augmented in 1978 by acquisition from private owners of Ozark Caverns, a major Missouri cave. With the cave came about 350 acres on the southern edge of the park. Were it located elsewhere, Ozark Caverns would qualify as a separate state park. It is one of three show caves in the state park system, in addition to Onondaga, a state park itself, and Fisher Cave, in Meramec State Park. All were once privately owned and operated commercially for the tourist trade. Ozark Caverns was never as splashily illuminated as some show caves or as much modified inside for the convenience of tourists, and park managers have wisely removed the electrical wiring. Here visitors carry electric lanterns and view the speleological wonders as the first explorers did with their candles or miner's carbide lamps.

The instrument of the cave's creation, a small stream, flows perpetually through the cavern with little fluctuation in volume. Seeps from the sides and ceiling dissolving and redepositing carbonate materials have created a typical cave wilderness of stalactites, stalagmites, "soda-straws," helectites, and cave coral. The most famous form is known as the Angel's Shower. In this speleo-

A beautiful stalactite cluster rains a continuous "Angel's Shower." NICK DECKER

them complex a massive group of stalactites "rains" a continuous shower that falls free for eight feet to be caught in a shining (when lighted) crystalline basin rising from the floor of the cavern. Built up over who knows how many thousands of years, Angel's Shower is utterly unique in the cave world.

The guided tour traverses about a half-mile, round-trip. En route one sees an occasional sleeping bat, usually the eastern pipistrelle, a solitary species clinging to the ceiling, or perhaps a little brown bat or a big brown bat. A band of rare male gray bats often inhabits an unvisited part of the cave. The visitor may also glimpse the blind grotto salamander in the cave stream. A few small invertebrates live in the darkness, and what appear to be claw marks in soft cave forms suggest that bears once visited.

Ozark Caverns was originally known as Coakley Cave, named for an Irishman who settled in the little valley, still called Coakley Hollow, shortly after the Civil War. That the cave was known before that is attested by names inscribed on a "name wall" that are dated in the 1850s. Mr. Coakley installed a gristmill that he operated until about 1890, deciding then to move the mill and its machinery to a site near the thriving town of Linn Creek—now submerged beneath the waters of Lake of the Ozarks. Remnants of a milldam can still be seen just downstream from the confluence of the cave stream with the larger flow of spring-fed Coakley Hollow Creek.

Boggy open meadows, or "fens," dot the creek downstream to the lake. Fed by cold, seepy groundwater, they resemble boggy wetlands found to the north in Minnesota or Canada. Rare plants like Riddell's goldenrod, swamp wood betony, and various sedges are relicts perhaps left behind thousands of years ago when glaciers retreated from northern Missouri. Where once an old house stood in front of the cave entrance, today there lies a lush fen that was restored by removing the fill gravel placed there decades ago. So unique is this spring-fed valley that the stream and its associated seepy fens have been designated Coakley Hollow Natural Area. An inviting visitor center with a museum, situated fifty yards from the cave entrance, provides the starting point for a self-guided foot trail that loops through the natural area. It is also the place where groups are outfitted with lanterns to begin a naturalist-led tour through the cave.

Ozark Caverns was opened to the public in 1951 by the owners of the Bridal Cave Corporation. Ralph ("Ohli") Ohlson and his wife, Mary, purchased it in 1956 and continued its commercial operation until 1978 when, deciding to retire, they sold it to the state.

The lake area is one of the most intensively developed playgrounds in the United States, where congested traffic slows to a frustrating crawl on summer and autumn weekends along the principal through routes. These and many intersecting "lake roads" are lined with lodges, restaurants, tackle and curio shops, and a variety of rides, water slides, and other places of entertainment. Indeed, what was once an area catering seasonally to the fishing, boating, swimming, and sunning crowd has now become urbanized with extensive shopping centers and a growing year-round residential population.

Thus it is all the more remarkable that just a short turnoff from Highway 54 one finds the state park, a 17,200-acre oasis of natural beauty and tranquillity where there are no ungrammatical signs, no garish neon or billboards, no angry honking of horns. It is the public's great good fortune that the Grand Glaize shores and surrounding lands were kept in the public domain and in their natural state.

Montauk State Park

ORIGINATING IN A SERIES of springs adjacent to Pigeon Creek in Dent County, the Current River begins its journey south in Montauk State Park. More than forty million gallons of cool, clear water bubble up from the ancient dolomites underlying this park each day. Many more springs add their flows to this "running river" (*la rivière courante*) as it hurries toward Arkansas. The river twists and turns, entrenched in the hillscapes of the Ozarks, and its rugged beauty has made it the most popular of Missouri's float streams. Leonard Hall, the dean of Missouri's conservation writers, put it best: "One thing which makes Current River unique is that it lives out its entire life within the heart of the Ozark highland and thus is always in character."

Much of the Current River is now managed by the National Park Service as part of the Ozark National Scenic Riverways. Established in 1964, the riverway marked the first attempt by the federal government to create a linear river park. Three of the oldest and most popular Missouri state parks—Big Spring, Alley Spring, and Round Spring—were ceded to the new federal riverway. But Montauk, where the river is born, remains a state park, and what a treasure it is.

One of the "first-generation" parks, acquired by the state in 1926, Montauk is perhaps best known as one of Missouri's four "trout parks"—three in the state park system, the other two being Bennett Spring and Roaring River, and one, Maramec Spring near St. James, under management of a charitable trust. The long cold spring branches of Montauk provide ideal habitat for hatchery-bred rainbow trout, with the fishery managed by the Missouri Department of Conser-

vation. The handmade stone dam and spillway that control the outflow of water from the rearing ponds were constructed by the Civilian Conservation Corps in 1935. As at Bennett Spring, the CCC company at Montauk was composed of veterans of World War I, and it included several experienced stonemasons. The rough-and-tumble character of the stonework, which gives the impression of a natural fall of rock rather than a man-made feature, has merited its inclusion on the National Register of Historic Places.

Almost any weekend from early spring to late fall, anglers from Missouri and many other states flock to the park and line up along the "runs," trying to catch one of the delectable beauties that are released to the wild every day. The most extraordinary spectacle is the old-fashioned trout-opening-day ritual on March 1 each year. Thousands of ardent anglers descend on the park and stay up all night visiting with friends and readying equipment, the better to jockey for position in the cold dawn, literally shoulder to shoulder, as they wait for the opening siren before whipping the stream to a froth. It probably used to be a male-bonding ritual, with young boys proudly accompanying their fathers to their first opening, but nowadays there is many a blue-haired grandma in the stream. Surely one of the most colorful, if not bizarre, events of the year in the parks, opening day at the trout parks has come to signal the beginning of a new year for the entire system.

Rising from the springs and hatchery area, steep wooded ridges hem in the fledgling Current River, forming a narrow valley of superb scenic beauty. The slopes are covered with a mature forest of white oak, shortleaf pine, black oak, north-

*Fishermen work the white oak pool at Montauk
Spring, headwaters of the Current River.*
OLIVER SCHUCHARD

ern red oak, maples, and flowering dogwood. In places, the river flows below tall pine-capped bluffs of stained dolomite. The park is well noted for its spring wildflower display—the fire pinks, purple phlox, white and yellow dogtooth violets, bellwort, false Solomon's seal, trillium, columbine, coral root, showy orchis, and ladies' tresses—and, of course, the flowering dogwood, wild plum, shadbush, and redbud.

Montauk Spring today really consists of seven springs in one, but back before the turn of the century there was a single big spring outlet. Popular accounts indicate that a sounding was made that proved this spring to be at least two hundred and fifty feet deep. Then, in 1892, a torrential local downpour in Crabtree Hollow washed sand and gravel and debris into the spring. The filled spring reportedly belched for several days before the bubbling water formed the seven springs we see now.

No doubt it was the presence of the spring that attracted the first white settlers to the valley, not far into the nineteenth century. The name *Montauk* is an Indian word—not Osage, but Algonquin. It means "island country" or "fort country." Though most of the settlers were from Kentucky or Tennessee, some of the early pioneers came from Montauk Point in Suffolk County on Long Island, and they named their new post office in Missouri after their old New York home. The village of Montauk was the second town established in Dent County.

The rushing waters from Montauk Spring were ideally suited to powering gristmills, and the little valley was home to four different mills, the last of which is still standing. The first was built in 1835 and operated by A. W. Hollerman. Twenty-five years later, the Stephenson family built and operated both a gristmill and a turbine sawmill. Tim Hickman purchased the old Hollerman mill with its large wheel, but then in 1865 he built a third mill powered by turbines. The new mill was destroyed by fire in 1895. Undaunted, Hickman sent for a Missouri millwright, William J. Furry. Using the turbine salvaged from the burned mill, Furry was able to turn the virgin timber of the hillsides into sturdy timbers for the rebuilt mill. Completed in 1896, this mill was of the roller type, with fairly elaborate machinery.

The same CCC company that built the dam and spillway restored the 1896 mill in 1935, as well as building roads, cabins, foot trails, and shelter houses. Set into the new stone foundation placed under the building are two old buhrstones filled with concrete, in the center of one of

The Montauk Mill is all that remains of a once-thriving village. TOM NAGEL

which is the inscription: "Veteran Co. 1770 Sec. 2 Feb. 10, 35."

The last remnant of the once-thriving village of Montauk, the mill is now open to the public, and much of the original machinery is still intact. The steel rollers were removed in 1942, however, for the war effort. When the mill was operating, grain was moved by bucket elevator to a bin at the top of the mill. Then it was dropped through many pairs of horizontal steel rollers between which it was crushed. As it passed between each pair of rollers, the grain was sieved through vibrating silken screens, called bolts. So the wheat passed from roller to roller, becoming finer and finer, and the bolts sifted the wheat, separating it from the bran and removing impurities. On the main floor, the flour, middlings, shorts, and bran were sacked. In recent years, the parks division has undertaken further restoration of the mill and the mill store.

The 1,350-acre Montauk State Park offers a variety of accommodations, something for every taste: campgrounds, housekeeping cabins, a motel, and the Dorman L. Steelman Lodge. The facilities are open year-round, and a meeting room is available for small conferences. Even angling, on a "fish-for-fun" basis, is available for the adventurous during the winter months. During the fishing season, there are trout derbies and naturalist-led amphitheater programs. And of course the park offers hiking trails and access to the Current River, Missouri's preeminent float stream.

Lake Wappapello State Park

T HE ST. FRANCIS RIVER once flowed through the piney ridges of the southeastern Ozarks below Sam A. Baker State Park before dropping into the Mississippi lowlands of Missouri and Arkansas, where it eventually joined the White River on its way to the Mississippi. It was presumably from the lowlands that the Choctaw people gave the river its Indian name of Cholo-Holley or "Smoky Waters." Before 1936, there were a number of small communities in the Ozark portion of the St. Francis River. One of them was a small Wayne County railroad town named Wappapello.

In 1936 Congress passed the Overton Act, which authorized the U.S. Army Corps of Engineers to develop the St. Francis Basin Project to control flooding on the lower Mississippi River. Accordingly, the Memphis district began construction of a dam across the St. Francis River near Wappapello in 1938, the first of the large corps dams in Missouri. This was also the site of the first government-funded archaeological survey of a reservoir area in the state, conducted by an undergraduate student at the University of Missouri, Carl Chapman. Chapman would later become the dean of Missouri archaeology and would be credited with lobbying through congress the Archaeological and Historic Preservation Act of 1974, which has provided millions of dollars for cultural resource surveys and mitigation at federally funded reservoirs and other construction projects throughout the nation. State parks at two recently constructed corps reservoirs in Missouri, Harry S Truman and Mark Twain, have benefited from studies funded with more than $1 million each under this program.

In addition to submerging archaeological re-mains, the Wappapello project displaced several towns, eight schools, and hundreds of farms and people. Many complained that the best farmland in Wayne County was being destroyed. The controversy associated with these disruptions left scars that were slow to heal. Nevertheless, the 2,700-foot-long, 109-foot-high dam was completed in 1941, and it created an 8,400-acre lake at normal pool. The lake can reach more than twice that size at high water, backing up almost to Sam A. Baker State Park.

Notwithstanding the loss of human and natural resources in the St. Francis Valley, Lake Wappapello is one of the more beautiful corps reservoirs in Missouri. The water is all from the Ozarks, and clear. The hills surrounding the lake are steep and scenic. The forests that cover these slopes are rich and diverse. With the Mississippi Lowlands not far away, the addition of southern cherry bark oak, sweet gum, and devil's walking stick add an interesting bottom-country component to the typical Ozark flora of shortleaf pine, white oak, and sour gum. The fishing is excellent for some species, especially crappie and catfish.

Not far from the dam itself is a ridge known as Allison's Peninsula, named for the family that once lived there, and on it their cemetery still remains. In this area, the state of Missouri operates Lake Wappapello State Park on 1,854 acres given by the corps as a donated lease in 1957. Along with Table Rock State Park, leased to the state on the same day, it is the oldest of the corps reservoir parks in the system.

A budding fisherman reels in his catch.
WANDA DOOLEN

Only a bold hand dares grasp the devil's walking stick, found in abundance at Lake Wappapello.
PAUL NELSON

This state park is well known and popular in southeast Missouri, southernmost Illinois, and western Kentucky and Tennessee, but still it is seldom crowded and offers a relaxing hideaway, especially if you enjoy lake fishing. The facilities include campgrounds, a marina, picnic grounds, a swimming beach, and tidy little kitchen-equipped cabins that are perfect for a family escape.

Several trails in the park lead into the Ozark forest. One leads also to the old Allison family cemetery. The sunsets over the lake from this point are superb. Another trail connects with adjacent public lands and is long enough for overnight backpacking.

Besides the intrinsic attraction of a quiet, wooded, lakeside park, Wappapello also is a convenient point from which to explore nearby features. The park is virtually surrounded by corps of engineers land, most of which is undeveloped. One such area, the Johnson tract, is a large expanse of little-disturbed forest that is being managed as a natural area. The University of Missouri operates a training camp for its school of forestry on nearby state forest land. The Poplar Bluff unit of the Mark Twain National Forest is just to the west, and the fascinating bottomlands of Mingo National Wildlife Refuge are just across the dam to the east. Mingo is a large swamp that Missourians once attempted to drain but which has now been restored for wildlife habitat. A sizable acreage has been designated as a wilderness area and offers a unique opportunity to canoe through a preserved cypress swamp. It and the lake at the park are excellent places to watch eagles and other raptors in winter.

At the state park itself, there is a special quality of early morning light that will lift you from the summer doldrums. Arise early, walk to the water's edge, and enjoy the golden shafts of light piercing the cool morning mists, sparkling the dew on numberless leaves across the dark green hills opposite you, and then steadily creeping across the still waters of the deep-shaded cove. Although some of us would have preferred that the "Smoky Waters" still flowed unvexed through the southeastern Ozarks into the great Mississippi lowlands, a visit to Lake Wappapello State Park is a lovely trip indeed.

Grand Gulf State Park

"GRAND GULF BEGINS with a canyon a few miles north of the Missouri-Arkansas line in Oregon County, Missouri, which carries a fair-size stream of water. The stream disappears into a subterranean cavern. A few miles below in Arkansas is the famous Mammoth Spring which is a small river rising from the bowels of the earth. It is an established fact that the gulf and the spring are connected. Tests have been made by emptying sacks of oats into the stream in the canyon and observing the grains emerge in the spring. A lost river, born in Missouri, reborn in Arkansas."

Notwithstanding the accuracy of the "sack of oats" experiment reported by Otto Rayburn in 1941, the use of fluorescein dye by more recent investigators has confirmed that water from Grand Gulf does make the nine-mile journey to Mammoth Spring. But, heck, local old-timers knew it all along. Added to the state park system as recently as 1984—though considered for park status at least as early as 1939—"Missouri's Little Grand Canyon" has a long history as a public attraction and a source of pride and wonder to nearby Ozark residents. The area is steeped in folklore and is a popular picnic and sparking area. Unlike the Grand Canyon, which is wider than it is deep, Grand Gulf is truly a chasm, deeper than it is wide.

Comparisons to the Grand Canyon aside, Grand Gulf *is* a spectacular landscape. To understand its story, one must turn to the geologists for an explanation of the gulf's origin. It began, like the rest of the Ozarks, with the deposition of sediments, the formation of limestones and dolomites, the uplifting of the layers, and the dissolving action of mildly acidic groundwater, which carved fissures and channels in the bedrock. Here at Grand Gulf is a cave system whose roof collapsed thousands of years ago. The result is a vertical-walled canyon about three-quarters of a mile long. Bussell Branch, a surface stream draining two dozen square miles that once flowed above the cave system, became diverted into the chasm in a process geologists call stream piracy. Over the years, the gulf was further altered by the pour-off from Bussell Branch. All of this water passes through a two-hundred-and-fifty-foot natural tunnel—the part of the cave that remains intact—and then flows into a large circular chasm, the remnant of a collapsed cave chamber. The stream resubmerges back into the cave system and begins its Stygian journey toward rebirth in Mammoth Spring.

The walls of the gulf are festooned with herbaceous greenery and, in the lower sections, flood debris. These walls—or cliffs—rise as much as a hundred and thirty feet at the natural bridge. Their steepness requires explorers to make their way upstream a short distance to gain safe access. Then, walking downstream, you can enter the tunnel, which is some seventy-five feet high. When you notice that the flood debris reaches this same height, you quickly scan the sky for possible thunderheads before proceeding. The ceiling height drops to about ten feet on the downstream side of the tunnel. Emerging into the chasm and working your way around some large blocks of dolomite—part of the collapsed roof—you come to the extant portion of the cave, which acts as a drain for all the water flowing into the gulf. The passage is blocked by mud and debris beyond the entrance, but the parks division has been investigating ways to remove the

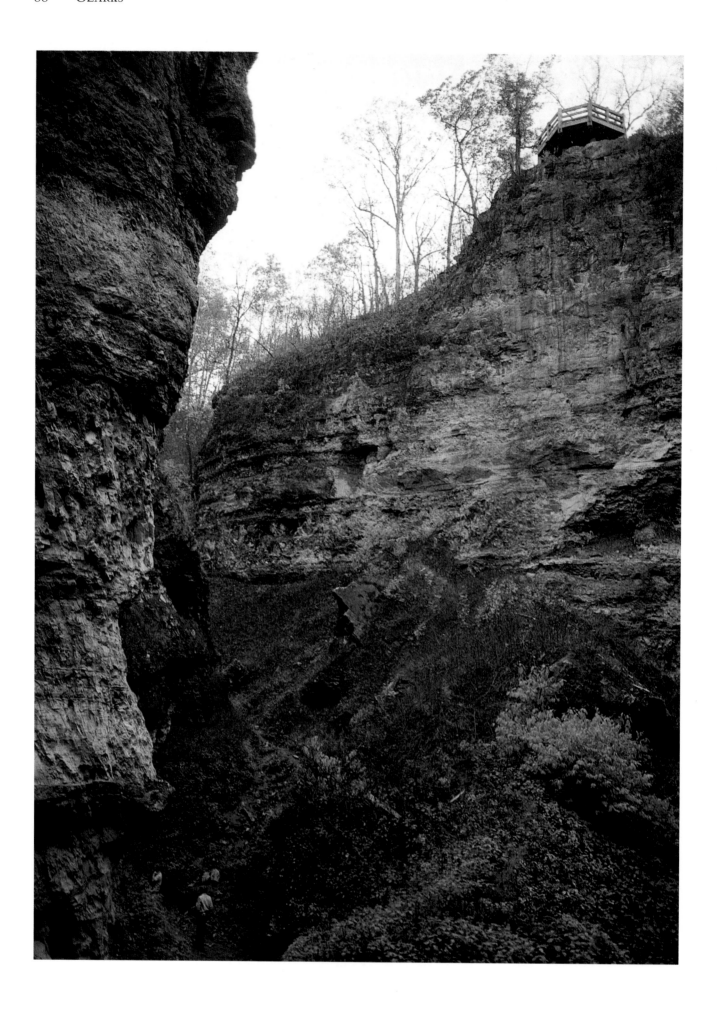

plug. Most ingenious is a camera-carrying robot named STEVE that has been trying to find its way past the flood debris and on into the cave.

This passage from the chasm to the cave has long fascinated local scientists and spelunkers. How can so massive a cave system pinch out into such a small, unimpressive end? Fortunately and intriguingly, accounts by earlier explorers give us the answer. In her now-classic *Cave Regions of the Ozarks and Black Hills* (1898), a young scientist, Luella Agnes Owen, recounted her exploration, along with two companions, in the Grand Gulf. She described what she saw after entering the cave at the downstream end of the gulf: "The ceiling dipped so we were not able to stand straight, and the guide said he had never gone farther; but to his surprise here was a light boat which I am ready to admit he displayed no eagerness to appropriate to his own use, and swimming about it, close to shore, were numerous small, eyeless fish, pure white and perfectly fearless; the first I had ever seen, and little beauties."

Bravely, Luella Owen used the boat to explore the underground stream even further—without her guide. The boat had apparently been left by an earlier exploration led by Maj. M. G. Norman, who owned the property surrounding the gulf. Access to the cave was available, according to local residents, until the early 1920s, when a great storm filled the gulf with downed trees and other debris. Ever since, that stream and Owen's "little beauties" have remained unviewed. Heavy rains now fill the entire gulf to depths exceeding one hundred feet. A hike on the woodland trail surrounding the gulf reveals evidence of debris that floated along the shorelines, indicating past highwater marks of this huge, temporary natural bathtub.

In 1959, the Missouri General Assembly narrowly defeated a locally sponsored measure to allow the state to acquire Grand Gulf as a state park. But local interest in creating a park continued unabated. In 1970 the L-A-D Foundation of St. Louis forest owner and conservationist Leo Drey purchased the land in order to assure its

An overlook perches one hundred feet above Missouri's little grand canyon, the Grand Gulf. Rainwater from a twenty-seven-square-mile area enters a water-filled cave to the left, eventually exiting at Mammoth Spring seven miles to the southeast in Arkansas. TOM NAGEL

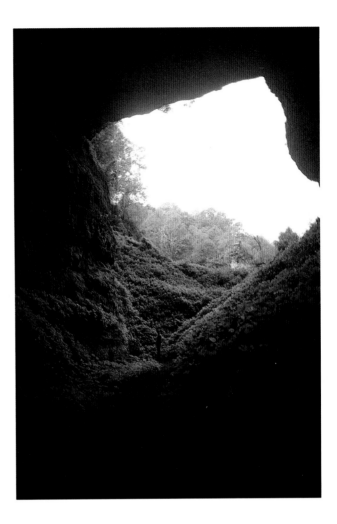

Herbaceous greenery festoons the entrance to the natural bridge, which links a larger chasm to the Grand Sink. PAUL NELSON

preservation. In 1971, the U.S. Department of the Interior designated the gulf as a national natural landmark. And finally, in 1984, the land came into the state park system through a lease agreement between the foundation and the state, thus assuring its continued availability for public enjoyment and enlightenment.

The parks division has laid out trails and installed boardwalks and overlooks at this 165-acre day-use park, so visitors can get close to the edge of the gulf without endangering themselves or the environment. There is even some wheelchair accessibility, unusual for a site of this type. And excellent outdoor exhibits provide artistic renderings of the geology, so visitors can visualize the processes that produced "Missouri's Little Grand Canyon."

Roaring River State Park

ROARING RIVER IS ONE of the "grand old ladies" of the Missouri state park system. A classic in many ways, it has a setting as close to breathtaking as any park in Missouri: a deep, narrow valley, cupped by high, forested slopes—the look of mountainous terrain. Roaring River itself is a clear Ozark spring branch emerging from a mountainside in a rocky grotto that is superbly picturesque. The park is one of Missouri's oldest, dating back to the 1920s. Rustic timber and stone structures built in the depression era provide the core of the developed facilities. It is a popular park, drawing many visitors from a four-state region to engage in many forms of traditional state park recreation. The adjacent lands of the Mark Twain National Forest provide a valuable buffer. The surrounding county of Barry, the nearby county seat of Cassville, and the park itself are steeped in Missouri history. And, finally, the park with its large, long-protected acreage harbors a remarkable assortment of native southwest Ozark species and natural habitats.

So, befitting a grand lady, Roaring River has many virtues, many classic features. Sadly, for a number of years Roaring River bore an undeniably frayed appearance, with funding inadequate for her needs. But now, under the parks and soils sales tax program, this wonderful old park is once again receiving the fond attention that her rank and lineage deserve, rejuvenating her ageless grace, charm, and beauty.

Roaring River Spring emerges at the base of a steep mountain slope in a deep blue pool beneath a shaded dolomite bluff. A small trickling flow from above the bluff falls into the pool, spraying and refreshing the clumps of ferns and mosses that line the limestone ledges. This grotto of blue and silver water, gray rock, and delicate green ferns in quiet indirect light is as lovely a scene as any in the park system. Ironically, this scene is in part a cultural creation, as the pool results from a dam. The pool may also explain why the river doesn't roar anymore: the spring is now submerged in it, so the water no longer cascades over the rocks to the streambed below.

From the grotto, the spring branch carries twenty million gallons daily out into a canyon-like valley surrounded by steep slopes covered in Ozark forest and open glade. The intensely rugged hills that embrace the valley of Roaring River are part of the White River section of the Ozarks, a region distinguished by the large scale of its scenery, the dramatic depth of its valleys, the size and openness of its glades, and the unusual wealth of its native plant life in both Appalachian and southwestern species. At Roaring River the insight of the old Ozark adage becomes clear: "Our mountains ain't that high, but our valleys sure are deep!" Driving south toward the park from Cassville on Highway 112, the traveler passes gently rolling uplands; very near the park boundary, the mild upland abruptly "falls off" into steep, hilly terrain. One travels *down* into the mountains at Roaring River.

Since people first used the southwestern Ozarks, the rushing cold purity of the river has been a magnet. Indians camped there, and later American settlers found utilitarian work for the waters of the spring branch, developing mills for

Roaring River spring emerges in a peaceful grotto.
OLIVER SCHUCHARD

grain, sawtimber, wool, and locally grown cotton. But despite these developments, the river still attracted people to its beauty and restfulness.

Barry County itself has not always been a very restful place. The Butterfield Overland Express crossed it down the main street of Cassville in its brief but exciting life in the late 1850s. Early in the Civil War, the pro-Confederate wing of the Missouri General Assembly convened briefly in the county courthouse at Cassville after adjourning from Neosho, having earlier been driven out of Jefferson City by the Union army. Gov. Claiborne Jackson signed the Missouri Act of Secession there on October 31, 1861, paving the way for Missouri's acceptance by the Confederacy as its twelfth state. The hills around Roaring River served as hideouts for wartime guerrillas and outlaws, and large-scale troop movements traversed the countryside nearby, going north and south.

Sometime after the war the spring branch was stocked with trout and a small resort community

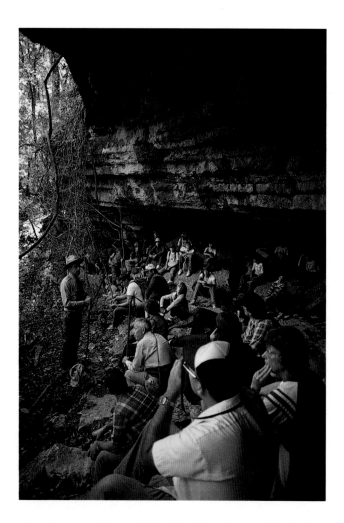

A park naturalist explains local geology in the shade of a rock shelter in the Roaring River Hills Wild Area. TOM NAGEL

grew up in the valley. Part of the valley floor was subdivided into hundreds of tiny lots for cottages and commercial development. By the turn of the twentieth century, wealthy businessmen from as far off as Kansas City and St. Louis used Roaring River as a sporting retreat. One of these St. Louis businessmen, Dr. Thomas M. Sayman, tried to interest Gov. Arthur Hyde and his game and fish commissioner, Frank Wielandy, in purchasing the area as one of Missouri's first state parks in 1924, but the price was too steep. Sayman then appeared somewhat mysteriously at a courthouse sheriff's sale of much of the Roaring River property in 1928, and won the bid for $105,000. Rumors that the eccentric and spectacularly bald promoter planned to develop an elaborate tourist resort were laid to rest when he promptly donated more than 2,500 acres to the state of Missouri.

In the 1930s the primary development of the park was undertaken by Company 1713 of the Civilian Conservation Corps and by crews of the Works Progress Administration. This work, under the supervision of the National Park Service, illustrates well the rustic style of CCC park architecture. It included a fish hatchery and related structures, rental cabins, Deer Leap Trail, picnic shelters and restrooms, and the original three-story park lodge of native stone and timber. The CCC camp enrolled hundreds of young men from 1933 until 1939, and for the most part the facilities they built are still sound and in service. Even the officers' barracks area has survived as Camp Smokey, now serving as a youth camp.

One CCC effort, however, had a rather tortuous history. In 1936 the crew began construction of a thirty-acre artificial lake, with a beach and a large bathhouse, contoured to the steep slopes of the narrow valley. By early 1939, park officials realized that the lake was silting up too fast ever to be successfully maintained—a consequence of erosion from the unprotected, overgrazed headwaters—and they proposed construction of a swimming pool in order to make use of the pretentious bathhouse. Later that year, a disastrous flood damaged much of the CCC work in the valley, and crews had to be diverted to cleanup and repair of higher-priority facilities. The bathhouse became a clubhouse for group activities, and then deteriorated to the point where it was used only for storage. It has since been beautifully renovated and is now a nature center, where the visitor may learn about the perils of land abuse as well as about the wonders of the White River Hills. One could scarcely imagine the building was once a bathhouse, as there is no lake in sight.

The central attraction at Roaring River today,

Hoarfrost formed by mist rising from the spring coats trees in the valley as the rugged White River Hills stand guard. MERLE ROGERS

of course, is the opportunity to fish for the rainbow trout that are stocked regularly in the spring branch. Anglers come from Arkansas, Oklahoma, and Texas, as well as Missouri, to try their luck. Over the years the owners of scattered parcels of land adjacent to the park, and even inside the park boundaries (some of the original subdivided tracts), have been prone to capitalize on the park's popularity by developing commercial "attractions." Some of these have been reasonably appropriate, but most—including a neon-studded video arcade—have degraded the park atmosphere, and the process of buying them out has been painfully slow owing to the state's perennial shortage of funds. In addition, the state itself has on occasion given in to pressures to provide more and more facilities to satisfy a never-ending series of popular demands. The result, predictably enough in such a narrow valley, was that the park began to show the abuse. Some visitors, even while enjoying the park scenery and waters, won-

dered about the future.

Over a long period of struggle, the tide seems to have been reversed. Year by year, as funds were available, the state purchased one after another of the tiny inholdings and, in years of easier funds, some of the more offensive commercial structures. The state bond issue and the parks and soils sales tax have accelerated the pace, and most of the worst inholdings have now been purchased. The CCC structures are being rehabilitated and other structures renovated to harmonize better with the landscape and original architecture. Along the spring branch itself, worn-out gravelly areas are being restored with grass and native shrubs. And a new lodge is planned—located up on the hill to ease some of the congestion in the narrow valley. Roaring River is enjoying a renaissance.

From its beginnings, Roaring River State Park harbored a treasure trove of natural wonders out beyond the developed areas, in the wilder reaches of the hills. Besides the spring itself and the mountains, this 3,400-acre preserve shelters more than its fair share of interesting rocks, plants, and animals. A well-developed trail system provides good access to these resources.

Geologically, the park has many small caves, several small springs, and rocks from at least six different formations. At about the 1,200-foot elevation, a contact zone between two of these layers has produced a "bench," or narrow level rim along the side slopes of the mountains. This bench is a good place for examining outcroppings of such rocks as Compton limestone and Chattanooga shale, as well as shelter caves and small springs.

Cloaking the hills are several distinct plant communities, including various forest types, savannas, and dolomite glades. The forests harbor rarities such as the beautiful yellowwood tree, the Ozark chinquapin, and the Ozark spiderwort. Open-range grazing and fire suppression—resulting in the invasion of the eastern red cedar and the closure of open areas—have reduced the glades, but several superb examples still exist and support glade plants such as blazing star and blue false indigo, plus rarer forms like Ashe's juniper, a species typical of central Texas and eastern Oklahoma. Park staff intend to restore more of the once-widespread glades.

Animal life in the park is generally characteristic of the Missouri Ozarks, but again with the addition of several southwestern species, including armadillos and roadrunners. Two uncommon species of salamander, the gray-bellied and the rare Oklahoma salamander, live in the park's clear, shallow streams. In the winter, several bald eagles roost regularly in the valley.

Most of these natural treasures are protected by special designated areas. A remnant cove of old-growth forest has been designated, for example, as a state natural area. The wildest portion of the park, including over half of the park's total acreage, is now the Roaring River Hills Wild Area. In the remote fastness of these wooded hills and hollows, one can gain the solitude that enveloped visitors to the early Missouri wilderness.

As a grand and venerable place, Roaring River guards multiple treasures, stories, and impressions. Probably no other Missouri state park, in fact, has as many stories and legends associated

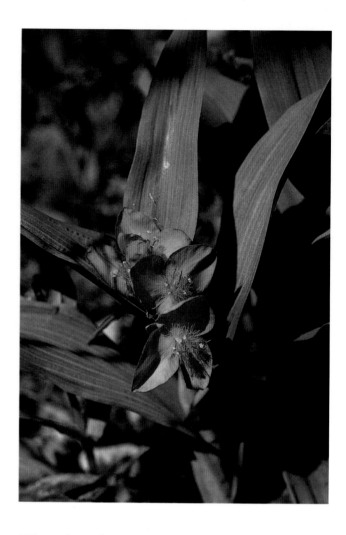

Hikers along the River Walk Trail in spring may see the flowering of Ozark spiderwort, a species restricted to the White River Hills section of the Ozarks.
TRACIE SNODGRASS

with it as Roaring River—from old mountain hermits and outlaw hideouts to eccentric millionaires and adventurous CCC youths. There are memories and reveries of your own here also. To discover them, linger when you visit, then visit more than once and in different seasons. This is good advice for all the state parks, but especially so for one of the "grand old ladies."

Table Rock State Park

THE GEOGRAPHIC REGION known as the "Ozarks" has various definitions, depending upon one's point of view. There is a generalized area that most people can agree is the Ozarks, but the geologist, botanist, and historian always seem to draw the outer boundaries differently, and they differ also about where the true heart of the area lies. From a cultural point of view, many would argue that the heart of the Ozarks, the cultural core if you will, would be in the upper White River valley, straddling the border between Missouri and Arkansas.

The reasons that the upper White River valley might be so defended are several. First of all, this valley is physically near the center of almost anyone's definition of the Ozarks, the geologist excepted. Also, the people who settled the White River valley were a relatively homogeneous group, at least in comparison to Ozark border areas. The settlers of the White River valley were old-stock Americans primarily from the uplands of the Southeast. They were migrants from the same rugged country that Horace Kephart described in his classic study, *Our Southern Highlanders*. Most of the Ozark region was dominated by these people, but in the White River valley the highland stock was nearly undiluted.

Besides the ethnic character, the valley's geography has encouraged a sense of region. The White River blithely ignores state boundaries, and to some extent the settlers see themselves as White River valley residents—not in place of but at least in addition to being Missourians or Arkansans. Also, this is one Ozark area where people readily identify themselves as Ozarkians.

Beyond these factors, several literary works have helped to establish this region's cultural identity. One of the first literate explorers of the Ozarks was Henry Rowe Schoolcraft, who traversed the region on horseback in 1818 and 1819. His writings dwell admiringly on the upper White River, its tributaries, and the picturesque landscapes around these streams. Almost a century later, the writer Harold Bell Wright produced a romantic and enormously popular novel, *Shepherd of the Hills*, which for good or ill shaped the image of the people of the Ozarks for the national public, and to some extent eventually the self-image of Ozarkians themselves. *Shepherd of the Hills* is set in the heart of the White River country. Finally, the most widely known student of Ozarks culture, Vance Randolph, spent years collecting the music, stories, and folklore of the Ozarks, focusing a lion's share of his attention on the White River vicinity.

The White River is long and sinuous, originating in northern Arkansas, flowing north into Missouri, where it curves in a graceful arc, flowing then south back into Arkansas, with several second-thought loops back into Missouri, finally leaving Missouri for good, and then sliding out of the hills and through the lowlands of eastern Arkansas to join the Mississippi River. The "upper valley" is generally the region near the state line, embracing the whole length of the river in Missouri, plus some of the major tributary valleys, including all or parts of Barry, Stone, Taney, Christian, Douglas, and Ozark counties.

According to Elmo Ingenthron's history, *Land of Taney*, perhaps the happiest time for this region was during the 1850s when settlers had begun to reap their harvests of corn, cotton, and wheat in the fertile larger valleys, and the lovely landscape was at peace. The Civil War was prob-

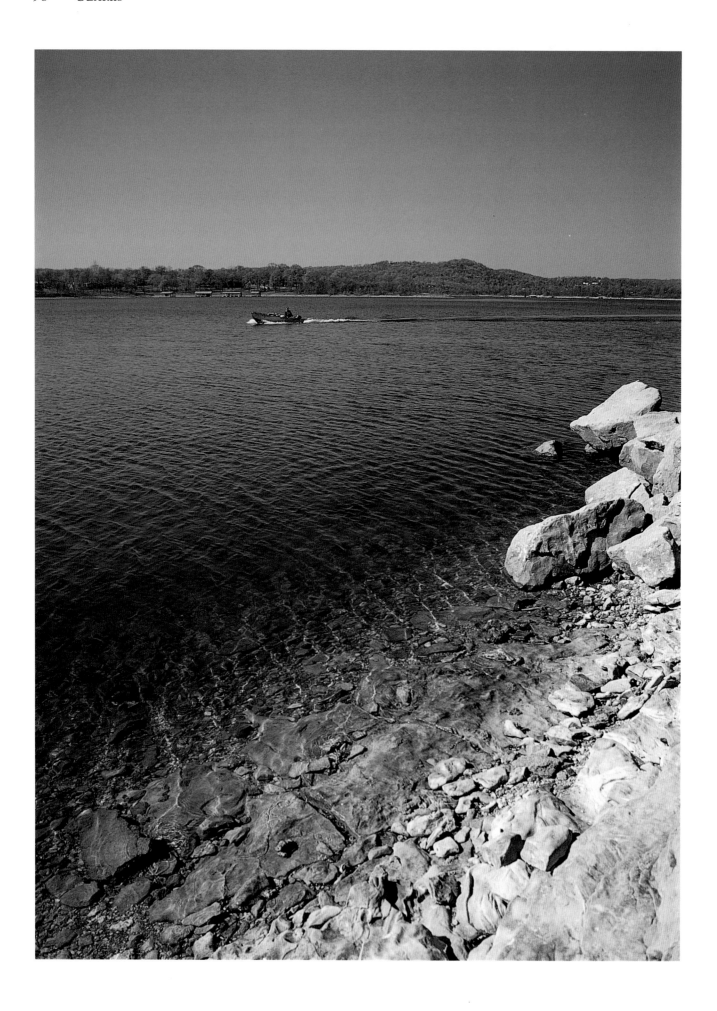

ably more vicious and divisive here than any-
where else. Every county courthouse along the
border was burned by one side or the other, and
the land was practically depopulated. In some
ways, the region never fully recovered from the
brutalities of the war and its vendetta-ridden
aftermath.

Through all its history, the river was the soul of
the landscape. It carved the valley, cut the bluffs,
and shaped the surrounding hills. The river built
the soil that supported the farms of the valley.
But the river could also be a source of power that
would usher in the modern world.

The promise of power and the peril of flooding
eventually brought down upon the White River
the sentence of death by drowning. The first dam
on the White was Powersite, constructed in Ta-
ney County in 1912, creating Lake Taneycomo.
Eventually, the U.S. Army Corps of Engineers,
under the authorization of the Flood Control
Acts of 1938 and 1941, constructed four major
dams in the upper White River valley: Norfork,
Bull Shoals, Table Rock, and Beaver. By combina-
tion of these reservoirs, not a single mile of the
original White River still flows free in Missouri.
The headwaters of some of its tributaries are all
that are left of this once-great river system.

Table Rock Dam in Taney County, at 252 feet
by far the highest dam in the state, is the only
one of these corps dams constructed within the
boundaries of Missouri. Opposition to the dam
was fierce, but a powerful combination of utility
and chamber-of-commerce interests prevailed,
and the 43,000-acre reservoir was completed in
the late 1950s.

Construction of these large lakes climaxed the
boom in tourism that had begun on a smaller
scale with Lake Taneycomo in the 1920s. With
new high-standard roads for access and the at-
traction of the lake water, plus the allure of the
scenic hills, Forsyth, Branson, and other area
communities underwent revolutionary change.
No longer an isolated region, the White River
country became instead a fringe of the Sun Belt
and faced a second invasion from the North, this
time of tourists, vacationers, and retirees.

The intensity of the industrial-level tourism
around Branson must be seen to be believed. For
miles along certain roadways, there are wall-to-
wall attractions ranging from miniature golf em-
poriums and fast-food franchises to country mu-
sic palaces. Needless to say, much of the original
culture of the valley has been displaced. Ironi-

*Park visitors can rent a boat at the park marina, then
enjoy the crystal waters, rocky shorelines, and glade-
dotted hills.* TOM NAGEL

cally, a commercialized version of rustic Ozark
culture serves as a chief theme of the local tour-
ist industry. If real Ozarkians are now scarce, nu-
merous imitations, some in fair earnest, are
nevertheless offered in abundance. "Hillbillies,"
some in neon and some in genuine homespun,
are all over the place in "Ozark Mountain
Country."

Nestled in the midst of all the bustle lies Table
Rock State Park. The park is leased by the state
from the corps of engineers and consists of about
350 acres along the shore of Table Rock Lake
near the dam and south of Branson. The park
provides a full array of lake-oriented facilities, in-
cluding camping and picnic areas amid the oaks
and hickories along the winding lakeshore, a boat
launch, and a full-service marina.

Table Rock Lake, for all the controversy that
attended its birth, is a beautiful body of water. It
is known for the superb clarity of its waters, a
fact that scuba divers will attest. You can rent
diving equipment at the marina and see for your-
self. The fishing is excellent, especially for bass
and for trout stocked by the department of con-
servation's Shepherd of the Hills Hatchery close
to the park. And of course the lake is a favorite
also for swimming, boating, and water-skiing.

Table Rock State Park is indeed worth a visit. It
provides the perfect access to a marvelous lake—
and while you're there, be sure to take in a natu-
ralist-led walk or evening program. It can also be
your base for exploring the lakes and hills of the
upper White River country. You may enjoy the
abundant tourist attractions of the region. Even if
you don't, or need a break, you can find along
some backwoods byways much that is still un-
spoiled and inviting.

*Table Rock Lake is famed for the stunning clarity of
its waters.* TOM NAGEL

Nathan Boone Homestead State Historic Site

H E CAME TO THE PRAIRIE not so much by pleasurable design as by necessity, probably driven as much as drawn. Col. Nathan Boone, soldier, surveyor, explorer, son of the famed Daniel, was broke and starting over again at the age of fifty-seven. This was his second experience of this sort, having been uprooted from a Kentucky home as a young man when he and a sixteen-year-old bride followed his land-bereft father into Missouri at the turn of the nineteenth century. In fact, it is a sad historical irony that the Boones—several generations of them—probably blazed more new trails, discovered more new caves, springs, and mountains, and walked over more unclaimed land than any other single family in American history, and wound up with very little of it for their trouble.

Col. Daniel Boone—the storied frontiersman, hunter, and Indian fighter—and his enterprising sons left indelible marks on the history and geography of Missouri. Such places and place-names as Boonville, Boonsboro, Boone County, the Boone's Lick Trail, and the Boone's Lick Country mark their enterprises and explorations. Prominent among the family's cultural legacies is this frontier homestead near the town of Ash Grove, northwest of Springfield, with the log house that was home to Nathan and his family for the last nineteen years of his strenuous life. Although never the subject of tall tales and sometimes fanciful biographies like his illustrious father, this son of Daniel Boone rivaled his father in contributing to the development of the American frontier—particularly with respect to Missouri.

Daniel Morgan, the seventh child and third son, and Nathan, the tenth and youngest, helped their parents move to Missouri in 1799 after

Daniel the elder had lost his holdings in what is now West Virginia in a land-title dispute. The Boones had been drawn to Missouri by the promise of grants of land from the Spanish authorities. Daniel was given land in the beautiful Femme Osage valley, and his sons and other relations secured neighboring grants.

The elder Boone's land difficulties surfaced one last time late in his life when the land commission for the newly created Territory of Missouri refused to confirm his claim to the 1,000 arpents of land given him by the Spanish authorities. It took an act of Congress in 1814 to give Daniel title to his land as an honorarium for the "arduous and useful services" he had rendered to his country. Unfortunately the good news about the land arrived almost simultaneously with his creditors from earlier land problems in Kentucky, and after the sale of his newly patented land he was left virtually penniless at the age of eighty.

Thus it was that he lived with one or another of his children, moving in with Nathan in 1820 on completion of Nathan's imposing two-story stone house on a hill overlooking the Femme Osage and his Spanish grant lands. It was in this new house that his famous father died later the same year, a circumstance that has led to it being called the "Daniel Boone Home." This beautiful house still stands and is operated by a private owner as a tourist attraction. (Efforts by the state to acquire it for a historic site have repeatedly been rebuffed.)

Long before building his new home, Nathan had manufactured salt with his brother Daniel Morgan at the salt springs (now Boone's Lick State Historic Site) in the central Missouri region that bears their name. When Indian attacks on

Nathan Boone's last homestead on the rolling Spring-field Plateau has changed little since it was built in the 1830s. James M. Denny

American settlements were incited by British agents in the War of 1812, both Daniel M. and Nathan served as captains of companies of rangers formed by the U.S. army to repel the attackers. Nathan's company was disbanded in 1815 and, until his return to military service in 1832, he prospered in civilian life in St. Charles County, serving as a delegate to the constitutional convention held in St. Louis in 1820.

When the Fox and Sac Indians behind Chief Black Hawk took arms against a federal order to leave their lands in northern Illinois and Wisconsin, Nathan once again answered the call. He was at this time in midlife, fifty-one years of age. For the next twenty years, Nathan's military service was almost continuous, punctuated by occasional furloughs or leaves of absence. He was sent to Fort Gibson in Arkansas on recruiting service, and in 1834 joined an expedition against the Pawnees. It was probably during this period that he saw and made note of the ash grove on the rolling Springfield Plateau where he would one day move his family. Later he was stationed at Des Moines, Iowa, and led his dragoons on a campaign into Sioux territory.

It was during one of his furloughs from military service that he had to make an adjustment in what must have seemed to be a recurrent family nightmare. In 1837 Nathan had to sell his beautiful home and all of his lands in St. Charles County to retire a debt he had acquired as bondsman for a friend who turned out to be less than trustworthy. The friend, a county official, had absconded with the county funds.

Nathan, then fifty-seven, turned his eyes to the prairies of southwest Missouri, where some of his sons may already have filed claims on part of the property that became Nathan's last home. The financial disaster in St. Charles County no doubt precipitated the move to the less grand accommodations of a log home on cheap prairie land. These prairies had remained largely unsettled by pioneers until a fairly late date owing to the common perception that a lack of trees indicated lesser fertility. The difficulty of turning heavy prairie sod also made these lands less attractive until the availability of the steel plow developed by John Deere after 1837.

The site of this new Boone home was on rolling prairie in a shallow swale formed by a tributary of Clear Creek, which itself runs west to the Sac River only a mile and a half away. This landscape probably looks today much as it did when Nathan first saw it, but with modern pasture grasses replacing the native prairie flora of those days. Patches of trees stand along the creek, and a few more mark the position of the several springs on the property and the family burial plot. One is struck by the fact that the house sits very gently on the land and is small in scale, emphasizing the horizontal rather than the vertical as the landscape itself seems to do. The house is sited as good pioneer houses tended to be, so that it is tucked under the brow of the low rise to the northwest, somewhat protected from the brunt of winter winds.

The house is comfortable, but not very large. (One wonders if there was lingering bitterness in the family's ongoing remembrance of the stone mansion in the Femme Osage country.) Architectural historians would call this a double-pen log cabin. That is, the rooms are two log "boxes" separated by a center hallway, or "dogtrot," the whole covered by one roof. The passageway may have had open ends like a breezeway for some period after the house was constructed, but it is enclosed now. A chimney and a fireplace at each end serve the two rooms. The facade of the house facing the hillside is plain, but the side facing to the southeast, toward the creek and down the valley, has a veranda. This veranda is of the variety that seems to be subtracted from the mass of the house and is thus under the main roof, rather than tacked on.

The house was originally sided with hand-riven walnut clapboards, and these survive intact on the protected wall under the veranda roof. The clapboards remind us once again of the care and importance that in past times were accorded small details, since each is beaded at its bottom edge. That is, a molding plane was applied by hand to every board individually in order to finish its edge with a rounded groove. Some of this siding may yet survive on the other side of the house as well, but it presently sports two—possibly three—complete layers of siding, and architectural surgery will be required to determine if original material is buried under these modern repairs.

Occasionally a historic site provides a small grace note that reduces "HISTORY" to a more familiar scale. The Boone house gives us such a moment when we notice that one of the clapboards under the veranda displays "A, B, C . . . " cut with a knife in a style both antique and childlike. The alphabet is not complete, and we are left to wonder whether the child didn't know all of the letters, or whether we are seeing a moment of parental discovery and angst, frozen in time. In any case this small bit of graffiti reminds us that the Boones—suspended somewhere between myth and legend—were really people too.

The interior of the house is simply two large rooms, each some seventeen feet square, with the

hallway between. The degree of survival of the historic fabric on the interior is stunning as you realize the original fireplace mantels, doors, and woodwork trim are in place, and all demonstrate the care and precision of handmade work. The trim boards are beaded, all of the doors are made of planks with Z-braces, and in one corner of the hallway a winding stair leads to a large one-half-story loft above.

The upper space is essentially one large room—perhaps a sleeping loft—except for one small chamber at the head of the stairs. The purpose of this little room, perhaps eight feet square, is uncertain, but its construction is interesting. Its walls are built entirely of hand-cut walnut boards, and even in the gloomy light of this attic space you need only run your fingers over the surface to feel rather than see the shallow hills and valleys that proclaim that the entire wall has been painstakingly shaped by hand with a smoothing plane.

Nathan was able to enjoy his new home on the prairie only at sporadic intervals between his army assignments. Soon he was headquartered for several years at Fort Leavenworth, Kansas, and later at Fort Gibson. From Fort Gibson he led three companies of dragoons on a seventy-nine-day horseback reconnaissance over the western prairies and up the Arkansas River to provide protection for traders using the Santa Fe Trail. He was then sixty-three years old. After a furlough, he rejoined his company in 1845 and set up camp at Evansville on the Arkansas line, assigned "to

preserve the peace among the Cherokee," who recently had been herded by the army from homelands in Georgia to Indian territory in Oklahoma.

Back at Fort Leavenworth and by now a major, Nathan took sick leave on September 9, 1848, and returned to his home at Ash Grove. After years of rugged army life on the frontier, the old soldier's health was failing. Still on sick leave, he was promoted in 1850 by grateful superiors to lieutenant colonel of the Second Dragoons, but three years later he resigned from the army at age seventy-two.

He had only three more years to live on this final homestead, and following his death in 1856 he was buried a few hundred yards north of his home. Later his wife, Olive, the once-sixteen-year-old bride, joined him. There they still lie, amid their children and grandchildren.

The luck of Boones with land had never run smoothly, and even this last homestead left the Boone family forty-one years later when it was sold at auction at the courthouse door in Springfield in 1897 to cover the indebtedness of one of Nathan's grandchildren. Perhaps fate finally smiled when on August 15, 1991, the Missouri Department of Natural Resources took title to 370 acres of the original Nathan Boone farm. One feels an inner satisfaction in knowing that there now will be a Boone homestead on the map forever, as if the grateful citizens of their adopted state are holding in trust for this illustrious pioneer family the land that eluded them in their own lifetimes.

Battle of Carthage State Historic Site

ANYONE WHO HOPES to understand
Missouri and Missourians, even in the
twentieth century, must eventually come to
terms with the Civil War and its continuing im-
pact in our own day. More Missourians fought in
the war, in proportion to the state's population,
than was the case in any other state. Some sixty
percent of eligible men saw action—at least forty
thousand served the Confederacy and about a
hundred and nine thousand the Union. Missouri
blacks provided more than eight thousand men
for Missouri regiments, and others enlisted in
other states. Fourteen thousand Missourians gave
their lives for the Union, and undoubtedly a
greater proportion for the Confederacy. More than
eleven hundred battles, engagements, and skir-
mishes were fought within the state, a number
exceeded only in Virginia and Tennessee. And
the vengeful guerrilla warfare that enveloped
Missouri—termed by historian Michael Fellman
the "inside war," or the "war of ten thousand
nasty incidents"—drew virtually every man,
woman, and child into the maelstrom.

In a state with a relatively high percentage of
"native-born" families, people whose ancestors
weathered the war or perhaps lost their lives in it,
the legacy of that conflict is ever-present. And for
newcomers or even visitors, the lingering pres-
ence of those times may utterly fascinate.

Of the literally hundreds, perhaps thousands,
of sites in Missouri associated with the Civil
War, the state park system focuses on five: Battle
of Carthage, the site of one of the earliest con-
flicts, in July 1861, and perhaps the only one in
American history in which a sitting governor led
his own state army against a federal government
force; Battle of Athens, the site of a clash a

month later in far northeast Missouri, possibly
the northernmost conflict in the war; Battle of
Lexington, the site of an encounter in September
1861 that marked the high tide of the Southern
cause in the state; Fort Davidson, the site of the
September 1864 battle of Pilot Knob that doomed
Confederate dreams of redeeming Missouri; and
Confederate Memorial, where we honor the van-
quished dead. Many other parks in the system
have Civil War connections—Hunter-Dawson,
Jefferson Landing, Bollinger Mill, Roaring River,
St. Francois, Mark Twain, Arrow Rock, and Sap-
pington Cemetery, to name a few—and the Na-
tional Park Service protects and interprets the
battlefield at Wilson's Creek as well as White-
haven, the home of Gen. Ulysses Grant. But for
thousands, perhaps hundreds of thousands, of
Missourians, *their* battlefield or building or other
significant site—the most important one of all
because it is where they live or where their own
ancestors took a stand—goes unmemorialized.

Battle of Carthage, the state's newest Civil War
historic site, illustrates the problems of preserv-
ing and interpreting these sites. The battle was
one in a series of armed conflicts, beginning at
Boonville in June and culminating in September
at Lexington, by which militia forces sympa-
thetic to the South, organized for the most part
as the Missouri State Guard, sought to wrest con-
trol of the state from federal forces that included
among their number some of the hated "Yan-
kees" from northern states but also a good many
Missourians loyal to the Union. At Carthage on
July 5 the action was fierce, but it lasted less
than a day and it swept across miles of country-
side leaving few permanent marks. How to pre-
serve and interpret such a site?

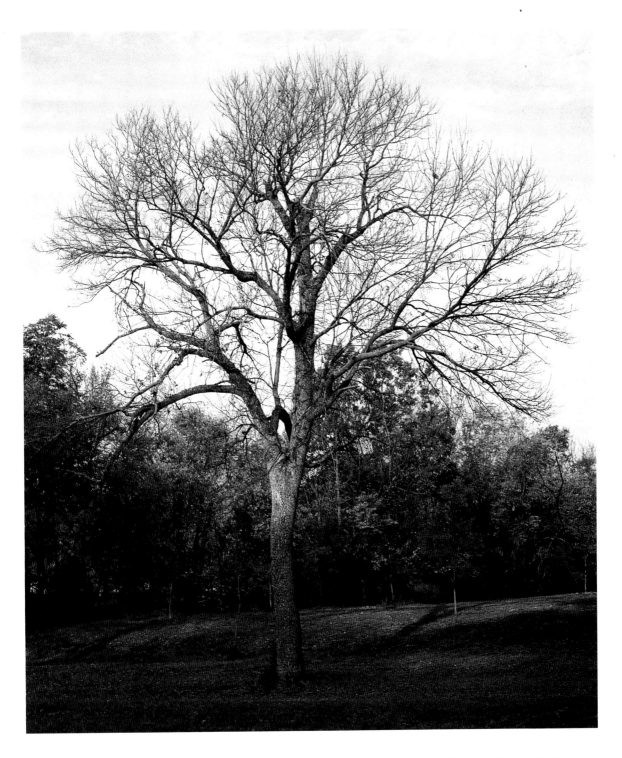

Visitors today walk where both armies once camped on successive nights, on the terrace in front of Carter Spring in Carthage. ARNE LARSEN

The Battle of Carthage was hardly earth-shattering in the larger scheme of things; it did not produce a clear victory, nor was it particularly well fought. The inexperience of both sides told—which is hardly surprising considering how early in the Civil War the battle took place. Bull Run, often referred to as the "first" battle of the war, did not occur until two weeks after Carthage. Still, the Battle of Carthage was a major turning point for the cause of the South in Missouri, if only for a few months.

Prior to the encounter at Carthage, the tide of events was going strongly in favor of the Union. Federal troops had driven Gov. Claiborne Fox Jackson and his pro-Southern forces from the capital at Jefferson City, routed them at Boon-

ville, and sent them fleeing toward the southwestern corner of the state. Now a Union detachment under Col. Franz Sigel was trying to prevent Jackson from linking up with other Missouri forces and with a Confederate army under Gen. Ben McCulloch in northwest Arkansas. At Dry Fork Creek about six miles northwest of Carthage, at eight-thirty in the morning on July 5, Sigel's and Jackson's forces met and squared off for a test of strength.

Jackson had about six thousand men eager to fight but inexperienced and undisciplined, most armed only with their flintlocks and squirrel rifles and fully a third with no arms at all. Sigel's force was much smaller, numbering about eleven hundred, most of whom were St. Louis Germans properly armed and well drilled. As the firing began, Sigel, fearing an attempt of Jackson's superior numbers to encircle him and cut off his supplies, commenced an orderly retreat. Thereupon the action shifted southward about two miles to the next creek crossing, over Buck Branch, then another three miles to Spring River, and finally into Carthage at Carter Spring, where Sigel's rearguard artillery continued masterfully to cover his withdrawal. The battle goes down in the books as a victory for Governor Jackson's state guard; though his troops let a numerically inferior enemy slip from their grasp virtually unscathed, they gained a momentum that would carry them as far as Lexington.

For years, residents of Carthage have been concerned about memorializing the battle, no one more so than Richard Webster, a powerful state senator from the town who happened to be a history buff and who especially wanted to increase the flow of tourists to Carthage. Finally, in 1990, just before his death, Senator Webster succeeded in passing legislation to establish an eight-acre

historic site focused on Carter Spring in Carthage, where Sigel and Jackson ended the day's hostilities. But the battle was much bigger than the site, as is often the case with messy wars. The parks division, accordingly, is placing interpretive displays at the spring and encouraging visitors to take a fifteen-mile self-guided auto tour to other battle zones at Dry Fork, Buck Branch, and Spring River, where interpretive signs will be erected with the cooperation of the landowners. Dry Fork, in particular, survives almost unaltered, its farm fields and creek probably looking much as they did on the day of the battle.

Battle of Carthage has gained new significance in our own day. Because of the problems in adequately interpreting this site, and the extent of public interest in numerous other Civil War sites around the state, the parks division has now embarked on an integrated Civil War marking program for the entire state. It will include not only battle sites but places of guerrilla activity, sites of political significance, key garrisons, and the homes of some of the leaders. Recognizing that it is unfeasible and also unnecessary for the state to own all these sites, the plan is to develop a readily identifiable marker system with travel routings and supporting literature that will encourage thematic tours by visitors. Obvious examples include the route of Claiborne Jackson's march to Carthage and his triumphant progress with Sterling Price back to Lexington, or the sites along the Hannibal and St. Joseph Railroad where guerrilla action against the bridges led to an early assignment for then-colonel Ulysses Grant. Promoted in conjunction with bed-and-breakfasts and other local interests, the program will encourage people to explore the mystique of the Civil War and its lingering presence in our time.

Stockton State Park

SAILING MAY NOT BE the most familiar outdoor recreation in Missouri, but a sizable group of freshwater sailors pursue their sport here. Among these folks, there is general agreement that there is no better sailing in Missouri than at Stockton Lake, a corps of engineers reservoir in southwest Missouri, primarily in Cedar and Dade counties. The prestigious Governor's Cup has been held here. The secret of the fine sailing at Stockton Lake is the steady southwest breeze off the Springfield Plateau that plays over these 25,000 acres of open water. Combine this dependable source of wind power with the lake's ultraclear waters and mostly natural shoreline scenery and you have a majestic setting for sailors from Missouri and neighboring states.

Headquarters for most Stockton sailors is Stockton State Park, 2,175 acres of land leased from the corps and developed for recreation by the state of Missouri. The marina area is admirably suited to welcome visitors. In addition to the traditional campgrounds and picnic areas, the park also offers a full-menu restaurant and a small but convenient lakeside motel. Besides sailing, the park is popular with lake fishermen, who enjoy the unspoiled shoreline and elbowroom of the uncrowded lake. The park also offers naturalist-led walks, evening programs, and junior-naturalist activities during summer months.

Stockton State Park is located on a long northsouth peninsula that once was known as Umber Point, a prominent ridge dividing the valleys of the Sac and Little Sac rivers in Cedar County. Sources vary about whether *Umber* derives from a settler's surname or from the Latin *umbra* or French *ombre*, meaning "shady place." We do know that Cedar County is named for a principal creek west of the Sac, and in turn from the long-lived eastern red cedar that grows so abundantly all over southwest Missouri. Located in the western Springfield Plateau region of the Ozarks, Cedar County is, in fact, not as "shady" as some other places, being a transition zone for prairie, savanna, and dry forest.

Extensive archaeological work, performed in conjunction with the reservoir construction project in the 1960s, reveals this area to have a complex prehistory, but one typical of the rest of the Osage River basin. The recorded history is meager. We know that the citizens changed the name of the county seat twice, first from Lancaster to Fremont in 1847, shortly after the establishment of the county, and then in 1859 from Fremont to Stockton. Capt. John C. Frémont and Commodore Robert F. Stockton were both associated with the conquest of California in 1846–1847 during the Mexican War; Frémont (the son-in-law of Missouri's powerful senator Thomas Hart Benton) was leader of the "Bear Flag Revolt" to establish a republic of California, and Stockton was the naval officer who proclaimed California a U.S. territory. The name change to Stockton might have been in protest over Frémont's leadership of anti-slavery forces as the first presidential candidate of the Republican party in 1856. The town was partly burned during the Civil War by a Confederate general, J. O. Shelby, and then later rebuilt. Apparently before the turn of the century, a small crossroads settlement named Umber gathered itself into temporary existence on the Umber ridge before fading away after World War II. Several old cemeteries are still on the ridge.

Since the Civil War, the biggest event by far in

the county has been the construction of Stockton Lake by the U.S. Army Corps of Engineers. Authorized by the Flood Control Act of 1954, the dam across Sac River was completed in 1972. Since then, the Sac and Little Sac rivers have formed one of the clearest lakes in the state. Um-

Sailboats brighten the breezy waters at Stockton Lake. NICK DECKER

ber Point is now in the state park, and sailboats brighten the breezy waters.

Pomme de Terre State Park

BEFORE THE FIRST white settlers came to southwest Missouri, wandering French trappers and traders had visited and explored the area's many beautiful rivers, including one they apparently named for a tuberous plant that grew in the vicinity and fed the local Indians—possibly the widespread groundnut or American potato bean (*Apios americana*) or the now rare prairie turnip (*Pediomelum esculentum*), also known as Indian breadroot or wild potato. *Potato* in French is *pomme de terre,* and thus a fine western Ozark river was named.

For thousands of years, American Indians lived along the river. They left evidence of their passing not only in the usual middens, or refuse from their campsites, but also in some intriguing burial cairns built of stone rather than earth. The Indians are long gone now, and the few wandering French were replaced in the 1820s and 1830s by an aggressive breed of settlers from the hills of Tennessee and Kentucky. An old history book describes them: "Democrats of the Andrew Jackson type—men who partook more of the stern nature of the old hero of New Orleans; resolute, fiery, and unconquerable by nature." Appropriately, these folks named their county Hickory, Jackson's nickname, and their county seat Hermitage, the name of Jackson's beloved Tennessee homestead.

What we find today at Pomme de Terre is not a river but a remarkably attractive, clear lake dating from the 1960s, compliments of the U.S. Army Corps of Engineers. The state park at "Pommey" consists of 735 acres in two separate parcels, one on the Hermitage side, the other on a peninsula accessible from the south, or Pittsburg, side of the lake.

The emphasis at Pomme de Terre is on water-based recreation, and the park offers a variety of quality opportunities in a setting of quiet, usually uncrowded, beauty. The two park units are separated by several miles of road and function almost independently. Each has a full set of facilities for visitors. The park has more campsites than any other Missouri state park, over two hundred and fifty. Part of the reason that camping is popular at Pomme de Terre is the shoreline location that many of the sites enjoy—bacon seems to smell better frying here in the early morning when its aroma mixes with the fog off the lake. Both campgrounds offer nearby beaches and fine swimming.

Pomme de Terre also offers a fishing opportunity unique in Missouri. Some time ago northern muskies were stocked in this Ozark lake; these fish survived and now provide exotic sport for those who seek this large and unusual fish. A number of real lunkers have been taken, and the marina operator in the park can help novice muskie fisherman in choosing gear and guides.

Located in the western Springfield Plateau section of the Ozarks, the land around the lake is rolling rather than mountainous, and the woodlands show the influence of the prairies of the nearby Osage Plains to the west. Today, park staff use prescribed burning to unveil a landscape once dominated by ancient three-hundred-and-fifty-year-old post oaks. The trails and picnic area of the park's south side are an outstanding outdoor educational classroom where each spring visitors can witness a renewal of this once widespread oak parkland, replete with wildflowers and rich prairie grasses. There is also an interpretive trail to the ridgetop earthen burial mounds and rock

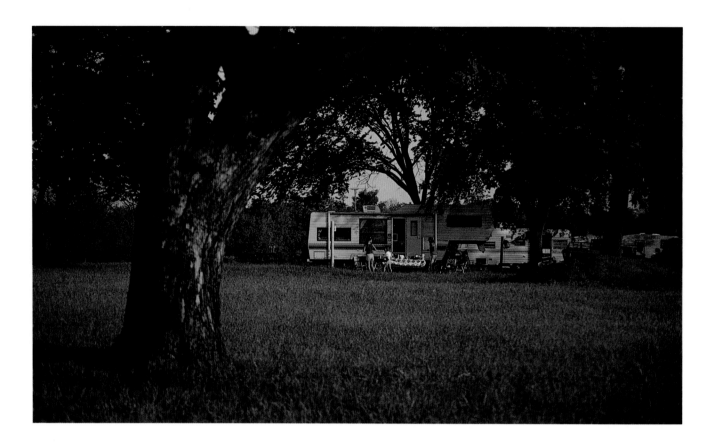

The campground at Pomme de Terre combines nice facilities with a pleasant tree-shaded setting close to the lake's shoreline. TOM NAGEL

The sun's evening rays bathe Indian Point in gold. TOM NAGEL

cairns of the Indians who occupied this area. Excavations of several of the mounds have revealed materials from the Late Woodland period, while materials in the rock cairns are from the later Mississippian cultural tradition.

All in all, Pomme de Terre, with its evocation of French traders and of Indians who roamed the prairies and oak savannas, is a pleasant park that offers a near-ideal setting for a family campout.

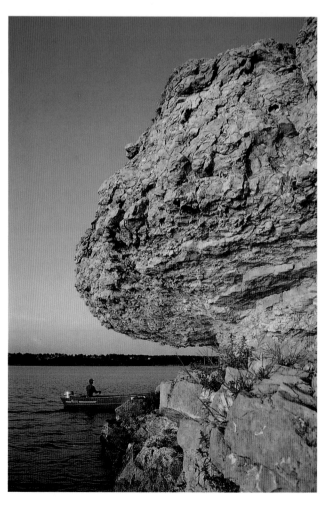

Harry S Truman State Park

THE VISITOR ARRIVING by automobile at Harry S Truman State Park winds for miles along the curvy spine of a narrow ridge. Closer to the park, steep valleys alternating on either side of the road provide nickelodeon glimpses of Truman Lake in the distance. A great bend of the Osage River has created a long peninsula so pinched at one point that one can see the lake reaching close through valleys on both sides. Suddenly the park entrance appears and the landscape opens out into upland prairie. One now has a choice, as the road splits to follow two different prongs of the ridge. Along its outer margins, as seen either from a vehicle through winter's leafless woods or from a boat nosing into U-shaped coves, the undulating ridges of the peninsula end abruptly in steep bluffs or sheer cliffs.

This idyllic park is an outcome of a hotly contested dam and reservoir project in a region of the state no stranger to controversy. The Osage River was dammed for the first time in 1931 by a private utility corporation, Union Electric of St. Louis. The resulting reservoir, Lake of the Ozarks, backs up from Osage Beach just about to Warsaw, Missouri. Some years later, a second dam at Warsaw was proposed for construction by the U.S. Army Corps of Engineers, and in 1954 the Flood Control Act authorized Kaysinger Bluff Dam and Reservoir as part of a larger scheme for flood control in the Missouri River basin. In 1962, the purposes of hydroelectric power and recreation were added to the project, and construction actually began in 1964. Along the way the name of the project was changed, perhaps as a public-relations gesture in the face of mounting opposition, from Kaysinger Bluff to Harry S Truman Dam and Reservoir.

The project was truly gargantuan. The reservoir would permanently cover 55,600 acres in four counties, about the size of Lake of the Ozarks, but at full pool it could flood more than 200,000 acres, much of it good farmland. The waters would consist of the backed-up flows of several major streams, including the South Grand, the Pomme de Terre, the Sac, and the Osage itself. More than four thousand archaeological sites would be submerged, and several thousand families dislocated. The opposition was strong, but belated and ultimately unsuccessful, and in December of 1979 Truman Dam generated its first hydroelectric power.

The landscape and culture of the basin over which the dam battle was fought were complex and diverse. The upper Osage basin lies primarily in the Springfield Plateau section of the Ozarks, with some headwaters in the tallgrass prairie country of eastern Kansas and western Missouri. In the vicinity of the dam site, the Osage valley is deeply cut and surrounded by a rugged, mostly tree-clad terrain. Prairie and savanna openings are frequent and help to support abundant wildlife.

Early Indians probably hunted Ice Age mastodons and ground sloths here. The famed Rodgers rock-shelter south of Warsaw, which revealed some ten thousand years of nearly continuous occupation by native Americans, has water lapping into it at full pool. Subsequent native people, the Osage, gave their name to the river. A powerful and far-ranging tribe, the Osage played a key role in the early fur trade and exploration conducted by Frenchmen such as Charles du Tisné, who led an expedition through the area in 1719. American pioneers began permanent settlement in the 1830s.

A shaded bluff offers a stunning vantage point over-looking the lake. NICK DECKER

A marina caters to park visitors' every outfitting need. TOM NAGEL

The dam controversy was far from the first conflict to divide this area. In the 1840s a vicious series of fights between outlaws and outlaw-like vigilantes came to be known as the "Slicker Wars" after the habit of one side to strip and whip, or *slick* with hickory switches, the bare backs of their captured foes. Again, although the area was overwhelmingly southern in background, the Civil War brought divisions of allegiance and murderous guerrilla warfare. The town of Osceola, seat of St. Clair County, was probably most notable in this regard. In 1861, the notorious Kansas jayhawker and later United States senator from Kansas, James Lane, descended upon Osceola and, after plundering everything of value, burned the town to the ground. It was in retaliation for this Union atrocity that the far more widely known raid by Missourians on Lawrence, Kansas, took place in 1863. Much of this basin history and prehistory, plus a good deal of corps showmanship, is now displayed in lavish style at the corps visitor cen-

ter perched atop Kaysinger Bluff.

The park that was deeded to the state and opened in 1983 amid these scenes of historic and contemporary discord is itself a peaceful, well-run, and highly attractive recreation area. The 1,440-acre park consists of a two-lobed peninsula jutting into the central part of the lake close to Truman Dam in Benton County. Park planners took advantage of a superb location and easily controlled access to create one of Missouri's finest reservoir-based state parks. There are abundant tidy campsites, clean sand beaches, shady picnic areas, convenient boat launches, and a fully equipped marina. Fishing, sailing, and pleasure boating are all popular, and trails wind through the woods and out to rocky overlooks.

Perhaps because of the park's semi-isolated peninsular setting, the wildlife seems to feel secure and allows close observation. It is not uncommon to see deer and wild turkeys feeding along the grassy shoreline near the campground beach, plus fox squirrels and cottontail rabbits. In the winter, numerous bald eagles roost in the park on the tall limestone bluffs bordering the lake.

Truman State Park captures the character of

The western wallflower dots the natural oak savannas during the springtime. TOM NAGEL

both the prairies to the west and the Ozark woodlands to the east. Fires once swept across the Osage Plains from the west, their frequency and intensity inhibiting the growth of trees. But in the rugged dissected hills along the deeply entrenched Osage River and its tributaries, the fires slowed their pace. North-shaded slopes and steep valleys gentled them often enough to allow open woodland or savanna trees to flourish. By 1980, after decades of effective fire control, portions of the park were dominated by thickets of red cedar and oak. But beneath these thickets under a blanket of leaf debris lay diminutive prairie plants and small clumps of native grasses kept barely alive by their well-developed root systems and just enough light. Three prescribed burns and, a decade later, the landscape has been totally transformed.

Today, in places, widely spaced oaks shade a mantle of prairie grasses and wildflowers. The brilliant orange beauty known as western wallflower dots the limestone barrens here in May and June. This member of the mustard family and other species such as stickleaf, Missouri spurge, and plains muhly occur in no other state park. Thanks to the fossiliferous limestone exposed throughout the savanna, a dense cover of the small, single-leaved adder's-tongue fern blankets the ground in spring. This tiny fern owes its name to a serpent-like fruiting stalk protruding from its single leaf. Other savanna areas are being restored, so by the year 2000 visitors entering the park will drive for several miles through a primeval landscape.

It is somehow fitting that this superb park that anchors the reservoir named for Missouri's only elected United States president should once again exhibit a prairie landscape not unlike the area on the Osage Plains of Missouri where Harry Truman was born.

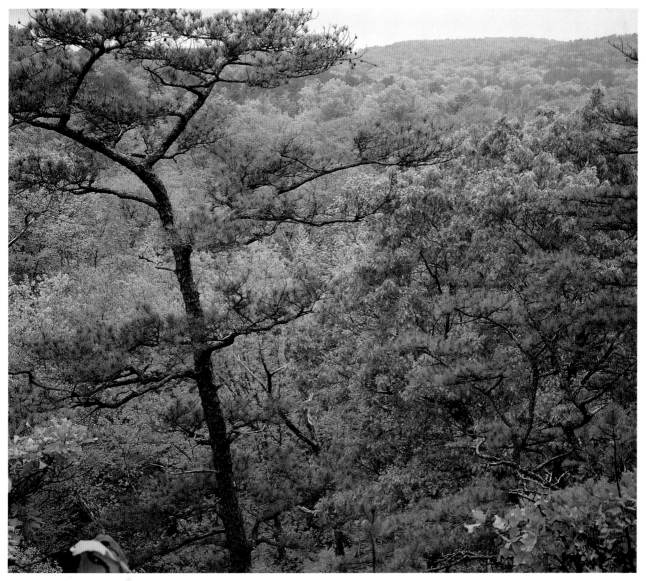

A shortleaf pine stands sentinel overlooking the rugged hills of the Ozark Border at Hawn State Park.
TOM NAGEL

Introduction

ALTHOUGH physiographically part of the Ozark Plateau, the Ozark Border natural division is a broad ecotonal belt to the north and east, comprising about thirteen percent of the state, in which the characteristic species of the Ozarks grade into those of adjacent natural divisions. This is owing to a complex arc of successively younger geologic formations marking the northeastern rim of the Ozark dome. Located along the lower Missouri and Mississippi rivers, the division is characterized by highly dissected hills with narrow, loess-covered ridges and deep valleys, covered in presettlement times by a mosaic of denser forest areas in valleys, variably open savannas, and some notable prairies, which total perhaps about ten percent of the whole. An aerial view of the river hills reveals narrow, linear bands of sandstone glades that snake along midridge contours, especially along the lower Missouri River. In an arc beginning in St. Louis County near the Meramec River and running southeast to Perryville are prominent dolomite glades, as well as some exposures of Lamotte sandstone.

Culturally this region experienced millennia of significant occupation by native peoples, who have left evidence of their activities in many places. It was among the earliest regions settled—and, in places, mined—by the French and old-stock Americans, though they avoided some of the roughest river hills and sought out the valleys and the broader plains more distant from the big rivers. After about 1830, significant numbers of Germans settled in the region, which supposedly reminded them of home. The region divides readily into sections drained by the Mississippi and the Missouri rivers.

We begin in the Mississippi River section with the wilds of Hawn State Park in the rugged hills of western Ste. Genevieve County. Located east of the Precambrian core of the Ozark dome, Hawn is characterized by fantastic cliffs and ledges of the ancient Lamotte sandstone of the Cambrian period, its acidic soils clad in pines and draped with ferns, mosses, orchids, and other unusual plant and animal species. The Pike Run Hills of St. Francois State Park, a refugium for both plants and people, are perhaps the most classic representation of the Ozark Border landscape, with a rich assemblage of plant species on the rugged hills, in glades, and in the fens along Coonville Creek.

We consider next two parks prominently associated with native peoples, Mastodon in Jefferson County, where human artifacts have been found in direct association with the bones of extinct Ice Age mammals dating from perhaps twelve thousand years ago, and Washington, a superb site where Indians of the Mississippian tradition carved birds, animals, and other ceremonial symbols into exposed slabs of dolomite bedrock sometime between A.D. 1000 and 1600. Bollinger Mill on the Whitewater River of western Cape Girardeau County, originally constructed by a Swiss-German settler in 1799 and twice rebuilt, illustrates the early and continuing importance of gristmills in rural areas, while the associated Burfordville Covered Bridge, along with the Sandy Creek bridge in Jefferson County, represents an important era of nineteenth-century transportation history.

Missouri Mines State Historic Site and St. Joe State Park in the old lead belt of St. Francois County offer opportunities to explore the fasci-

nating mining history of Missouri, from the French enterprises of the eighteenth century to the industrial behemoths of the twentieth, and to ponder the impacts on the economy and on the landscape. Finally, at the northern margin of the region in the lower Meramec Valley, Castlewood and Robertsville state parks, both sites of early nineteenth-century settlement, anchor the Meramec River Recreation Area, a twentieth-century concept of a linear series of open spaces along the Meramec corridor to provide public recreation for the St. Louis metropolitan area.

In the Missouri River section of the Ozark Border, we move generally from east to west, beginning in western St. Louis County with the Dr. Edmund A. Babler Memorial State Park, an exemplar of highly dissected "river hills," luxuriantly wooded owing to rich loess soils that have developed on windblown deposits of silt on the slopes along the Missouri River. North of the river in Montgomery County is Graham Cave, a rock-shelter in a sandstone exposure along the Loutre River valley, where ten thousand years of human habitation have been documented archaeologically.

And in Boone County in central Missouri, also north of the river, are three quite disparate parks—Rock Bridge, which represents well the wooded riverine terrain and the sinkholes, caves, and other karst features of the northern Ozark Border; Jewell Cemetery, the burial place of several prominent leaders of Missouri's "Little Dixie" region; and Finger Lakes, an old coal strip mine now redeveloped for motorcycle recreation as well as for swimming and fishing.

Hawn State Park

SOME STATE PARKS can be experienced by canoe, by motorboat, by car, even by trail bike, but there is only one way to really take in the pleasures of Hawn State Park, and that is by foot. True, the campgrounds and picnic areas, some of the most pleasant in the park system, are accessible by automobile. But to see the bulk of this park and to savor its riches, the visitor must leave the family sedan behind and strike out across the sandy, pine-needle-strewn forest floor.

Arriving by car at the northern end of this foot-traveler's park in the rugged hills of western Ste. Genevieve County, the visitor is treated to one of the loveliest vistas in the state. After passing the park office, the entrance road turns south and descends a steep slope to the campground and picnic area located in the valley of Pickle Creek. The rolling forested hills of the eastern Ozark Border provide a wide-angle, windshield-framed spectacle that immediately tells the visitor that this place is something special. And special it is!

Hawn State Park preserves Missouri's most exemplary concentration of distinctive Lamotte sandstone landscape features. *Lamotte* is the name given by geologists to the very old, coarse-grained sandstone formation that overlies the ancient igneous rocks of the Precambrian. The Lamotte is composed of sands weathered from the Precambrian granites, and its sculpted outcrops provide a contrast to the more usual dolomites and limestones that poke through most of Missouri's landscape. The park's principal streams, Pickle Creek and River aux Vases, have carved steep-sided valleys into the thick beds of the Lamotte, reaching igneous rock in places to create shut-ins.

The unique ability of this sandstone rock to hold groundwater moisture and to produce acidic soils in turn allows for a very distinctive flora. The park supports a mixed pine and hardwood forest and a whole assembly of unusual and rare plants. In some places the oak-pine forest gives way to pure stands of mature shortleaf pine—Missouri's only native pine. These stands are among the finest left anywhere in the state. Parts of the park have a forest floor literally carpeted with needles over the whitish sands of the Lamotte.

Prior to settlement, the park was covered with enormous pines, some of their trunks measuring four feet thick. Much of the landscape was more open than it is today, mantled in a mosaic of prairie wildflowers and shrubs amid the pines. Visitors can visualize what some of the landscape must have looked like at the open pineries near the picnic shelter, around the amphitheater, and in the extensive grove at Botkin's Pine Woods Natural Area.

Hawn State Park features some of the finest hiking trails to be found anywhere in the state. The Whispering Pine Trail, built with the cooperation of the Ozark Chapter of the Sierra Club, consists of two five-mile loops and leads south toward the River aux Vases. A shorter trail leads up Pickle Creek from the picnic grounds to the scenic shut-ins. Hikers are attracted to the changing faces of the landscape: terraced fern-and-moss-covered cliffs sheltering terrarium-like miniature gardens, overhanging rock shelves along the tea-colored clear streams, shattered blocks of sandstone and volcanic talus, distant pine-clad hills, uplands here and there broken by sandstone boulders and exposed slabs of bedrock.

Hawn State Park is beautiful year-round, but especially so in the spring. Both dogwood and redbud are plentiful, and they are joined by the fragrant blossoms of the rose azalea, one of Missouri's showiest flowering shrubs. Hawn is the only state park featuring the azaleas. Along the sandstone bluffs the diligent observer may find the rare eastern clubmoss called ground cedar (*Lycopodium tristachyum*). It is known only from Ste. Genevieve County—at three sites, in and near the park.

In a few remote corners of the park, the erosive action of the water on the sandstone has produced boxed canyons that are cooler, damper, and shadier than the surrounding hillsides. These micro-habitats provide refuge for plants and animals found normally in more northern states, left behind here when the Ice Age glaciers retreated. They have become living museums.

Among the rich plant life are many species of ferns: cinnamon, royal, sensitive, and lady fern, broad beech, bracken, Christmas, common polypody, and marginal shield fern, bulblet fern and common woodfern, narrow-leaved spleenwort, silvery, ebony, pinnatifid, and Scott's spleenwort, and two very rare species, hay-scented fern and spinulose shield fern. There is an abundance of the beautiful showy orchis and other orchids, two of which are quite rare—green adder's mouth and rattlesnake plantain. Other relicts include partridge berry and Canadian white violet.

Even the creeks themselves are special. With its clear water, sandy bottom, shaded surface, and lack of much aquatic vegetation, Pickle Creek provides a distinctive habitat. Fish biologists report that the creek supports at least twenty species of fish—various minnows, darters, and shiners, even an occasional smallmouth bass. It has been designated an outstanding state resource water.

The diversity of the flora and fauna is important—probably more so to the scientist or naturalist than to the average park visitor. But even the least knowledgeable park user will recognize Hawn State Park as a distinctive natural setting. Probably nowhere in the park system is there greater opportunity for solitude and for private recreation. Recognizing the importance of these values, park officials have designated most of the park as the Whispering Pine Wild Area.

Hawn State Park is named for Helen Coffer Hawn, a rural Ste. Genevieve County public school teacher who lived with her mother and

brother in a rented cottage, but dreamed of creating a "little park" for the people of Missouri. Through her will, after her death in 1952, she gave nearly 1,500 acres of magnificent wild hills and streams to the state. She had acquired them tract after tract in at least twelve separate purchases between 1932 and 1941 and had hoped to acquire still more that landowners were unwilling to sell, including the impressive columnar Chimney Rocks.

Development at Hawn was held up for more than a decade by the state's inability to acquire the Chimney Rocks, which were thought at the time to be essential in order for the area to have "park appeal." When the area was finally opened to the public, it was called an "outdoor recreation area" rather than a park, and the parks division shared its management with the conservation department for timber-stand improvement and hunting as well as other recreation. After four years and a number of citizen complaints, the park board took over sole management. Sixteen additional purchases by the state in the years since Helen Hawn's extraordinary gift have brought the total holdings to more than 3,200 acres, still without the Chimney Rocks. But no one today would think of suggesting that Hawn lacks park appeal.

Situated about halfway between Highway 67 and Interstate 55, the park is rarely discovered accidentally by motorists. For years, people learned of Hawn most often by word of mouth, and the visitors singing its praises were folks interested in less-developed recreational areas and appreciative of its natural amenities. Respecting that tradition and those values, park officials have exercised great care in providing visitor facilities. The state plans to add 1,300 more acres in order to protect the watershed of Pickle Creek from encroaching development and to open new hiking, camping, and picnic areas at some remove from the delicate vegetation in Pickle Creek valley. Visitors can help by staying on the trails, eschewing the temptation to climb on moss-and-lichen-covered slopes and ledges.

If you hike about a mile south from the campground, the trail leads up a remnant erosional knob of sandstone called Evans Knob. You're only about three hundred feet above Pickle Creek and not that far from the park comfort station, but standing there in that old forest—mostly white oak, shortleaf pine, and scarlet oak with a sprinkling of flowering dogwood and wild blueberry—you feel transported back in time. Back to the mid-nineteenth century, before this remote, rugged terrain was taken from the public domain and when the nearest hint of spreading civiliza-

Azaleas accent a ledge of Lamotte sandstone at Hawn. TOM NAGEL

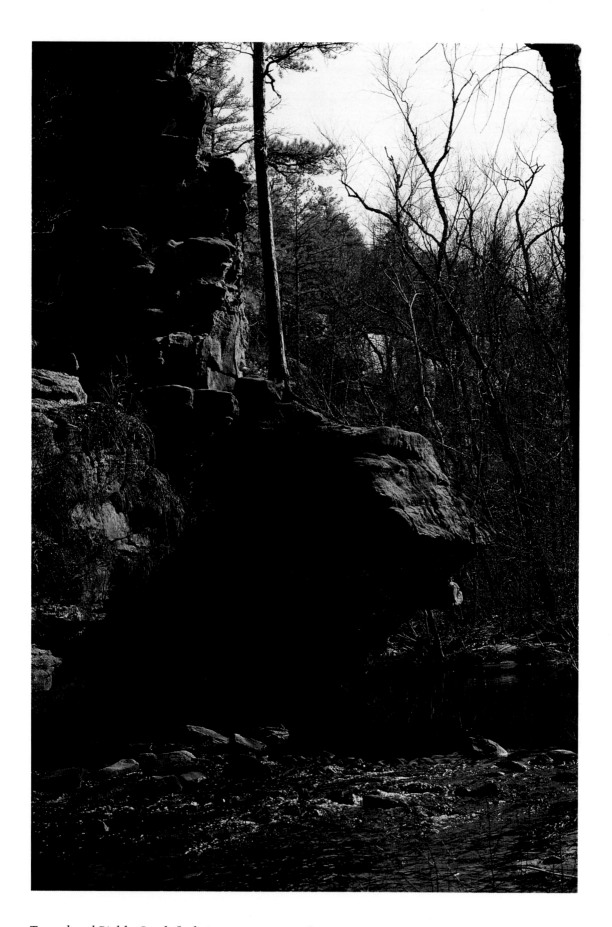

Tea-colored Pickle Creek finds its way past a sandstone bluff. PAUL W. NELSON

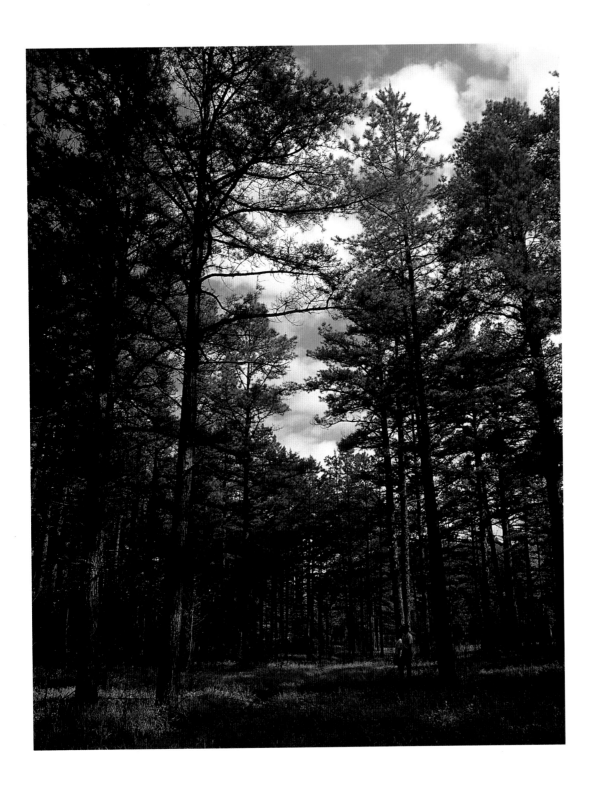

Hawn State Park features the park system's best representation of shortleaf pineries with a prairie-like understory of grasses. KEN MCCARTY

tion was the old plank road several miles to the north (now State Route 32). You are too far away to have heard the wagons hauling pig iron from Iron Mountain to the river at Ste. Genevieve, just as now you cannot hear the automobile traffic speeding between Farmington and Weingarten. Or you may be transported back further, to the days of ox-drawn French charettes hauling lead from Mine La Motte—named for Antoine de la Motte Cadillac, the governor of Louisiana who discovered the mine that in turn gave its name to the sandstone so characteristic in the region. Or back even further, when the Indians roamed free and stalked game in the piney woods. That is the magic of Hawn State Park.

St. Francois State Park

"THEY LOOK LIKE THE fragments of a broken up world piled together in dread confusion, and terminating finally in an abrupt bluff on the margin of Big River." Thus, in 1870, Sam Hildebrand is reported to have described his Civil War hideout in the Pike Run Hills of St. Francois County. These hills have been a hideout and a refuge for a long time. Ten thousand years ago, as the last ice age ended and the climate moderated, the spring-fed seepages along the narrow, shaded valleys of Pike Run became isolated strongholds for delicate water-loving plants that had perished elsewhere in the warmer and drier Ozarks. Much later, when Americans began to settle the eastern Ozark Border region, the rough and remote hills surrounding the Pike Run valley tended to attract people seeking refuge, permanent or temporary, from the outside world. And during the Civil War, these same hills were the favorite refuge for one of Missouri's most notorious Confederate guerrillas.

In 1964 the St. Francois County Court conveyed about 1,350 acres at the heart of this wild and rugged region to the people of Missouri for a state park. This was matched by another 1,050 acres donated by the St. Joseph Lead Co. In a sense, these valuable gifts insure that the Pike Run Hills will continue to be a refuge—for the rare and beautiful plants along the streams, for the wild animals of the forests and hills, and for refuge-seeking people. Folks today don't visit here to escape the long arm of the law, but rather to find refreshment and renewal amid the beauty of these ancient hills, beside the waters of Pike Run, now known as Coonville Creek, and along the banks of the historic Big River.

St. Francois State Park is named for the county in the northern reaches of which it is located, not for the ancient mountains just to the south. The park lies within the eastern Ozark Border and is a superlative example of the intricately dissected topography so characteristic of this part of Missouri, especially along the larger streams. The underlying bedrock has been carved over millennia by water draining to the Big River. The resulting hills and hollows are cloaked in a dense forest of oak, hickory, and red cedar, with several glade openings on south-facing slopes.

The soul of this landscape, and the setting for its most exciting natural features, is the valley of a stream that by local tradition has long been known as Pike Run, but that came to be called Coonville Creek (probably after the nearby Coonville School) by government mapmakers, and thus, a little reluctantly, by the rest of us. Today the name *Pike Run* appears on no official map of the area, but it lives on in the local name for the rugged region of which the stream is the heart— the Pike Run Hills.

An inviting trail leads up the valley of Coonville Creek. One of the first things that will strike you about this small stream is the clarity of its waters. Another will be the beauty of its musical flow over bedrock ledges, not rushing and turbulent in normal seasons, but gentle and refreshing. Pausing at one of the many pools, you can lose yourself in the aquarium-like world of graceful native fish, aquatic insects, and delicately floating leaves. Over eighteen different kinds of fish live here, including the colorful southern redbelly dace, the orangethroat darter, and the nocturnal slender madtom.

Along the valley, the trail passes a number of small springs and seeps. These cool, dependable

The Pike Run Hills have long been a refuge for plants and man. TOM NAGEL

Queen of the prairie graces a boggy fen in the valley of Coonville Creek. PAUL W. NELSON

waters help account for the steady clear flow of the stream. Around some of the seeps, boggy soils support plant communities that scientists call fens. Growing in these fens are botanical rarities such as the grass pink orchid, swamp wood betony, and swamp thistle. The rarest jewel in this valley is the queen of the prairie, with its luxuriant deep green foliage and tall summer-flowering spikes bearing dense clusters of pink blossoms. All of these features render Coonville Creek one of the premier small streams in the Ozarks. It has been designated an outstanding state resource water, and its valley is a Missouri natural area. But fear not, Coonville wears its titles lightly. It is a friendly stream that will call you again and again to wander in its valley and along its banks.

The same rugged isolation that helps to explain the unique natural character of Coonville Creek also has made the Pike Run Hills a hideout for human refugees. The most famous of these by far was an extraordinary outlaw named Sam Hildebrand. Hildebrand came from an established and respected family in the Big River valley—the imposing 1832 Hildebrand home of ashlar stone still stands today very near the park boundary—and as a child Sam roamed all over the Pike Run Hills. When the Civil War broke out, the terrible division of Missouri clove right through the Big River neighborhood. Though sympathizing at first with the Union cause, Sam turned to the Confederacy when Union militia killed three of his noncombatant brothers in cold blood and drove his mother from their family home. He became a bitter rebel bushwhacker who killed for revenge, and he was so deadly that his small band tied down large numbers of Yankee troops all over southeast Missouri. When federal soldiers were hot on his trail, Sam often headed for the Pike Run Hills. The small cave where he reputedly hid out is still concealed in the park, high on a bluff above the Big River.

In the early twentieth century, the narrow hollows and coves of these hills proved ideal for the time-honored Ozark custom of making moonshine whiskey. Up one of the side hollows off Coonville Creek, a lovely spring emerges from a shaded, mossy grotto. Moist ledges glisten with ferns and liverworts, dogwood branches and wild hydrangeas nod overhead, and the gurgle of springwater over shiny pebbles soothes the ear. Perhaps old John Thomas Forshee enjoyed the peaceful quiet of this beautiful spot as much as he appreciated how perfect it was for the moonshine still that he set up there in the 1920s. The "revenoors" eventually caught John Thomas and sent him to prison. But Forshee Spring is still hidden in the hills, and it is just as alluring as ever.

At 2,735-acre St. Francois State Park, the state provides an immaculately kept campground and lovely picnic sites, and the Big River provides swimming and wading holes. During the 1980s an outstanding interpretive program was developed, and many activities are available to park visitors. When you visit St. Francois, don't miss the opportunity to talk to the naturalist or one of the other park staff. Then seek out some of the hidden treasures waiting for you here.

Mastodon State Park

"BESIDES THE MASTODON'S head, I have found near the same place, several highly interesting remains of antediluvian animals, one of which especially merits attention. It is the head of a nondescript animal, which appears to have been superior in size to the largest elephant, and which resembles somewhat the Mastodon in the hind part of the head, but the front part is entirely different; and until it is recognized or proved to have been previously discovered, I shall name it Koch's Missourium, in honor of the state it is discovered in, and intend, in a very short time to give a minute description to it, as well as of a great many relics not herein mentioned."

This was how self-styled naturalist Albert C. Koch, writing in 1839, described his sensational find at what became known as the Kimmswick Bone Bed, just south of St. Louis in Jefferson County. Calling his creature *Leviathan Missouriensis*, Koch was not hindered by a scholar's knowledge of anatomy (or any other science, for that matter). Thus, he was free to fill in gaps in his creature's reassembled skeleton with bones from other animals and other locations. Koch traveled the country displaying his beast and other fossil discoveries with a flair for showmanship that P. T. Barnum would have hailed.

Koch eventually agreed to sell his collection to the British Museum for several thousand dollars along with an annual stipend. The true scholars at the British Museum were not impressed with Koch's fanciful creations; but they recognized what was clearly a significant collection of Pleistocene animal bones. Koch's Missourium, properly reassembled, turned out to be a mastodon (*Mammut americanum*) after all. It still resides in London, where it has recently been on public display at the Natural History Museum.

Koch made his most famous discovery at the base of a limestone bluff near the junction of Rock and Black creeks, near the village of Kimmswick and not far from the Mississippi River. Many prehistoric animals made their way to this site, probably attracted by the sulphur springs and salt licks. And many of them died there, some perhaps trapped in the marshy ground.

Over the years following Koch's initial diggings, many would-be paleontologists, and some fast-buck artists, were attracted to the ancient bones at the site. For nearly ten years beginning in 1897, Charles W. Beehler of St. Louis conducted extensive excavations and established a small museum there. During this period, it was not unusual for teams of visiting scientists to make the twenty-two-mile train trip down the Iron Mountain route to view the marvelous fossils. Perhaps to increase interest in this strictly commercial venture, it was alluded that human bones and some stone tools had been found in association with the bones of extinct species of animals, but professional scientists remained skeptical owing to inadequate controls and documentation—especially after later examination demonstrated that the purported human bones were not from humans.

During 1940–1942 Robert McCormick Adams, a St. Louis archaeologist, conducted scientifically oriented excavations at the Kimmswick site with Works Progress Administration funding. Though he discovered a projectile point from the Early Archaic period (circa 7000–5000 B.C.) in undisturbed loess above the bone bed, he did not find

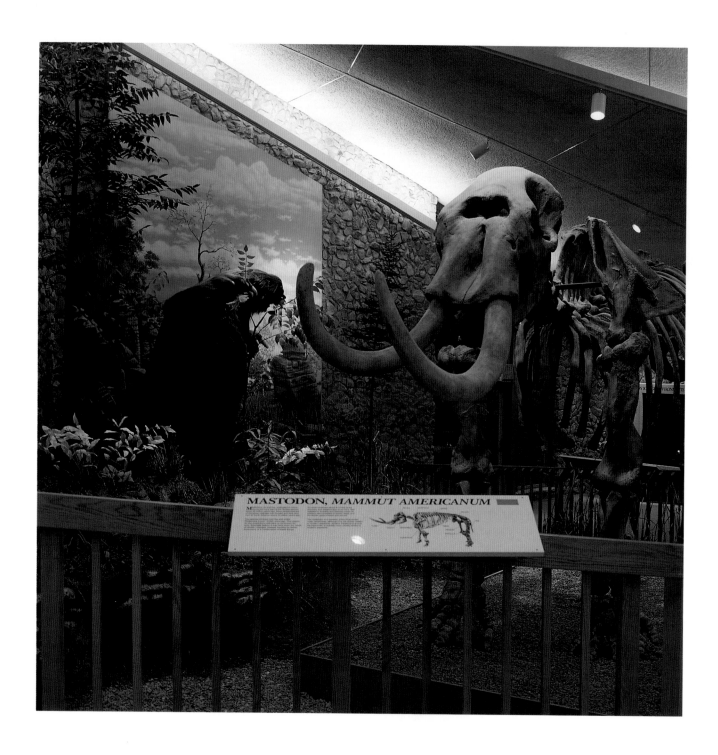

*Full-size replicas of a mastodon skeleton and a giant
ground sloth, or glossotherium, loom over the many
smaller exhibits in the museum at Mastodon State
Park. Bones from both species found at the park have
yielded evidence suggesting association with human
beings.* B. H. Rucker

any direct evidence for the association of humans with mastodons or other extinct species. Then the discussion rested for a time, though other scientists and untold amateurs continued to pick over the site.

The 425 acres that today make up Mastodon State Park, including most of the old bone beds, were acquired in 1966 by the state highway department as part of the right-of-way for the new Interstate 55 heading south out of St. Louis. Four years later, after completing the new highway, the department declared the acreage surplus property and made plans to auction it off. Local residents, long proud of the historic significance and scenic beauty of the area, organized the Imperial Improvement Association to try to save the land as a park.

The highway department was determined to realize a financial return on the tract; thus highway officials would not consider simply transferring the property to another state agency. But they agreed in the fall of 1970 to delay any sale to give county officials time to explore the park option. A state archaeological survey presented to the state park board a month later dashed cold water on the dreams of the local residents. Despite the generous volume of bones retrieved from the site over the past hundred and forty years, the report expressed doubts concerning the extent of undisturbed Pleistocene deposits remaining. In an effort to put to rest the putative connection of mastodon bones with human artifacts, it stated, "No cultural material has ever been found at the site to show man's involvement and contemporaneity with these mastodons."

Local advocates were neither pleased nor deterred by the negative report. One bright spot was a tentative endorsement by Robert McCormick Adams. Although not sure what was left of the bone-bearing deposits, he thought the development of the bone beds as an interpretive area would "keep alive the vast importance of this site to American history."

Local enthusiasm for a park continued unabated, but action lagged. In spring 1974 the highway department finally went ahead with its auction, and some St. Louis developers delivered the winning bid of more than $568,000. An explosion of activity ensued, including a lively protest before the highway commission. Four area women—Dorothy Heinze, Marilyn King, Hazel Lee, and Rita Naes—then took it upon themselves to form the Mastodon Park Committee to shepherd the project. Within a few months the women had secured a commitment from the highway commissioners to delay awarding the bid for eighteen months to see if the committee could equal the amount offered. In addition, they secured an agreement with state park officials not only to accept the property as a state park but to request half the purchase price in the form of a grant from the Land and Water Conservation Fund.

Holding dances and other events, often with fabulous home-cooked meals, and appealing to all sorts of individuals and organizations, the women of the Mastodon Park Committee started raising money. After three months, they had about $24,000. The 1970 archaeological report still haunted the project—was all this effort justified? One conservation organization solicited for help responded that it was a "quite ordinary and common site" not meriting state park status. And indeed, without continuing archaeological significance, the site was nothing special; it was cut by roads in several directions, had sewer easements clear through it, was crossed by a large power line, and had been dug over for lime.

Fortunately, in retrospect, the local park promoters did not listen to all the expert advice they were receiving, but kept plugging away on faith. Their ceaseless lobbying of local representatives and other efforts were acknowledged in 1975 when the legislature appropriated $200,000 in state funds toward the purchase. By the deadline, they had raised enough money on their own, including a $28,000 pledge from the McDonnell Douglas Personnel Charity Trust, to go over the top with funds to spare. The committee presented a check to the state, and Mastodon State Park became a reality in July 1976.

The successful effort led Gov. Christopher Bond to declare the "campaigning and fund raising for saving of the historical site . . . one of the finest projects to celebrate the Bicentennial in the state." But the Mastodon Park Committee did not rest on its laurels; the four women continued to raise money to help in developing the recreational and interpretive resources of the new park, insisting on new archaeological excavations to search especially for evidence of possible human association with the mastodons.

Since qualified Missouri archaeologists were not particularly interested in working on the site, state park officials contracted for initial reconnaissance with a research team from the Illinois State Museum, much to the consternation of the Mastodon Park Committee. After a century of pilferage, they were reluctant to see any bones leave Missouri, even if only temporarily. But they soon became endeared to the scientists. Almost immediately after beginning work, in May 1979, the Illinois researchers discovered a Clovis spearpoint, a very ancient and distinctly shaped pro-

jectile, in direct association with mastodon bones. Halting all excavation, they put out a call to the dean of Missouri archaeologists, Carl Chapman, and other specialists who raced to the scene along with a gaggle of TV, radio, and newspaper reporters to examine the stunning find.

The discovery at Mastodon State Park is now considered the first undisputed evidence of the association of man and mastodon in North America. The 1979 excavation and two subsequent ones have yielded two Clovis points, other tools, and waste flakes resulting from the manufacture of chipped stone tools, as well as bones from a species of sloth, a bison, a miniature horse, a wild pig, a stag moose, and a giant armadillo. While no datable materials have been recovered, it is believed that the site dates to about twelve to fourteen thousand years ago, based on the similarity of the points to others recovered in the West. The finds are especially significant at a time when scientists from many disciplines are interested in the phenomenon of widespread extinction of large mammals at the end of the Ice Age and are considering the possibility that early man may somehow have been involved.

Prodded and aided by the Mastodon Park Committee, the parks division has built a beautifully designed interpretive center at the crest of the hill beneath which the discovery was made. Octagonal in shape, the structure leads the visitor back through the epochs of human and natural history in the area, past a life-size replica of a mastodon skeleton, and out to a self-guiding trail that wends down the hill to the excavation site at the base.

It was in this 1979 excavation that the first evidence of man's association with mastodon was unearthed— a twelve-thousand-year-old projectile point in contact with a fragment of mastodon bone. K. W. COLE

What remains of the site is being preserved, and there are no immediate plans for further excavation. Although the Mastodon Park Committee and other friends of the site would undoubtedly like to see excavations continue—we are, after all, mortal and would like to accomplish and to know all we can in our own lifetimes—it is accepted practice to preserve a substantial portion of exceptionally significant sites such as Mastodon so that future generations of scientists, armed with technologies we can scarcely imagine, may make yet more stunning discoveries.

Washington State Park

WASHINGTON IS THE petroglyph park. Indian rock carvings are found in a few other places in the state, including Thousand Hills State Park, but this one park along the Big River in northeastern Washington County contains almost two-thirds of all the petroglyphs yet discovered anywhere in Missouri.

The glyphs are carved in horizontal slabs of Cambrian limestone bedrock that outcrop as ledges in the rocky, barren glades for which this Ozark Border park is also noted. They are found in three different locations in the park: one large group of about two hundred is precariously close to State Route 21, which apparently obliterated some others during its construction; another group of about forty is east of the entrance road at the south end of the museum; and the third and largest group, numbering some 238, occurs on ledges overlooking Maddin Creek near its junction with Big River, on a tract recently added to the park. The glyphs depict animals, birds (including dozens of thunderbirds), turkey tracks, snakes, human figures and footprints, hands, genitalia and phallic signs, arrows, maces, cups, houses, geometric shapes, and other abstract symbols. The carvings have been known since the first lead miners and farmers arrived in the area. Two groupings have been protected in the park since the first tract was donated to the state in 1932 by A. P. Greensfelder, a civic-minded St. Louis engineer and planner, and the third ("Cresswell") grouping was added in a combination purchase and donation from John and Mildred Graff of Boulder, Colorado, in 1990.

The petroglyphs have been described and analyzed by numerous archaeologists over the years, yet they remain something of a mystery. Although there is abundant evidence of earlier peoples from the Woodland and even earlier traditions in the area, archaeologists believe the thunderbirds and other ceremonial symbols are the work of village people of the Middle Mississippian culture during the period between about A.D. 1000 and 1600. These people would thus seem to have been related in some way to the great center of Mississippian culture at Cahokia, Illinois, and across the river at St. Louis, and to many other Mississippian settlements such as those at Towosahgy, Lilburn, and elsewhere up and down the Mississippi River. The Big River is the only other river in Missouri with large Mississippian villages along its length; even the Meramec, to which it is tributary, does not have such villages. Archaeologists thus speculate that these villages in the "lead belt" along Big River may have been part of a trade network for galena crystals, which have been found in Mississippian sites throughout the central part of the country. But, because of key differences between the sites along Big River and those along the Mississippi, some scholars believe that what we see at Big River is evidence not so much of the migration of peoples as of the diffusion of Mississippian ideas into an indigenous Woodland culture.

Whatever the connections with more distant areas, the petroglyph complexes at Washington State Park were almost certainly major ceremonial sites. Young men may have been initiated into secret societies here, the glyphs serving as memory aids for the complex sequences of songs and rites that were part of the ceremonies, the directional arrows perhaps pointing the way through the maze. There is much we do not—perhaps cannot—know about the petroglyphs

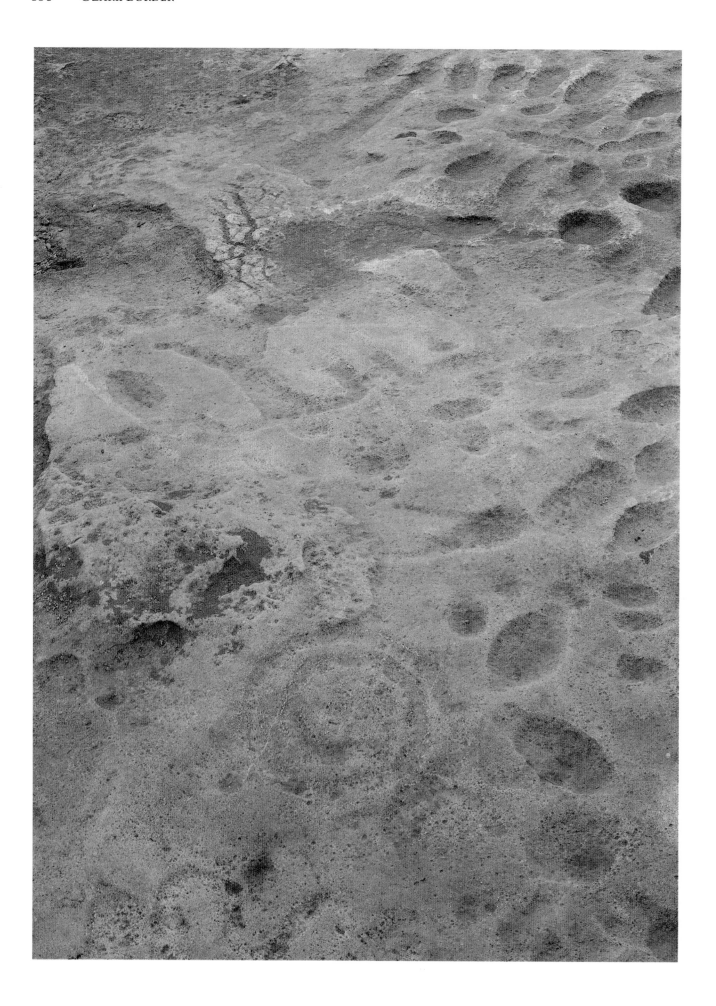

here, but we can feel their power and sense that this place was sacred.

The petroglyphs are not the only examples of masterful craftsmanship in stone at Washington State Park. Not long after the land was donated to the state for a park, an all-black company of the Civilian Conservation Corps set up camp and began to develop the rugged tract along Big River for recreational use. Inspired by the Indian petroglyphs in the park, the members of the company named their barracks area Camp Thunderbird and titled their camp newspaper the *Thunderbird Rumblings*. Between 1934 and 1939, these young men, aged eighteen to twenty-five, built many rustic stone structures influenced by both the rock carvings and the natural rock outcroppings in the park. Among the truly notable features in this park is the dining lodge, of rough random-ashlar stone, with an Indian thunderbird symbol carved in the stone facing at the gable end and repeated in interior details such as the handmade iron door hinges. The park also boasts handsome rustic rental cabins; an octagonal lookout shelter of random-cut native limestone open on all sides to views of the campground, bluffs, and Big River; another shelter of native stone resembling a natural outcropping of rock, set into a hillside offering a spectacular view of the river valley; and a 1,000-step trail winding up the hill behind the shelter, its highly ambitious, labor-intensive construction blending beautifully into the natural park environment.

The African-Americans in Company 1743 of the CCC were known for their high morale and consistently hard work, and they won an outstanding reputation for their product. All of their work within the original 1932 boundaries of the park, including fourteen buildings and extensive stone roadside work, is now recognized as the Washington State Park Historic District on the National Register of Historic Places. But racial prejudice was never far from the surface in the 1930s. When the company completed its work at Washington and was transferred to Mark Twain State Park in northeastern Missouri, citizens in nearby communities protested the stationing of blacks in the park. But other citizens countered with petitions of support, on the grounds that the company's work and conduct at Washington had been exemplary.

The landscape now at Washington State Park is

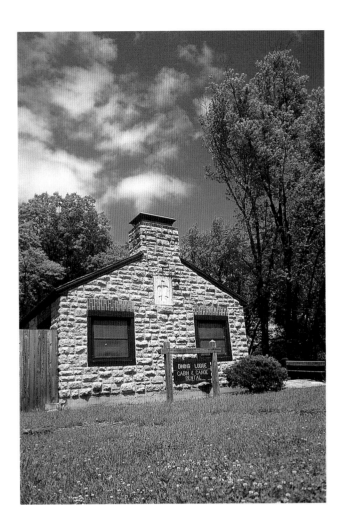

The black stonemasons of Company 1743 of the Civilian Conservation Corps carved a reproduction of the Indians' thunderbird motif in the gable of the dining lodge. Paul W. Nelson

not entirely the same as that which attracted the Indian rock carvers or perhaps even the black stonemasons. The bluffs and rocky outcrops are still there, of course, but the hills have become much more densely forested so that the vistas are not as open. Here is how the naturalist Henry Rowe Schoolcraft described the country when he traveled in the vicinity of Potosi in 1818–1819: "The growth of prairie grass in the open postoak woods and prairies is of the most luxuriant kind. . . . The barrens are also covered with a profusion of wild fruits . . . and wild flowers."

Place names like Old Mines, Cannon Mines, Baryties, and Mineral Fork remind us that this was mining country. The French mined lead seasonally in this area in the eighteenth century, their shallow "diggings" dotting the landscape, but it was probably not until permanent settlement around the turn of the nineteenth century

Indians of the Mississippian cultural tradition carved hundreds of animals and other symbols in the ancient limestone bedrock of Washington State Park.
Oliver Schuchard

Celandine poppy is among the many spring wild-flowers that grace the 1,000 Step Trail painstakingly laid by the CCC through what is now Washington Upland Hardwoods Natural Area.
RON MULLIKIN

of the glades is unusual too, with the top of the glade food chain represented by the coachwhip snake and the swift eastern collared lizard. The lizard is a favorite of visitors as it folds its front legs up against its chest like a little tyrannosaurus and sails along on its hind legs, jumping over rocks in its path.

In the late 1980s, preliminary clearing of invading eastern red cedars commenced on the glade located near the petroglyph parking area. While at first the glade appeared ragged, persistence in continued brush removal and several prescribed burns paid off. In the spring of 1991 the glade erupted in a grand floral display, as if the wildflowers were rejoicing in their release from woody bondage. Park scientists also intend to resurrect a major glade complex and its unique biota found in the western part of the park.

Washington Upland Hardwoods Natural Area along the limestone bluffs and talus slopes that face the Big River offers a strong contrast to the drier woodlands and glades typical of most of the park. This rich, north-facing slope has produced a mature stand of hardwoods with a luxuriant ground cover of ferns and woodland wildflowers. Tall specimens, up to a hundred feet, of elm, bur oak, sugar maple, basswood, and Kentucky coffee tree are common. Understory trees include pawpaw and American bladdernut. In spring, this area hosts the park system's showiest display of woodland wildflowers. Everywhere, just before the leaves unfold on the tress, is a carpet of green

The eastern collared lizard with its ability to run on its hind legs is the show-off of the park's rocky glades. TOM NAGEL

that the vegetation began to change. Settlers brought with them cattle, goats, horses, and hogs to feed on the lush grasses. As Schoolcraft observed, the "growth of grass in the woods affords ample range for cattle and horses, and they are kept constantly fat." But more than a century of open-range grazing wiped out most of the original grasslands and wildflowers. Subsequently, without thick ground cover and fire to suppress them, growths of eastern red cedar, sugar maple, and oaks formed dense thickets.

In some of the prominent, rocky openings, or glades, scattered along the hillsides are remnants of the once dominant cover of prairie grasses and wildflowers. Among the many flowering species are some found in few other parks, including the thick-leaved Fremont's leather flower, the delicate blue-violet nemastylis or celestial lily, and a rare primrose, *Oenothera triloba*. The animal life

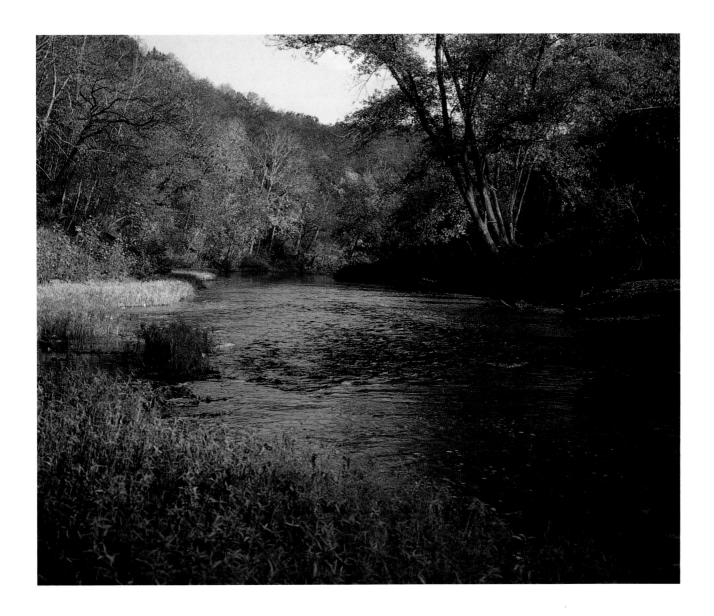

Big River flows sometimes languidly, elsewhere through riffles, along the east and north borders of Washington State Park. TOM NAGEL

interspersed with blue-eyed Marys, purple trilliums, smooth yellow violets, candle anemones, and bright yellow celandine poppies, among dozens of other species. The best way to view this area is to walk the trail—part of the 1,000 steps so carefully laid by the CCC stonemasons—down from the picnic shelter to the dining lodge. Partway down the hillside is the old stone shelter house. Looking over the parapet wall one has an outstanding view of the river valley below. At 1,800-acre Washington State Park, the landscape that inspired native American rock carvers, African-American stonemasons, and the Anglo-American naturalist Henry Schoolcraft remains to work its magic on us.

Bollinger Mill State Historic Site

THERE IS SOMETHING captivating about covered bridges and old gristmills; they hark back to what we think of as simpler times, before automobiles, before electricity, when roads and bridges were designed for slower, horse-powered vehicles and when running water was the usual power source for local commerce.

In western Cape Girardeau County two of these historic features have survived side by side in a classic picture-postcard setting. The Burford-ville Covered Bridge, completed about 1868 after nearly ten years of delays brought about by the Civil War, spans the Whitewater River just upstream from the four-story mill built at the same time on the foundation of a much older structure.

Despite the name, there is no "white water" to be found on this river. And just a few miles downstream, the Whitewater is beheaded by a diversion channel, part of the public works system designed to drain the Missouri bootheel for agriculture. But it was still wilderness in the 1790s when a twenty-five-year-old North Carolinian named George Frederick Bollinger arrived.

Bollinger, of Swiss German heritage, received a Spanish land grant from the commandant at Cape Girardeau on condition that the land be developed and settled. He built the first mill at the present site at the turn of the nineteenth century and brought twenty German and Swiss families from his home state of North Carolina to the new settlement. These settlers, who established what may have been the first Protestant (German Reformed) church in Missouri, became the nucleus of a prosperous farming community that persisted in the area, known as the "Whitewater Dutch." Local farmers and even pioneers living on the St. Francis and Black rivers, as much as seventy-five or a hundred miles away, are said to have brought their corn and wheat to Bollinger's mill, the largest in the area.

Bollinger went on to serve as both an officer in the War of 1812 and a statesman. He was elected to all four territorial assemblies and after statehood served in the Missouri senate, rising to president pro tem.

Bollinger replaced the original log mill and dam with a stone structure around 1825. He died in 1842, but his family continued to operate the mill for two more decades. At the beginning of the Civil War, one of his daughter Sarah's sons was implicated in an attack on a wagon traveling by the mill, the wagon being part of a column of federal troops that was headed toward the county seat at Jackson. Union forces retaliated and burned the mill in September 1861. Only the masonry foundation survived.

In 1865, Solomon R. Burford purchased the property from Sarah. Two years later Burford rebuilt the mill with brick on the old limestone foundation—the structure that visitors see today. The adjacent settlement, which became known as Burfordville, had a post office (it's still there, zip code 63739), stores, a blacksmith shop, a two-room school, and, of course, the mill.

The mill continued in commercial use until about 1948, operated by the Cape County Milling Company. A descendant of Bollinger's, Julia Vandivort, and her husband, Clyde, purchased the mill in 1953, and in 1961 their son Paul gave it to the Cape Girardeau County Historical Society, which in 1967 donated the twenty-one-acre historic site to the state. That was the same year the Missouri legislature authorized the state park

Bollinger Mill and the Burfordville Bridge present a rare survival of two nineteenth-century treasures— side by side. OLIVER SCHUCHARD

agency to maintain all four of Missouri's remaining wooden covered bridges as historic sites. With recent additions the park is now about forty acres.

The 140-foot-long Burfordville bridge was originally built by Joseph Lansmon of yellow poplar. It utilizes the "Howe truss" design, in which diagonal wooden compression members are used with vertical iron rods in tension to form trusses. The bridge was "restored" in 1950 by the state highway commission, including the addition of a corrugated metal roof. Park officials later replaced the metal roof with a wood shingle one; and they found an English millwright, Derek Ogden, to expertly restore the milling apparatus.

Bollinger Mill is an impressive structure rising four stories above the Whitewater River. Part of the millpond is diverted through the old limestone-block "catacombs" of the mill where the turbine is housed. This watery basement also houses a variety of nesting birds (mostly pigeons) that can be seen darting in and out of several openings in the walls.

The first floor of the mill is also of limestone construction and houses several wooden bins used for collecting the freshly ground grain as it dropped through wooden chutes from the buhrstones on the second floor. Transportation of grain between the floors was achieved with belt-driven elevators whose small cups carried the grain upstairs and with chutes through which the force of gravity brought it back down.

Exhibits on the second floor interpret almost two centuries of milling on the banks of the Whitewater River—a history that parallels the industrialization of milling. The upper floors of the mill contain examples of machines that performed the various steps in the milling of grain. This collection of roller mills, sifters, separators, bran dusters, and other devices is representative of a major evolution in the milling process, an evolution that contributed to the decline of thousands of small rural mills and the growth of large milling centers in Buffalo, Minneapolis, St. Louis, and Kansas City. The capacities of these large merchant mills provided enough surplus to export around the world.

The old buhrstones and one of the turbines found in the mill were restored and are used today to demonstrate the pre–Civil War process of making stone-ground cornmeal. The "run" of stones, originally imported from France, consists of two stones, each forty-two inches in diameter, placed one over the other. Corn is fed into the center of the upper "runner" stone and is ground between it and the lower "bed" stone as the runner stone turns. A pattern of shallow grooves cut in the facing surface of each stone creates a shearing action as the grooves cross each other when the upper stone is turning. These same grooves move the meal outward from the center, and it is collected around the outer edge of the stones as it exits from the slight gap that is maintained between them.

And there are other fascinating features. At the end of the bran bin a still faintly discernible drawing of a steamboat race has been executed in chalk, perhaps by mill workers during some idle moments. Leaving the mill, one notices a different kind of signature. To the left of the main door, carved in the limestone, are the initials *SRB*—left by rebuilder Solomon Richard Burford.

Sandy Creek Covered Bridge State Historic Site

MOTORISTS HEADING SOUTH from St. Louis toward Hillsboro may not realize when they cross Sandy Creek on State Route 21 that just a short distance downstream is located another of Missouri's last remaining covered bridges. Once fairly numerous, the covered bridges still standing numbered only eleven by 1942. The decline continued until 1967, when the Missouri legislature authorized the state park system to preserve the four remaining structures. Sandy Creek Covered Bridge, originally built in 1872, still carried traffic until 1984.

The bridge was constructed of white pine by John Hathaway Morse for $2,000. The seventy-six-foot-long structure followed the Howe truss design and reportedly could handle up to seventy tons. Fourteen years later, during the spring floods, it was destroyed. But Henry Steffin was able to salvage about half the original timbers and rebuild the bridge for only $889.

After another flood in 1940, the wooden piers were replaced with concrete supports. And, once again, in 1952, the Jefferson County Chamber of Commerce renovated the bridge, protecting it with a corrugated metal roof and placing a historical marker on it. Following total restoration in 1984, the barn-red bridge today has a wood shingle roof as it did originally.

The bridge is located on the old Hillsboro–Lemay Ferry Road. Ferries were often used in early Missouri, especially on the larger streams, and some of the first bridges were often built by ferrymen as toll bridges. Although guidelines for bridge construction were included in many of the early road laws, it was not until the state's first public bridge code in 1825 that bridge building really caught on. The code required that any

structure costing more than twenty-five dollars be built by the county court.

By the mid-1840s, most of the state had caught the bridge-building fever. The first covered bridge was reportedly a span built in 1851 across Perche Creek in Boone County by Travis Burroughs. (The first covered bridge in the nation may have been one built in Pennsylvania in 1804.) Burroughs bridge, near Columbia, was on a road that followed the old Boone's Lick Trail.

Although several structural designs were popular, far and away the most successful was the Howe truss, which is represented in three of the four structures still standing in Missouri—Burfordville at Bollinger Mill, Sandy Creek, and Locust Creek in Linn County. The design was patented in 1840 by William Howe, whose nephew Elias went on to sewing-machine fame. The essential feature of the Howe truss was its use of metal verticals functioning as tension members and wooden diagonals functioning as compression members. With the iron truss rods, Howe truss bridges are often considered to be transitional from wood to iron. But covered bridges were practical as well as quaint; the addition of roof and sides served to protect the structural timbers from the elements.

Sandy Creek gets its name from the exposures of St. Peter sandstone along the south-facing slopes of a long ridge (called locally Sandy Ridge or Sand Ridge) north of the creek. Some of the outcroppings have formed glades and rocky barrens with characteristic dry-land flora and fauna.

The Sandy Creek site includes about 200 acres of undeveloped land adjoining the bridge. This part of the site runs about a mile south of the creek to a local prominence called Fort Hill. This

The fully restored bridge provides a bright red focal point for the deeply shaded picnic area at Sandy Creek. OLIVER SCHUCHARD

conical little hill displays a small prairie glade typical of the kind found in this eastern Ozark Border region of Washington and Jefferson counties. In early May, the glade on Fort Hill is given to displays of purple and gold: on close inspection, the purple really comes from the pale violet, limp petals of the coneflower and from the lavender bells of Fremont's leather flower, while the gold turns out to be the giant blossoms of Missouri primrose.

No formal trail system leads into the Fort Hill area of the site, but visitors are encouraged to explore it on short hikes of their own devising. With a lunch in the creek-side picnic area, a stroll through the old bridge, and a hike into the woods, this small historic site can provide all the requirements for pleasurably whiling away a lazy May afternoon.

Missouri Mines State Historic Site

MISSOURI'S EARLIEST exploration and development were fueled by two commercial enterprises. The first of these, the fur trade, is widely known and acknowledged. Americans seem to be at least generally familiar with the romantic saga of the traders and their exploits in penetrating the region's rivers and hills, dealing with the natives, and competing for territory and trading grounds. Less familiar is the story of the other great thrust of European enterprise on the Missouri frontier: mining. The passion to find and exploit Missouri's underground wealth, especially lead and iron ore, beginning with the French in the earliest years of the eighteenth century, was every bit as responsible as the fur trade for the region's exploration, and it was a greater factor in its settlement. The story of mining in Missouri rings with courage, innovation, and achievement, as well as with a measure of greed, exploitation, and abuse. We have here an epic tale of a process that fundamentally shaped the state. This important story needs to be told, and Missouri Mines State Historic Site is dedicated to that mission.

Federal Mill No. 3 in Flat River, St. Francois County, was built by the Federal Lead Co. in 1906–1907, at a time when fifteen different mining companies operated in the "old lead belt" of southeastern Missouri. Surrounded by communities with names like Leadwood, Rivermines, and Leadington, this large industrial complex functioned as a processing center for the rich lead ores mined in the region. After 1923, the Federal Mill facility was owned by the venerable St. Joseph Lead Co., which had been active in the area since 1864, and it grew to become a major center of industry with twenty-six buildings and much

large equipment spread over twenty-five acres. It was the largest plant of its type in the world, the hub of an enterprise with 1,000 miles of mine tunnels and 250 miles of underground railroad track beneath all the nearby communities. St. Joe had bought out all its competition by 1933 and was the sole employer for thousands of mine workers in the region. Around the middle of this century, after two centuries of productivity, the local veins began to play out, and St. Joe developed a "new lead belt" some thirty miles to the south and west around the tiny hamlet of Viburnum. The functions of the Federal Mill complex dwindled, and in 1972 operations ceased.

In 1975 the expanded St. Joe Minerals Corp. offered the entire complex, along with over 8,000 acres of land, to the state of Missouri for recreational purposes. For several years the state wrestled with the problem of how to convert this huge acreage, much of which was covered with the unsightly remains of mining operations, into a public park. With proper facilities and management, much of the acreage offered a range of outdoor recreation possibilities. An obvious focus was on an already established pattern of use by off-road recreational vehicles on the most-altered lands, especially the broad expanses of sandy "tailings," the by-product of ore processing. As plans proceeded to develop the park for these and other uses, the question still remained of what to do with the huge and now derelict industrial facility at the Federal Mill complex on the north end of the property.

Some park professionals dreamed of a mining museum, and, indeed, before St. Joe pulled out it allowed park staff to select any items they wished to keep for a museum—a locomotive and

The maze of buildings and other structures at Federal
Mill No. 3 comprises one of the most extraordinary
mining museums in the United States.
OLIVER SCHUCHARD

ore cars, diggers, mechanized shovels, and drills. But the mill complex was still a big headache—an invitation to vandalism and injury, the many buildings run-down and ugly (to some) and incredibly expensive either to renovate or to remove. Over time, park officials began to appreciate that this industrial complex, with its large number and variety of mining-related buildings, its many gigantic implements of industrial technology, and its location in the heart of one of the most legendary mining regions in the United States, ought to be retained in its entirety and developed to tell the story of mining in Missouri. What had been perceived by some as an awkward liability became transformed into an exciting resource and an interpretive opportunity perhaps unrivaled anywhere in the country.

Once this fundamental direction was set, a long process of research and evaluation followed. Parks division staff discovered that the Federal Mill complex was even richer in interpretive potential than they had dreamed. At the same time, it was clear that to make these valuable resources meaningful and accessible to visitors would require a significant investment of funds. The very scale of the artifacts and historic structures rendered the resource extremely difficult to work with. Fortunately, enthusiasm for the project swelled within the park system, and also among many local community leaders and state legislators. St. Joe and the state mining industry council took an interest, donating funds to assist development. Now, Missouri Mines is well on its way toward becoming one of the most important interpretive centers for industrial mining technology and architecture in the United States. A tremendous amount of work remains to be done, but already the potential has been revealed, and visitors are in for a real treat.

Driving down the entrance road from State Route 32 one is immediately struck by the immensity of the mill complex sprawling in the valley, with its powerhouse, headframe and crushers, foundry, machine shop, and all the other buildings utilized for crushing, grinding, and concentrating the ore and for maintaining the widespread operations. Entry for visitors today is through the gatehouse, just as it was for thousands of mill workers for more than half a century. In the mill yard, one is in awe of the aging buildings and all the apparatus overhead, quiet now but still showing the signs of former enterprise. Some of the more significant structures are being renovated to interpret the milling process, others for other historical exhibits. The powerhouse is already an extensive museum of Missouri mining geology and history.

The headframe sitting astride the main shaft was the point of connection between the mill complex and the mine, some thousand feet below.
OLIVER SCHUCHARD

The housings that once contained moving conveyor belts form geometric patterns against the sky behind the now-silent mill. OLIVER SCHUCHARD

The story at Missouri Mines focuses of course on the long enduring boom of the old lead belt, of which the mill was a part, but it reaches out to include the whole story of mineral wealth and its development in the state. It begins with basic ge-

ology, which the excellent rock and mineral collection in the powerhouse helps to illustrate. Missouri's underground resources include lead and iron, but also copper, silver, barite, zinc, granite, limestone, and coal. Human use of these resources began with native Americans who quarried flint and mined richly hued ores for the making of paints.

The French developed the first real lead mines in eastern Missouri in the early 1700s, and Anglo-Americans joined in with enthusiasm by 1800, utilizing the technological innovations of Moses Austin, who made his mark—and went bankrupt—in the Missouri lead region before securing a Spanish charter for a colony in Texas in 1821. After the Civil War, the rowdy, western-style boomtowns of far-southwest Missouri exploited lead and zinc in the Tri-State District, at the junction of Missouri, Oklahoma, and Kansas, but the old lead belt continued to produce as well.

The mining districts of the state influenced immigration patterns, encouraging people from mining-related cultures of Wales and central Europe to settle in Missouri, and newly discovered resources of barite in southeastern Missouri and coal in northern and western Missouri began to be exploited. The importance of all this activity was reflected in the state's establishment in 1870 of the School of Mines, now known as the University of Missouri at Rolla, and in 1889 of the Bureau of Geology and Mines, also at Rolla and now the Division of Geology and Land Survey in the Missouri Department of Natural Resources. The late nineteenth and early twentieth centuries also saw upheavals of labor protest and violence hit Missouri's mining industries, especially in the coalfields of north Missouri and in the old lead belt of the Ozarks. Probably the most important developments in our own era have been the discoveries at the Viburnum Trend, the "new lead belt," which secured Missouri's position for a time as the leading producer of lead in the nation and in the world, and the increasing public concern over the environmental effects of mining, particularly in the Ozarks.

Mining has been, from the beginning, an integral part of the state's heritage, intimately related to its settlement, development, economy, and environment. Missouri Mines tells the exciting story of that epic saga, amid the hulking structures that were so much a part of it.

St. Joe State Park

IN 1972 WHEN THE St. Joe Minerals Corp. shut down its great lead-processing mill at Flat River, nearby ore deposits having largely been exhausted, the future of the mined-out area already had been forecast by popular usage. Aficionados of the new and versatile off-road vehicles (ORVs)—dune buggies, all-terrain vehicles (ATVs), 4x4 trucks, and "dirt bikes" (powerful motorcycles with knobby tires)—found a challenging playground in the abandoned piles of mine waste and the several hundred acres of desert-like surface left behind in a tailings "slime pond." Why not, company officials asked themselves, donate the whole area to the state for a park?

Mining and the disposal of spoils had transformed about 2,000 acres lying south of the great mill. But flanking the mined land on the east, west, and south the company owned more than 6,000 additional acres, largely second-growth Ozark woodland but mostly natural nevertheless. At its southern tip the property even included a short reach of the St. Francois River in its scenic valley. At the encouragement of the director of the new department of natural resources, the company offered the whole tract to the state, including the impressive but deteriorating Federal Mill, now Missouri Mines State Historic Site. Gov. Christopher Bond announced acceptance of the gift in December 1975; the deed of transfer was recorded in September 1976.

Thus Missouri acquired not only its second-largest state park but a highly diverse recreational area accommodating thousands of ORV users and also inviting traditional natural-park uses such as hiking, camping, horseback riding, and nature study. Now at 8,260 acres, St. Joe is second in area only to the 17,200-acre Lake of the Ozarks State Park.

Shortly after the transfer the Southeast Missouri Regional Planning and Economic Development Commission at Perryville secured funding to study the economic, social, and physical impact of the new park and develop a master plan for it. In the commission's report, published in March 1979, the planners predicted the park could expect "nearly 500,000 visitors each year when fully developed." In 1990 St. Joe reported 470,801 visitors.

ORV operators and their families, joined in recent years by the ATV enthusiasts, make up most of the visitors and probably always will, because there are few other places where the churning wheels and noisy exhausts can be turned loose without bringing complaints from neighbors and accusations of damage to soil, plants, and wildlife. One other state park also acquired in the mid-1970s welcomes them—Finger Lakes, in an old coal-mining area north of Columbia. Motorcycles and other ORVs had once ranged through many of the parks, causing numerous complaints, but the general assembly effectively excluded them in 1971 when it passed a law restricting all motor vehicles to park roads and to a maximum speed of twenty miles per hour. Hence the effort to secure areas where bikers could pursue their sport.

Following the master plan, ORV and ATV use is strictly confined to the mined area, where the noise is muted by surrounding woods; this area is circumscribed by a bicycle trail where neither motors nor horses are allowed. As they arrive, either in their highway-licensed vehicles or hauling their ATVs in trucks or trailers, visitors are

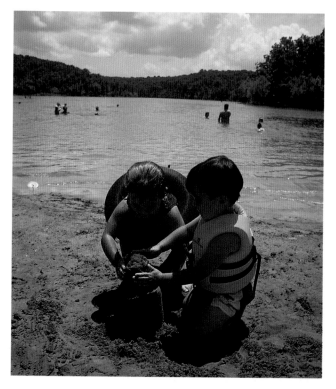

St. Joe's substantial acreage offers recreation to suit many tastes: (clockwise from top left) challenging the slime flats (OLIVER SCHUCHARD), enjoying Monsanto Lake (RON MULLIKIN), insisting on pedal power (RON MULLIKIN).

directed through a headquarters gate where each gets a copy of the special rules and is checked for basic safety equipment—helmets for riders in open vehicles, an orange flag to help avoid collisions on the trails, and the like. Next they go to a staging area, where they find concrete ramps for unloading, as well as picnic tables, shelters, and restrooms.

From the staging area they wheel out into the 2,000-acre ORV riding area and step on the accelerator. The riding terrain ranges from 800 acres of sandflats to brushy and wooded slopes rising to higher elevations. The slime pond itself fills about 400 acres of the meandered valley of a branch of the Flat River into which pulverized rock mixed with water ("slime") was pumped to settle out; it is a hundred feet deep, behind a dam that was jerry-built over the decades by adding material as needed at the top. Trails in the area are created, and re-created, by the operators, although dune buggies and three- or four-wheelers, the wider vehicles, are instructed to stay out of the wooded trails. The mere possession of alcoholic beverages is banned in the ORV riding area, and driving while "under the influence" is, of course, strictly prohibited. Nearby, with direct access to the ORV area, is a special campground for the vehicle users.

Four small, clear-water lakes were impounded by the tailings deposits in the upper arms of the little valley: Jo Lee, Pim, Monsanto, and Apollo. All are popular with anglers, yielding the typical pond species—black bass, crappie, bluegill, and channel catfish. Monsanto and Pim lakes have excellent swimming beaches, their sandy bottoms (created from mine residue) sloping gradually into deeper water. There is also a heavily used picnic area with playgrounds for children and ample parking space.

The twelve-mile paved bicycle and hiking trail that encircles the ORV area was created on the abandoned bed of a railroad used by the mining company to haul raw ore from the producing mines to the processing mill. It is growing in popularity as cycling clubs in nearby lead-belt cities and from as far away as St. Louis increas-

ingly schedule special events here. An equestrian trail, with its own staging area, winds through oak-hickory woods and expands into a network in rugged hills in the southern end of the park. Some campsites are reserved for equestrians, but they are lightly used, it is said, because most riders bring their mounts in for a single day or, at most, a weekend.

The natural history of this diverse park is only beginning to be appreciated. Within the lands not undermined and out of earshot of the playful motors, park naturalists have identified up to a thousand acres of savanna-like areas, expanses characterized by scattered, big trees within a matrix of grassland and shrubby vegetation, a terrain common in the Ozarks when the first white settlers arrived. Also, many glades with their distinctive communities of grasses and wildflowers can be found on rocky but sunny slopes.

A significant stand of native shortleaf pine relieves the deciduous monotony along the eastern side of the park, while on the western side the Harris Branch watershed, while not officially so designated, is considered a significant natural area. The diversity of geologic and vegetative types also allows for a diversity of wildlife. Birding and wildflower expeditions are certain to become more popular as people discover that there is more to St. Joe Park than slime flats.

The St. Joe company not only gave Missouri a site for an excellent mining museum, a popular recreation area, and a park with beautiful natural assets, it may also have bequeathed to the state and the nearby city of Flat River some potentially serious problems. Most obvious is the dust billowing from the wheels of the ORVs and settling everywhere. Incorporated in the dust is the residue of lead-mining operations, with all the dangers that might entail. And then there is the dam that holds back those millions of tons of mine waste. Viewed from below, the dam looks precariously steep, almost fragile, and the great New Madrid fault isn't far away. The department of natural resources is taking steps to evaluate these dangers.

Castlewood State Park

IMAGINE YOURSELF BACK in time to the Fourth of July, 1922. Your family has planned a weekend vacation to a river resort not far from St. Louis. Early on Saturday morning, you arrive at the Missouri-Pacific station in Webster Groves where you load your supplies onto one of the special resort trains. Another car will carry the family canoe. After a short ride, the train unloads its reveling recreationists—up to ten thousand a weekend—at the several small resort depots along the Meramec River in western St. Louis County.

Your family gets off at Castlewood Depot at the grand staircase that leads up to the big hotels and clubs; you are staying at the Castlewood. As soon as everyone is settled in, you all change into bathing suits and hurry back down the staircase to the bottom of the palisade bluffs, where you take a ferry across the river to the large sandbar downstream known as Lincoln Beach. The Meramec River is dotted with floating swimmers and canoes; the beach is literally covered with sunbathers and kids designing sandcastles.

Hard to imagine? Not really. From 1915 to about 1940, St. Louisans by the thousands flocked to the Castlewood area for weekends of canoeing, swimming, dancing, clubhouse partying, and even gambling. But after World War II, many of the hotels and clubhouses declined—and the natural beauty and recreational value of the lower Meramec River went unappreciated as the area became a kind of industrial dumping ground.

Today, after nearly two decades of effort by citizens and government alike, much of the dormant potential of the river is being rediscovered. In 1975, the Meramec River Recreation Area was established by gubernatorial proclamation. The centerpiece of the MRRA, as it has come to be known, is Castlewood State Park. The park, stretching for nearly five miles along the river, incorporates much of the old resort area, including the grand staircase, Lincoln Beach, and the site of the old Lincoln Lodge. It represents a vital state park concept, a park that is linear in its relationship to a major river as well as suburban in its close proximity to the expanding St. Louis metropolitan area. Encompassing some 1,800 acres, the park is contiguous to nearly 5,000 additional acres of private or public open-space land.

The heart of the park—and the section first opened to the public—was once part of the old Ranken estate, a sprawling collection of parcels assembled in the late nineteenth century. This section, just east of the community of Castlewood, includes the lower mile of Kiefer Creek as it meanders toward the Meramec River. And below the sheer, south-facing bluffs, the Meramec itself swings south, then east, then north, and then east in large meanders. Here, its broad floodplain averages over a half-mile in width.

A hike along the River Scene Trail leads one atop the white cherty limestone bluffs—the "castle fortress," maybe the origin of the park's name—where a truly majestic view awaits. Look south across the river's plain into the wooded alcoves of Tyson Valley, or upstream as the bluffs arc to the southwest, or downstream as far as Fenton—in every direction the view is great. At this distance even a defunct automobile assembly plant appears to be just part of the scenery. Across the river some two hundred and thirty feet below—now grown up in willows—is the

The sun rising behind Castlewood bluffs illuminates the Meramec valley. Tom Nagel

Morschel Woods is bottomland forest of rare quality.
TOM NAGEL

old Lincoln Beach, formed from sand dredged by the Union Sand and Gravel Company, which operated a separation plant for aggregate on the east bend of the river. Huge mounds of gravel and old equipment bear witness to the Meramec's contribution to Missouri's leading mineral industry— the Meramec alone has been the source of nearly a quarter of the gravel mined in the state.

Along the river's bank can be found large river birch and also the uncommon green hawthorn.

On the south side of the river near the old community site of Morschels is a small stand of native bottomland forest. Most such stands were long ago cleared away for agriculture or industry, but here at Castlewood the visitor can still experience the feel of a floodplain forest with its silver maple, box elder, black willow, white ash, sycamore, slippery elm, and hackberry.

By contrast, as you enter the park via Ries Road from the north, a beautiful drive through a canyon-like area, you pass through the more typical upland forest of the eastern Ozark Border, dominated by white oak, northern red oak, and shagbark hickory. If it is spring, the drive will be

highlighted by the floral displays of the redbud and dogwood. The road descends these dissected hills to arrive in the relatively flat valley of Kiefer Creek.

Undoubtedly the best way to view this park is from the river; after all, the Meramec River is the area's main feature, now as in 1922. An easy day's float can begin at the Times Beach access on Interstate 44; the trip will end at the Castlewood boat ramp at the eastern edge of the park. First-time floaters will be surprised at the quality of the scenery; even though there is constant evidence of surrounding urbanization—blufftop homes, power lines, railroad bridges—the overall mood is one of nature at peace. The float trip provides a case lesson in the wrong and right ways to deal with floodplains. At deserted, bought-out Times Beach the floater sees the remains of what happens when society attempts to build in the path of an unpredictable river and when it cannot properly handle the toxic wastes it produces. But at Castlewood State Park, the floater sees flood-plain land used in a way compatible with its natural character.

The unincorporated community of Castlewood abuts the park boundaries on the northwest. An unsuccessful speculative subdivision development in the 1870s, the area was developed as Castlewood Camp in 1895 by the Meramec Realty Company. The camp featured hotels, clubhouses, stores, boathouses, and the like, and led to the boom in river-based recreation. During Prohibition in the 1920s, many of the clubhouses became private, and speakeasies flourished. After repeal in 1933, taverns and gambling became popular. Today's visitor to the park, however, is probably unaware that this parkland was once dotted with clubhouses and summer homes.

Proposals to establish a state park on the lower Meramec date back to the 1930s, when the Lake Meramec Association proposed a dam near the river's mouth to create a twenty-mile-long lake to provide recreation for the urban multitudes. Then, when the Ranken estate was about to be cut up and its timber removed in 1939, it was suggested for acquisition as a state park. But the area continued to decline, despite renewed interest in the late 1950s and early 1960s in reclaiming it as a recreational resource. The real catalyst for action was the proposed sale again in 1973 of certain parcels of the Ranken estate at a time when funding from various sources might creatively be combined. Responding to this golden opportunity was a citizen conservation group, the Open Space Council of St. Louis. Through a large bequest to its foundation, the council was able to help the state acquire two of the tracts—nearly

1,100 acres—for more than $1.3 million, half of which came from the federal Land and Water Conservation Fund. The land was transferred to the state in 1974, and by 1985 ten additional tracts had been added to the park through the continued efforts of the Open Space Council and the parks division.

The success story at Castlewood prompted the addition to the Meramec River Recreation Area of other open-space lands acquired by the state (both the conservation department and the parks division), by the county, and by several municipalities. Though progress has slowed with the decrease in federal funding for recreation lands, the dream of a greenbelt along more than a hundred miles of the lower Meramec with both public and private recreation facilities and interconnecting trail systems still lives.

Imagine yourself sometime in the future—it's the Fourth of July. Your family has planned a weekend vacation . . .

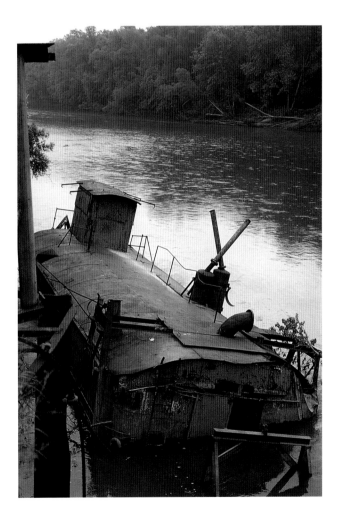

A rusty gravel barge offers mute testimony to the industrial past of the lower Meramec. TOM NAGEL

The Roberts family cemetery is a reminder of the park's earlier days as a nineteenth-century planta-tion. OLIVER SCHUCHARD

Robertsville State Park

THE NEWEST STATE PARK on the Meramec River is Robertsville, which lies south of a great bend in the lower river in east-central Franklin County. The 1,100-acre tract was purchased by the department of natural resources in 1979 as part of the state's commitment to the Meramec River Recreation Area, a string of parks, conservation areas, and other recreational facilities along the lower Meramec anchored by Castlewood State Park. Robertsville lies just about one mile upstream from a large arboretum run by the Missouri Botanical Garden. The park features a variety of facilities: campground, river access, swimming area, trails, and picnic areas.

The future of this land as a public park is yet to be written, but we know at least the rudiments of its past as part of a large plantation. The River Hills Plantation was for much of the nineteenth century the home of Edward James Roberts. Roberts came to Missouri from Virginia in 1830 at the age of fourteen. Seventeen years later, he married Ann M. Robertson of St. Louis County. Their sprawling farm of more than three thousand acres was situated on the rich bottomland along the Meramec, and there they raised horses, mules, cattle, swine, wheat, corn, Irish potatoes, sweet potatoes, oats, and hay. Agricultural records show that the plantation yielded ten thousand pounds of tobacco in 1850. The 1860 census indicates that Roberts held twenty-five slaves. The Roberts family cemetery still remains, now within the park.

It would be expected that such a substantial landowner would be active in civic affairs, and Roberts served as a local tax collector and as an election judge; he was also a master Mason. When the Frisco Railroad extended west from St. Louis, it established a station on Roberts's property, giving him the opportunity to develop an all-purpose business listed as "Mill–Store–Money Lending." The station survives today as Robertsville, population one hundred, but the trains no longer stop. Much of Roberts's land north of the railroad remained in single ownership nearly to the present. The state bought it with the help of the Land and Water Conservation Fund from a group of investors whose elaborate plans for a resort and golf courses failed to materialize.

The Meramec River borders the tract on the north and west, while Calvey Creek forms the eastern boundary. Much of the land is situated in the floodplains, which offer some fine sloughs and other wetland habitat attractive to a variety of waterfowl. High in the branches of an old, whitened sycamore are the nests of some great blue herons. Heronries are sensitive to changes in habitat and to molestation by careless observers; thus, this rookery is being protected by the park.

In the central area of the park a small hill rises about a hundred and sixty feet above the surrounding lowlands. This hill represents an erosional remnant—often called a "lost hill"—formed by the changing courses of the Meramec River and Calvey Creek. When one stream cuts off another or when one stream occupies the channel of another, the resulting stream piracy will often leave a remnant of dissected ridge that then appears to be an independent hill.

With more than two miles of frontage along the Meramec River, Robertsville State Park, officially opened to the public in 1989, will undoubtedly prove a popular camping and boating area. As more of its history and its resources are explored by parks division staff, who knows what else the future may hold.

Dr. Edmund A. Babler Memorial State Park

MANY THINGS ABOUT Babler State Park are special—its origin, its funding, its facilities, its rich botanical diversity, and its location, in St. Louis County on the fringe of Missouri's largest metropolitan area. Because of its location, Babler is one of the most heavily visited parks in the system. When dedicated in 1938, the park was a long drive into the country. Now, it is an open-space oasis amid a suburban landscape that is simply exploding with growth.

The park was given to the state as a living memorial to St. Louis physician Edmund A. Babler by his two brothers, Jacob and Henry. Their father, Henry J., Sr., was a Swiss émigré to Wisconsin who later, in the 1870s, settled in Eldorado Springs, Missouri. The family prospered in Missouri, the brothers establishing themselves as leaders in St. Louis by the early twentieth century. Jacob went into law and later became a prominent figure in the insurance business and in Republican politics, with oil and real estate interests on the side. Henry was also in insurance, while Edmund earned his medical degree from the Missouri Medical College (now Washington University Medical School) in 1902 and became a renowned, and beloved, surgeon. The brothers started acquiring land in the drainage of Wild Horse Creek with the idea of creating a park in 1926. After Edmund's sudden death from pneumonia at age fifty-four in 1930, Jacob and Henry determined to complete a handsome park in his memory for the people of Missouri. They donated the first tract of 868 acres to the state in 1934 and added nearly 800 more acres within two years. Since then the state has acquired additional tracts, bringing the total to nearly 2,500 acres.

The mid-1930s were years of New Deal–sponsored work relief in the parks, and Jacob Babler, through his friendship with Congressman John J. Cochran of St. Louis, arranged for a substantial allocation of labor from the Civilian Conservation Corps—more than for any other park in Missouri—to develop Babler Memorial Park. In addition, in order to provide for the operation of the park into the future—and probably also to ensure a continuing role for himself in development decisions—Babler in 1936 established the "Jacob L. Babler Perpetual Endowment Trust Fund" with an initial contribution of $1.5 million.

The evidence suggests that Jacob Babler took a decidedly proprietary interest in the park, visiting the CCC crews at work there almost daily, meeting with Harland Bartholomew, who designed the park for him, commissioning a noted New York sculptor to create a statue of his brother, even traveling to Washington, D.C., to discuss plans with Conrad Wirth, head of land planning and CCC activities for the National Park Service. Wirth was so taken with Babler's enterprise that he personally supervised "cutting the vistas" at Babler Park. At the dedication ceremony in 1938, the principal speaker was Harold L. Ickes, the secretary of the interior.

The park that Babler built is a fascinating mix of urban and rural. The massive stone gateway, the entry avenue wider than a city boulevard with stone gutters and curbing, the grand vista of clipped lawn and manicured trees directing the eye toward the full-length bronze statue of Dr. Edmund Babler ministering to the weak and poor, the looping, figure-eight road system—all are evocative of great urban parks such as St.

The Edmund Babler monument in its carefully land-scaped park setting reminds the visitor that Babler has urban as well as rural characteristics.
OLIVER SCHUCHARD

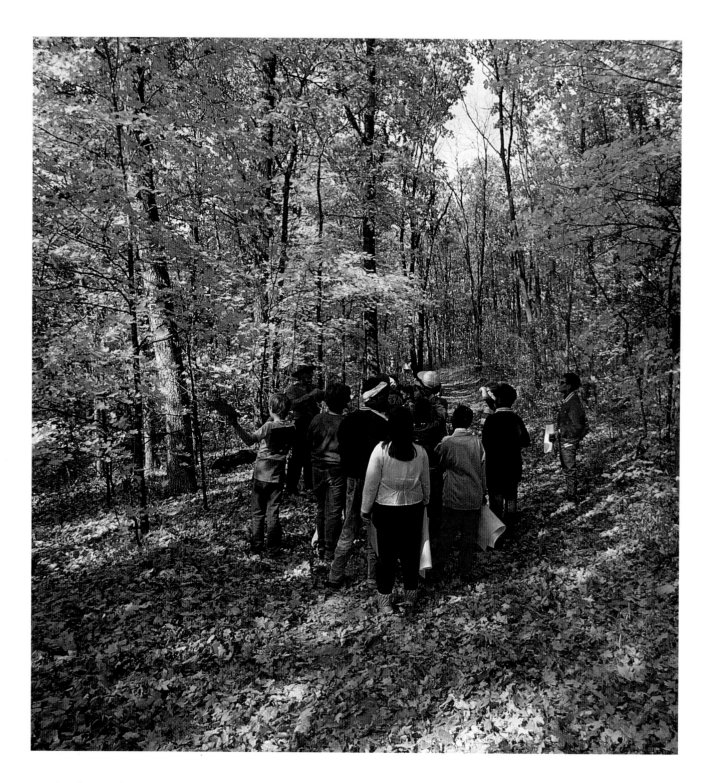

A school group learns about the forest communities of the northern Ozark Border from a naturalist at Babler. NICK DECKER

Louis's Tower Grove and Forest parks. Other structures, like the handsome, rambling stone lodge (now operated by the state division of youth services as a boys' camp), the stone and timber picnic shelters and stable, and the service

buildings, restrooms, bridges, and underpasses, though somewhat more elaborate and certainly more numerous than at any other park, have the rustic mien and unobtrusive siting of typical CCC construction. Twenty-two structures from the CCC era are now part of the Babler historic district on the National Register of Historic Places.

Jacob Babler shared the vision of St. Louis planners and civic leaders of a great outer loop of

parks interconnected by parkways. Accordingly, he continued to buy up tracts and secure right-of-way donations for an extension of Clayton Road to the park and for a corridor from the park to the Missouri River. But he was unable to realize this larger vision before he died in 1945. Some two decades after his death, when full control of the remaining assets passed to the state, the park board began to sell off the outlying tracts (much to the consternation of some who still shared the larger vision) in order to consolidate its holdings at the park and undertake more extensive development.

The trust fund established by Jacob Babler—administered until 1968 by a special board of trustees—provided for maintenance and development but with some special management provisions. The Bablers placed certain restrictions on use of the land: they wanted the park limited to day use with no camping. No hunting was to be allowed, and the park was intended "for the Caucasian race," though the trustees could at their discretion provide additional facilities for other races in segregated areas. All state parks were in effect segregated at the time, like other public facilities, but the trust provisions created concern for a time after the Supreme Court anti-segregation decision in 1954. Today the park is heavily used by blacks as well as whites, and overnight camping is permitted, though the campground was built on state-purchased land.

Some areas of the park have seen unusual service. In 1942, one area was turned over to a military police battalion and was used as a prisoner-of-war camp for German and Italian soldiers captured in Africa. More recently, part of the park has served as a residence for juveniles on a "work-release" program. The youths have received counseling while providing a work force for park maintenance programs.

One of the special distinctions of Babler Park is the Jacob L. Babler Outdoor Education Center for the Disabled, a barrier-free resident camp with special facilities constructed on state-purchased land in the early 1970s. The year-round center includes sleeping cabins, recreation and dining facilities, a mile-long paved nature trail, and a twenty-five meter, heated, handicapped-accessible swimming pool. It is available to any not-for-profit organization and is used some ten thousand camper-days per year. Go there when it is in use, and it will warm your heart, or make you cry.

The park also offers the usual picnic areas, more than a dozen miles of hiking and biking trails, horseback-riding rentals run out of the original, CCC-era stable, and more "urban" facil-

A residential outdoor education center offers special facilities for the disabled. David Bradford

ities such as ball diamonds, tennis courts, horseshoe pits, and an Olympic-size swimming pool. A recent addition is a handsome new visitor center, with special exhibits about the natural history of the park. A walk-through diorama, for example, explores the intricate interrelationships among birds, mammals, reptiles, insects, microorganisms, and other creatures in an old-growth forest environment.

Babler State Park represents a classic Ozark Border landform: rugged with loess hills and highly dissected ridges. These "river hills" drain directly into the Missouri River, a short distance to the north. Because of its proximity to the glaciated area of Missouri and the Missouri River, Babler displays rich forest communities. On southern and western exposures, the forest is typically Ozarkian in character with stunted oaks and hickories. Shadbush and lowbush blueberry signal that other plants of the rocky, cherty Ozarks can be found. Yet hidden on the north and east slopes and in deeper valleys is a taller, more luxuriant forest, essentially untouched for sixty years. The trees in Babler's deep ravines exhibit a timeless character in their massiveness, species mix, and canopy structure, a character that complements the stately design of the park entrance and other public areas.

Two forested areas are particularly noteworthy, Cochran Hollow and Babler Southwoods Hollow. Cochran Hollow is a forested ravine just north and east of the John Cochran shelter. This rich upland forest features large oaks, many over one hundred years old. White oak, northern red oak, sugar maple, mockernut hickory, and walnut form the canopy, with an understory of flowering dogwood, redbud, and pawpaw. The ground-cover

Old-growth northern red oaks and sugar maples reach for a bite of sky from a secluded cove in the Missouri River hills at Babler. PAUL NELSON

flora is equally lush with golden seal, mandrake, ginseng, tick trefoil, broad beech fern, maidenhair fern, and Christmas fern. In the Babler Southwoods Hollow Natural Area, near the campground, the old-growth white oak and sugar maple forest all but dominates the remaining flora. Except for some green ash and black walnut and one or two other species, the understory is limited—probably owing to the dense, closed canopy and the mat of decaying sugar maple leaves.

These high-quality natural features immediately adjacent to the St. Louis metropolitan area, coupled with classic park design and distinctive recreational opportunities, make this a true gem of the state park system, thanks to the splendid vision of the Bablers.

Graham Cave State Park

I N THE HILLS ABOVE the Loutre River in Montgomery County is an outcrop with a large cave created by the contact of St. Peter sandstone and Jefferson City dolomite. Caves in dolomite or limestone are common, in sandstone rare. What happened here is that the dolomite below was more soluble and slowly dissolved away, leaving a cavity under the sandstone. Some of the sandstone crumbled and collapsed into the cavity, enlarging it, and leaving an archlike entrance a hundred and twenty feet wide and sixteen feet high. Originally the cave extended about a hundred feet into the hill. An accumulation of debris and dust over the years then filled the lower part of the cave with about seven feet of deposit.

What is noteworthy, though, is not so much the cave, rare as it is, as what has been found in the debris on its floor. For this cave, like others so favorably situated, was an admirable shelter for animals and people down through the years. Just how many years would one day be discovered.

The cave was a mile north of the early nineteenth-century settlement of Loutre Lick, now known as Mineola, then noted for its mineral springs with reputed medicinal powers. This "lick," like the more famous Boone's Lick further to the west (now a state historic site), was owned by the sons of Daniel Boone, whose claims dated from 1802 during the Spanish colonial era. Their trail west, the Boone's Lick Trail, went right past the Loutre Lick. Dr. Robert Graham, a Scotsman who came to Missouri from Kentucky in the wave of migration that followed the close of the War of 1812, settled in the area in 1816 and purchased from Daniel Morgan Boone a portion of his rich bottomland along the Loutre River.

The land in this area declines in value rapidly as it ranges away from the river, climbing to the rugged and rocky escarpment that rims the edges of the valley; so much so that Graham did not pursue ownership of the ridgetop quarter-section that contained the cave until 1847, and even then he took out a patent directly from the United States government. Graham raised black Angus cattle brought from Kentucky and is said to have mined saltpeter from the cave to be sold in St. Louis for manufacture of gunpowder.

Graham's son, D. F. Graham, used the cave for his hogs during winter and early spring, but he also became interested in archaeology, digging numerous Indian mounds in the vicinity and even making a test excavation in the cave. His collection of artifacts grew so large that his wife made him build another structure, the "relic house," to store them. After his death, his son Benjamin, who had studied at the University of Missouri, offered the artifact collection to the university. Professors Jesse E. Wrench and J. Brewton Berry, who were interested in archaeology, visited the cave in 1930 to assess its potential, but did little digging. This was before the formation of the Missouri Archaeological Society or any formal structure for archaeological study at the university. Benjamin, meanwhile, used the cave for his sheep and also to store machinery. Benjamin's daughter Frances married Ward Darnell who, years later in 1948, began bulldozing the debris in the cave to enlarge the shelter for his livestock. Archaeologists, by this time much better organized, got wind of Darnell's activity and persuaded him to stop until they could conduct salvage excavations.

From 1949 through about 1955, the University

In the floor of Graham Cave, a sandstone rock-shelter that is now a national historic landmark, archaeologists have uncovered a ten-thousand-year record of almost continuous human habitation.
OLIVER SCHUCHARD

The valley of the Loutre River at what is now Graham Cave State Park was identified in a 1929 survey as one of the seven beauty spots of Missouri.
TOM NAGEL

of Missouri and the Missouri Archaeological Society conducted extensive excavations in the cave. The results were staggering. Within a deep portion of the deposits the cave contained well-stratified materials revealing an almost continuous history of occupation over the last ten thousand years. The lower levels contained a thick record of man's presence in the area from about ten thousand to nine thousand years ago. And these discoveries—the oldest known in Missouri up to that time—were being made just as the new carbon-14 technology for dating organic ma-

A sandstone ledge collects a wintry buildup of ice.
BRUCE SCHUETTE

terial like bone or wood was substantially revising archaeologists' notions of when early peoples had arrived on the continent. It had once been thought that they must have arrived less than three thousand years ago; discoveries in New Mexico were forcing scientists to push their estimates backward, but the hard evidence came with radiocarbon dating at places like Graham Cave.

The lowest deposits in the cave belonged to the period referred to by archaeologists as the Dalton Period (after Missouri Supreme Court Judge S. P. Dalton, the amateur archaeologist who first studied the distinctive projectile point that characterized the period). During this period, native peoples were adjusting to the rapidly changing climate, vegetation, and animal life after the retreat of the glaciers. Another adjustment in thinking was involved here, because before carbon-14 dating became available scientists thought the last glaciers had retreated perhaps as much as twenty-five thousand years ago; now they were finding evidence of the last, or Wisconsin, glacier still in Wisconsin as recently as ten thousand years ago, at the same time as the early occupation of Graham Cave. Because of this, the deposits found in the cave were highly important for scientific understanding of people's adaptations to a changing environment. These were probably the best-preserved deposits from this

time in the state—and undisturbed portions of the site being "banked" for the future may still retain that distinction.

The extremely significant discoveries at Graham Cave, including not only the oldest materials but also the remarkable evidence of lifeways and adaptations to the environment over ten millennia, were recognized in November 1961 when Graham Cave became the first archaeological site in the nation to be designated a national historic landmark. Proud of the historic discoveries on her land, Frances Graham (Mrs. Ward) Darnell, great-granddaughter of Dr. Robert Graham, in 1964 donated to the state 237 acres of land that had been in her family's hands for nearly a century and a half. This was the core of what is today Graham Cave State Park.

Today the park protects not only the cave that sheltered the Indians but also some 350 acres of the land that supported them. A rich bottomland forest along the Loutre River grades into oak-hickory woodlands and then into rocky sun-drenched glades. Glades within the park are found on sandstone, several limestones, and dolomite bedrock that outcrop here at this northern edge of the Ozark Border, the glades on each type of rock producing their own characteristic plant and animal life. The importance of these remnant glades has led to designation of an 80-acre tract as the Graham Cave Glades Natural Area. Prescribed burns are now used to keep these glades open, sunny, and carpeted with wildflowers, as they were when the Indians were there. And park scientists are also restoring the biological richness of the open woodlands around the glades by removing the young thickets of eastern red cedar found throughout the natural area. Unique to the park system are isolated carpets of a mosslike fern called spikemoss, which grows on dry, exposed sandstone glades.

A walk through the natural area will take you by some of the park's glades. Another short trail leads to the Loutre River, where there is a boat-launch area, and a trail from the lower picnic area passes a new interpretive shelter before arriving at the cave. In addition to several fine trailside interpretive displays, an exhibit area in the park office displays artifacts from the excavation, and a diorama of the cave area tells the story of both the Indians and the landscape they inhabited for nearly ten thousand years.

Rock Bridge Memorial State Park

THIS IS HINDSIGHT, of course, but the area south of Columbia was probably destined to become a state park, if not preserved in some other way, because of its oddity. There are so many natural phenomena there to excite human curiosity. Flowing creeks that disappear underground. Natural ponds called sinkholes that act like funnels, holding water for only a short while after heavy rains. Deep holes in the earth that open at bottom into extensive caverns. Bats boiling out at dusk. A spectacular chasm where a stream emerges from the foot of one cliff only to flow toward another cliff and beneath a massive arch of limestone topped by trees. This is the centerpiece, the rock bridge that gave the park its name. All are characteristics of a karst landscape underlain by porous and water-soluble limestone.

The first recorded owner of this curious landscape was Nathan Glasgow, who, old land records show, bought it from the federal government for $1.25 per acre before Missouri became a state in 1820. He quarried stone from a flanking bluff and used it to build a low dam across the upstream end of the natural bridge, thus enhancing the power of the water to operate a gristmill. His was the first of a succession of mills at the site over the next century. A paper mill established in 1840 didn't last long. It was followed by a whiskey distillery built by James McConathy, who marketed his product as "McConathy's Rye," touting its quality derived from the pure water of Little Bonne Femme Creek (now Rock Bridge Creek).

The mill-converted-to-distillery was raided by Union soldiers in 1863 and destroyed by fire in 1889, but it was rebuilt two years later by a new owner. It continued to prosper until the Missouri legislature passed a local-option liquor law in 1907. Boone County declined to vote itself wet, and the distillery fell into ruin. There were at times in the late nineteenth century both a general store and a post office at Rock Bridge. It was for decades an active community center, a place for political rallies, celebrations, and family picnics, and the tradition continued even after the old distillery burned down and the store closed. The geologic wonders were an enduring attraction.

Jess and Mary Calkins came from Nebraska in 1922 to buy Rock Bridge and 860 adjoining acres. The Calkinses opened a "gay, modern amusement park," according to an announcement in the *Columbia Evening Missourian* of July 23, 1922. It offered "a merry-go-round, doll racks, popcorn and fairy floss candy machines," and also "elaborate fireworks in the evening." The Calkinses soon added a dance floor, built beneath the branches of an ancient oak, and it became a popular attraction.

When the Calkinses' daughter Naomi married Columbian Dennis Ingrum, the newlyweds received as a wedding gift a deed to the Rock Bridge and 320 acres. They were to farm the area most of the rest of their lives, rear their children there, and continue the tradition of Little Dixie hospitality. In all the years that Dennis Ingrum farmed the land, he always made visitors from town feel welcome, sometimes entertaining the "city girls" from Stephens College with a demonstration of the processing of molasses from sorghum cane. A field trip to Rock Bridge and Devil's Icebox was standard for geology classes, and initiated university students would return with their dates for a lark.

*Rock Bridge Creek trickles under the natural bridge
in the stillness of a winter morning.*
OLIVER SCHUCHARD

"Dad always wanted to share the beauty of the place with others who loved it, too. He wasn't interested in getting rich," daughter Mary Toalson told writer Jacki Gray, explaining why Dennis Ingrum rejected big offers from developers but agreed to sell his land at a modest price for a state park. Although always privately owned, the Rock Bridge and its neighboring caves had been a semi-public area for more than a century when, in 1961, sudden tragedy struck a Columbia family, starting a movement to preserve the area permanently for public use. That is why the word *memorial* appears in the official name of the state park. Lewis Stoerker was a popular professor of speech and dramatic arts at the University of Missouri when his daughter Carol, age nine, was struck and killed by a car. Grief-stricken, Stoerker conceived the idea of establishing a park to memorialize his beloved Carol, a place where children could run and play in safety. He knew about Rock Bridge and started approaching landowners in the area. Dennis Ingrum quickly said he would sell—for a park.

The Stoerkers and their daughter had many friends, young and old, who rallied to the cause. Auctions were held, teenagers collected money, 4-H clubs and scout troops helped. Columbia businesses made gifts. At one point, Dr. Frederick Middlebush, a former president of the University of Missouri, handed Professor Stoerker a check for $10,000. By 1966 the fund exceeded $85,000, and a committee went to see the state park board. The board agreed to accept the proposed park provided the citizens group could raise a total of $175,000 to match another $175,000 the board would seek from the federal Land and Water Conservation Fund to acquire the needed land. Although such arrangements rarely work out exactly as planned, the memorial park association donated more than 1,100 acres to the state during 1967 and 1968, and the state purchased several hundred acres in addition.

Public use of the area increased after the initial acquisitions were completed and the state park became official. On April 10, 1974, at a celebration of the fiftieth anniversary of the state park system, Gov. Christopher Bond dedicated a stone monument and plaque at the park in "appreciation to the Rock Bridge Memorial Park Association, Inc., and the Columbia community" and "in memory of Carol Stoerker." Piece by piece the park has been expanded until by 1990 it totaled more than 2,200 acres.

Next to the famous bridge itself and only a short distance from it, the outstanding geologic feature of the park is a precipitous entrance to a steep, rocky chasm known as the Devil's Icebox.

A boardwalk now starts at the natural bridge, leads to the icebox (a sinkhole that has collapsed into the cave), and then descends into it by sturdy plank steps installed by the parks division to prevent damage to the fragile plant life that clings to the rock walls. At the bottom is an entrance into the cave system, and in midsummer one perceives at once whence the name *icebox* derived. The cave stream runs by, accompanied by a steady flow of chilling air. The cave has been determined by explorers, in 1926 and later, to extend over three miles along its main channel, making it the sixth longest cave in Missouri. And there are lengthy side channels, or tributaries, several miles of them mapped. Since the cave can be entered from this point only by boat, through places where the water is nine feet or deeper and other places where passengers must lie prone to clear a low ceiling, only experienced cavers are allowed to enter by themselves. From time to time the park staff or approved volunteer leaders conduct "wild cave tours" for novice spelunkers, taking no more than eight or twelve persons at a time, two per canoe.

No entrance to Devil's Icebox is allowed at all from April 1 through August 31 to prevent disturbance of a maternal population of the endangered gray bat when the flying mammals are rearing their young. Other species that use the cave are the big brown bat, the little brown bat, the eastern pipistrelle, and the endangered Indiana bat. A small flatworm, the pink planaria, is known from no other place in the world. Other species present but not unique to Devil's Icebox or this area include marbled and dark-sided salamanders,

Spelunkers explore the deep haunts of Devil's Icebox Cave on expeditions led during fall and winter by trained park staff. SCOTT SCHULTE

many insects, spiders, and a variety of small aquatic amphipods and isopods.

The mouth where the Devil's Icebox stream emerges into the large canyon—really a collapsed portion of the cave—between the icebox and the rock bridge is known as Connor's Cave. Visitors may enter Connor's Cave at any season, but one hundred feet into the hillside it becomes impassable. If this tunnel were larger, Connor's Cave would also be a rock bridge, extending from the collapse canyon to the icebox. If these karst features seem complex, a visit will make them obvious.

Another cave of legend in the park is Polly's Pot, named for a man named Polly who was the first to explore it. Not marked on any map given to park visitors, it appears on the surface as a small opening to a vertical shaft forty feet deep. A permit is required to enter it, and few do because of the physical effort required to rappel down the narrow shaft and climb back out. The park management keeps an iron gate locked over the opening to prevent an unwary hiker from falling into it—and disappearing like Alice into Wonderland. Even if the unlucky tumbler were able to bounce up unhurt as Alice did after her free-fall, she would find a limited wonderland to explore—a cavern about a quarter-mile long—unless she nibbled a mushroom and became very tiny. Water leaving Polly's Pot has been traced to Devil's Icebox, but the connecting passage is underwater and too small for ordinary humans.

The surface watershed of the underground Devil's Icebox stream is dotted with hundreds of sinkholes, funnel-like depressions resulting from the collapse of the cave roof; each sinkhole provides direct conduit into the cave system. To protect the stream and its cave life from pollution by agricultural chemicals or human wastes draining into these sinkholes, some of the watershed was acquired by the state in 1975 with the help of the Nature Conservancy. A foot trail leads visitors over part of this "sinkhole plain," where a bit of native grassland has also been restored, interesting in itself for its wildflowers and birdlife.

Mid-Missouri forest is trying to restore itself in the hills and stream valleys, but it will take a long time. To help protect the stream and the bottomland forest, limestone bluffs, and wooded hills along its course, over 700 acres in the eastern end of the park have been designated the Gans Creek Wild Area. It is a delightful place for

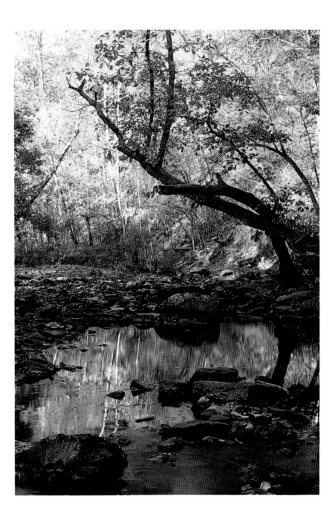

Gans Creek reflects autumn's glory as it flows languidly through the wild area. TOM NAGEL

hiking, birding, and botanizing, or even cross-country skiing along a high ridge.

A picnic shelter and many picnic sites are available at the park, and an original log house has been renovated for a children's playhouse. Here and there in the park are sites of other cabins or barns, some marked with interpretive signs. A visitor center is planned, with an exhibit area, classroom space for programs or field trips, and a staging area for caving expeditions and naturalist-led hikes. Only primitive camping is permitted in the park, and that only by reservation in advance with the superintendent.

To an extent that early visitors to the icebox and even citizens who contributed their dollars for the park in the 1960s could scarcely have imagined, Columbia has sprawled its way southward in recent decades. Rock Bridge Memorial State Park has become an island of green in a sea of urbanization, and a welcome reminder of what this northern Ozark Border area once was.

A boardwalk provides access to Devil's Icebox while protecting both people and vegetation. TOM NAGEL

Jewell Cemetery State Historic Site

J UST SOUTH OF COLUMBIA is a small cemetery where Missouri's twenty-second governor is buried, along with the founder of William Jewell College. The site is bordered by a low stone wall with an iron gate. The cemetery was once part of the estate of George Jewell, who founded one of Missouri's early dynasties. In 1841 he deeded the cemetery to his son William and grandson Thomas, and more than forty descendants of George Jewell are buried there. A plaque on the gate reminds visitors that only Jewell kin are to be buried within. The most noteworthy are William Jewell and Charles Hardin.

William Jewell (1789–1852) was a man of many parts: physician, politician, reformer, architect, and ordained minister. As mayor of Columbia, Jewell pushed for surveying and paving the city's streets. As a minister, he helped establish the first church in early Columbia. As a state legislator, he worked for prison reforms and more humane punishments and, in 1833, for a bill establishing Columbia College—part of an effort by the citizens of Columbia to obtain the state university. He later chaired a committee to raise subscriptions for the university and himself pledged $1,800 to the fund.

Deeply committed to education, Jewell contributed $10,000—provided the Baptist Church would pledge $16,000—for the establishment of a Baptist college. He was joined in this endeavor by, among others, Waltus Watkins of Watkins Mill (now a state historic site) and the Reverend Robert James, Frank and Jesse's father. The college in Liberty, Missouri, chartered in 1849, was named for Jewell; as an architect, he took charge of its construction until his death.

One of the early graduates of William Jewell College was William's nephew Charles Henry Hardin (1820–1892), who obtained his law degree there. Hardin practiced law in Fulton, whence he was elected to the Missouri legislature—first to the house of representatives and later to the senate. At the outbreak of the Civil War, Hardin, a Constitutional Unionist, introduced in the senate a successful amendment intended to prevent a precipitous decision in favor of secession, and then he returned to his farm near Mexico in Audrain County. But in 1872 he returned to the senate, part of the Democratic resurgence in postwar Missouri, and in the fall of 1874 he was elected governor, having previously defeated ex-Confederate Brig. Gen. Francis M. Cockrell for the Democratic nomination.

Like his uncle William Jewell an advocate of education, Charles Hardin founded Hardin College for women in Mexico, to which he contributed some $80,000, and in 1889 he led the fundraising campaign for the establishment of the Missouri Military Academy in Mexico. He earned his right to burial in the cemetery through his mother, a daughter of George Jewell.

Jewell Cemetery came under state management in 1970, after the state legislature in 1967 mandated the state park board to "suitably mark and maintain every grave of a former governor of this state, which is not within a perpetual care cemetery." In addition to Dunklin's Grave and Sappington Cemetery, which like Jewell are state historic sites, the parks division also has a program to mark with plaques all governors' graves in the state and even out-of-state (there are two governors' graves in California).

Jewell Cemetery is a tiny remnant of the nineteenth century amid the late twentieth-century

*The Jewell family cemetery, resting place of Gov.
Charles Hardin, harks back to the nineteenth
century.* OLIVER SCHUCHARD

sprawl south of Columbia, regrettably now sand-
wiched between a major roadway and a trailer
park. But within its stone walls the site retains
its integrity. The earliest grave dates from 1822,
the most recent from 1968.

At the back of the cemetery are about twenty
unlettered but neatly quarried blocks of native
limestone, presumably markers for the graves of
slaves belonging to members of the Jewell family;
if so, they are an intriguing exception to the re-
striction noted on the plaque on the gate that
burial be limited to Jewell kin. Burying slaves
with their masters was not a common nine-
teenth-century practice. Perhaps these stones are
bearing mute testimony today to the humanitar-
ian ideals of William Jewell.

Finger Lakes State Park

"Mr. Peabody's coal train done hauled it away."

—John Prine

NO DOUBT THERE ARE visitors to Finger Lakes State Park who do not recognize this area, just north of Columbia, as a man-made landscape. Several decades have passed since the last Peabody Coal Company shovel ripped up the northern Boone County overburden to reach the coal measures below. There has been some recovery, both from natural seeding and from man-assisted replanting. Still, the rugged terrain—steep ridges and deep ravines, many of which are water-filled—is the telltale aftermath of a resource-extraction process known simply as strip-mining.

Neutrality is an elusive posture when the subject of strip-mining comes up. Everyone recognizes coal as our most important and most abundant fossil fuel. Its extraction, whether by shaft mining or strip-mining, has always been accompanied by controversy: cave-ins, black lung, black water, denuded hillsides. There are now several laws, federal and state, that regulate this vital industry, laws to protect the miners and laws to protect the environment.

Most of northern and western Missouri is underlain by coal deposits; indeed, Missouri ranks among the top ten states in the quantity of its coal reserves. The coal occurs in lenses interbedded with shales, sandstones, and limestones dating back in time to the Pennsylvanian period, when large, salamander-like amphibians and early reptiles were the dominant land creatures.

Although these coal lenses or beds are not as massive or of as high a quality as those found in some states to the east and west, coal mining has been an important industry in Missouri.

In just a little more than three years, beginning in 1964, the Peabody company removed some 1.2 million tons of coal from its Mark Twain Mine. This mine tapped into one of Missouri's major coalfields—one that stretches from western Callaway County northwest across Boone, Howard, Randolph, and Macon counties. After ceasing its mining, Peabody undertook some initial reclamation, planting the barren piles of waste and stocking some water-filled pits as fishing lakes.

In the early 1970s the U.S. Department of the Interior undertook to identify strip-mine areas with potential as "reclamation for recreation" projects. The Mark Twain Mine was considered a good candidate. In 1973, the Peabody company donated most of the present park's 1,100 acres to the state of Missouri. And federal matching funds were obtained to develop the new park as a demonstration project.

The park will never make it as a "natural area" like nearby Rock Bridge Memorial State Park, but as a recreation area Finger Lakes is a real success. The lakes offer good fishing, one area has been developed as a swimming beach with a changing house—the most popular swimming hole in the Columbia area—and several of the finger lakes in the eastern half of the park have been connected to form a canoe trail of about a mile and a half. A campground has been developed at the north end of the park.

But the real measure of the park's popularity lies in its use for motorcycles of the "dirt-bike" variety. Some seventy miles of rugged motorcycle

Dirt bikes tear up the tailings at Finger Lakes.
OLIVER SCHUCHARD

*The beach at Finger Lakes State Park is one of the
most popular swimming holes around.*
GAYLE MOONEY

trails have been developed across the old mine
spoils. Close to Highway 63 in the western part
of the park, bike riders and state park planners
have developed a "motocross" course. This area
is host to numerous events drawing riders, pro-
fessional and amateur, from all over the country.
In many places and to many people, off-road ve-
hicles are themselves quite controversial. Perhaps
it is fitting, then, that this lively sport has found
a home in a park born of controversy over strip-
mining. Here motorcycle and all-terrain-vehicle
enthusiasts can enjoy the use of a challenging
landscape without harming some fragile, natural
setting. Perhaps other, more natural parks are less
pressured as a result.

All in all, Finger Lakes State Park represents a
creative and successful recycling project. Lying
on the sandy beach after a swim, almost uncon-
sciously a visitor realizes that the background
music one hears is the whining drone of the
small-engined dirt bikes, modulating in pitch as
they alternately climb and descend the hilly mo-
tocross track a few ridges away. One can't help
but make a mental comparison with the giant
shovels that roamed this landscape thirty years
ago, the roar of their great diesel engines rever-
berating as they lifted dirt and rock and scooped
the rich black coal into waiting trucks.

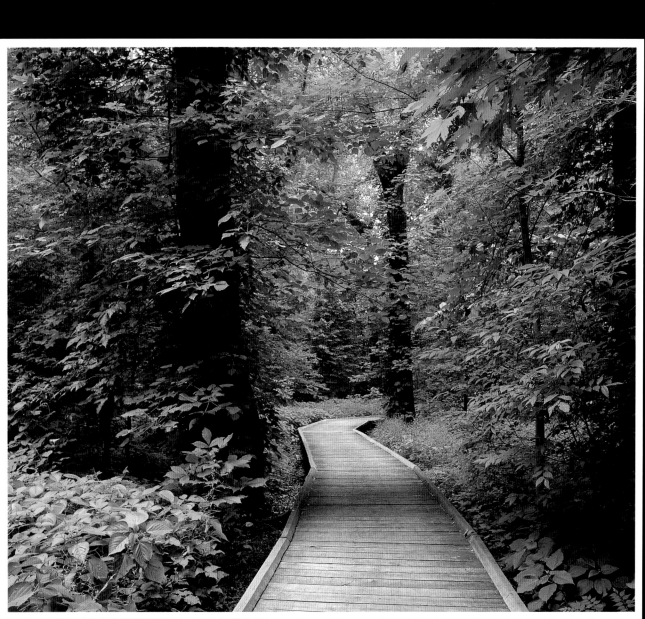

The magnificent swamp forests of the Mississippi Lowlands have been reduced to a tiny remnant at Big Oak Tree State Park. OLIVER SCHUCHARD

Introduction

THE MISSISSIPPI LOWLANDS division in extreme southeastern Missouri is a flat, alluvial plain shaped by outwash from the great glaciers. At one time—more than sixty million years ago—part of the Mississippi Embayment, an extension of the Gulf of Mexico, the region today is the northernmost extension of the Gulf Coastal Plain and harbors many species characteristic of that region. Clearly set off from the Ozarks and the Ozark Border to the west and north by an escarpment one hundred to two hundred and fifty feet high, this is the most distinctive region of Missouri, culturally as well as physiographically and biologically.

The natural vegetation that occupied this flat region less than two centuries ago was unlike any found elsewhere in the state. Imagine a vast, jungle-like forest of giant oaks, ancient bald cypress swamps, and impenetrable thickets of giant cane stretching five hundred miles southward to the gulf coast. The massive glacial outwash that shaped this landscape during more than a million years carried in its waters silts ground fine by thousands of miles of braided channels, then carried aloft by strong winds to create sand dunes and ridges. Even after the glaciers retreated, floodwaters from the Mississippi and from rivers draining the southeastern Ozarks continued to nourish the landscape. Though interrupted by north-south-trending sandy ridges elevated only a few feet above the surrounding terrain, most of the lowlands were swampy, bathed in nutrient-rich floodwaters much of the year. The resulting elm and sweet gum, bald cypress and tupelo gum, and oak and hardwood forests were botanically diverse, containing many species at the northern or western limits of their range, and they were extremely productive for wildlife.

The region is distinctive also in having been the most thoroughly altered by human beings—through deforestation, ditching, and draining—with most of the alteration occurring in the past hundred years. Because it has undergone such rapid transformation in the twentieth century, the area has had a demographic and social history quite unlike that of any other region. And, because it is unique and also so remote from most of Missouri's population, the region is certainly the least known and understood in the state.

The Mississippi Lowlands natural division has two quite distinct sections, the Lowlands themselves, poorly drained and of slight relief, and Crowley's Ridge, a series of low hills that form the most prominent topographic feature. The three units of the state park system are all in the Lowlands section. We begin with Big Oak Tree State Park in Mississippi County, one of the few spots anywhere in the lowlands where one can experience the magnificent bottomland forest and bald cypress swamp that covered virtually the entire area before the headlong deforestation that began in the late nineteenth century. Not far from Big Oak Tree is Towosahgy State Historic Site, where archaeological excavations have documented a fortified ceremonial center of the town-dwelling peoples of the Mississippian tradition who occupied this area and much of the southeastern part of the country between about A.D. 1000 and 1400.

The Hunter-Dawson home in New Madrid, built in the late 1850s and occupied by the interrelated Hunter and Dawson families until the 1960s, can be taken as an evocation of the southern character of the region in the antebellum pe-

riod, but it is probably better understood as a home reflecting the lives and activities of entrepreneurial families that were deeply involved for well over a century in virtually all aspects of the stunning transformation of the Mississippi Lowlands from "swampeast" Missouri to the richest agricultural region in the state.

The Crowley's Ridge section is a northeast-trending series of hills in the western part of the region that probably once bordered an earlier channel of the Mississippi. Of great interest both geologically and biologically, and one of the earliest-settled parts of the region, this section is an obvious candidate for interpretation in a state park.

Big Oak Tree State Park

DRIVING SOUTH ON State Route 102 from East Prairie, across the billiard-table-flat farmlands of Mississippi County, it is easy to pick out the boundaries of Big Oak Tree State Park. The 1,000-acre preserve stands out as an oasis of tall trees surrounded by miles of soybeans, a living time capsule for an environment that once stretched across the entire bootheel of southeastern Missouri. Big Oak Tree is a monument both to the original forested wilderness of "swampeast" Missouri and to the dedication of citizens who wished to insure that at least some part of that once great landscape would be forever protected from logging and drainage.

One's first impression is of the height of the forest and the size of the trees. The canopy rises to a hundred and twenty feet, with some of the park's giants grabbing another twenty feet of sky. For a time in the 1960s this small park in the Missouri bootheel was home to nine reigning national champions on the American Forestry Association's roster of big trees; that is, nine trees were the largest recorded representatives of their species anywhere in the nation. Tiny Big Oak Tree State Park outranked Olympic National Park, which had seven champions on nearly a million acres, and it was in turn outranked only by Great Smoky Mountains National Park, with fifteen. Today, Big Oak Tree is the home for at least eight state champion trees, and a national champion persimmon as well. One swamp chestnut oak—near the picnic grounds at the park's entrance—has been measured at 142 feet in height, making it Missouri's tallest tree, with a crown spreading nearly a hundred feet. The circumference of this old oak is fully 21 feet. That makes it only a foot shorter and four inches less in circumference than the giant for which the park was named.

The great bur oak that gave its name to the park lived there for 396 years. Once scheduled to be cut down as a curiosity for fairgoers to the 1904 Louisiana Purchase Exposition in St. Louis, the stately tree survived another half-century before finally succumbing in 1952 to tree rot and lightning strikes. So in 1954 the giant came down; but the park it inspired and the bottomland forest in which it grew both lived on.

The big oak and all the other incipient national and state champions were found on an eighty-acre tract of virgin hardwoods that in 1937 became the object of an urgent campaign by local residents to save some remnant of their natural heritage. Reaching the front page of the *St. Louis Post-Dispatch* and other newspapers, the effort to save the big oak became a statewide crusade, even enlisting Gov. Lloyd Stark, a prominent nurseryman in private life, who fired off a telegram to the Mississippi Valley Hardwood Company of Memphis asking it not to destroy the tree. Though some doubtless thought only in terms of a single tree, many people realized that what was at stake was a part of Missouri's heritage—the magnificent swamp forest of the bootheel—that was in imminent danger of disappearing forever.

Logging had begun with a vengeance in the area as soon as railroads crisscrossed the lowlands in the 1880s. New legal mechanisms for drainage in the early twentieth century and an extraordinary cotton boom in the 1920s, when the boll weevil further south pushed large-scale production north into Missouri, resulted in the nearly complete transformation of bootheel lands

This majestic bur oak is a worthy successor to the original big oak tree for which the park was named. Tiny resurrection ferns grow along its mighty limbs, which reach as high as a hundred and twenty feet. OLIVER SCHUCHARD.

from about seventy percent "unusable" in 1907 to only three percent by 1930. But still the logging continued on the last vestiges of forest, spurred no doubt by economic pressures for liquidation during the depression years of the 1930s. The Mississippi Valley Hardwood Company and associated firms had already cut nearly three-quarters of a million acres in the area when they were asked to spare the eighty-acre tract surrounding the big oak.

Still, with the Great Depression constricting the state's finances, Missouri officials could not afford to pay $100 to $125 per acre for the key tract and sufficient cutover land surrounding it to serve as a buffer or game refuge—especially at a time when parkland in the Ozarks was being purchased for $2 to $5 per acre. The state park board and the conservation commission, with help from a private donor, Jacob Babler, agreed to split the cost of the original 80-acre tract provided local citizens could raise enough money or secure donations for a 920-acre buffer. Thus began a campaign for donations to save the big trees. Area schoolchildren contributed their small change, business leaders gave their big change; everyone wanted to help, it seemed, despite the depression. In 1938 the 1,000-acre park was dedicated.

The eighty-acre tract of virgin forest was designated a national natural landmark in 1986, and more than ninety percent of the park has been designated a state natural area in recognition of both the virgin timber and the high quality of the second-growth forest surrounding it. Very little of the Mississippi Embayment forest that once stretched from southeastern Missouri to the gulf remains. The general characteristics of the park—the poorly drained clayey soil, the dense understory, and, of course, the big trees—are so different from anything else in the park system that even casual observers find themselves wanting to know more about the local environment. A boardwalk allows even the less adventurous of us to explore these dense, damp woods and gaze, awestruck, at the towering canopy. Some find it almost spooky to be there, but even more people, probably, think of themselves as in a cathedral. (Be prepared with mosquito protection in the summertime, if you want to be able to enjoy your reverie.)

In the wetter areas, the forest is made up mostly of bald cypress with its odd-looking "knees," along with cottonwood and willow. But on the higher ground—six inches is enough to make a difference here—forest inundation is more seasonal. This periodic flooding with slow drying provides a richly diverse overstory of mixed hardwoods: shellbark hickory, pecan, slip-

Bird-watchers can catch a glimpse of some of the hundred and fifty species recorded at the park, such as this barred owl. OLIVER SCHUCHARD

pery elm, sweet gum, hackberry, persimmon, pawpaw, possumhaw, blue beech, pumpkin ash; and the great oaks: bur, shumard, overcup, and swamp chestnut. Various kinds of vines draped throughout the understory create a jungle-like setting, and colonies of resurrection fern cling to the giant trees up near the canopy. The fern is only one of the epiphytes—plants that grow on other plants without parasitizing their hosts—found in Big Oak Tree; bittersweet is also apparent, and pretty, in the fall.

Giant cane, a common species of tall grass on the forest floor, has such an affinity for its own kind that it forms thickets, or canebrakes. It was here, amid the canebrakes, that one of Missouri's rarest birds, the Swainson's warbler, was last known to nest in the late 1970s.

Bird-watchers from all over the country visit Big Oak Tree to record some of its more than a hundred and fifty known species, including several rare in Missouri. The chirp of the hooded warbler is hard to describe but easy to remember, and the bird's bright yellow plumage makes it easier to spot than some other warblers. The woods are sometimes pierced by a loud "cuh-cuh" from the blackfish crow, a species usually found along the Atlantic and Gulf coasts. And, high overhead, you might see the Mississippi kite gathering a meal of insects on the wing. This rare bird was seen nesting in the park in 1990. More common species include the prothonotary warbler, pileated woodpecker, rose-breasted grosbeak,

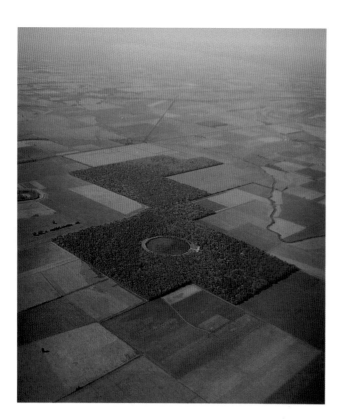

Big Oak Tree State Park lies adrift in a vast agricultural sea like Noah's Ark, crowded with native species seeking refuge. An artificial lake, altered water cycles, runoffs of silt and pesticides, and dying oaks are symptomatic of the now-isolated ark's decay.
Greg Henson

wintering bald eagle, and a host of waterfowl.

For all its marvels, Big Oak Tree State Park today is an endangered landscape, just as it was in the 1930s. Many of the park's oaks are growing older and dying, with virtually no young ones to replace them. The Swainson's warbler has disappeared from the canebrakes, though no one seems to know why. The park's original open marshy lake, known as Grassy Pond, is now an unhealthy thicket of dying cottonwoods and black willows. On the fringes of this now-obscured lake are still-living massive bald cypress trees, these too now being hidden by a young growth of willows, red maples, and sugarberries. As the bald cypress trees die, only these thickets will be there to replace them. A new park interpretive center, imaginatively designed like a tree house, explains not only the natural forest and swamp ecosystem that once existed throughout the southeastern lowlands, but also what threatens the health of that ecosystem in the park today.

Unaware of the potential consequences, in 1959 park officials agreed to build an artificial lake in the heart of the swamp for fishing. The consequence was destruction of a biologically rich natural bayou that provided food, shelter, and nesting for many wetland plants and animals. Another, more ironic consequence is that the best fishing today is not in the lake but in borrow pits all around it. Compounding the problem, officials further agreed to build a drainage ditch through the swamp because some adjacent farmland became flooded when water levels were high. Beavers dammed the ditch, but park officials obligingly dynamited the dams. In the 1980s, however, park scientists observed that the swamp was dry for most of nearly every year, owing to the disruption of natural flood cycles by the drainage canals circling and bisecting the park. They stopped the dynamiting, offering instead to buy the affected farmland—though farmers were not eager to sell. And they initiated studies to determine whether different water cycles might encourage regeneration of oaks.

The magnificent forest at Big Oak Tree is dying, and extraordinary measures must be taken soon to resuscitate it: more land, a more natural flood cycle, less pollution. Those children who worked so hard to save the big oak trees from annihilation in the 1930s may today as adults decide whether to save the very swamp-forest ecosystem in which those oaks were born.

Towosahgy State Historic Site

ALTHOUGH THE Mississippi River now flows some three miles to the east, the great "Father of Waters" once passed within a few hundred yards of Towosahgy State Historic Site. The ancient Indian village was situated on a sand ridge—Pinhook Ridge—in the gooseneck of a now-abandoned oxbow in what is known today as the New Madrid Floodway. The river provided both fish and game as well as water and a transportation artery for the original inhabitants. The sand ridge kept their buildings above the level of most floods, and the broad fertile floodplain was ideal for raising crops. The people who lived here would have known a monumental swamp forest of sweet gum, cypress, and sycamore like that at Big Oak Tree, with occasional sand prairies along the ridges, but they must have done considerable clearing or burning as well—precursors in taming the Bootheel for agriculture.

Towosahgy—the name is an Osage Indian word for "Old Town"—was a thriving village up to about A.D. 1400. The builders of the town were part of the sophisticated Mississippian cultural tradition that spread up and down the river from its center, the great ceremonial city at Cahokia, Illinois. These were urban dwellers, and their fortified (walled) towns were scattered as far north as Wisconsin and as far south as the mouth of the Arkansas River, also east as far as Georgia and west to Oklahoma. But most of these Mississippian sites have been destroyed or severely altered—by the river itself or by modern agriculture or other developments. At Towosahgy a premier remnant of this important phase of Missouri's history is preserved.

To the untrained eye, there is not a great deal to see at Towosahgy. Seven mounds, six of which surround a central plaza, are clearly visible and impressive. The visitor will also notice the borrow pits from which the mound dirt was removed, all by hand labor. The larger ceremonial mound on the north end of the plaza measures 250 feet by 180 feet and rises some 16 feet. Archaeologists tell us that hundreds of houses once stood within the town: wood and cane structures plastered with clay, their thatched roofs supported by as many as five center posts. A stockade with a moat protected the community on three sides, with the oxbow on the fourth.

The Mississippian people practiced a communal life-style. They raised crops of beans, maize, squash, and sunflowers in fields outside the village walls. To this diet they added wild game, fish, river mussels, persimmons, wild plums, and a variety of nuts. A trade network allowed them to obtain other necessary items: salt, paint, chert for tools, and ceremonial materials. Large dugout canoes provided much of the transportation.

The site was known for years as "Beckwith's Fort," after the property's owner at the time of the first recorded scientific investigations by Cyrus Thomas of the Smithsonian in 1891. Despite its use for agriculture, which had obliterated surface evidence of the stockade, the "fort" was one of the best preserved Mississippian fortified sites in the region when, in 1967, the park board purchased a sixty-one-acre tract and began limited archaeological investigations in cooperation with the University of Missouri-Columbia. Excavations revealed ceremonial structures on top of the large mound and evidence of three or four stockades in succession along the fortification line. Three bastions or watchtowers were uncov-

Today a humble hill, this largest of Towosahgy's mounds was a focus of sophisticated ceremonies by Indians of the Mississippian tradition until about A.D. 1420. OLIVER SCHUCHARD

ered, and two on one line suggested they were spaced about every one hundred feet. Excavations on five different houses indicated that the floors of the structures were below the level of the ground, and the walls were formed by posts placed in narrow trenches.

After a long period without excavations from 1974 to 1988, during which the site was closed to the public, investigations were resumed in 1988 preparatory to developing the site for public visitation. This time, excavations at the north end of the fortification line revealed a wide moat outside the stockade and evidence of *five* sequential stockade lines. Most exciting, though, were excavations of the entire depth of deposits at the front of the large mound, which revealed a much longer period of occupancy than had previously been thought; instead of four hundred years, from about A.D. 1000 to 1400, radiocarbon dates now indicate that the mound was utilized for more than one thousand years, from about A.D. 400 to 1420. Numerous ceremonial items were uncovered indicative of the high status of individuals associated with the mound—mica, fluorite, and quartz crystals, crinoid-stem beads, earplugs and an earspool, a red-painted elbow pipe, and fragments of carefully decorated water bottles and effigy vessels. When the village was abandoned, it was apparently not a quick or desperate action. The temples were destroyed, pushed down the front of the mound, and very carefully capped with a thick deposit of clay. Was the material so sacred that the Indians didn't want anyone tampering with it, and were they perhaps intent upon returning one day?

One discovery was of special interest to seismologists interested in earthquake history along the New Madrid fault. Fissures were found where white sand from below had been blown into the brown sand above, indicative of a strong quake in the fourth century A.D. and perhaps another in the period A.D. 400–900.

Plans for development of the site call for construction of a service building and residence for a full-time site administrator, and some reconstruction of a small part of the stockade line and at least one house, so visitors will be better able to visualize the village that once was. There is always a fine line between the responsibility to preserve the site and the desire to glean more information, but there will probably be some ad-

This 1971 excavation revealed the rectangular pattern of a small house near the stockade that enclosed the village. Two different periods of stockade construction located in earlier excavations are marked by colored posts. JOHN COTTIER

Excavations at the front of the large mound in 1989 revealed dramatic evidence of prehistoric earthquakes along the New Madrid fault—fissures (like the one running diagonally across the upper right) where white sand from below had been blown up into darker deposits more than a thousand years ago. JAMES E. PRICE

ditional investigation and, one day, an interpretive center for visitors. Towosahgy has secrets yet to reveal, and others to keep.

The Hunter and Dawson families who lived in this handsome antebellum home in New Madrid from the eve of the Civil War until the 1950s helped to shape the stunning transformation of the Mississippi Lowlands. OLIVER SCHUCHARD

Hunter-Dawson State Historic Site

THE HUNTER-DAWSON HOME in New Madrid reminds us that Missouri, a border state with mostly upper South affinities, also had many ties with the deeper delta South. Featuring bald cypress lumber from nearby swamp forests, this fifteen-room mansion was built in 1859–1860 by William Washington Hunter, a fifty-two-year-old successful Bootheel businessman. Although Hunter died before the house was completed, his widow, Amanda Watson Hunter, and her seven children moved in just prior to the outbreak of the Civil War. In 1876, the house passed to Ella Hunter and her husband of two years, William W. Dawson. It remained in the Dawson family until it passed to the city of New Madrid in 1966 and then in 1967 to the state.

The frame house was built by the combined labor of Hunter's own slaves and hired craftsmen. It displays traces of many architectural traditions—most notable are Georgian, Greek Revival, and Italianate influences. The house features nine fireplaces, family and formal dining rooms, a kitchen, seven bedrooms, a sun-room, a sitting room, and double formal parlors. Hunter also built the grain house and privy that remain on the present seventeen-acre site. Mrs. Hunter selected most of the furnishings in the spring of 1860, according to records in the family papers. Much of this furniture, which came from the Cincinnati company of Mitchell and Rammelsberg, may still be viewed in the home.

The grounds feature many large trees typical of the Bootheel. Oaks, gums, elms, and pecans grace the estate, many of which were present long before Hunter began construction of the house. The site boasts the state champion sweet gum and cherry bark oak and at least a dozen other huge oaks.

Without knowing something about the people who lived there, historic houses seem little more than empty shells. The Hunter and Dawson family stories breathe life into the old mansion, for these were families intimately associated for more than a century and a half with virtually all aspects of the development of the southeastern lowlands of Missouri. William Washington Hunter came to New Madrid in 1830 from Washington County, Missouri, where his parents had settled six years earlier after leaving their native Virginia. He went to work in a fur-trading post and mercantile store owned by Robert Goah Watson, and he rose quickly as a merchant; his success was no doubt aided when he married the boss's daughter, Amanda Jane, in 1836. Amanda's father had been born in Scotland but came to America to work for his uncle, who in 1805 sent him to New Madrid to operate his Indian trading post. The New Madrid earthquakes of 1811–1812 devastated the area and most of the residents fled, never to return, but Robert and his wife stayed to rebuild their business. After Watson's death in 1855, William Hunter and Amanda's brother continued the business in partnership.

With his own brother, A. S. Hunter, William established a general mercantile store, the Crystal Palace, where the latest products could be purchased hot off the most recently arrived steamboat. He also entered into partnership with R. B. Turner for the trade of dry goods, produce, and furs from their steamboat on the Mississippi River. And along St. John's Bayou, east of New Madrid, he operated Hunter Mill Farm, a steam-run saw and gristmill. This was where much of the cypress for his home was milled.

William Hunter combined his business dealings with an interest in civic matters, and in 1855 he helped organize the Dunklin and Pemiscot Road Company, which constructed a plank road through the swamps to settlements further south in the Bootheel. A friend of Stephen Austin, probably from his Washington County years, he had encouraged the early settlement of Texas, where he acquired land holdings. When he died in 1859, Hunter owned at least fifteen thousand acres in Missouri, Arkansas, and Texas. He also owned thirty-two slaves, who were inherited by his widow and seven children in the division of his estate.

During the Civil War, after William died and Amanda and the children moved into the house, local folk history maintains, Union forces under Maj. Gen. John Pope forced the Hunter family from its two-year-old home so that it might serve as a military headquarters. Control of the Mississippi River was key to both sides' strategies during the war, and New Madrid and nearby Island No. 10 were scenes of battle during the conflict. Amanda's son William Colson Hunter, along with many other local men (including William Dawson's father), joined the Confederate forces.

William Dawson married Amanda Hunter's daughter Ella in the house on Christmas Eve in 1874; when they moved into it in 1876 after Amanda's death, they brought another distinguished lineage into association with this storied mansion. Dawson's great-grandfather on his mother's side, Pierre Antoine Laforge, came to New Madrid in 1791 just after the community was founded in Spanish Louisiana; he served as an interpreter and, after the Louisiana Purchase, as civil commandant and judge of the court of common pleas. His grandfather on his father's side, Dr. Robert Doyne Dawson, was a physician and lawyer who came to New Madrid from Maryland in 1800 to represent a client who had several Spanish land grants. He served in both the territorial and state legislatures and represented New Madrid at Missouri's constitutional convention in 1820; with his wife's brother, John H. Walker, he helped to assure that the "bootheel," where Walker grazed thousands of cattle, was included as part of Missouri.

William Dawson, educated at Christian Brothers College in St. Louis, followed in his grandfather's footsteps by serving three terms in the Missouri General Assembly, from 1878 to 1884, when he was elected to the United States Congress for one term. Despite continuing agricultural interests, he served also in other civic capacities and, beginning in 1914, for three terms as circuit clerk of New Madrid County. He was

Many of the furnishings originally selected by Amanda Hunter in 1860 for her new home, like this ornate, half-canopy Mitchell and Rammelsberg bed, were still in the home when it became a state historic site. NICK DECKER

succeeded in that office by his daughter, Lillian, whom he trained. His son, William Dawson, Jr., was involved in agriculture all his life, but he also served for more than twenty years as cashier of Hunter's Bank and in 1933 became owner of the New Madrid Oil Company. A bachelor, he lived with his mother in the house after his father's death in 1929, and then was joined by his sister Lillian after their mother's death in 1933.

William died in 1956, and Lillian not until 1975; but as early as 1960 efforts had begun to interest the state park board in acquiring the house as a state historic site. Then in 1966 the city of New Madrid bought the decaying old home for $15,000, with many of Amanda Watson Hunter's 1860 furnishings still intact, and a year later donated it to the state. City officials were undoubtedly encouraged by state park director Lee C. Fine, who had grown up just down the street from the stately old mansion and who was distantly related to the Hunter family.

A bare-bones summation can scarcely suggest the manifold connections these remarkable families—and their equally remarkable home—had with the settlement and development of the Mississippi Lowlands from Spanish times to our own, and more remains to be discovered through additional historical research. The Hunter-Dawson home, beautifully restored to the 1860–1880 period, reflects the success of the earlier generations and carries their tradition proudly into the twentieth century.

Although the Missouri River has been channelized along its entire course through the state, its valley is still a dramatic landscape of bluffs and bottomlands now accessible via the Katy Trail. JAMES M. DENNY

Introduction

AMONG THE MOST ALTERED but also most important and characteristic of Missouri's presettlement landscapes is the Big Rivers natural division. Comprising only about five percent of the state, the division is defined as the floodplains and terraces of the largest rivers, especially the Mississippi and Missouri but also the lower portions of the Des Moines and the Grand. These floodplains, with their bottomland forests, wet prairies, sloughs and marshes, islands, and sand and mud bars, have been severely diminished during the course of the twentieth century by upstream damming, diking, and dredging to deepen, narrow, and stabilize the main channels for commercial barge navigation and flood control, largely under the auspices of the U.S. Army Corps of Engineers.

On the Missouri, for example, scientists have calculated that fifty percent of the original surface area of the river within the boundaries of Missouri was lost between 1879 and 1972, that the island area was reduced by ninety percent, that some fifty miles of river length were removed by straightening, and that most backwater habitat was eliminated as the margins silted in and accreted, both physically and legally, to the mainland, where they were placed under plow by the owners of the adjoining land. Fisheries were devastated, with an eighty percent decline in the commercial harvest between 1947 and 1963 alone, and wildlife has been greatly diminished, with several species virtually eliminated.

Above St. Louis, the Mississippi river has been turned into a series of slack-water pools by the addition of locks and dams, leaving more backwater areas but also creating problems with dredge spoil and shifting water levels. Below St. Louis, and to some extent above, the Mississippi channel has been greatly constricted by floodwalls and agricultural and industrial levees, so that the natural vegetation and the normal cycles of flooding, silting, and drying have been drastically altered, with serious consequences to both natural habitats and man-made structures when levees are breached or overtopped.

As a result, very little natural habitat remains along the big rivers, and what little there is, with several notable exceptions, is poorly represented in the state park system. Until the early 1970s, most Missourians turned their backs on the big rivers, regarding them as barge canals or, worse, as open sewers, the river margins often invisible behind levees or floodwalls or desecrated by urban blight. Even those who realized what had happened, and who cared, regarded the situation as too hopeless for amelioration. But finally, during the 1970s, with a heightened level of environmental awareness in the wake of the first Earth Day and with creative and determined leadership by citizen organizations and some agency professionals, public opinion concerning the rivers began slowly to turn around, and even the corps of engineers began to show interest in working with the state to mitigate some of the damage. Since then, the state departments of conservation and natural resources and various federal agencies have been restoring water quality and fish and wildlife habitat along the rivers. But there is still need for the special management and interpretation mission of the parks division, and it is to be hoped that appropriate sites featuring bottomland forest, wet prairie, and other riverine landscapes will be acquired for new state parks along the margins of the big rivers.

If the natural features along the floodplains and terraces of the big rivers have been severely altered and are underrepresented in the park system, the same is not true of the cultural features. In fact, the state has quite a string of historically significant parks and sites along the big rivers—most of them, to be sure, beyond the bounds of the Big Rivers natural division as physiographically and biologically defined, but still close enough to be considered here. It is perplexing that most social and cultural scholars who have attempted to delineate regions in Missouri have not identified the big rivers as a distinctive area. Yet most everyone recognizes the vital role played by the rivers in channeling transportation and settlement in the state, especially during the nineteenth century. Thus our consideration here includes key communities and other sites—many of which by natural criteria might be classified as part of the Ozark Border or the Glaciated Plains division—that have been influenced in a significant way by their proximity to the big rivers. Paradoxically, many of these sites still retain a measure of their integrity because they were left in the backwater of a century and a half of progress in transportation—by rail, highway, and air—that took the pressure of development off the cultural borders of the big rivers even while intensifying destruction of the natural channels in a futile effort to compete.

The Big Rivers division logically segments into Mississippi and Missouri River sections—and, especially if one is focusing on physical characteristics and presettlement vegetation, on lower and upper sections of each.

We begin on the lower Mississippi at Trail of Tears State Park in Cape Girardeau County. Commemorating one of the most tragic episodes in Indian-white relations, the expulsion and forced march of some thirteen thousand Cherokee from Georgia across the Mississippi (here at Moccasin Springs) to Indian country in the Oklahoma territory during the devastating winter of 1838–1839, Trail of Tears State Park is also a sizable, quite wild representation of the rich upland forest along the Mississippi, together with bottomland habitat along Indian Creek. Traveling upstream, we arrive next at the Felix Vallé House State Historic Site. Though located in Ste. Genevieve, which was established about 1750 as the earliest permanent French settlement on the west bank of the Mississippi, the house was built by a Jewish merchant in the Federal style and purchased by the Vallé family. It is interpreted to show the successful transition of this prominent French family into an American milieu during the nineteenth century.

Further upstream at Herculaneum, on a high bluff overlooking the Mississippi, is Gov. Daniel Dunklin's grave, a tiny one-acre site that invites consideration not only of the state's fifth governor but also of the fascinating role of these bluffs in the manufacture of lead shot by Moses Austin and other early American entrepreneurs. In St. Louis, rampant urbanization and, more recently, massive land clearance for the city's celebratory arch have obliterated most of the early historic structures along the waterfront. But in this great river city, with its complex cultural and architectural history, the state has recently restored and dedicated the house where the "king of ragtime," Scott Joplin, lived and composed some of his best-known works around the turn of the twentieth century.

Continuing to the upper Mississippi River, above its junction with the Missouri, we stop at Wakonda, a park on the river floodplain where gravel was mined by the state highway department between 1924 and the early 1980s, forming pretty little fishing and swimming lakes for recreationists and a surprise for ecologists. Finally, overlooking the lower Des Moines River in the far northeastern corner of the state is Battle of Athens State Historic Site, locus of the northernmost battle of the Civil War, but equally significant for containing the entire street grid and several structures of an antebellum river town entirely within the bounds of the site.

Some miles southeast of Athens, along an old slough of the Des Moines River, archaeologists have recently discovered the site of an Illinois Indian village that may have been one described by Marquette and Jolliet on their exploration of the Mississippi in 1673. The Illinois were the dominant tribe in northeastern Missouri, so the state plans to develop a new historic site here.

If the Mississippi River section of the Big Rivers natural division is represented by rather disparate parks, none of which focuses primarily on the riverine environment, the Missouri River section, especially in its upper reaches, has several parks that do focus on river ecology. And in its lower reaches, where high-quality natural areas are scarce, the new Katy Trail following the river for 170 miles provides a marvelous linear connection for a series of significant historic and cultural sites, as well as a passing glimpse at various features of the natural scene, some of which call out for acquisition, restoration, and interpretation as part of the state park system.

We begin with the Katy Trail, a railroad right-of-way along the north bank of the river starting at Machens, just downstream from St. Charles, and continuing upstream to Boonville before

striking off through the Ozark Border and a segment of the Osage Plains to Sedalia and Clinton, at more than 230 miles in total length far and away the longest such rail-to-trail conversion in the nation—and, because it follows the lower Missouri for much of its length, probably also the most historic. In our consideration of individual state parks and historic sites along the Missouri, we then return to St. Charles, site of Missouri's first state capitol, which occupied the upper floors of a row of commercial buildings along the riverfront for several years in the 1820s. Next upstream is Deutschheim, commemorating the German heritage of settlers in Hermann beginning about 1838. And then Jefferson City, the state capital since 1826, where three restored buildings on the old Jefferson Landing evoke the commercial vitality of the Missouri waterway during the steamboat era in the mid-nineteenth century. The parks division also maintains the capitol grounds, operates the Missouri State Museum, and offers guided tours of the state's impressive capitol building with its treasure trove of public art.

About seventy miles further upstream is a cluster of related sites: Boone's Lick, the salt springs on a tributary stream north of the river where Daniel Boone's sons manufactured salt beginning about 1806; Arrow Rock across the river, a thriving mid-nineteenth-century town that was associated for a time with the Santa Fe trade and later was a political powerhouse of southern gentry, where the state has restored and interprets several buildings including the courthouse, the Huston Tavern, and the home of artist George Caleb Bingham; and Sappington Cemetery several miles west, burial place of Dr. John Sappington of Arrow Rock and his extended family, including two Missouri governors.

The dividing point between the lower and the upper Missouri River sections in the state is near Glasgow in northwestern Howard County, above which the floodplain is less constricted (owing to softer, more easily eroded bedrock of Pennsylvanian age) and prairie was more prevalent in the presettlement landscape. This is also the approximate boundary between the Missouri River section of the Ozark Border natural division and the Glaciated Plains to the west and north. The first

state park upstream from this juncture is Van Meter, the site during the seventeenth and eighteenth centuries of the principal village of the Missouri Indians, after whom the state was named. Though most of the park is on the uplands, the approach to it is across the broad Missouri floodplain, and the magnificent upland hardwood forests testify to the rich loessial soils formed from silts picked up from the glaciated plains to the west and deposited in thick mounds here along the river. At the base of these bluffs, a small relict of the once-expansive wetland marshes of the Missouri still exists in the floodplain.

Continuing upstream, we arrive at Lexington, the site of a major victory of the Missouri State Guard on behalf of the Confederate cause during the first summer of the Civil War, as Union troops for a time failed to control the vital Missouri River artery. And south of the river a few miles, near Higginsville, is Confederate Memorial State Historic Site, a cemetery and park on the grounds of what was formerly the Confederate Home of Missouri, now a memorial to the forty thousand Missourians who fought for the Confederacy. In Kansas City, in a comfortable neighborhood south of the river, are the home of the noted regionalist painter Thomas Hart Benton and the studio in which he died in 1975 after putting the finishing touches on his last great mural.

On the Missouri River north of Kansas City three state parks exhibit aspects of the riverine environment. Weston Bend, like Van Meter, offers richly forested Missouri River loess hills, and it also includes structures by means of which the region's tobacco culture may be interpreted and offers access to a small portion of the floodplain. Lewis and Clark, about fifteen miles upstream, preserves a portion of the shoreline of an oxbow lake that the famed explorers visited and described on the Fourth of July, 1804, during their epic journey to the headwaters of the Missouri and beyond, while Big Lake State Park, on the shore of the state's largest remaining natural oxbow lake in far northwest Missouri, offers access to an outstanding remnant marshland rich in bird life.

Trail of Tears State Park

THE VIEW FROM Shepard Point is grand and serene. The Mississippi River stretches lazily north, limestone bluffs two hundred feet high stand guard on the west, and bottomland farms line the valley. You can easily imagine Huck Finn and Jim waving to a passing stern-wheeler as the strong brown current carries them downriver. Or your attention may be drawn to the lush green forest that cloaks the amazingly rugged hollows that find their way through the bluffs to the river.

Regardless of what vision this eye-filling view evokes in today's park-goer, it once overlooked one of the sorriest episodes in American history. And it is that infamy, not the natural splendor, that gives Trails of Tears State Park its name. Here, at Moccasin Springs in the winter of 1838–1839, the Cherokee nation in a forced march ferried the Mississippi en route to a new home in the Oklahoma territory. Many Cherokee died during that hard winter, and some are thought to be buried in and around the park.

The extensive forests of the park, despite some early logging, closely approach the great woods that the Cherokee confronted. Trail of Tears State Park preserves Missouri's best sizable example of what botanists call "western mesophytic" forest. *Mesophytic* refers to the relative moisture in the soil; here, on the deeper, richer soils protected in the cove ravines along the river, growing conditions mirror those of the Appalachian Mountains to the east. So the forest along these Mississippi River breaks is very different from that found in the Ozarks to the west.

In contrast to the Ozarks, Trail of Tears features trees of greater size and greater diversity. Oaks and hickories abound, but they find themselves in the company of many typically eastern species—cucumber tree, tulip poplar, and American beech. The ground cover is rich, too, a wildflower lover's delight. One may find the rare pennywort, a delicate plant flowering early in the spring, or see beechdrops, tiny parasitic plants found only at the base of American beech trees. The state has set aside a particularly outstanding example of this river-break landscape as Vancill Hollow Natural Area, 300 acres in the middle of the park.

North of Vancill Hollow and the overlook drive, the Indian Creek Wild Area preserves an even larger portion of the park, where the visitor may, in the words of a park brochure, find "opportunities for solitude or private and unconfined recreation." The wild area extends all the way to Indian Creek, which forms the park's northern boundary. The bottomland of Indian Creek is jungle-like, featuring dense canebrakes and a profusion of grapevines dangling from large sweet gums and black willows. Into Indian Creek empty a labyrinth of rugged hollows, sheltered and moist and home to a variety of ferns, mosses, and flowering plants. Higher up, above the creek, a forest of black gum, white oak, bitternut hickory, tulip poplar, sassafras, and deciduous holly provides a dense cover. There is even a colony of shortleaf pine at one point above the creek. This "wild" area certainly deserves its designation, but, despite its ruggedness, the Indian Creek

Thousands of Cherokee Indians crossed the Mississippi River and camped near here during the harsh winter of 1838–1839 on their infamous "trail of tears." OLIVER SCHUCHARD

The rich river breaks along the Mississippi, as here at Vancill Hollow Natural Area, are characterized by such Appalachian species as American beech, tulip poplar, and cucumber magnolia growing amid a luxuriant ground cover. TOM NAGEL

Wild Area is readily accessible by means of the ten-mile Peewah Trail.

No doubt the Cherokee viewed this rugged terrain and dense forest as just another obstacle—along with the harsh weather and disease—that hampered their involuntary eight-hundred-mile trek. The story of their removal began in 1829 when President Andrew Jackson, responding to pressure from the state of Georgia, where gold had just been discovered on Cherokee land, asked Congress for legislation to remove the southern Indians to lands west of the Mississippi. Congress responded a year later with the Indian Removal Act. Some of the pressures on Jackson are, perhaps, understandable—after all, by 1829 the young nation's white population had more than tripled to 12.5 million since Independence, and the demand for more land was inexorable. But it is clear that "Old Hickory" was still an "injun-

fighter" at heart, strongly believing that Indians could not be assimilated into the white culture that was bursting the seams of the already settled areas. The irony is that the Cherokee, and the other members of the so-called Five Civilized Tribes, had already demonstrated a willingness to accept white culture and to live in peace. Most of the Cherokee leaders could read and write English and understand the law, and thousands of Cherokee had learned to read and write in their own language since the development a decade earlier of a syllabary by the remarkable Cherokee statesman Sequoyah. The Cherokee lived in houses and practiced farming, and acculturation had been furthered even more by considerable intermarriage with whites. Nevertheless, circumstances and policy dictated that the Cherokee had to go.

Removal did not occur right away, however. Even though some Cherokee tribal leaders actually favored relocation, most of the chiefs resisted the federal and state efforts to move them out. With the support of many white church leaders, the Cherokee took the matter to court and eventually obtained a favorable ruling by the U.S. Supreme Court. This only prompted Jackson to

move faster. A fraudulent treaty was enforced on the Cherokee, one signed by only a few hundred tribal members—compared with the more than fifteen thousand Cherokee signatures on petitions to the contrary. Several small bands left their homelands, more or less resigned to their fate.

In spring of 1838, the remaining Cherokee were rounded up by a force of some seven thousand federal and state troops, disarmed, and placed in primitive, unsanitary military stockades, awaiting a break in the worst drought ever recorded in the region; more than fifteen hundred died of cholera and measles during the confinement, and many others were ill as the forced migration began that fall. Divided into thirteen contingents of about one thousand Indians each, the exodus proceeded across Tennessee, Kentucky, and Illinois.

The first groups reached the Mississippi in November, where their crossing was held up by river ice in the unusually harsh winter. The Cherokee camped on both sides of the river, waiting to cross or awaiting the remainder of their contingent so they could move on, and many died in the cold and inclement weather. The group led by Chief Jessy Bushyhead was held up at the river for more than a month, during which time his daughter, Otahki, reportedly died and his wife gave birth to a baby, Eliza Missouri. Otahki is said to have been buried in the park, on a knoll above the encampment at Moccasin Springs, but no confirmation has been found. Wishing to commemorate the tragedy of the Cherokee, the Cape Girardeau Rotary Club in 1961 erected a monument to Otahki and the many others who died at the river crossing.

From the Mississippi, the Cherokee took several routes across Missouri, some of which will be marked as part of the Trail of Tears National Historic Trail, established by law in 1987. The main route apparently took them through the county seat of Jackson (named for the president who had forced their removal) and then northwest through Farmington, Caledonia, Steelville, and St. James, where it turned southwest to

The daffodil-like aroma of a deep cove in spring leads one to the flowering cucumber magnolia. Many fine specimens of this tree may be found at Trail of Tears. GREG HENSON

Waynesville and Springfield, then across the corner of Arkansas to "Indian Territory." One of every four Cherokee died in the stockades or during the forced migration. The remainder arrived in Oklahoma a broken people and politically divided. In spite of everything, the Cherokee built a remarkable society in their new homeland, copying many features of the white civilization that had expelled them.

Trail of Tears State Park was a gift to the state by the people of Cape Girardeau County, who authorized a $150,000 bond issue to purchase over 3,000 acres in 1956. A handsome new interpretive center provides exhibits on the natural history and native peoples of the area and on the tragedy of the Cherokee. The 3,400-acre park is a superb preserve of an original Mississippi River landscape; it is also a reminder of the bigotry and intolerance of a young country feeling its way in an experiment called democracy, and a memorial to a resilient people who embraced the experiment for themselves and who persevered through its growing pains.

Two front entrances remind us that Felix and Odille Vallé's home served also as headquarters for the Menard & Vallé mercantile establishment.
OLIVER SCHUCHARD

Felix Valle House State Historic Site

A VISIT TO Ste. Genevieve is a step back into Missouri's colonial and territorial past. As the first permanent settlement in the state and a place relatively lightly touched by the centuries, Ste. Genevieve preserves the most outstanding survivals of eighteenth-century French colonial structures anywhere in the country, and its assemblage of early nineteenth-century French, old-stock American, and German buildings is similarly unparalleled. Fortunately, a significant number of the homes and commercial buildings have been restored by private individuals, by historical associations, or by the state.

The last decade of the eighteenth century and the first two decades of the nineteenth witnessed considerable changes in Ste. Genevieve. The little French settlement of farmers and traders established around 1750 on the west bank of the Mississippi fell victim to the vagaries of the river and, after a series of particularly severe floods, was finally moved a few miles north around 1792 to a more secure location on Petites Côtes, a slight rise between the forks of the Gabouri River near its junction with the Mississippi. This 1790s settlement is the Ste. Genevieve we know today. A few years later the community was invaded by land-hungry Americans seeking concessions in the hinterland to the west from a suddenly more liberal Spanish officialdom. Spain had secured the west bank of the Mississippi when France lost its empire in North America in the early 1760s, and then traded it back to France in 1800, just before Thomas Jefferson's purchase of the Louisiana Territory in 1803. The purchase unleashed a floodtide of Americans, who soon overwhelmed the French in Ste. Genevieve.

Among the new arrivals was Jacob Philipson, of a Philadelphia Jewish family, who had migrated to St. Louis to begin a mercantile business and then in 1811 moved his business to Ste. Genevieve. Ste. Genevieve was a logical port of trade for manufactured goods coming west from Philadelphia and for lead and furs from Missouri's interior going east. In 1818, Philipson built a one-and-a-half-story home and store of local ashlar stone on the southeast corner of Merchant and Second streets. Built in the Federal style, the structure is evidence of the new American influences on the community. The building was divided on the first floor into two distinct areas, one for Philipson's mercantile business and the other for his residence. Two separate front entrances on Merchant Street are testimony to the original dual purpose of the structure.

Jean Baptiste Vallé (1760–1849), the last of the commandants of the post of Ste. Genevieve before the Louisiana Purchase, bought the building from Philipson in 1824. Vallé used it as headquarters for Menard & Vallé, a commercial enterprise involved in much of the fur trade with the Indians of southern Missouri and Arkansas. Head of the leading French family in Ste. Genevieve, Vallé then owned a large portion of the block that included Philipson's stone building. His personal residence, which still stands on the opposite corner of the block, was a typically French Colonial, vertical-log structure built in the 1790s.

Jean Bte. Vallé's youngest son, Felix, began to live in the stone building presumably soon after his father purchased it. With his wife, Odile Pratte Vallé, and their son, Felix made his home there for the next fifty years. He worked as a clerk for Menard & Vallé in the commercial side of the house and eventually took much of the re-

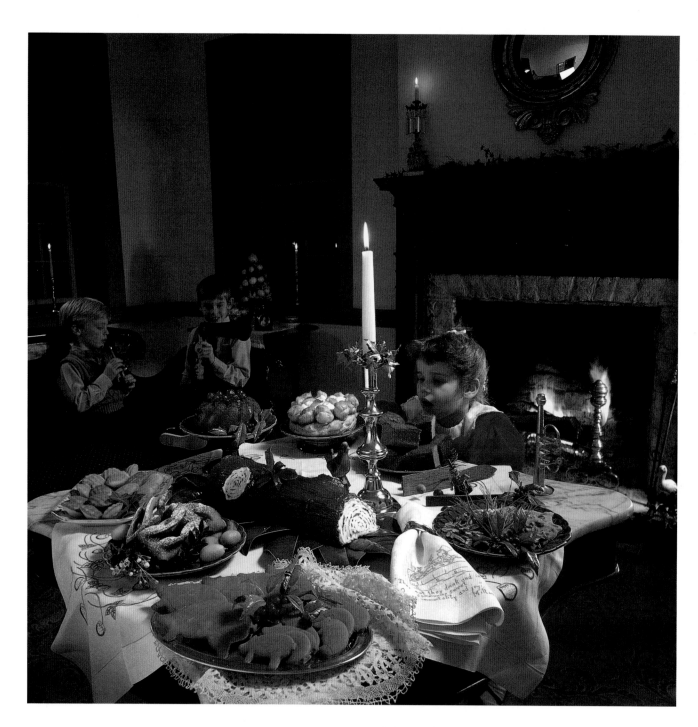

Children gaze in wonderment at some of the thirteen desserts prepared for le réveillon, *a traditional French Christmas celebration.* WILLIAM HOPKINS

sponsibility for the firm's operation. In the early 1840s, when the Menard & Vallé partnership dissolved following the death of Pierre Menard, Felix Vallé founded an enterprise with James Harrison, called the American Iron Mountain Company, to mine for iron ore in nearby St. Francois County. Probably not long afterward, Felix and

Odile modernized their home, removing one of the two front doors and turning it into a center-hall Victorian house.

Across a side street from the Vallé home is a small frame structure known today as the "Mammy" Shaw house. It was originally built around 1818 by Jean Baptiste Bossier as a commercial structure. Dr. Benjamin Shaw purchased the heavy-timber frame building in 1837 and presumably enlarged it to its present configuration around 1840. Dr. Shaw and his wife, Emile "Mammy" Shaw, were contemporaries of the Vallés; Mrs. Shaw, widowed in 1849, lived in the

house for over fifty years. Another neighbor, just up Merchant Street, was Dr. Lewis F. Linn, who had moved to Ste. Genevieve in 1816. A prominent physician, Linn served as a United States senator from 1833 until his death in 1843.

Vallé and Harrison's American Iron Mountain Company thrived, adding a successful rolling mill in St. Louis in partnership with Pierre Chouteau, Jr., scion of the founding family of St. Louis. They employed nearly one thousand men in the Iron Mountain vicinity by 1869. Vallé died in 1877, leaving most of his vast estate to his wife, Odile, their son having died a number of years earlier as a young man. Mrs. Vallé gave three-fourths of the funds to build the "new" Catholic Church that still stands in the center of town, and she continued to live in the modest stone house on Merchant Street until her death in 1894.

As early as the 1930s, the federal government recognized the significance of the Felix Vallé house when architectural drawings of the structure were incorporated in the Historic American Buildings Survey. In 1970, the family home was donated to the state by descendants of the Vallé and Rozier families. The Rozier family was descended from Ferdinand Rozier, a Frenchman who had arrived in Ste. Genevieve in 1811 with his business partner, John James Audubon. Audubon dissolved the partnership shortly after their arrival in Ste. Genevieve to pursue his calling as an artist, but Ferdinand Rozier and his family lived for many years near Felix and Odile Vallé on Merchant Street in another house originally built by Jacob Philipson.

After careful study, which included the discovery that the house had originally had two front entrances leading to separate sections, the Felix Vallé house was restored to its original appearance and furnished as it may have been during the 1830s. The house boasts a great expanse of original ceiling paint, protected for more than a century by a plaster ceiling placed over it during the remodeling around 1850; the newly revealed 1818 paint is literally covered with thousands of flyspecks, a hint of life before wire screens. Outdoors, the restored sidewalks are gravel—not too popular with the locals today, but mandated by a city ordinance of the early nineteenth century.

The site was opened to the public on a year-round basis in 1983. An archaeological study of the yard undertaken in 1988 revealed the location of several significant features, including a building believed to have been the original kitchen. Rehabilitation of two outbuildings on the site is ongoing, and the kitchen may be reconstructed in the future.

In 1989 the state purchased the Shaw house across the street for use as an administrative building, a reception area for visitors, and living quarters for the site administrator. The property has had a colorful history since the days of Mammy Shaw, especially during the depression years of the 1930s when it was the focal point for a colony of artists attracted to the French heritage and peaceful surroundings of Ste. Genevieve. Because the house and a later structure attached to it were altered many times over the years, the buildings are not suitable for period display pieces. Yet few buildings in Ste. Genevieve have been as intimately involved in as many aspects of the life of the community during the last two centuries as the Mammy Shaw house. Its use for both residential and public purposes is pragmatic preservation in action.

That a state historic site in the leading French colonial community in the nation consists of a series of nineteenth-century American buildings presents a certain irony. Interpretation of the interaction of French and Anglo-American culture in the early nineteenth century, as at the Felix Vallé house, is entirely appropriate and necessary, and none of the other museum houses in town does it. Nevertheless, one is struck by the lack of a traditional French Colonial vertical-log structure from the eighteenth century among the park system holdings. The parks division has recognized this problem and indicated its intention eventually to acquire such a property. Among the obvious candidates is a farmhouse on a beautiful site fronting on the old common field south of town that in the mid-1980s was discovered to have vertical logs beneath its clapboard siding. Tree-ring dating of the logs by a University of Missouri scientist establishes that they were cut in 1793, and archival research suggests the house was built for Pierre Charles Dehault Delassus de Luzières, a high-ranking French nobleman who served as commandant.

In 1990, the state's Revolving Fund for Historic Preservation came to the rescue of a highly significant, carefully restored, early nineteenth-century building about to be sold to a group from Peoria, Illinois, and moved there as a surrogate for the French heritage Peoria has lost. The Bequette-Ribault house, tree-ring dated to about 1808, is one of only three extant buildings in Ste. Genevieve exhibiting a type of construction common in the early years—*poteaux en terre,* or "post in the ground," in which the side walls extend into a trench in the ground to form the foundation. The state hopes to sell the building, with restrictive covenants to ensure its preservation, to some person or group who may operate it

as a museum house. Ste. Genevievians recognize the desirability of having as many houses as possible open to the visitors who are increasingly being attracted to their extraordinary community.

The French are noted for their fine cuisine and their joie de vivre, and the staff and volunteers at the Felix Vallé house, while most of them cannot claim to be French, have a reputation for staging soirées that would rival those of Felix and Odile. Most special is *le réveillon*, a Christmas celebration that by French tradition calls for thirteen desserts. After preparing feverishly until the last minute, the hosts don period costume to welcome their visitors to the house, simply decorated with boughs of native shortleaf pine and bathed in candlelight. On the elegant dining table are the pièces de résistance: *bûche de Noël*, the Yule-log cake; *gâteau de sirop*, a cake made with Louisiana cane syrup; madeleines, tiny shell-shaped cookies; *gâteau St. Honoré*, a cream-puff ring like an ornamented crown, topped with miniature caramelized cream puffs, named for the patron saint of French pastry chefs; *croquembouche* (literally, "melts in the mouth"), a pyramid of the tiny caramelized cream puffs; and on and on to the count of thirteen. Enjoy a slice of *bûche de Noël* and a chat with other guests, then join in singing French carols accompanied by autoharp—and imagine that you have just spent a Yuletide evening with Felix and Odile Vallé.

Dunklin's Grave State Historic Site

ATOP A HIGH BLUFF overlooking the Mississippi River about one mile north of the town of Herculaneum is the final resting place of Missouri's fifth governor, Daniel Dunklin. Daniel Dunklin (1790–1844) was born in South Carolina, but the pioneer spirit led him to journey west—first to Kentucky, next to Ste. Genevieve, and then to the lead belt in the vicinity of Potosi, where he was admitted to the bar and practiced law. He joined the command of Gen. Henry Dodge during the War of 1812 and then, in 1815, opened a tavern in Potosi, married a Kentucky girl, Emily Haley, and was appointed Washington County sheriff. It was at his tavern in 1822 that Dunklin was nominated to make his successful campaign for election to the Missouri legislature as a Jacksonian Democrat.

Dunklin was elected governor in August of 1832 after serving one term as lieutenant governor. A progressive, he championed public education, humane treatment for prisoners, and a state institution for the deaf and dumb. In 1834 he recommended a state university be founded and supported by the sale of land. Later that year he submitted to the legislature a report calling for a state system of tax-supported schools, a state board of education, and common schools supported by local taxation on the basis of property ownership. For his success in securing enactment of the state's first comprehensive public school law in 1835 Dunklin has been called the "father of Missouri public schools." His financing system was adopted in some of the larger cities, and, though the sparsity of population in small towns and rural areas made such funding difficult, the seed was planted for a later day. While in office Dunklin also added additional counties to north-

west Missouri through the Platte Purchase.

When President Andrew Jackson offered him the position of U.S. surveyor general for Missouri and Illinois, Dunklin resigned as governor with three months remaining in his term. Under his federal appointment, he surveyed and named some of the counties south of the Missouri River. His own name was later given to one Bootheel county.

Dunklin moved to Jefferson County in 1840 to an estate he called Maje near the lead-smelter community of Herculaneum. Three years later, Gov. Thomas Reynolds assigned Dunklin the task of establishing the final boundary between Missouri and Arkansas. But, on July 25, 1844, Dunklin died of pneumonia; he was buried in a small field near Maje.

Some forty years later, his son James L. Dunklin sold the family farm to Charles B. Parsons, superintendent of St. Joseph Lead Co. It was about this time that Dunklin's remains were moved to the present one-acre cemetery on the bluff. There Governor Dunklin lies between his daughter and son beneath a stone vault.

The town and bluffs of Herculaneum have a long and fascinating history of their own. Moses Austin picked the site where Joachim Creek enters the Mississippi in 1808 as an alternative to French-dominated Ste. Genevieve for use as a depot for shipping lead mined and smelted near Potosi. In 1810 he erected a shot tower on the bluffs north of town, from which molten lead was dropped through a sieve to the water below to form round lead shot. Austin named the new town after the ancient Roman city of Herculaneum, a twin to Pompeii, both of which had met a tragic end in the fury of Mount Vesuvius in A.D.

79. In addition to its claim as the last home and final resting place of Daniel Dunklin, Herculaneum was also the birthplace of Thomas Clement Fletcher (1827–1899), Missouri's first native-born governor, who served during the Radical Republican era immediately following the Civil War.

Despite its small size, the site offers in addi-

The small family burial plot of Gov. Daniel Dunklin, a Missouri pioneer, sits high above the Mississippi at Herculaneum. OLIVER SCHUCHARD

tion to its historical associations a superb view of the Mississippi, some three hundred feet below.

Scott Joplin House State Historic Site

"IF YOU ARE ALIVE to impulse you felt the ground wave under your feet, and you dropped into sublime reverie." In flamboyant promotional prose, St. Louis music publisher John Stark described the effect of Scott Joplin's infectious music on fairgoers to the 1904 Louisiana Purchase Exposition. It was the heyday of St. Louis and the heyday of ragtime—the music craze at the turn of the century. And Joplin was proclaimed the "king of ragtime." The thirty-six-year-old musician performed at the world's fair, although, being black, he was well out of the limelight. His music, played by white performers in their own versions, won more attention than he did, especially his beautiful rag "The Cascades," written to evoke the fair's spectacular display of fountains, lagoons, and waterfalls.

By that time, with royalties from his music increasing, Joplin was able to spend less time in the hectic world of ragtime piano playing—a world usually limited, for black pianists, to the tenderloins of the city—and to devote more time to composing and teaching. In fact, it was ragtime's origin and reputation as the favorite musical entertainment in such convivial if shady establishments as saloons, gambling joints, and sporting houses that Joplin tried to rise above.

Scott Joplin first obtained fame in Sedalia, where he lived for five years beginning in 1894. His was not an overnight success story, however. He grew up in a musical family in Texarkana, Texas, and he started piano at an early age. By the time he was eleven, word of young Joplin's proficiency had spread to the white community, and he became the pupil of an old German music teacher. Seeking his fortune in music, the teenage Joplin arrived in St. Louis in 1885, where he played in local honky-tonks in and around the city. In 1893, he traveled to Chicago to play among the bustling entertainments that sprang up around the Columbian Exposition. After settling in Sedalia, Joplin tried his hand at composing and, with the help of friends, even studied music at George Smith College, an institution for blacks sponsored by the Methodist Church.

Ragtime was a composite of elements of late nineteenth-century popular music with the syncopated rhythms of black banjo players. The bright tunes readily lent themselves to the virtuosity of piano players, whether in the parlor or in the brothel. Joplin worked at translating the elusive rhythms of ragtime into musical notation. In Sedalia, he composed one of his earliest and best-known rags, the "Maple Leaf Rag." For two years, he struggled to get the piece published before Sedalia music dealer John Stark brought it out in 1899. "Maple Leaf Rag" was a national hit at a time—before TV, radio, or even the gramophone—when popular music was promoted through sheet music and piano rolls. The rag sold seventy-five thousand copies within six months, and ultimately more than a million; it put both Joplin and Stark on the road to success.

Despite barriers of race and age—Stark was nearly twice Joplin's age—the two men shared an unusually sympathetic relationship. Stark moved his burgeoning publishing company to St. Louis, flush with the success of the "Maple Leaf Rag," and Joplin soon followed. St. Louis offered a bigger field for his genius, and he had a number of friends there, including Alfred Ernst, director of the St. Louis Choral Symphony Society, with whom he would study classical music.

Recently married, Joplin settled into a second-

Workmen lay a brick sidewalk as restoration of the Scott Joplin house nears completion in the summer of 1991. OLIVER SCHUCHARD

story flat in a large brick house at 2658-A Morgan, now Delmar Boulevard. The building, located in a formerly German part of town, had been built in the 1860s for Jacob Haag, a music teacher. Haag had relocated to a wealthier German community in south St. Louis but retained the building on Morgan Street as income property, dividing it into a four-family flat and adding a two-story addition to the west. Most of the buildings in the neighborhood were rental property by the 1890s, with multifamily dwellings crowded in beside more substantial original houses, themselves by then divided into smaller units. The Joplins would have found a busy neighborhood, still with a few Germans but becoming increasingly black. Their flat, though not grand by the standards of the era, did have a bathtub and gas lights, and it was comfortable and appropriate for a man of Joplin's stature. Other musicians came to visit and study with him, perhaps occupying the attic above the couple's second-floor flat.

While in St. Louis, Joplin composed many of his best pieces: "The Entertainer," "Gladiolus Rag," "The Cascades," some waltzes, a folk ballet, and the first of two ragtime operas. Even though his career as a composer continued to flourish, his personal life suffered. His baby

daughter died only a few months after birth, and his marriage deteriorated. Joplin's wife had little interest in music, so Joplin increasingly turned to his ragtime contemporaries for companionship. His friends included fellow composer-performers like Tom Turpin, rotund owner of the popular Rosebud Cafe, and Louis Chauvin, a Creole with whom Joplin composed "Heliotrope Bouquet." Separating from his wife in 1903, Joplin left St. Louis briefly, and then he left the city for good in late 1907, heading for New York—once again following his publisher, Stark.

Happily remarried, Joplin devoted more and more time to "more serious" music, his dream being to transform classical music to embrace folk and rag themes. His association with Stark ended in a financial dispute, but Joplin worked hard on a second opera, *Treemonisha*, then struggled for four years to get it performed. He finally produced at his own expense a trial performance without scenery or orchestra; it was a disaster and a serious blow to his spirit, from which he never recovered. Obsessed with the opera and weakened by disease, he entered the state hospital, and there he died on April 1, 1917.

In 1973 the motion picture *The Sting* restored Joplin to his proper standing among American composers. In fact, the use of Joplin's rags to score the Academy Award–winning film started a national revival of interest in classic ragtime. Even Joplin's ill-fated *Treemonisha* was finally accorded the full-scale production of which the composer died dreaming.

His St. Louis home, cradle of his most productive and successful period, was rescued from demolition in 1977 by Jeff-Vander-Lou, Inc., a not-for-profit neighborhood development corporation, just after it had been designated a national historic landmark. It had the misfortune to be located in a part of the city that, despite the presence of a number of historic buildings, was slated by the Land Clearance for Redevelopment Authority for complete obliteration and transformation to commercial or light industrial uses. Though the St. Louis Board of Aldermen voted $100,000 for restoration, the money was tangled in controversy for years. Finally in 1983, after complex negotiations, the site was donated to the state for restoration as a historic site. In 1986 the state purchased several neighboring buildings to protect what remains of the historic neighborhood.

The site entered a long process of restoration in 1985, the first major stage of which was completed in 1991. The site features the Joplin flat, restored and furnished appropriately for the period during which Joplin lived there. It also includes exhibit galleries, a room for musical performances, and a small sales shop. Long-term plans call for rehabilitation of the corner commercial structure to the west and re-creation within it of a new Rosebud Cafe, which will feature live ragtime music and offer some of the atmosphere of the music's golden age. The site is intended as a nucleus for the creation of a black cultural center as well as a memorial to the creativity of an enormously gifted Missourian.

Seen from the rear, the house where Joplin lived displays its newly restored porches and masonry. Next door are the ruins of a building in which a new Rosebud Cafe will be brought to life. OLIVER SCHUCHARD

Wakonda State Park

WHAT A PARADOX it is that twentieth-century technological man, in his quest for Pleistocene gravels, would accidentally have created not only an aquatic playground but also a refugium for one of Missouri's most endangered natural communities, the sand prairie.

The landscape near Wakonda State Park in northeast Missouri was shaped during the Pleistocene by the southward thrust of massive ice sheets and then by their last retreat when the big thaw set in. The last of the great glaciers, the Wisconsin, changed old drainage patterns, among them the route of the Mississippi, which shifted westward from where the Illinois River is today. The glacier had scraped boulders, gravel, and sand from the continental bedrock, then deposited its collections unevenly as it retreated. The Mississippi, distended for centuries, perhaps for millennia, by the glacial melt, carved a broad floodplain and in places along its margins left great deposits of sand in alluvial terraces on which sand prairies in time took root. At times of heavy melt the glacial outwash laid down concentrated lenses of the larger gravelly rock. In a swampy bottom just south of the Missouri town of LaGrange the gravel deposits were of exceptional depth and quality, although partially concealed by an overburden of alluvial silt.

After World War I, the increasing popularity of the automobile among both farm and city people dictated a rapid improvement in Missouri's road network. The new motorcars and trucks couldn't do very well on roads of gumbo and clay when it rained. Responding to a popular citizen initiative, a new state highway commission set for itself a major mission: "To lift Missouri out of the mud!" The obvious and practical method was to gravel the roads. The search was on for materials, and soon some alert road builder discovered the extensive and easily mined deposits near La-Grange. They turned out to be the best and largest source of road-surfacing material in the state.

In 1924, after test borings, the highway commission made its first purchase of gravel-bearing land, about a hundred acres, and contracted with the private Missouri Gravel Company to dredge, wash, and screen the surfacing material. The primary mining tool was the simple dragline, used first to remove and shove aside the overburden of sand and clay and then to scoop out the mixed sand and gravel. In 1929 the commission bought more land, and the gravel company enlarged its plant to produce two hundred thousand tons per year; in some years the volume was even higher. "LaGrange gravel" was shipped by rail all over the state, off-loaded to dump trucks, and spread by graders on the roadbeds. Thus was Missouri lifted out of the mud.

Between 1930 and 1965 approximately sixteen million tons of "surfacing gravel equivalent"—highway engineers' jargon for washed gravel containing thirty percent sand—were shipped from the LaGrange site. The total, both gravel and sand, reached twenty-six million tons before the department abandoned the site in the late 1980s. Some of the LaGrange gravel-sand mix went into concrete pavements and culverts, but most went to graveling 24,300 miles of secondary highways, including the state's network of "farm-to-market roads"—the routes designated by letters throughout the rural counties. Most are covered with asphalt now, requiring different materials, but underneath the blacktop lies LaGrange gravel.

So how did this accidental state park come

LaGrange gravel and sand were used to surface enough "farm-to-market" roads to reach around the earth, leaving behind a series of clean little lakes and ponds that have become highly popular for swimming and fishing. RON SUTTON

into being? Dredges scooping out the gravel dug deeply below the water table in the floodplain, creating lakes—clean little lakes because the river water that filled them was filtered through the glacial deposits. The new water bodies soon became popular for fishing and swimming, suggesting to Lewis and Marion county residents a

Spoil mounds left behind by mining provide a refuge for sand-loving prairie species now endangered by the virtual disappearance of natural sand prairies along the Mississippi. KEN McCARTY

park. The idea grew, and on June 5, 1960, the highway commission deeded 257 acres, on which it had exhausted the gravel deposits, to a receptive state park board.

Park officials invited suggestions for a name for the new park. *Wakonda,* a word in the Osage and Missouri Indian tongues meaning something consecrated, as by the Great Spirit, was suggested by Dr. Carl Chapman, noted archaeologist at the University of Missouri. Interestingly, a small river flowing north of the site but not through it is named *Wyaconda,* a Sioux variation.

Development was slow at first; park board moneys were scarce. Not until September 1967

was a contract let for construction of a combination bathhouse and concession building. Those facilities are still there and heavily used in season. Today there are also modern cabins with sleeping and kitchen facilities, a campground, picnic tables, and two playgrounds for children, the newest situated in a sylvan setting overlooking the main lake. As overburden was removed from the gravel beds, it was shoved to the sides of the excavation where it now forms embankments above the open water. Although the landscape is recently man-made, the well-watered silty soil promotes rapid tree growth, and visitors will enjoy the interesting sensation of walking and camping in an attractive, largely cottonwood "forest" that may be younger than themselves.

Not entirely accidentally, Wakonda boasts "the largest natural sand beach" in the state park system. Anyway, the sand is natural. It was put there by the glacier and the Mississippi and left over from the decades of gravel excavation. The beach is large enough not only for the browning of human bodies but also for volleyball and tetherball courts, badminton, and horseshoes. Anglers catch familiar Mississippi Basin species in the lake—black bass, crappie, other sunfishes, catfish, and carp. The concessionaire in season rents paddleboats and small boats for fishing. During hard winters some try ice fishing.

A new headquarters building contains the park office and space for exhibits. When installed, the displays could interpret the fascinating Ice Age origins of the region as well as the historic role played by the site in the building of Missouri's highways. A mastodon tusk was excavated in the gravel operations, along with other fossils of the Pleistocene epoch. Another characteristic of LaGrange gravel is its lithological beauty; it contains stone of assorted colors. One kind of polished pebble is identified by geologists as Lake Superior agate, an indication of how far the glacier carried its collections. Rock collecting is prohibited, however, as in most parks.

In 1991 the State Highways and Transportation Commission transferred an additional 740 acres to the state park, including about 220 acres of lakes and ponds created by the more recent gravel and sand excavations. The expanse of Wakonda State Park is thus nearly quadrupled, its lake area enlarged proportionately. There is also a signifi-

cant piece of protected habitat for wild ducks and other water birds that use the Mississippi flyway.

Most exciting to naturalists, however, is a hundred-acre area of seemingly naturally sculptured sand mounds, which mimic the soil conditions found on now-rare natural sand prairies. On these mounds, amazingly, a number of sand-loving prairie and sandbar species have found refuge. Sand grass, sand dropseed, winged pigweed, and an endangered umbrella sedge (*Cyperus schweinitzii*) blanket the undulating sandy mounds, as does the yellow-flowered evening primrose (*Oenothera rhombipetala*). All of these plants, and several others, are found in no other state park.

Sand prairies were once fairly common on the more stable sandy terraces along the Mississippi, Missouri, and other large rivers. But channelization since the 1920s and conversion of river margins to agricultural land relentlessly eliminated them. By 1949, when Julian Steyermark was making collections for his monumental *Flora of Missouri*, sand prairies and some of their characteristic plants were virtually extinct—except for one small remnant he discovered and described on the lower Des Moines River. Now it turns out that the spoil piles of the LaGrange gravel operations, quite by accident, have created another refuge for some of these species.

How did it happen? Highway department maps carefully marked as to dates of mining reveal that the prairie established itself on spoil piles created very early in the operations—back in the 1920s, when natural sand prairies still existed on nearby Mississippi River terraces that could provide a source for windblown seed. Those natural prairies are long gone now, victims of decades of "improvements" for barge navigation, but the man-made sand piles of Wakonda, protected from further disturbance for more than sixty years, have become the unheralded savior for a unique, vanishing natural community.

As it turns out, Steyermark's tiny sand prairie on the lower Des Moines River also still exists, having been carefully protected all these years by a family who regarded it as something special. The family has agreed to let park scientists maintain the site and use it as a source of seed for reestablishing yet other species that did not manage to make it on their own to Wakonda.

Battle of Athens State Historic Site

STANDING AT THE OLD Thome-Benning house and looking across the Des Moines River into Iowa, you can easily imagine the pro-Confederate volunteers' cannonballs hurling toward the pro-Union home guard, some landing in the river, some in the neighboring state, and at least one passing right through Joseph Benning's home—earning it the name *Cannonball House*. In and around the town of Athens that August morning in 1861 a battle raged for not quite two hours. When it subsided, northeast Missouri was left in the hands of Union supporters.

One of the early skirmishes of the Civil War and, perhaps, the farthest north, the Battle of Athens was a test between two strong-willed and passionate Missourians, David Moore and Martin Green, and their equally passionate partisans. Moore was a veteran of the Mexican War and thus had a knowledge of military matters. He had a reputation for fearlessness and profanity with which he bolstered his ardent pro-Union feelings. Immediately after South Carolina batteries fired on Fort Sumter, signaling the start of the Civil War, Moore began recruiting volunteers for a home guard. All over Clark County he posted placards that read:

> The undersigned is authorized to raise a company of volunteers in this county for Union service. All who are willing to fight for their homes, their country, and the flag of our glorious Union are invited to join him, bringing with them their arms and ammunition. Until the government can aid us, we must take care of ourselves.
>
> Secessionists and rebel traitors desiring a fight can be accomodated on demand.
>
> D. Moore

Martin Green, a judge of the Lewis County Court (Lewis is just south of Clark County) and a brother of Missouri's staunchly southern U.S. senator James S. Green, was equally committed—but to the Southern cause. He began recruiting volunteers with even more success than David Moore—even Moore's three sons joined up with Green—owing largely to the very strong pro-Southern views in northeastern Missouri. The early-settled areas near the Mississippi and lower Des Moines rivers in effect constituted a northeastern limb of Missouri's "Little Dixie," filled with Kentuckians and Virginians, though as the railroads came closer increasing numbers of families from more northern states migrated to the region. The patriotic zeal and organizing efforts of both men led to an eventual showdown at Athens on August 5, 1861.

Moore had selected Athens, one of the largest towns in Clark County and residence of most of the county's pro-South leaders, as the place to garrison his troops. Not the type to avoid confrontation, he had apparently chosen Athens not only to be close to the railroad north of the river at Croton, Iowa, from which he could be supplied, but also to control his major potential opposition. To garrison more than five hundred soldiers in a town of fewer than a thousand people was no small inconvenience to the locals. Moore solved the problem by taking over the homes and businesses of Southern sympathizers. George Gray's slaughterhouse, W. H. Spurgeon's dry-goods store, and the homes of Judge William Baker and the widow Jane Gray were among the many Southern properties he confiscated.

Green's two thousand volunteers outnumbered Moore's home guard by four to one, but Moore's

The restoration work on the Thome-Benning house carefully preserved the original hole (next to the kitchen door) where a cannonball had ripped through the house during the battle of Athens.
OLIVER SCHUCHARD

forces, augmented by some Iowans, were better supplied with muskets and ammunition from federal arsenals. When the smoke cleared there were only a few dozen casualties, but the pro-South forces were in retreat. Both Green and Moore went on to other fights: they opposed each other once again at Corinth, Mississippi. They both rose in rank to brigadier general. David Moore lost a leg at Shiloh, while Martin Green lost his life in the defense of Vicksburg.

In northeast Missouri, the big loser was the town of Athens, where bitter feelings remained long after the war. The town lost also, and more decisively, because the Civil War accelerated a change in the transportation focus of the nation from rivers to railroads. Athens, perhaps owing to its Southern sympathies, never did get the railroad bridge it had been banking on; when the railroad finally crossed the Des Moines River in 1887, it was near Revere, seven miles south. Athens went into decline and just about died by the early twentieth century.

One hundred years after the battle, the Athens Park Development Association organized and began purchasing land to commemorate the battle, an idea that had been promoted ever since 1900, when local residents held the first of a nearly annual series of August 5 celebrations. The new association wanted the state to develop the property, but the park board's historic sites advisory council demurred on the grounds that the site did not have high priority for preservation: the battle was actually "a relatively unimportant skirmish," the historians said; "the historical personages concerned were not of major importance," and the outcome of the skirmish "did not materially effect the course of the war"; furthermore, the only building that bore any physical evidence of the battle, the Benning (Cannonball) house, was "in a serious stage of deterioration."

Undaunted, the association continued to acquire tracts, financed with the proceeds from motorcycle hill climbs it staged annually up a steep embankment along the river. The association's members displayed their local pride as they proclaimed in one of their publications: "Like Martin Green's Rebel Gunners of 1861 this gun crew is out for Big Game. And they rebel against the lassitude and historical short-sightedness that have permitted this priceless heritage of Athens to slip from the community's grasp."

It was not until 1975 that the state accepted the donation of land, and then as a park rather than a historic site. With a ten-acre lake for swimming, excellent fishing on the river, and a good place for a campground, the property could provide much-needed recreation facilities in a corner of the state relatively deficient in public lands. No historic restoration was contemplated, but park officials did encourage the association to substitute battle reenactments for the hill climbs, as events more appropriate to the site and less damaging to the terrain.

Several years later, in the course of an archaeological survey occasioned by the need to run a waterline across the park to the new campground, it became apparent that the property contained a number of prehistoric Indian sites, the site of a large historic Sauk Indian village still occupied as late as the 1830s, and nearly the entire townsite of Athens as laid out in 1844 by Isaac Gray in nine blocks of eight lots each. By this time, prevailing ideas about what sorts of historical phenomena were most significant for preservation and interpretation had changed greatly from the early 1960s as a consequence of what was being called "the new social history." Drawing largely on studies of communities, the "new" history focused on ordinary people and everyday events—history from the ground up—and on processes of change in communities over time.

Here at Athens were Indian villages dating right up into the period of white settlement, and

The snow trillium found in the Des Moines River Ravines Natural Area is a relict of glacial times.
STEVE SCHNEIDER

nearly the entire town plat of a dynamic mid-nineteenth-century steamboat riverport that was torn asunder by the Civil War, revived briefly after the war, then left behind in the transition from river to rail—and it was all within the boundaries of a state park. Still standing, in addition to the Cannonball House, built in 1843 by Arthur Thome and occupied during the war by Joseph Benning, were the Townsend-Gray house, the Widow Jane Gray house, and the McKee house, headquarters for the Union forces and years later a hotel. Of the fifty or so businesses in operation by 1860, little remained except for the stone foundation of Arthur Thome's large woolen, saw, and gristmill down by the river, but the buried remains of other foundations, as well as the entire street grid, could be archaeologically excavated, along with a wealth of other historical artifacts. In addition, there were buildings scattered here and there in Clark County that had been moved from Athens after its demise, some of which might eventually be moved back and placed on their original foundations. With this wealth of structural remains and substantial archaeological and archival potential, the parks division in 1985 made the decision to reclassify Battle of Athens as a historic site and began an ambitious research and development plan.

Archaeology is now exposing old foundations and roads, which are being stabilized, slightly reconstructed, or outlined with fences and plantings—"ghosted," the professionals say—in order to create on the ground a full-size map of the town, one that visitors can walk through. The parks division is restoring standing structures and has identified several houses that may be returned to the site. Interpretive signs help to orient the visitor, and the division plans eventually to build an interpretive center.

In the meantime, naturalists on the staff have discovered that the forested ravines along the Des Moines River northwest of the townsite possess outstanding and quite unique natural features. These coves shelter a rich flora that includes doll's eyes and snow trillium, relics of glacial times found nowhere else in Missouri. This forty-acre site is now protected as the Des Moines River Ravines Natural Area.

Several newly restored buildings, including the Thome-Benning, Townsend-Gray, and McKee houses and the stabilized foundation of Thome's mill, were dedicated in conjunction with an August 5, 1990, reenactment of the Battle of Athens that involved hundreds of reenactors and their families and was witnessed by nearly five thousand visitors. The Civil War is still vitally important at this site, but instead of celebrating famous historical personages and events of major, decisive significance, we are now invited to explore the war's impact on ordinary people caught in a vortex of change in this extraordinary, ordinary little river town.

Katy Trail State Park

EACH OF THE STATE PARKS and historic sites has unique features, but none is as unusual as the Katy Trail State Park. To begin with, it is more than 230 miles long and throughout most of its length only 100 feet wide. No other park can offer a visitor access to such a variety of both cultural and natural resources to be studied and enjoyed. No other opens to the diversity of landscapes and scenic vistas. And it is quite likely that all thirty of the state historic sites in Missouri together cannot offer the number of historic structures—homes, churches, commercial buildings, stations, bridges, even a tunnel—that lie within sight of this railroad corridor preserved for the enjoyment of hikers and bicycle riders.

Records are made to be broken, so the day will surely come when Missouri's Katy Trail will be surpassed in another part of the country. But as of 1990 when the first resurfaced segments were opened for public use, it was the longest rail-to-trail conversion—out of more than two hundred and fifty such conversions throughout the nation—since the movement to preserve old railroad corridors began in the 1960s. It is likely, too, that no other such trail can match the Katy for the historical significance and sheer magnificence of the Missouri River corridor, pathway for the exploration and settlement of the American West.

After the Civil War, when the nation's network of railroads was expanding, eastern entrepreneurs organized the Union Pacific Company South Branch to reach and serve the developing agricultural areas of western Missouri, eastern Kansas, and beyond to the Texas cattle country. In 1870, the South Branch was renamed the Missouri-Kansas-Texas Railway Company. It soon, and ever after, became known as the M-K-T or, more simply, the Katy.

When competing companies kept the M-K-T from using the Missouri Pacific line along the south bank of the Missouri River, the company built from Clinton and Sedalia to Boonville and Moberly for a junction with the North Missouri Railroad (now the Wabash). But that still wasn't enough. Under new management after 1888, the Katy perceived that by building along the north bank of the river from New Franklin, just across the river from Boonville, to Machens near St. Charles, it could achieve a more direct route to St. Louis. With the same stroke it could open a substantial region of east-central Missouri that was still dependent on primitive roads, horse-drawn vehicles, and uncertain riverboat service. At Machens the line would join the Chicago, Burlington and Quincy line for quick entrance to St. Louis and convenient access to Chicago. Construction of the new line began in 1892 and was completed in 1895 just in time for Katy trains to roll into St. Louis's brand new Union Station.

The new rail line transformed the economies of the counties through which it ran. Old towns built on the river boomed; new towns and hamlets quickly sprang up, one about every ten miles or so along the tracks. A few towns that found themselves inconveniently inland picked up and

For much of its 230-mile length, as here near the mouth of Moniteau Creek, the Katy Trail hugs the Missouri River bottoms, often passing at the foot of towering bluffs resplendent with the colors of the season. FRANK OBERLE

moved to be on the railroad. Now farmers had convenient and relatively inexpensive access to the St. Louis stockyards for their livestock, and to the milling centers of the nation for their grain. Holding pens and loading chutes accommodated shippers, and grain elevators appeared beside the tracks at many stations; some still stand. Railroad workers and farmers using the railroad were the lifeblood of these small towns, eating at the restaurants, buying from the general stores.

The railroad industry went into a long decline beginning about 1930 as better roads and ever bigger trucks began taking away freight business and buses and airlines took away passengers. Railroad companies began consolidating to survive, next abandoning unprofitable lines—often signing the death warrant for smaller towns along the route. In the 1970s and 1980s passenger trains no longer ran on the Katy line from Sedalia to Machens, and there were fewer and fewer freight trains. In 1986 the M-K-T Company announced that in August it would file with the Interstate Commerce Commission (ICC) for permission to abandon operations along its Sedalia to Machens route.

Many Missourians knew at once what to do. They had the example of the nature and fitness trail established by the city of Columbia after the M-K-T abandoned its spur from McBaine to Columbia in 1977. They also had experienced leaders, notably Columbia attorney Darwin Hindman, who had marshaled public opinion and persuaded the city to acquire and convert 4.3 miles of the abandoned right-of-way from Columbia toward McBaine. The Missouri Parks Association, the Conservation Federation of Missouri, and a dozen or so other conservation and civic groups joined a Katy Trail Coalition.

The state government also reacted quickly and positively, the parks division having tried unsuccessfully for years to secure such an abandonment and not wanting to miss this extraordinary opportunity. On September 16, Gov. John Ashcroft sent a letter to the director of the department of natural resources endorsing the goal of developing a state-owned biking and hiking trail along the full length of the abandoned line. On the same day—all this had been coordinated, of course—DNR fired off an official request to the ICC, asking the federal agency to "bank" the 199-mile right-of-way for future railroad use if ever needed and to issue to Missouri a certificate of interim trail use, as the ICC was empowered to do under a provision of the National Trails System Act.

Almost as quickly, vociferous opposition boiled

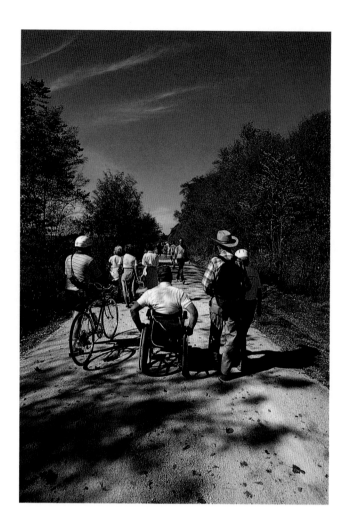

The trail is popular with hikers and bikers, and even the wheelchair-bound find its well-prepared surface inviting. JAMES M. DENNY

up among landowners and in towns along the route. Trail opponents argued that users of the trail would be irresponsible riffraff from the cities, trespassing on neighboring property, stealing, and perhaps committing other crimes. The same arguments had been used against other proposed rail-to-trail conversions—to some extent even along Columbia's 4.3-mile fitness trail—and in many instances had forced abandonment of trail plans. Overflow crowds attended hearings by a legislative committee in several towns along the route. Both proponents and opponents staged demonstrations on the capitol steps when the legislature debated the issue.

The landowners, backed by the Missouri Farm Bureau, filed suit in December 1986, contending that under Missouri law the abandoned land in the right-of-way rightfully must revert to the properties from which it was originally leased or taken by easement. For the state to take the land, their lawyers argued, would be unconstitutional,

a "taking without compensation." The Katy Trail Coalition and other organizations intervened with their own attorneys on the side of the state. The case dragged through the judicial process for three years before the U.S. Supreme Court, in a nine-to-nothing decision, affirmed on February 21, 1990, that the National Trails System Act was indeed constitutional, that rail-banking was a legitimate national purpose asserted by the Congress, and that the M-K-T company had a right to sell the right-of-way to the state for recreational purposes. The supreme jurists also told the landowners, as the lower courts had already told them, that they could take their individual petitions for compensation to the court of claims.

Meanwhile, the Katy right-of-way had become the property of the state. After the ICC gave its blessing in April 1987, an impatient proponent, Edward D. (Ted) Jones, had given the state $200,000 to buy the right-of-way, which the state did promptly. A resident of Callaway County, midway along the trail, Ted Jones was founder and chairman of a nationwide investment company and a man of genuine vision and commitment. M-K-T began salvaging the steel rails and taking up the ties, leaving the ballast of coarse gravel upon which a smooth surface could be laid for bicycle wheels and hiking shoes. But while the lawsuit was dragging on for three years, the legislature would appropriate no money for development and at most provided the bare minimum for patrol and maintenance. DNR posted Keep Out signs. Here and there landowners erected barriers across the trail to assert their claims of ownership, and got their pictures in the newspapers.

Anticipating reluctance by the legislature to appropriate sufficient funds even after the Supreme Court decision, and wanting to see results, Ted Jones pledged $2 million of his own money to restore the bridges and resurface the entire trail with crushed and packed limestone laid over the ballast. Jones was present and was honored with a special medallion when Governor Ashcroft, on April 28, 1990, ceremoniously opened the first pilot segment of the trail at Rocheport. When a second segment was opened October 6 at Augusta, the governor proclaimed it a memorial to Ted Jones and unveiled a monument in his honor. Three days earlier Ted Jones had died of cancer.

Little more than a year later, in December 1991, the Union Pacific Railroad donated to the state 33.6 miles of the old M-K-T from Sedalia to Clinton, thus extending the trail to more than 230 miles.

Hikers and bicyclists flocked to the trail, and parking lots were soon overflowing at trailheads on the completed segments. More than thirty thousand people used the trail in its first season of operation, and businesses sprang up almost overnight in towns along the way to provide food and drink. The people using the trail on a bright October day were typical: Many family groups walked together, including two young mothers with four young children; a two-year-old in a pink suit bringing up the rear was obviously quite tired but had no complaints, no tears—"she's had it," her mother said. A young couple pushed a carriage with a week-old infant—"early training," the father said. Dozens of athletic peddlers passed by on bikes, some singly, some in pairs, some riding tandem on bicycles built for two.

But the people did not detract from the observations of nature: A sound like running water was finally traced to the wind blowing over the

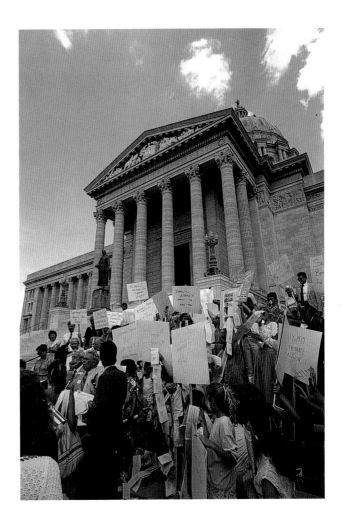

Citizens rally on the steps of the state capitol in support of the Katy Trail. Visible on its bluff across the river for many miles, the capitol is one of many cultural landmarks along the trail. JAMES M. DENNY

tunnel formed by tall trees on the river side reaching toward the tall bluff on the other. The autumn leaves of an ancient Virginia creeper, a gigantic vine, could be seen reaching almost to the top of a two-hundred-foot bluff; from a distance it looked like a celestial swipe of scarlet on the white face of the cliff. The Katy Trail is unique among all the units of the state park system in that its linear corridor traverses three of Missouri's six natural divisions: the Big Rivers, the Ozark Border, and the Osage Plains. Distinctive elements of these landscapes occur in a string of pearls ranging from the sand flats of the Missouri River to the four-hundred-foot limestone cliffs at Rhineland to remnant prairies near Sedalia. Once fully surveyed for its natural resources, the Katy Trail may be shown to contain one of the state's richest assemblages of plant species because it dissects so many different vegetative zones.

Most of the way from Machens and St. Charles to Boonville the trail hugs the Missouri River bottoms, for long stretches at the water's edge, and lies at the foot of steep hills or towering bluffs, themselves resplendent with wildflowers, shrubs, and trees, the whole gloriously colored in autumn. In places it passes through bottomland forest, in other places through croplands reclaimed from the floodplain. Most of the birds that nest in or migrate through Missouri may be seen along the river corridor, one of the nation's great migratory flyways. Audubon societies schedule birding trips, and several major river vantage points provide excellent viewing for great blue herons, bald eagles, egrets, and a host of shorebirds and waterfowl. Blufftops and cliff faces are haunts for red-tailed hawks, falcons, turkey vultures, and kestrels. In Warren County one may see some of the unique Missouri race of Canada geese, which for centuries have nested on the bluffs and led their flightless goslings to the river's edge. Certain stretches of the corridor contain wetlands for a variety of marsh and wet-soil species, and more will be restored or created in the future. Tributary streams have carved U-shaped valleys through the hills or steep canyons to break the bluffs. Here the hiker may see a deer stepping into trailside cover or glimpse a wild turkey like a brown ghost.

On its tangent from Boonville to Sedalia and then to Clinton the trail leaves the river and traverses the Ozark Border through rolling hills, mostly pasture and cropland, but also, and especially near the Lamine River, through deep, wooded valleys. Out on the Osage Plains near Sedalia and Clinton the remnant railroad corridor

prairies are home to the rare regal fritillary butterfly. Protected for a century by the railroad right-of-way and occasional mowing, these remnant prairies will now be restored with the aid of prescribed burns.

Not only does the trail traverse three different natural divisions, but it is also, and perhaps even more importantly, a pathway through history. From its eastern terminus to Boonville the trail parallels the river route taken by the Lewis and Clark expedition when it headed west in 1804 to explore uncharted territory, cross the Continental Divide, and blaze a trail to the Pacific Ocean. No doubt one or both of the intrepid explorers or some of their men, when they disembarked to take bearings or collect game for food, stepped on some of the same land now trod by users of the Katy Trail. This is surely true at Rocheport where, in their journals, the explorers recorded seeing a large limestone rock covered by "uncouth [Indian] paintings of animals" at the mouth of Moniteau Creek.

The trail follows the route of early settlers, some of whom had established outposts along the river even before Lewis and Clark came along. Louis Blanchette, a French-Canadian fur trader, is said to have built a cabin at St. Charles as early as 1769, and he was joined there by several other traders before the town was established in 1787. Farther upstream is the site of Cote Sans Dessein, a French village established in 1808 by Jean Baptiste Roy on a long narrow ridge ("hill without design") opposite the mouth of the Osage River. The village was once a prime contender to be the state capital.

Most of the early settlers along the Missouri, though, were Americans, mostly from Kentucky, Tennessee, and Virginia, who followed the lead of Daniel Boone. The aging Boone, already famous in legend and literature, came from Kentucky in 1799 to take up a land grant offered him by the Spanish government. A monument to the adventurous frontiersman as well as his original grave site lie near the Katy Trail just east of Marthasville. And farther upstream, near the western terminus of the Boone's Lick Trail, the Katy passes the site of Franklin, the leading city of interior Missouri before the river washed it away in 1827 and a starting point of the fabled Santa Fe Trail. Boone's followers brought with them the culture and traditions of the upper South, including, some of them, the institution of slavery. The Loutre Island Methodist Church in Warren County, constructed in 1841–1842 with slave labor and still in good condition, is a fine example of a southern Protestant church not far from the

The Rocheport tunnel provides cooling relief on a hot day. JAMES M. DENNY

trail, and many southern homes as well as a few log houses can be viewed from the trail.

Beginning about 1830 a gradually swelling tide of German immigrants began moving into the area, building new communities on both sides of the Missouri River. German culture predominates today in Augusta, Hermann, and some other towns in the region along the lower Missouri described as Missouri's "Rhineland." Several nineteenth-century homes along the Katy route in St. Charles, Warren, and Montgomery counties reflect German building styles. The trail passes several fine wineries, as well as small-town taverns where one can get a beer or soda.

Every old river town in Callaway and Boone counties has its historic structures—except Providence, which was once a thriving community but is now just a few foundation remains overgrown with brush and trees. Most of Rocheport is a historic district on the National Register of Historic Places. Boonville, where the Katy line turns southwest toward Sedalia, has seven historic districts on the national register. Some impressive residences built by prosperous farm families in the 1800s are within view of the trail in Cooper County. And Sedalia, once the railhead

on the competing Missouri-Pacific line and a destination for cattle drovers out of Texas after the Civil War, has numerous historic buildings.

The art and science of taking railroads over streams reached their zenith in the 1890s, a decade known to civil engineers as the "golden age of bridge building." The M-K-T company had to span many creeks and branches, and those crossings, metal-truss bridges now floored with planks, remain for trail users to admire and photograph. The trail also goes underground for 243 feet near Moniteau at Rocheport. The tunnel with its picturesque stone-masonry faces was quarried through a mini-mountain that left no room between it and the river channel to lay a railroad. The Rocheport tunnel itself is listed on the national register.

Three handsome railroad stations of notable design remain. The largest and most impressive of these is the Sedalia Depot, about all that is left of extensive M-K-T facilities that included a roundhouse and repair shops, stockyards, and a hospital for company employees. The depot at Marthasville near the other end of the line is a quaint frame structure with characteristic wide eaves supported by stylized stick bracketing. The only one of its kind left on the abandoned Katy line, it is typical of many that once served small towns in rural areas. The Boonville Depot was built in the mission style with stucco walls, a red tile roof, and extended eaves. A fourth depot of historical and architectural interest at North Jefferson, across the river from Jefferson City, was totally destroyed by an arsonist's fire in the dark night hours of October 28, 1988. Thus, a potential museum and rest stop for trail users was lost. But the others will be restored to serve as they always have, as way stations along the route.

We have only begun to explore the natural and cultural potential along this extraordinary pathway of wildlife and commerce and history. The most exciting years are yet to come. We can expect (and prod) public agencies to respond to renewed interest by restoring wetlands and other bottomland habitat and providing better access to the great river itself. We can encourage county commissions and town councils to plan ahead for the development that will surely come, in order to avoid sprawl or honky-tonk. And we can hope that citizens in small towns and rural areas along the route will use the enormous popularity of the trail as a stimulus to revitalize their local economies, restoring historic structures for bed-and-breakfasts or restaurants or residences. The travelers have embarked, and work has already begun on this historic pathway to the future.

First Missouri State Capitol State Historic Site

T HE RESTORATION OF Missouri's first state capitol in St. Charles in the 1960s was the catalyst that sparked the creation of the nine-block historic district surrounding it. This area, known as Historic South Main Street, features a variety of shops and restaurants occupying early nineteenth-century buildings along Main Street that were restored with private capital attracted by the newly refurbished historic site. The district, listed on the National Register of Historic Places in 1970, lies adjacent to the Missouri River immediately upstream from the old Route 115 bridge.

At 208–216 South Main, a simple Federal style, two-story brick row housed the capitol complex. The complex is really three separate but adjoining buildings; arched drives leading through the buildings to the rear yards separate the first floors of each. Originally built in 1818–1819 for commercial and residential purposes, the structures achieved their greatest fame as the seat of Missouri government for more than five years, from 1821 to 1826.

Selection of the new state's temporary capital city was embroiled in the controversies over admission of Missouri to the Union. The serene, parklike setting of the old capitol, as it appears today, belies the stormy nature of the first legislative sessions held there. The legislators—forty-three representatives and fourteen senators—were a mixture of tobacco-chewing frontiersmen and southern gentry. Before them was no simple task; they had to create a state government out of the Missouri Territory.

The population of the territory had grown rapidly after it was added to the United States with the Louisiana Purchase of 1803, and petitions for

statehood appeared as early as 1817. Missouri's admission to the Union was caught up in the national controversy over controlling the spread of slavery, which in Missouri was viewed as an issue of state rights versus federal autonomy. On March 3, 1820, the U.S. Congress passed legislation that would become known as the Missouri Compromise, whereby Missouri would be admitted as a slave state while Maine would be a free state. But the debate was far from over.

In the early summer of 1820 delegates from some fifteen counties assembled in St. Louis to draw up a state constitution, and on August 28 the first state election was held. In addition to choosing a governor, a lieutenant governor, and a representative to Congress, voters elected members of the general assembly. The assembly convened for the first time at the Missouri Hotel in St. Louis on September 19.

The new state constitution provided for a permanent seat of government to be located on the banks of the Missouri River "within forty miles of the mouth of the river Osage." But while Missourians thrust and parried over the location of the permanent capital and while the "City of Jefferson" was being prepared, Missouri's government would need a temporary home. Locating the temporary capital was one of the first tasks of the first legislature.

At least nine towns competed for the honor of being the temporary capital city. A bustling city of about a thousand people with excellent access to the most rapidly growing areas of the state both by river and via the Boone's Lick Trail, St. Charles presented obvious advantages. And its prospects were undoubtedly enhanced when some prominent citizens offered "to furnish free

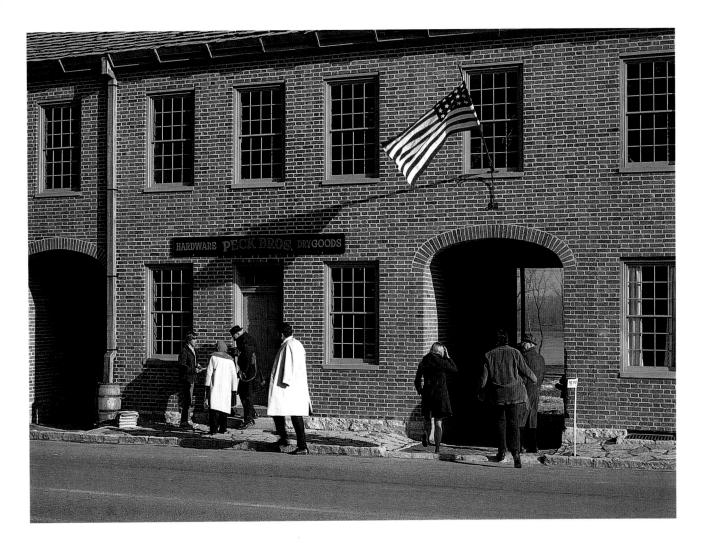

Missouri's first general assembly met above the Peck brothers' store on South Main Street in St. Charles, on the bank of the Missouri River. STATE PARK ARCHIVES

of expenses to the state, rooms suitable for the accommodation of both branches of the General Assembly, and also committee rooms." They had in mind rooms rented by the city and used as a courthouse. On November 25, 1820, Gov. Alexander McNair signed the bill designating St. Charles the temporary capital of Missouri; it would serve until October 1, 1826.

The buildings selected as the capitol were owned by the Peck brothers, Charles and Ruluff, who operated a general store and lived on the first floor of the middle building, and by Chauncey Shepard. The senate and the "room" of representatives as well as Governor McNair's office were upstairs. Today, all these rooms, including the Peck and Shepard residences and the store, have been restored and furnished to reflect the 1821–1826 period.

The legislators first convened in their new capitol on June 4, 1821, in an emergency session. What followed were weeks of debate, probably as rough-hewn as the pine flooring of the Peck brothers' building. The issue of slavery, per se, was not argued—it was taken for granted. Instead, the debate centered on a controversial clause of the Missouri constitution (article III, section 26) which made it mandatory that the general assembly pass laws "to prevent free negroes and mulattos from coming to, and settling in this state, under any pretext whatsoever."

Congress had made it clear that statehood would be denied unless this objectionable phrase, which seemed to jeopardize the constitutional rights of free black citizens, were deleted. But many of the legislators feared that free blacks might incite trouble among Missouri's heavy slave population—nearly one-sixth of the state's sixty-six thousand residents. Finally, the Missouri lawmakers relented to the extent of passing a "Solemn Public Act" declaring that section 26 of the Missouri constitution would never be construed to restrict the constitutional rights of any

The restored assembly chambers of the state's first capitol host a variety of historical reenactments.
JAMES REHARD

citizen of another state. On August 10, 1821, President James Monroe proclaimed Missouri the twenty-fourth state.

St. Charles remained the capital until the government moved to Jefferson City in the fall of 1826. Four Missouri governors ran the state's affairs from the capitol in St. Charles. McNair was replaced by Frederick Bates, elected in 1824, but Bates died less than a year later. Thereupon, senate president Abraham J. Williams became the temporary governor for a few months until a special election in December 1825 selected John Miller. Miller oversaw the moving of the state government from St. Charles to Jefferson City.

After 1826, the buildings were used for a variety of residential and commercial purposes. By the early part of the twentieth century the former capitol row—and, indeed, the whole neighborhood—had begun to decay. The site was marked by the St. Charles Knights of Columbus in 1921. During the next two decades, local VFW and DAR groups began efforts to convert the old capitol into a museum, and in 1938 the state planning board prepared a study recommending preservation of the buildings, but nothing happened. Finally, in 1961, after much prodding from

St. Charles citizens and officials, the state purchased the properties that had housed the old capitol, using money from a special Spanish American War fund controlled by the governor. The major funds required for restoration—some $600,000—were appropriated by the general assembly in recognition of the state's upcoming sesquicentennial, after appointment of a high-level First Missouri State Capitol Restoration Commission.

Restoration and furnishing of the structures presented vexing dilemmas to park historians and planners, because no records have been found that indicate the uses of particular rooms or describe their appearance or furnishings. State documents relating to the St. Charles sessions of the legislature were apparently destroyed in the spectacular conflagration that leveled Missouri's third state capitol in Jefferson City in 1911. But the process of restoration provided a few clues, such as the size and shape of the original rooms. Eleven of the rooms have been restored, and nine are furnished.

The restorations have been handled with such care that the building seems no older than it actually was when its halls reverberated with heated debates over state rights and slavery. And, just as the first state capitol brought a flurry of activity to the young town on the Missouri River, so too its restoration has given old St. Charles a new lease on life.

Deutschheim State Historic Site

I N THE 1830S MUCH OF the lower Missouri River valley was promoted as a second Germany to thousands of immigrants seeking economic, intellectual, religious, or political freedom. The result was the most intense immigration movement in the history of the state. By 1860 over half of Missouri's diverse foreign-born residents were German; today at least half of all Missourians claim at least one grandparent of German ancestry. Some towns like Hermann, founded in 1838, were conscious efforts to re-create German towns left far behind, with German language and customs and crafts. The region from St. Louis to Boonville along the Missouri and a smaller area along the Mississippi centered around Perry and Ste. Genevieve counties had become by the mid-nineteenth century, in the words of several writers, a true *Deutschheim*, or "home of the Germans."

Many of the settlers were attracted to the state by the prose of one of their fellow countrymen. Gottfried Duden had taken up the life of a gentleman farmer in Warren County in the 1820s. His 1829 collection of letters, entitled *Bericht über eine Reise nach den westlichen Staaten Nordamerikas* (Report on a Journey to the Western States of North America) is broadly—perhaps too broadly—credited with stimulating waves of immigration during the thirty years before the Civil War. A sample of Duden's promotional style explains his appeal:

I cannot describe the impression that the days of wandering in this river valley have made upon me. One can travel hundreds of miles between gigantic tree trunks without a single ray of sunlight falling upon one's head. The soil is so black here from the plant mold that has been accumulating since primeval days that one seems to be walking on a coal bed. . . . Settling next to charming hills, near never-failing springs, on banks of small rivers near their junction with large rivers, all depends entirely on the option of the settler without taking the price into consideration.

Duden warned his fellow countrymen that frontier settlement should not be undertaken lightly, but his romantic descriptions were more compelling. After discovering for themselves that opening the frontier was easier to read about than actually to undertake, some settlers blamed Duden for misleading them, calling his book "Duden's Eden." He revised the book in 1834, using the occasion to lambaste his detractors. Then, disillusioned, he eventually ceased promoting emigration. But the effects of his love for the Missouri valley could not be undone; German settlers left an indelible mark on Missouri's culture, industry, and politics.

Some of the communities in the Deutschheim region were settled by organized societies of German immigrants, of which seven functioned in Missouri. One such group, the *Deutsche Ansied-lungs-Gesellschaft zu Philadelphia* (German Settlement Society of Philadelphia), founded the city of Hermann. Another, the Emigration Society of Giessen, set up Dutzow four years earlier, downstream and on the opposite bank of the river. The founding society of Hermann was unique in that it was set up as a joint-stock company advertised throughout the eastern United States and Germany. Members bought shares of stock that entitled them to land in the proposed colony or that could be held in anticipation of

Caroline Pommer, widow of one of the organizers of the Philadelphia Society, which platted a colony at Hermann in 1838, built this handsome neoclassical home for her family and her musical instrument business in 1840. NICK DECKER

profits to be derived from the new "German Athens of the West." The society, organized in 1836, acquired eleven thousand acres in Missouri in 1837 and laid out the colony on paper before platting it in 1838. It was to be a culturally integrated, self-supporting economic complex based on farming, industry, and commerce to which Germans could come to preserve their heritage and traditions. About half the members came from the Philadelphia area, but the rest were from twelve other states, Canada, and Germany itself. Today, Hermann maintains much of the look and certainly the charm of a nineteenth-century German river town. Its well-maintained

historic district and seasonal events like the Maifest and Oktoberfest, along with the revitalized wine industry, attract many visitors.

Deutschheim State Historic Site includes two buildings donated to the state in 1978 by the Hermann Brush and Palette Club, a local preservation society. But it is impossible to separate these two houses from their setting—the rest of Hermann. The community of Hermann has developed an uncommonly strong sense of pride in its heritage. More than one hundred of the structures in the small town have been placed on the National Register of Historic Places. So visitors to the Pommer-Gentner and Strehly houses, operated by the parks division, can also see the German school building (1871), White House Hotel (circa 1868), Eitzen house (circa 1850), Poeschel house (circa 1840), and the Concert Hall (circa 1878), among many others. And tours of the old Stone Hill Winery and Hermannhof Winery (a former brewery) are as colorful as the Rhineland

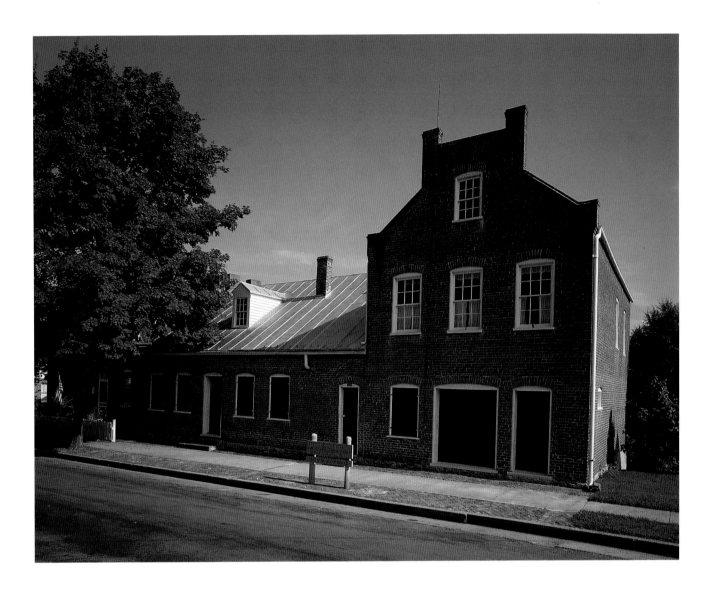

Carl Procopius Strehly and Eduard Muehl published the Wochenblatt *and* Licht-Freund *newspapers from Strehly's house in the 1840s. The two-story addition on the right was added later for a winery.*
OLIVER SCHUCHARD

wines they sell. At one time Stone Hill, founded after 1847, was the third largest winery in the world; the 1856 Hermann production was a hundred thousand gallons of wine. The industry crashed with Prohibition in 1920, but the last two decades have witnessed an aggressive comeback.

Of the two structures administered by the state, the Pommer-Gentner house is the older by two years. It was built in 1840 for the family of Caroline Pommer, widow of one of the organizers of the Philadelphia Society. The first two-story brick house in town, it is a sterling example of German neoclassicism on the frontier. Unable to

support the family by making musical instruments in Hermann as they had in Philadelphia, two of Pommer's sons became carpenters, another son sold furniture from the shop side of the house, and several more of her nine children ended up in St. Louis. After a succession of other owners from 1856 to 1882, the house came into the possession of G. Henry Gentner and his wife, who had arrived at Hermann in December 1837, four months before the town was even laid out, and raised their family on a farm southwest of town in the intervening years.

The Strehly house, a fine example of German vernacular architecture, was built over a period of twenty-seven years, beginning about 1842. The core of the house, two stories with a deep front porch reflective of borrowed French building techniques, was built by another early stockholder, Andreas Doldt, who sold it to Carl Procopius Strehly in 1843. The house had a stone ground floor, where Strehly and his brother-in-

law Eduard Muehl operated a full-service printing business. They produced two of the earliest German-language newspapers west of the Mississippi, the *Licht-Freund* (Friend of Light) from 1843 to 1847 and the *Wochenblatt* (Weekly Paper) from 1845 to 1855, as well as job printing and at least one book by Friedrich Muench, a frequent contributor to the papers. The *Licht-Freund*, a rationalist and religious biweekly with readership among German-Americans across the country, frequently editorialized against Catholics, structured Protestantism, and government regulation and promoted the abolition of slavery. Opposition to slavery was widespread in the German communities, and the strong Northern sympathies of most German immigrants helped hold Missouri in the Union. After Muehl died in 1854, Strehly sold the printing business and all his equipment to the Graf family, and went into the wine business. A legacy of the printing business can still be seen when entering the Strehly house: the doorstep is a block of lithographic limestone from the old printshop.

Since 1844 the Hermann town council had encouraged the development of the wine industry by making vacant building lots available to growers for no money down and with no payments required for five years, shortly extended to ten years. Carl Strehly took up several wine lots and by 1857 built a winery next to his house complete with a wine production floor, a vaulted brick cellar, and an upper floor to serve as a tavern where his wines could be sold and enjoyed. A beautiful hand-carved cask can still be seen in the winery, and grapevines planted by the Strehlys in the nineteenth century can still be seen running the length of the backyard.

Strehly joined the house and winery and enclosed the front porch of the house about 1869 to add more rooms. His daughter Rosa, who never married, lived in the house all her life, from 1867 to 1963, first with her parents, later with a nephew; as her income was limited, she made few changes in the structure. When she died, virtually the entire contents of the house went with the buildings to the Brush and Palette Club, which had previously, in 1952, saved the Pommer-Gentner house from destruction. The club gave both houses and their contents to the state in 1978, making possible the establishment of Deutschheim State Historic Site to serve as a museum of Missouri German culture and traditions.

The Strehly house has undergone major conservation and restoration, making it with its strong collections an extraordinary window on the daily life of a German middle-class family of limited means for the era 1860–1885. The Pommer-Gentner house is being restored and furnished to reflect the earlier settlement period of the 1830s and 1840s. Each house also has an appropriate period garden. With changing exhibits and an ongoing series of programs on German customs, Deutschheim State Historic Site reflects and interprets the special characteristics of German and German-American settlements throughout Missouri.

Jefferson Landing State Historic Site

WHEN CAPT. CHARLES B. MAUS returned home to Jefferson City in 1865 after Civil War service in the federal army, he decided that the name of the hotel he had built in the 1850s should be changed to more forcefully demonstrate his wartime sentiments. Thus did the old Veranda Hotel at the base of Jefferson Street on the Missouri River landing become the Union Hotel, and so also has it come down to us, in part as a testament to the strong pro-Union loyalties of Jefferson City's German population.

The lower end of Jefferson Street had been a lively commercial and transportation hub ever since the state's seat of government moved from St. Charles to the new city built for it in 1826. In 1839 James A. Crump built a sturdy stone building that served as grocery store, warehouse, tavern, telegraph office, and hotel for the growing state capital traffic. Business flourished in the area that became known as "the Landing," and Crump's Missouri House Hotel won a reputation as a meeting place for rivermen and legislators. The landing was the capital city's primary commercial center and official city wharf.

In 1852, Charles F. Lohman bought part of the stone building built by Crump and opened a general store with his brother-in-law, Charles Maus. Three years later Maus built his own new brick hotel and warehouse building across Jefferson Street from the old Missouri House Hotel, which had been renamed the Pacific Railroad Hotel in 1853. Perhaps to capitalize on the rival hotel's early reputation, he named his new hotel the Missouri Hotel. It became the Veranda Hotel two years later.

In 1855 the Pacific Railroad reached Jefferson City from the east, promising even more prosperity. For several years thereafter, Jefferson City was the rail terminus, and all passengers and freight going on upriver transferred there. Business boomed along with the state as Missouri experienced an epic burst of settlement and development, nearly doubling its population from 682,044 to 1,182,012 in the single decade of the fifties. During this time Charles Maus's brother Christopher built a modest brick structure a few doors south of his brother's hotel, where Christopher served as a saloon keeper.

Then came the war. Charles and Christopher Maus enlisted in the Union army, while a third brother is said to have fought for the Confederacy. Lohman stayed behind and bought more of what has since become known as the Lohman building. He developed one of the city's largest warehouse and mercantile businesses using the building's ground floor.

After the war, and the rechristening of the Union Hotel, Missouri River traffic began a steady but slow decline as the railroads rose in power and dominance. Tied as they had been to the steamboat trade, Maus and Lohman eventually relocated to Jefferson City's High Street in the mid-1870s. The old Jefferson Landing hotel, warehouse, and store buildings served as storage and tenements until the early twentieth century, when they were combined into a large shoe factory. Because of their declining condition they were about to be torn down for the proverbial parking lot in the late 1960s during our national craze for demolishing old buildings.

Almost miraculously, a combination of an alert local citizenry led by Elizabeth Rozier and support from the preservation movement all across Missouri resulted in a reprieve for this riverfront

*Charles Lohman's stone building on the wharf below
the state capitol served as a grocery store, warehouse,
hotel, tavern, and meeting place for legislators, river-
men, and, later, railroad engineers and passengers.*
OLIVER SCHUCHARD

complex. Four years later, state park officials proposed to restore the buildings to correct period appearance and open them to the public as part of an integrated approach to history and culture in the state's capital that would also include the park system taking over operation of the state museum and conducting the public tours of the capitol building. First Lady Carolyn Bond endorsed this plan, and her enthusiastic support led the state bicentennial commission to adopt the Jefferson Landing proposal as the state's official bicentennial project. All three of the remaining historic structures at the landing—the Lohman building, the Union Hotel, and the Christopher Maus house—were restored in time for their dedication on July 4, 1976.

As Missouri's oldest intact river-landing commercial district, Jefferson Landing tells an important story of how Missouri grew during those crucial years of the mid-nineteenth century. Missouri was the main conduit of national expansion into the far West, and much of that epic migration went right by the front doors of the hotels at Jefferson Landing—or stopped overnight, if there was room. Freight shipped to or from Jefferson City or transferred there from rail to steamboat also utilized the buildings. The lower doors of the Lohman building are double, apparently to provide easy access to freight for the boats that could pull up nearly to the building; built-in hoists above the top-floor doors helped to lift heavy loads.

Maybe things aren't quite as bustling down at the landing these days, but they generate a different kind of excitement. While the exteriors of the buildings have been restored to their mid-nineteenth-century appearance, the interiors have been adapted for modern use. A lack of documentary and architectural information made a reconstruction of period interiors impossible. Instead, the focus of Jefferson Landing State Historic Site has been on recapturing some of the original function of the landing area as a gathering place for the citizens of Jefferson City and their guests.

The Lohman building houses an exhibit area that tells the story of Jefferson City, the capitol, and the landing itself. Every year thousands of schoolchildren from all over Missouri tour these exhibits to learn of their capital's history. There are facilities also for public meetings and meetings of various local and state groups, and the site staff arranges noontime brown-bag lunches and films. The Union Hotel has a public gallery for the exhibition of Missouri arts, a gallery appropriately named in honor of the landing's savior, Elizabeth Rozier. The bottom level of the Union

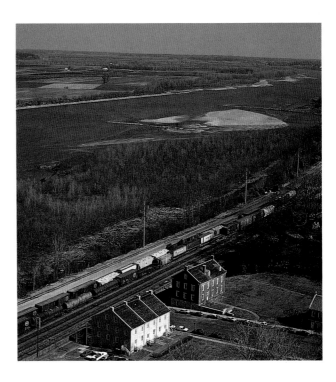

A bird's-eye view from the capitol dome shows Jefferson Landing, the railroad, and the now-channelized Missouri River. NICK DECKER

Hotel has even been restored to something of its old-time commercial bustle through its use as the Amtrak passenger-train station—once again a gateway to the city. The upper floors of the Union Hotel and the Lohman building house the offices and workshops of the Missouri State Museum and the outdoor exhibit program of the parks division. The Christopher Maus house has had its exterior restored and may someday open as a museum of daily life in the old City of Jefferson.

Just up the hill from the Christopher Maus house to the east is the governor's mansion with its lovely gardens and trees, and just to the south are the formal plantings and reflecting pool of the governor's garden. All of these grounds and the grounds of the capitol itself are cared for by the parks division.

Originally, all local lines of communication crossed at the landing—steamboat, river ferry, stagecoach, telegraph, and railroad. The hotels, saloons, warehouses, and mercantile establishments provided business activity by day and social activity by night. Today, the site staff is working to reestablish the landing as a gathering place through exhibits, public meetings, and special events both indoors and on the grounds. Rather than reconstructing the past, Jefferson Landing perpetuates a tradition of community activity within a historic setting.

A redbud native to Missouri frames the state's Roman Renaissance style capitol, built during a crest of progressive idealism after a disastrous fire in 1911 destroyed its predecessor, which had served since the 1840s. OLIVER SCHUCHARD

State Capitol and Missouri State Museum

Build us a new capitol, build it fine and large, build it grand and imposing, of Missouri marble, of Missouri granite, of Missouri onyx. Let it be a mute but eloquent monument of the resources of a great state, and, in no less a degree, an inspiring symbol of the fine and splendid citizenship which, proud of its state, voted the means and paid its taxes to put it there.

—Vandalia Leader, reprinted in *The Voices of the Press on the New State Capitol*, Jefferson City, 1911.

T HE ARCHITECTURE of public buildings, especially a seat of government, is intended to reflect the buildings' function as well as the people they serve. Missouri boasts a truly distinguished state capitol, one that in important ways reflects the best of Missouri's people and government. Its setting could hardly be better: in the heartland of the state on a bluff overlooking the broad and fertile valley of the Missouri River, a historic transportation corridor that was a key to the state's development, and backed by a city large enough to provide many urban amenities, yet small enough to retain the flavor of outstate Missouri.

The style of the capitol—Roman Renaissance—is typical of the public architecture of the early twentieth century when it was constructed. Considered a superb example of its kind, the building is grand and yet pleasingly balanced. But the aspect of the capitol that most elevates it to prominence among similar edifices in other states is its superb and lavish artistic decoration. The building is literally a museum of public art. This artwork is remarkable both for its quality

and abundance and for its faithful reflection of the themes, events, and people who have made up the story of Missouri. It is ironic that this extraordinary collection of decorative art was, in a sense, a fortuitous and almost accidental afterthought.

The present capitol building was constructed between 1913 and 1917 and dedicated in 1924. It was the second capitol building on that location, which in turn had been preceded by several other seats of government. American authority in Missouri was established following the Louisiana Purchase in 1804 at the Government House building in St. Louis. The state constitutional convention was held in 1820 in the Mansion House Hotel, also in St. Louis. The first general assembly met later that year at another St. Louis hotel, the Missouri Hotel. As Missouri was about to become a state in 1821, a temporary capitol was established at St. Charles, where it was to remain until a permanent seat of government could be prepared—at a location to be chosen by a special commission instructed to find a site on the Missouri River within forty miles of the mouth of the Osage River. Several sites were considered and rejected—including the leading contender, Cote sans Dessein, where old Spanish land titles could not adequately be cleared—before the general assembly in 1821 approved the present site and in 1822 named it the City of Jefferson in honor of the president responsible for the Louisiana Purchase.

The first capitol in Jefferson City was built in 1826, a handsome Federal style structure, but only forty by sixty feet in size. It not only served legislative needs, but the governor lived in it as well. The building burned in 1837 and was re-

The state capitol is a gallery of public art. Frank Brangwyn of London painted the murals in the dome representing earth, fire, water, air, agriculture, education, fine arts, and science. NICK DECKER

placed in 1840 on the present site, two blocks away, by a much larger and highly regarded Greek Revival structure. This capitol survived the Civil War and was enlarged in 1887–1888, but timber construction in the new dome made it, too, vulnerable to fire.

One of the most spectacular conflagrations in Missouri history was kindled in the dome of the capitol building by lightning on the stormy evening of February 5, 1911. The story of the fire is a dramatic one involving heroic efforts by hundreds of fire-fighting volunteers, prisoners, legislators, and public officials. In the end, many state records were saved, but the proud old building was ruined.

Every bit as heroic as the fire-fight was the ensuing struggle to erect a worthy successor. The old capitol had for years been too small to accommodate the growing functions of state government, but the legislature, tenacious in its her-

itage of antitax sentiment extending back to the days of Radical reconstruction after the Civil War, had repeatedly declined to expand facilities. In retrospect, the fire could hardly have come at a better time, for Missouri was at the crest of progressive idealism and had a governor, Herbert Spencer Hadley (nationally acclaimed prosecutor of the Standard Oil Trust), who was determined that Missouri should take its rightful place as a leader among the states. Though the Republican Hadley had previously been thwarted by conservatives in the Democratic-controlled legislature in his efforts substantially to raise taxes, he succeeded within two months of the fire in forging a bipartisan legislative coalition to authorize the issuance of $3.5 million in state bonds for a new and much larger capitol. Missouri voters approved the bond issue in August, and Hadley appointed a four-member State Capitol Commission to administer the planning and construction.

The bipartisan citizen commission chaired by Columbia newspaperman E. W. Stephens studied and fought through a series of issues concerning such matters as financing, an architectural competition, and choice of building stone. The commission announced a design competition that drew sixty-eight entrants nationwide and was won by Egerton Swartwout and Evarts Tracy of New York. Their classically symmetrical structure evocative of the nation's capitol in Washington, D.C., and built of Missouri marble from quarries at Carthage and Phenix, began to rise above the high ground overlooking the river in 1913.

And then came a most pleasant surprise. The special property tax levy that had been earmarked for the capitol bonds was in fact producing more funds than had been expected, while material and labor costs for the well-managed project were less than estimated. In response to a request from the commission, the attorney general ruled that these funds could not legally be used for any purposes other than the capitol. Under these circumstances, it was agreed in 1917 that another commission, the Capitol Decoration Commission, would be established to use the slightly over $1 million of surplus funds to decorate the building. The chairman of this second distinguished citizen commission was University of Missouri art history professor John Pickard, after whom Pickard Hall on the Columbia campus is named.

Over the course of eleven years, the decoration commission recruited some of the most notable artists of the day from both America and Europe and oversaw the creation of a resplendent collec-

tion of stained glass, murals, carvings, castings, and statuary. All of these works relate directly or indirectly to the people and history of Missouri, and the commission took great care to match artists to subjects and to ensure historical accuracy. Frank Brangwyn of London, whom Pickard considered to be the preeminent mural painter in the world, was commissioned to do the murals in the dome; N. C. Wyeth painted the Civil War battles of Wilson's Creek and Westport; Missourian Frank B. Nuderscher did a lunette of the Eads Bridge in St. Louis, using an optical trick that changes the viewpoint perspective from left to right as one walks past (a favorite of tourists); and a group of artists, the Taos Society, which included Oscar Berninghaus of St. Louis, was commissioned to paint frontier and Indian scenes. A surprising number of these works are extremely highly regarded, and in their totality the decorative arts of the Missouri State Capitol are indeed extraordinary.

The art is still there for all to see; but what is less known, though no less worth pondering, was the constant but successful rearguard action waged by the Pickard commission and other citizens and political leaders against the efforts of certain politicians, including on occasion the governor, to divert funds earmarked for capitol decoration to other needs of a perennially impecunious state.

The decorations of the 1920s were later supplemented by a masterwork of Missouri's Thomas Hart Benton, whom the legislature in 1935 commissioned to paint a mural on the four walls of the house lounge. Benton's *Social History of the State of Missouri* fills in with bold and vivid strokes scenes of everyday life in the state's past and, in so doing, offers a commentary from the perspective of the depression decade on the lofty themes of the rest of the capitol art. Highly controversial at the time, the mural is now Missouri's pride.

If you are visiting the capitol for the first time, you may be surprised to discover that your guides wear state park uniforms. In 1976, responsibility for the Missouri State Museum, for capitol interpretation, and for the Jefferson Landing State Historic Site was vested in the parks division, which also took over maintenance of the grounds. Your tour will cover all major aspects of the capitol building and its artwork. On your tour be sure to linger in the Missouri State Museum. This two-part museum, with a wing devoted to history (formally dedicated in 1919 as the Missouri Soldiers and Sailors Memorial Hall) and a wing devoted to resources, is an original part of the design of the building and covers much of the

Cutaway dioramas affording a 3-D view of the characteristic features of each of the state's six natural divisions fascinate children and adults alike on their visits to the Missouri State Museum. SUSAN FLADER

ground floor. A vigorous renovation program in the 1980s has made this museum probably the leading showcase of the state's history and resources. The natural history exhibits are arranged according to the six natural divisions of the state, with ingenious cutaway dioramas portraying the characteristic landforms and landscapes, while the history exhibits are arranged according to major eras and cultural groups.

And don't confine yourself to the interior of the capitol. Much of the excellence of the building is in its exterior design and statuary, including Karl Bitter's bronze relief of the signing of the Louisiana Purchase treaty, which sits on the terrace overlooking the Missouri River. The landscaping of the grounds has been upgraded to provide a handsome complement to the building, with seasonal floral displays and fine specimens of a large number of tree species native to the state.

The Missouri State Museum is legally a unit of the state park system, but the capitol building itself serves as the seat of government and is not a state park. It was thus an irony of history when supporters of the park system in 1990 found themselves calling on other concerned citizens and legislators to prevent an attempted diversion of nearly $1.4 million from the Park Sales Tax Fund for the purpose of repairing the exterior masonry of the capitol. One could imagine Herbert Hadley, E. W. Stephens, and John Pickard standing alongside them, arguing for the integrity of the dedicated park fund and calling on Missourians and Missouri officials once again to rise to their better nature and come up with the money necessary properly to maintain the most important building in the state. For the Missouri State Capitol is not only one of our most rewarding windows on the cultural and natural legacy of the state; it also represents a triumph of vision and vigilance by Missourians who dared to believe that their state could accomplish something truly great.

Boone's Lick State Historic Site

WHILE LEGENDARY PIONEER Daniel Boone spent his last years at his home in western St. Charles County, his sons explored and hunted much of Missouri. In 1805, Nathan and Daniel Morgan Boone began manufacturing salt at a Missouri valley site in what is now southwestern Howard County. Within six years the Boone brothers had lost interest in the salt business, but their enterprise gave these salt springs and a major interior region of Missouri a new name. Even today this part of the state is known as the Boone's Lick (or Boonslick) Country. And the trail the Boones and thousands of early settlers followed from St. Charles to the salt springs and the rich farmlands of the Missouri valley in Howard and other counties became known as the Boone's Lick Trail.

Salt springs, or salines, were desirable in a frontier society and relatively common in this part of the state, though few were as large or as well known as Boone's Lick. Lewis and Clark recorded "a large lick and salt spring of great strength" about four miles southeast of "a cliff called the Arrow Rock" on their trip up the Missouri in 1804, though it may have been across the river from Boone's Lick in what is now Saline County. The lick the Boones worked was on four hundred arpents claimed as a Spanish grant by James Mackay, from whom they leased it for a few years before buying several quarter-sections with their partners in the enterprise, James and Jesse Morrison.

In an interview more than four decades later, in 1851, with famed historian Lyman Draper, the aging pioneer Nathan Boone said they initially had six to eight men using forty kettles and one furnace to boil the brine. They produced twenty-five to thirty bushels of salt a day and boated it to settlements downriver, where it sold readily for two to two and a half dollars per bushel. As the business grew, Boone recalled, they added furnaces and kept fifteen to twenty men employed, making a hundred to a hundred and thirty bushels a day. They paid each man about fifteen dollars a month.

Producing salt was a long process. The brine, or saline water from the spring, was poured into large kettles that held from ten or twenty gallons to as much as one hundred gallons each. The brine was then heated over a stone furnace; as it boiled, various bitter compounds would precipitate out at the bottom of the kettles. This "bittern" or "powder scratch" had to be removed periodically with long-handled ladles. As the water evaporated, salt crystallized in the kettle. About two hundred and fifty to three hundred gallons of brine were required to obtain one bushel of salt. To boil all this water required hundreds of cords of wood.

Daniel Morgan Boone sold out to James Morrison in 1810, and Nathan pulled out two years later when he was appointed captain of the rangers in the War of 1812. Forty years later, Nathan would blame their departure from the salt business on insufficient profit and Indian pillaging of "working and beef cattle." After three years of disruption and occasional terror in the interior settlements, during which the salt operation was damaged and apparently shut down, Nathan Boone was appointed by the territorial government in 1815 to survey the overland route from St. Charles to the interior that he and his brother had earlier pioneered, hence the name *Boone's Lick Road*. A floodtide of settlement surged into

233

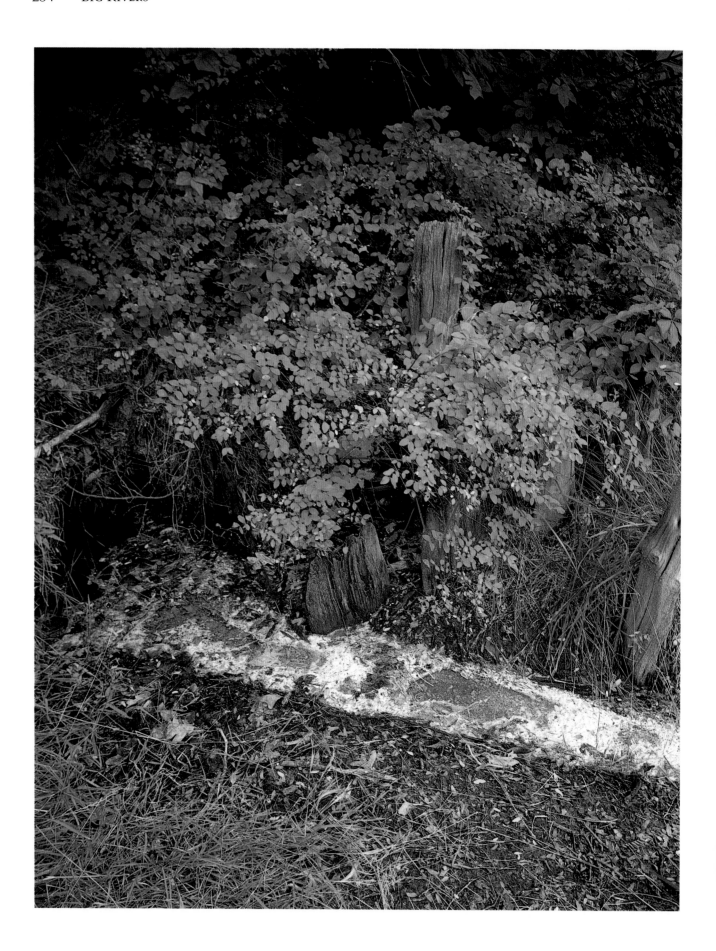

the Boone's Lick Country during the next few years.

The Morrisons continued making salt at the lick until 1833. The operation was managed for a time by William Becknell, who also operated a ferry across the Missouri in the vicinity of Boone's Lick and Arrow Rock beginning in 1818. It was from Boone's Lick that Becknell wrote in June 1821 about his intention to organize an expedition to trap, hunt, and trade in the southern Rocky Mountains later that summer. This was the expedition that was met near Raton Pass that November by a detachment of Mexican troops who informed Becknell and his men of Mexico's independence from Spain and invited them to Santa Fe—the storied beginning of the Santa Fe trade that brought prosperity and political power to the Boone's Lick Country.

After James Morrison advertised Boone's Lick for sale in 1831, the record becomes more murky. Despite litigation over a lease to Lindsey P. Marshall and purchase of the site by James and John Marshall at a sheriff's sale in 1850, there is little evidence of commercial activity until after the Civil War, when a Marshall relative from Canada, Henry Brown, bought a one-third interest in the property and formed the Boone's Lick Salt Manufacturing Company. After several years of effort, including drilling a thousand-foot well, they decided the lick was not salty enough to be profitable. As the nineteenth century wound down, W. N. Marshall proposed damming the springs to raise oysters and saltwater fish. His plan failed, supposedly, because he could not find adequate fresh water in which the oysters could spawn.

The Daughters of the American Revolution marked the site of Boone's Lick in the early twentieth century, but it remained relatively unknown. Then in 1960 Mr. and Mrs. J. R. Clinkscales of Boonville and Horace Munday donated to the state park board two small tracts totaling about seventeen acres that contained what remained of the salt lick. A limited archaeological survey at the time revealed evidence of a rock-lined furnace exposed in cross section by erosion of the banks of Salt Creek, which flows from the springs to the Missouri River. There were remains of a boxlike structure surrounding the well

The trickle of a saline spring is the only surface evidence of a salt manufactory operated by the sons of Daniel Boone, who helped open a promising region of settlement. OLIVER SCHUCHARD

that had been drilled around 1870, remains of another box around the lower salt spring, and various partially buried wooden timbers near the upper spring. The timbers were assumed to be from later activity not related to the early salt industry, on the theory that exposed wood would not have remained intact for a hundred and fifty years. And that was about it. The site would obviously require the visitor to exercise his or her imagination.

Over the succeeding decades, the remains were further obliterated until even the rock-lined furnace could no longer be seen. Historical records indicated five springs at the site, but only one still flowed at the surface. Then, in 1986, a brief, ten-day archaeological investigation led by Robert T. Bray of the University of Missouri–Columbia produced startling results. Bray found not one furnace, as in 1961, or two, as reported by Nathan Boone, or four, as reported by Jesse Morrison, but six—and four years later another investigation would raise that number to ten. Moreover, the timbers that had been seen at the surface in 1961 turned out to have been from the early activity at the site after all, and the remains of several well casings, two log cabins, and a brine-elevating delivery system were still there underground, perfectly preserved in the waterlogged, briny earth.

Most remarkable of all was a ten-foot-long octagonal shaft superbly hand-hewn from a log, with spindles at the ends and mortises in each face to receive the spokes of a wheel; it was the driveshaft for a treadwheel ingeniously designed to dip brine from the spring and elevate it to an aqueduct system that might have extended as far as five hundred feet in order to supply the various furnaces. It required twelve people to lift the nine-hundred-and-sixty-pound driveshaft from the ground and carry it up the hill to be transported to a specially built tank in which it is being conserved, utilizing a new technique that employs a supersaturated sugar solution. With these and other discoveries yet to be made at the site, the operations at Boone's Lick are finally beginning to come back to life.

Boone's Lick State Historic Site now contains about fifty acres set in a sea of rolling fields and wooded river breaks. A narrow, winding trail leads down the steep hillside into the spring valley. By the time you are halfway down the hill, your nostrils detect the odor of sulfurous vapors rising from the spring. Interpretive signs help you to visualize the layout of the substantial frontier industry once located here.

The saline water at Boone's Lick not only supported an industry and preserved its remains, but it has also produced a habitat for salt-loving plants and animals. Some of the grasses found around this and other similar licks in Howard and Saline counties might seem more at home along the seashore. Their names, like salt meadow grass and saltbush, tell the story. In the alkaline waters of Salt Creek, just below the lick, the rare plains killifish has found a most suitable home. This is the easternmost population of this two-inch-long topminnow, so named because of its habit of skimming along the water's surface looking for insects. These killifish thrive in water with relatively few other species.

Though it was once the terminus of the major road to central Missouri, Boone's Lick today is far enough off the beaten track and so peaceful that you can easily imagine yourself in another world—the world of the Boones and the Morrisons, scouting out the prospects and laying the foundations for a rich new region of settlement.

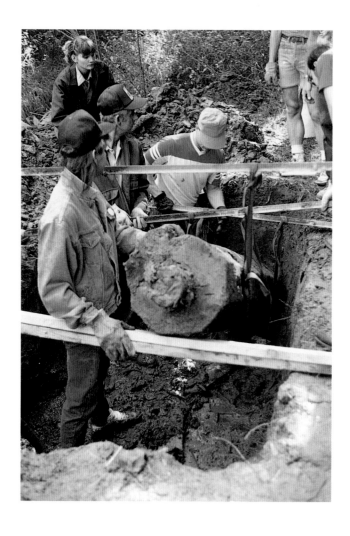

Archaeologists remove a hand-hewn, octagonal drive shaft for a treadwheel that dipped brine from the spring and lifted it to an aqueduct for transport to the salt furnaces. ROBERT T. BRAY

Arrow Rock State Historic Site

AS THE STATE'S FIRST historic site, Arrow Rock holds a place of honor in the state park system. Today, as in the past, it beckons to travelers passing through the Missouri River valley. Visitors enjoy the easygoing, small-town ambience of its current environment as well as the reminders of its pre–Civil War past as a flourishing river port in the heart of the Boone's Lick Country.

The Missouri River was and is the dominant geographic feature of the region, and it served as a road to empire for France, Spain, and the United States in succession, all three of them challenged by Great Britain for control of the fur trade and the territory it encompassed. Arrow Rock took its name from a landmark bluff along the river that rose sheer from the current at its base; whether the name referred to deposits of flint or to the bluff's shape or to some Indian legend we don't know. The name appeared as *pierre a flèche* in French records as early as 1732, though the landmark was known long before that to the Miami, Missouri, and Osage Indians who hunted the area. An important Indian trail known as the Osage Trace crossed the Missouri River here through an opening in the steep bluffs that bordered the future townsite.

Located at the point where the main east-west overland route intersected the north-south flow of the Missouri River, the Arrow Rock area witnessed most of the phases of early westward expansion. The site was noted by Lewis and Clark on their epic expedition upriver in 1804 and again by William Clark in his journal of the expedition to construct Fort Osage in 1808, when he termed it "a handsome Spot for a Town." Before the first organized town, the Arrow Rock was as-

sociated with the factory system and the fur trade, with the War of 1812 when George Sibley constructed a blockhouse and trading post in the vicinity, with the first generation of settlement near the Boones' salt lick across the river, and with what turned out to be the successful Becknell expedition to Santa Fe in 1821.

Settlement greatly increased in the area after the War of 1812, and several ferries began operating near the Arrow Rock in the next decade, including one owned by David Todd, whose niece would marry Abraham Lincoln, and another operated by William Becknell. The bluff above the ferry on the south bank of the river was a point of departure for wagon trains to Santa Fe for a decade after 1821, but the town was not platted until 1829—on land donated in part by John Bingham, uncle of George Caleb. The plat by M. M. Marmaduke featured a grid pattern of regular blocks, a public square, and east-west and north-south streets, beginning at the edge of the bluff with Water Street. The place was confidently named New Philadelphia, but that was changed in 1834 to the more workaday Arrow Rock.

Among the early residents was Joseph Huston, who had settled on a farm in the area in 1819, served many years as a Saline County judge, and in 1834 built the Federal style brick building on Main Street that has served for more than a century and a half as a tavern and gathering place and at times as a hotel and dry-goods store. George Caleb Bingham, who had moved with his mother to a nearby farm in 1823, built a small brick house in town in 1837. The town had at least five physicians in the early years—Charles Bradford, William Price, George Penn, Mathew Hall, and John Sappington—of whom Sapping-

ton, a pioneer in the use of quinine for treating malaria (a scourge in low-lying riverine areas), was far and away the best known. And it was home to three future governors of the state, Meredith M. Marmaduke, Claiborne Fox Jackson, and John S. Marmaduke. Probably no other town in the state was more of a powerhouse than Arrow Rock, which became the center of the so-called Boone's Lick Democracy that controlled Missouri until the Civil War.

During 1839–1840, the town served as Saline County's temporary county seat, and a one-story weatherboarded log building at the corner of Fourth and Main is traditionally considered to have been the courthouse. In 1843 an Arrow Rock Academy was established, only to succumb after a few years and be replaced by a succession of other schools. Methodist Episcopal, Baptist, Presbyterian, and Christian churches were organized, and several of their buildings still stand, as do the buildings of several lodges and, of course, many other residences and commercial structures.

Despite all the architectural survivals of this thriving riverport, which boasted a population of more than a thousand by the 1850s, perhaps nothing better expresses the power and optimism and vision of this community than the gutters that line the streets. Quarried limestone blocks, individually shaped and carefully laid in concave troughs, undoubtedly by craftsmen among the large black slave population, still grace the streets of Arrow Rock today. Records suggest the streets were improved in the late 1850s, with proper grading, macadam surfacing, flagstone walks at the intersections, and a sixteen-foot sidewalk, half its width covered with awnings, along the commercial row on the north side of Main Street—improvements befitting a town of distinction. There was also an effort at this time to extend east Main Street directly to the river by making an enormous cut through the bluff, but the pitch was so steep that the project was abandoned, and the gulch that marked its beginnings has ever since been derisively known as Godsey's Diggings. Merchants continued to use the gentler road via the Big Spring valley, where Santa Fe traders once rendezvoused, to reach the steamboat landing south of town. But some began laying more ambitious plans for the Louisiana and

Missouri River Railroad that was to angle southwest across the state and cross the river at Arrow Rock.

These happy prospects were dashed by war, a war in which many citizens of Arrow Rock would take leadership roles, mostly on the losing side. The town was occupied at various times by soldiers of both sides and repeatedly harassed by guerrilla raids, but it escaped any major destruction. The pall would settle in gradually over the years, as the town failed to get its railroad, the leading families (most now among the vanquished) no longer wielded the influence of yore, and younger sons sought their fortunes in the cities. The population had already shrunk to six hundred by 1873, when a series of arson fires wiped out many businesses and homes.

Beginning about 1912, the seemingly inevitable descent of this once-proud town was paralleled by a gradually rising commitment to recapture some of the past and carry it with renewed pride into the future. It began with the efforts of the Missouri Society of the Daughters of the American Revolution to mark and commemorate historical trails, principal among them the Boone's Lick and Santa Fe trails, and to identify some of the structures of interest still along their routes. Indeed, in 1912 the Daughters, together with members of the Women's National Old Trails Road Association, furnished Joseph Huston's old hotel as the Old Tavern Rest Room, with "relics" useful for "teaching Missouri history to the passerby."

After World War I, the members of the Marshall, Sedalia, and Arrow Rock chapters of the Missouri DAR encouraged the state's political leaders to acquire the Arrow Rock Tavern to ensure its preservation. Their efforts culminated in the purchase of the building and its contents by the state of Missouri in 1923 from Nettie M. Dickson of the DAR, with the understanding that the Missouri DAR would be responsible for preservation of the structure and that its members would serve as custodians and managers of the tavern's food and lodging services. Challenged by a matching grant of $6,000 from the general assembly in 1926, the DAR conducted a statewide campaign for contributions to restore the building, perhaps the first large-scale citizen campaign for historic preservation in Missouri. Today, although the DAR is no longer directly involved, the tavern still functions as a house museum and a restaurant, with the old ballroom upstairs turned into a meeting room and Joseph Huston's store of the 1840–1850 era offering period dry goods. The building has been beautifully re-restored, its brick now natural again instead of

Limestone gutters, made of blocks carefully quarried and carved by slaves in the decade before the Civil War, line the main street of Arrow Rock near the old Saline County courthouse. OLIVER SCHUCHARD

The Huston Tavern has accommodated western travelers since the 1830s and still serves a hearty fare to its visitors. OLIVER SCHUCHARD

white, and with the old fish-shaped weather vane still turning on the roof.

In 1926 the state acquired about thirty acres south of town around the Big Spring, by now known as the Santa Fe Spring, and near the ferry landing, as well as the one-cell vaulted stone jail, and established Arrow Rock State Park. The Academy Boarding House, a four-room log house possibly constructed in the 1820s and owned by Dr. George Penn during the period of his medical partnership with Dr. John Sappington, was added to state holdings in 1930. Penn, who served as surgeon with Col. Alexander Doniphan's First Missouri Volunteers during the Mexican War, helped found the Missouri Medical Association after his return. The log structure owned by

Penn, located along the road that led to the Big Spring, was later associated with the Arrow Rock Academy incorporated by the state legislature in 1843.

Despite the depressed condition of the economy in the 1930s, the state acquired the George Caleb Bingham house and significant property fronting on Main Street in 1934. Bingham served as a trustee of the Arrow Rock town board and was elected as a Whig representative of Saline County to the general assembly in 1848, all the while actively painting the portraits, scenes of western life, and unflinchingly realistic canvases depicting frontier politics that made him known nationwide as "The Missouri Artist." After his Arrow Rock years he served as state treasurer during the Civil War and for two years in the 1870s as state adjutant general, in addition to teaching art at the University of Missouri. A number of Bingham's paintings, engravings, and prints are exhibited at the site. The Bingham

home was renovated in 1936 as a Works Progress Administration undertaking; a more authentic restoration based on archaeological findings was completed in 1966, and in 1968 the house was designated a national historic landmark.

In addition to renovating the Bingham home, the WPA workers built a three-arched stone bridge, a swimming lake (since drained), and picnic facilities, including a shelter, on the parkland south of town. They also built a gazebo-like lookout shelter on the bluff east of the Bingham home. During the early years of the twentieth century the river channel slowly meandered to the far side of its floodplain, where it has since been stabilized by the corps of engineers, so the current no longer dashes against the big Arrow Rock but flows more deliberately some distance

George Caleb Bingham, preeminent painter of Missouri River life in the mid-nineteenth century, built his home in Arrow Rock in 1836.
STATE PARK ARCHIVES

Santa Fe Trail Days is one of several popular special events that occur throughout the year at Arrow Rock. SUSAN FLADER

from town. For a time, vegetation on the bluffs obscured any view of the river from the overlook—or from any other point in the park. But in recent years the parks division has sought to open the view in a number of places, so that one now sees the river in the distance across bottomland fields.

Citizens of Arrow Rock—a town that has persisted, though with a population of less than a hundred instead of more than a thousand—in 1959 joined with others to establish the Friends of Arrow Rock, Inc., a private not-for-profit organization dedicated to preserving and promoting the historic town. The group's first project was to acquire, restore, and furnish the log building known as the Old Court House, which it donated to the state in 1962. Whether or not this is the building that actually housed the Saline County court in 1839–1840 or that George Caleb Bingham depicted in his famed *County Election,* the carefully beaded walnut siding suggests that it is one of the older buildings, and it is a favorite on tours of the town. The Friends of Arrow Rock, in addition to having saved and restored several important buildings over the years, conducts tours of the town and hosts a number of special events each year, usually in conjunction with the state.

For its part, the state in 1960 purchased the 1847 brick home of Dr. Matthew W. Hall and undertook its restoration. Hall was a member of the state legislature during the crisis of 1861, when he stood by his fellow townsman, Gov. Claiborne Jackson, and supported secession from the Union. The Hall house, furnished and interpreted as a residence of the 1850s, is located at the edge of Arrow Rock's commercial area along Main Street.

Most of the town of Arrow Rock, including the historic state-owned area, was designated a national historic landmark in 1964 in recognition of its role in the early history of western exploration and settlement and of the significant historical roles played by many distinguished townsmen. In the 1970s the state acquired nearly a hundred additional acres south of town in order to develop a larger camping area for visitors to the site, a new entry to the complex, and a visitor center. It also reclassified the area from a park to a historic site. The long-awaited interpretive center is now a reality. It not only presents the history of this remarkable town but explains the larger context in which it functioned. For Arrow Rock was the center of an extraordinary concentration of power and influence in antebellum Missouri and it was also a way station in the development of America's western empire.

Sappington Cemetery State Historic Site

THE HUGE RED CEDARS are visible for a quarter-mile before you arrive at Sappington Cemetery, five miles west of Arrow Rock in Saline County. These magnificent trees were greatly beloved by the pioneers, not only for their general associations with scriptural passages, but also as an evergreen reminder of the promise of everlasting life in an otherwise deciduous world. Nearly every pioneer home had one or more in the yard, and every old cemetery in Missouri featured them. They are frequently older than the houses they are standing by, and these at Sappington Cemetery are perhaps older than the first burial, the largest being over two and a half feet in diameter.

Thomas Gray, in his famous "Elegy Written in a Country Churchyard" of 1750, fixed forever in our consciousness the sense of romance and history embodied, literally, in a country burying ground. When he wrote those famous lines, "The lowing herd wind slowly o'er the lea, / The plowman homeward plods his weary way, / And leaves the world to darkness and to me," he might well have been writing of a visit to Sappington Cemetery. Even today, when the visitor's eye strays outward from the limestone-walled enclosure, through the small, wooded grove surrounding it, and onto the high rolling prairie, it is met by a scene of bucolic peace, the grassland studded with grazing cattle.

This is the heartland of Missouri's Little Dixie, and extending to and beyond the horizon are the sites of the great country estates of the previous century, their very names—Experiment, Prairie Park, Fox's Castle, Lilac Hill, Val Verde—evoking mental images of an agrarian elite that graced Missouri's antebellum society. The gentry that once lived and laughed and loved and died in those great halls now lie here, beneath our feet.

Our first impression of Sappington Cemetery, other than of the neat orderliness of the limestone wall topped by its cast-iron fence, is dominated by the curious elevation of the Sappington vaults and by the size of the huge eastern red cedars that flank them. Dr. John Sappington (1776–1856), after whom the cemetery is named, was a celebrity of his day, not only southern gentry but also a noted physician and a consummate politician. For several decades he was the power broker of the Boone's Lick Democracy, the so-called Central Clique that controlled Missouri for most of the first half of the nineteenth century. Two of his sons-in-law, who lie nearby, and one grandson became governors of the state.

Sappington made money through his promotion of quinine as an antifever remedy in the treatment of malaria, the most common disease in the Mississippi and Missouri valleys. His unconventional treatment saved thousands of lives and became in time the standard treatment for nearly a century. He used his money to buy rich Saline County farmland and his enormous prestige to steer the course of events. His daughters married some of the most powerful men in the state—men made more powerful no doubt by their association with John Sappington.

To the left upon entering the cemetery gate is the handsome grave of Missouri's eighth governor, Meredith Miles Marmaduke (1791–1864), and his wife, Lavinia Sappington Marmaduke (1807–1885). The Marmaduke tombstone consists of twin white columns connected by an arch on which are carved two clasped hands and the single word *Farewell*. Marmaduke was

242

*Stately red cedars flank the grave of Boone's Lick
power broker Dr. John Sappington.*
OLIVER SCHUCHARD

elected lieutenant governor in August 1840; when Gov. Thomas Reynolds committed suicide on February 9, 1844, Marmaduke served out the remaining nine months in the term. Unlike his wife's brother-in-law, Claiborne Jackson, Marmaduke was a strong Union supporter. His son, John Sappington Marmaduke, however, became a Confederate major general. He followed his father as governor by forty years, serving during 1885–1887.

Missouri's fifteenth governor, Claiborne Fox Jackson (1806–1862), married not just one but three successive daughters of John Sappington: Jane, Louisa, and Eliza. At the cemetery he is buried with his third wife, Eliza W. Sappington Jackson (1806–1864). Their graves are marked by two twin pillars inscribed "Gather my Saints together unto me."

Jackson was the doomed protagonist of Missouri's Southern hopes. He began his term as governor on January 3, 1861, during the crisis of secession, and felt compelled by his beliefs to lead Missouri into alliance with the Confederacy. When federal forces drove him from Jefferson City in the summer of 1861 and a Unionist, Hamilton Gamble, was appointed provisional governor on July 30, Jackson set up a government in exile in Neosho. In October, his government seceded, to become the twelfth state in the Confederacy. He died of pneumonia in exile in Little Rock, Arkansas, on December 6, 1862, and it was many years before his body was returned to Missouri.

The land on which the two-acre cemetery is located was part of a quarter-section patented by John Sappington in 1837 but deeded to Claiborne Jackson in 1853, at a time when Sappington was distributing most of his property to his children in order to avoid possible jealousies after his death. The cemetery, which contains 111 headstones, mostly of Sappington kin, was maintained by the family until 1901 and then by the Sappington School Fund, an endowment established by Sappington in 1854, before the advent of a local public school system, to provide education to indigent or orphan children of Saline County. Offered to the park board as early as 1949 for management in conjunction with Arrow Rock, the cemetery finally came into the system in 1970 pursuant to the park board's new statutory authority to maintain every grave of a former

Gov. Claiborne Fox Jackson, who died in exile during the Civil War, was married to three daughters of John Sappington. OLIVER SCHUCHARD

governor that is not within a perpetual-care cemetery. Thus was established Sappington Cemetery State Historic Site, with all its evocation of a vanished southern aristocracy.

Try a visit on a late Sunday afternoon in mid-November. You will likely have the place entirely to yourself and not hear a sound other than the quiet rustling of the dry but not yet fallen oak leaves, and the peculiar swooshing of the breeze passing through the huge red cedars. The melancholy air of the cemetery will be heightened by the low angle of the cool, pale yellow, autumnal sun. If the dream of that long-lost society could be remembered, this is where it could be conjured. If there ever was such a life lived in old Missouri before the great, all-changing war, this is the charmed spot that could summon it once again—if only before the mind's eye.

Van Meter State Park

A FIRST-TIME VISITOR to Van Meter State Park will likely find the place quiet, maybe even sleepy. State Route 122 approaches the park in Saline County across the broad bottomlands of the Missouri River floodplain. The park is part of the steep loess hills—known locally as the Pinnacles—that loom up and border that floodplain, overlooking the river and its valley.

At the park one sees a lovely walnut-shaded picnic ground with a CCC-era shelter, a small campground, a small lake, and pleasant woods—not a very imposing array. But appearances can be deceptive. On a winter afternoon, standing on the hills where the leafless trees allow a view of the mostly bare and hushed Missouri River valley, the visitor senses a strange presence in the air. The late afternoon sunset across the valley washes the bleak and rugged hills in a persimmon glow; the presence grows stronger, as if breathing from the hills. There is almost a yearning in the air.

The first Europeans who touched what is now Missouri soil, it is generally believed, were Frenchmen, the Jesuit missionary Father Jacques Marquette and the adventurer Louis Jolliet. While exploring the Mississippi River in 1673, they passed the mouth of a great brown behemoth flowing from the west and heard from friendly Indians of a tribe that lived further up that continent-draining river. Later on, that tribe's name was recorded on their map as *Oumessourit*, a word meaning "people of the big canoes" in one of several rough interpretations. *Oumessourit* evolved thereafter into *Missouri*. Thus was the name for a group of people, a great river, and eventually a state first recorded in a European language.

About forty years later another Frenchman, Etienne Véniard sieur de Bourgmond, went to live for a time with these people who had been called the Missouri. Bourgmond found a proud and vigorous people who welcomed the Frenchman and helped him establish fur-trading contacts and eventually a nearby outpost, Fort Orleans (1723–1728), the exact site of which has yet to be found. The Missouri, a Chiwere Siouan people related to the Winnebago, Ioway, and Otoe, had their principal village on the commanding upland at the great bend of the Missouri in and near what today is Van Meter State Park. In Bourgmond's time they numbered at least a thousand families (perhaps five thousand people) and exploited all aspects of their environment, both near and far. They hunted buffalo far out on the prairies, deer in the woodlands, and waterfowl along the river; they fished for sturgeon and gar; they tended corn, beans, squash, and pumpkins on the rich river floodplains and perhaps on the uplands near the village; and they gathered walnuts and pecans, pawpaws, plums, and other fruits and nuts from the abundant trees.

In the decades following their discovery by white men, the Missouri fared badly. Unlucky alliances in the tangle of competing European powers, ravaging European diseases, especially smallpox, and well-armed Indian rivals, like the Sauk and Fox, combined to reduce and disperse them. Before 1800 the remnant bands fled to live among the Otoe and other related tribes in neighboring states. In 1910, only thirteen Missouri of full blood survived, and by 1930 no full-bloods remained.

The core of Van Meter State Park was donated to the state in 1932 by Annie Van Meter and her

A CCC-era picnic shelter graces a walnut grove on the Van Meter homestead, occupied by members of the family for a century before they gave it to the state in 1932 for a park. OLIVER SCHUCHARD

brother, Charles Pittman, in memory of her husband, Abel. Abel Van Meter had come to this land in the year of his birth, 1834, with his family and their slaves from Hardy County, Virginia. Abel's father soon became the biggest cattle dealer in west-central Missouri, grazing his cattle on the rich prairie grasses that abounded in the area and driving them to market in St. Louis and other cities. Abel, too, was a prosperous farmer and livestock dealer who came to own nearly 3,000 acres in the area, about 500 of which were donated for the park.

Ironically, the initial decision to preserve this area as a state park probably had less to do with the Missouri Indians, about whom very little was known at the time, than with a nearby series of ditches, embankments, and mounds known as the Old Fort. The fort had been reported on as early as 1878 by G. C. Broadhead, an assistant state geologist, and again in 1910 by Gerard Fowke, representing the Smithsonian Institution. It was thought to be related to the much older Hopewell culture dating to about the time of Christ; in fact, by the 1930s it was considered Missouri's preeminent Hopewell site. Abel and Annie Van Meter were well aware of the site's importance, having hosted Fowke when he worked there in 1906, but the fort was not on their land.

It is at least conceivable that Annie Van Meter was encouraged to donate her land with the thought that leverage could then be placed on the state to acquire the adjoining tract that included the Old Fort—in spite of the fact that the state game and fish commissioner, who was responsible for parks at the time, touted the site solely as a former key waterfowl-shooting area where a lake and marsh could be reestablished. At the first meeting of the new Missouri Archaeological Society in 1934, Henry W. Hamilton of Marshall, a passionate amateur archaeologist and astute political lobbyist, was appointed to chair a committee to investigate preservation of the fort, and at every meeting thereafter the fort was prominently on the agenda—until 1939, by which time the group had negotiated with the landowner, secured an appropriation from the legislature, provided for proper supervision of work on the site, petitioned the governor for approval, and celebrated the park board's acquisition of the Old Fort.

It was also around this time, 1939, that archaeologists began searching in earnest for the Missouri Indian villages described by Bourgmond and Lewis and Clark. They identified two different sites, both near the park: the village on the Pinnacles, which had earlier been thought to be a considerably older site, and a less prepossessing

site on the floodplain a few miles upstream known as Gumbo Point. In the late 1950s, through the good offices of T. M. Hamilton, brother of Henry, portions of the upland village, known as the Utz site after one of the landowners, were added to the park by a donation from Mr. and Mrs. W. P. Lyman and an exchange with another owner. The core of the village site was later transferred to the University of Missouri, which established the Lyman Archaeological Research Center and Hamilton Field School, at which studies were made that would dramatically alter prevailing notions of the significance of the site. Robert T. Bray was hired jointly by the university and the park board to direct the center and to initiate a program of archaeological research at other parks and historic sites.

In the course of summer excavations that park visitors were welcome to view, it became apparent that the village site and the Old Fort were closely related. But the fort had not been built two thousand years ago by Hopewell peoples, nor had the Missouri Indians moved into the area from the Great Lakes region as recently as the seventeenth century, as scholars thought in the early 1960s. Rather, the artifacts suggested that the Missouri Indians had lived in the area at least since about A.D. 1350 and that it was *they* who built the fort.

No one is certain anymore that the Old Fort was a fort, or why the Missouri built it. Nor are archaeologists certain just when or why the Missouri left their commanding city on the Pinnacles for the seemingly less favorable site on the gumbo—some think they were using both the uplands and the floodplain seasonally during

Archaeology students from the University of Missouri excavate a portion of the Missouri Indian tribal village in Van Meter State Park. ROBERT T. BRAY

Bourgmond's time—nor why the tribe withered so tragically and faded away. What we do know is that the Missouri were a proud and creative people during their years on the Pinnacles, and that the site supported them well for more than three hundred and fifty years.

Why did so many people—the Missouri and the French and the Van Meters and the Utzes—find this locality so attractive? Part of the reason must be the quality of the wind-deposited loess soil that is heaped up into the imposing bluffs that border the river floodplain. Some of the ravines that cut through the loess hills today support rich forests of red oak and basswood and walnut now designated as the Van Meter Forest Natural Area. To the west spans the broad valley of the Missouri, once covered by bountiful wet prairie and marshes interspersed with timber-lined sloughs. All of this once-rich marshland and prairie is now gone, victim of agricultural drainage ditches and levees, except for a small remnant on the west edge of the park that is being restored. In this remnant is found an endangered aquatic snail known nowhere else in the state, as well as the giant reed grasses and sedges, knotweeds, bulrushes, and cattails that once provided substance and sustenance for the Missouri.

Until recently, Van Meter State Park has been an out-of-the-way place offering little interpretation of its key resources. But the park now boasts a fine new visitor center. The center helps travelers understand the Missouri River valley with its rich loess-soil forests and formations, and also the contributions of Bourgmond, the Van Meters, and, most important, the people called Missouri who provided the state with its beautiful name. Present at the dedication on Earth Day, April 21, 1990, was ninety-one-year-old Truman Dailey ("Soaring High") of Red Rock, Oklahoma, the last living male of the Otoe-Missouria tribe.

Thus there is meaning in the yearning one

The Van Meter marsh is a rare survival of Missouri's presettlement river wetlands. KEN MCCARTY

feels from the hills on a leafless winter afternoon. It is the yearning of long-forgotten people to proclaim themselves, and not to be forgotten. Here in the heart of Missouri we have a park that is heavy with the shades of an earlier people, a place that is, in a real sense, sacred.

Battle of Lexington State Historic Site

THE CIVIL WAR in Missouri is probably best known for the vicious guerrilla-type warfare that grew out of the cruel divisions among the state's citizens. Perhaps this degeneration was inevitable given the state's border location and the strong and conflicting convictions of the day, but in the early months of the war there was some hope that it need not be so. The victors write the histories, often leaving the hopes and aspirations of the vanquished little appreciated. Battle of Lexington State Historic Site affords an opportunity to ponder the vision and the virtues of the vanquished, who at Lexington were victors for a time.

One of the most important but often overlooked factors of the Civil War in Missouri was a body of citizenry known as the Missouri State Guard. This organization, which never numbered more than twenty-two thousand men at any one time, was mobilized in defense of the state against what it viewed as an invasion by the hostile armies of the United States. This small force, surrounded on three sides by Northern states and contested within the state by Missouri forces loyal to the Union, for the better part of a year bore the brunt of defending the South west of the Mississippi. The Missouri State Guard was the only border state army to make so bold a campaign, and it did so with little assistance from the official Confederate States Army.

The leader of the Missouri State Guard was probably the most popular man in Missouri. Sterling Price was a Virginia-born tobacco planter from Chariton County who had served Missouri as legislator and governor and his nation as congressman and brigadier general of Missouri volunteers in the Mexican War. His politics were

representative of very many, perhaps most, Missourians: he was a conservative Democrat, opposed to abolitionism but also in love with the old Union, as he demonstrated when he presided over the state convention in February 1861 by which Missouri decided there was at the time no cause to secede. But when actual conflict came, Price's Southern loyalty was aroused. He was known for his great moral and physical courage, and this courage was a prime attraction for the men who came to serve in the state guard.

Price's rough and ready Missourians, despite their lack of equipment, supplies, and discipline, won for the South two of its most important victories west of the Mississippi. Except for a small but crucial skirmish at Boonville, they were never driven back on a battlefield. After they finally disbanded in 1862, Missouri State Guard veterans made up the core of some of the most highly regarded and decorated units in the regular Confederate States Army. Yet today one can search many standard war histories in vain for any reference to this extraordinary force. Even few Missourians seem to have heard of the state guard.

In many respects, the finest hour of the guard was its victory in September 1861 over the federal garrison at Lexington, on the Missouri River. It marked the high tide of hopes for uniting the state behind the pro-Southern government that Missourians had elected in 1860 and for driving the detested "Yankees" from the state. Both hopes were doomed to failure in short order, but few observers in the North or South seemed to think so at the time.

The events leading up to the battle at Lexington had begun in May 1861 when Gov. Claiborne

William Oliver Anderson's Greek Revival home served as a hospital during the battle of Lexington, but it was repeatedly attacked by both sides, and bullet holes still riddle the brick. B. H. RUCKER

Fox Jackson, with authority from the state legislature, expanded and reorganized the state militia to repel a feared invasion of federal troops following the secession of the deep southern states. After Union forces, composed mostly of local German volunteers, arrested state troops encamped near the federal arsenal in St. Louis on May 10, and after observing firsthand the ensuing riot that resulted in the deaths of twenty-nine civilians fired on by Union soldiers, Sterling Price offered his services to the governor and was appointed major general of the Missouri State Guard. A federal force composed largely of Missourians, including many German volunteers, moved quickly in June to occupy Jefferson City and other major river towns and rail centers. Price and the growing body of his hastily called raw recruits, along with Governor Jackson and other pro-South state officials, were forced to flee to the refuge of far southwest Missouri, where Price drilled the guard into a rough semblance of an army. Meanwhile, the delegates whom Missourians had elected in February to decide the issue of secession reconvened in St. Louis, declared state offices vacant, and elected new officials. Missouri now had two governors—Claiborne Jackson and Hamilton Gamble—and two sets of state officials who claimed legitimacy, a situation that would persist throughout the war.

With the reluctant help of a Confederate force stationed in northern Arkansas, Price's state guard advanced in early August toward Springfield, where it met and defeated a Union army under Gen. Nathaniel Lyon at Wilson's Creek, one of the bloodiest battles of the Civil War. After this victory, the Confederate units returned to Arkansas, leaving Price and the Missouri State Guard to defend their cause against the now thoroughly aroused might of the United States government.

In late August, Price led his army north toward the Missouri River. Flush with their success at Wilson's Creek, the Missourians hoped to rally the citizenry in the populous pro-Southern counties of the Missouri valley. They also hoped to open the Missouri River for the many north Missourians who would rally to the Southern cause but who were prevented from joining Price by Union control of the river crossings. As Price continued northward, his ranks were swollen with new recruits. His march began to seem a triumphal progress, and a portent of a reunified state.

Lexington was, and is, a lovely Missouri River town in Lafayette County. In 1861 it was a prosperous trading center for the tobacco and hemp plantations of the area and one of the largest communities in Missouri. It was also strongly pro-Southern in sentiment, though with a substantial German population in the rural areas. Recognizing Lexington's importance, federal troops had occupied the town since July, headquartering at the Masonic College campus, situated on a ridge that ran toward and overlooked the Missouri River. By early September the garrison was commanded by a courageous young colonel named James A. Mulligan, an Irishman from Chicago, who strengthened his defenses with an elaborate system of entrenchments and ramparts much too large for his three-thousand-some troops to defend—an indication perhaps that he anticipated substantial reinforcements.

Not far from these defenses was the stately home of one of Lafayette County's leading families, that of William Oliver Anderson. Anderson owned a factory that processed hemp into rope and bagging, but financial reverses led him to serve also as county sheriff. His two-and-a-half-story Greek Revival home had been constructed in 1853 of brick made at the site by slaves; it boasted beautiful millwork including a handsome stairway of native black walnut, front-porch columns with cast-iron Corinthian capitals, and cast-iron sills and lintels. The property surrounding this fine home with its sweeping view of the river valley included slave quarters, a carriage house and horse barn, a summer kitchen, a riverside warehouse and wharf, extensive gardens, and an orchard. Married to a cousin of Sterling Price, Anderson refused to take an oath of loyalty to the federal government and was arrested and imprisoned. The house, confiscated by Union troops, was fated to endure bloody turmoil.

Price arrived within sight of Lexington on September 12. The state guard had grown by now to twelve thousand men and was enlarging daily. Mulligan's federal troops numbered only about thirty-five hundred, about half Illinoisans and half Missourians, many of them German or Irish immigrants. After sharp skirmishes on the outskirts of town, Price waited several days for his supply wagons to catch up, then decided to lay siege to the fortified garrison rather than waste blood and supplies on a frontal assault. "It is unnecessary to kill off the boys here," he supposedly said; "patience will give us what we want"—a judgment he might ruefully recall three years later after his debacle at another battlefield that is also now a state historic site, Fort Davidson.

Once the state guard was in control of the area, recruits flocked in all the faster. With the arrival of Gen. Thomas A. Harris and his four thousand northeast Missouri men from across the river,

Time has gentled the remains of a Union defensive trench on a hill overlooking the Missouri River valley. B. H. RUCKER

each of the guard's nine divisions was represented at Lexington except the first, which was fighting in southeast Missouri. On September 17, Price moved to surround the federal garrison on College Hill and cut off Mulligan's access to the river and to drinking water. The siege was on.

With effective blocking of Union lines, the siege warfare took on a casual, almost festive air—at least for those outside the lines. But the bombardment went on night and day, fifty-two hours straight. The reinforcements Mulligan kept expecting never arrived; most were never sent, but a few were intercepted north of the river by Gen. Mosby Monroe Parsons of Jefferson City.

The Anderson house, which lay outside the Union entrenchments, was being used by the federals as a hospital. Normally, both sides would have respected the neutrality of such a site, but the Anderson house was in too strategic a location, and it was too far from the regular Union lines to remain unmolested. As a result, it was attacked repeatedly by both sides, a deep loess gully from the river offering an approach almost to the back door. The scars of battle still mark the walls and brickwork of the house—except where a summer kitchen, subsequently removed, left a "bullet shadow." A bullet may still be found in a piece of door trim, and the path of a cannonball is clearly visible through the attic. Blood still stains the wooden floors of an upstairs bedroom.

At length, the Union troops weakened in the heat and drought of the Missouri September. The story is told that when federal soldiers sent some women for water from a spring east of the Union breastworks, the state guardsmen allowed the

women to drink all they wanted but would not let them carry any water back to the federal troops. Toward the end, Price's men employed a novel tactic in closing in on the Union entrenchments. They found some large bales of hemp, possibly in Anderson's warehouse, wrestled them into position, soaked them with water (to prevent hot shot from setting them ablaze), and rolled them from behind, shooting as they advanced. This version of movable breastworks functioned well enough to earn the siege the nickname *Battle of the Hemp Bales.* As the bales approached early in the afternoon of September 20, Mulligan was forced to surrender.

The Union troops had fought gallantly from inside their embattled fort, and Price and the state guard treated them with no less gallantry. In fact, the Battle of Lexington, besides being the highwater mark of the cause of the South in Missouri, was also one of the last Civil War engagements in which the civilities of the old style of warfare were so prominently honored. Price took command of a large store of arms, ammunition, and supplies, but federal officers were allowed to keep their swords. Mulligan and his wife were treated as honored guests in Price's entourage. All of the enlisted men were paroled after they had been treated to a speech from Governor Jackson reminding them to go home to Illinois and mind their own business, and to one from General Price commending their bravery. Local Union soldiers were released into the community. Commissioned officers were imprisoned at Lexington. The federal entrenchments and guardsmen's hemp bales kept casualties fairly low, but some sixty-five men in total were killed and nearly two hundred wounded.

In the glow of this victory, the Southern press lionized Price, the Northern press agonized, and sunshine patriots swelled Price's army to as many as twenty-two thousand Missourians, a good number of whom drifted away when supplies ran out and hard marching resumed. And hard marching did resume before long, when, in late September, Price withdrew to southwest Missouri in the face of federal forces converging from Kansas and St. Louis. These forces ultimately pushed Price out of Missouri entirely in 1862. Claiborne Jackson headed a government-in-exile until his death later that year. Price transferred to regular Confederate service, and eventually over forty thousand other Missourians served in Southern armies. Many other Missourians, of course, followed equally strong convictions into the federal army.

After Price's withdrawal, Lexington was retaken by federal troops in October and remained under federal control thereafter except for several short-term occupations by Confederate guerrillas or expeditionary forces. Price himself passed through the area again during his unsuccessful effort to retake the state in 1864. After the war the town of Lexington gradually declined in prominence, along with the river trade that had led to its rise, but it retained its southern charm. The Anderson house was purchased in 1865 by the Tilton Davis family, who lived there for the next fifty years; it is their furniture that may be seen in some of the rooms today.

In the 1920s the Lafayette County Court acquired the Anderson house and a portion of the battlefield, and the Works Progress Administration helped to restore the house during 1933–1934 in one of the first government-sponsored efforts at historic restoration in the state. The house was offered to the state park board as early as 1939, with the thought that the Daughters of the Confederacy would furnish it and cooperate in attracting visitors; nonetheless, it remained in county hands until its transfer in 1955 to the Anderson House and Lexington Battlefield Foundation, which in 1958 donated it to the state. A reenactment of the battle on its centennial in 1961 reportedly attracted fifteen thousand people.

Today, more than one hundred acres of the original battle site are preserved in the historic site, including the northern part of the federal entrenchments and the Anderson house. The site offers a self-guided walking tour of noteworthy features and a tour of the house itself, which has been beautifully restored and landscaped to reflect the late 1850s. Visitors are oriented to the site and to the Civil War in Missouri at a new interpretive center on the grounds.

Lexington is brimming with history and still evokes the atmosphere of the antebellum Missouri river town. Not everyone has a consuming interest in Missouri's tragic Civil War history, but even if you just enjoy beautiful Missouri valley scenery, handsome architecture, or an exciting story, you will want to visit Lexington. Your trip may not clear up all the contradictions that surround the war in Missouri, but if you allow the spirit of the place to speak to you, you will leave with new insights. Maybe, too, you will leave with some appreciation for a stalwart body of Missourians who, at the high tide of their soon-to-be-dashed fortunes, proved their capacity to show generosity toward their equally stalwart but vanquished foe. Missouri, and the nation, might not have suffered quite as terribly in the next four years if such antique virtue had continued to prevail.

Confederate Memorial
State Historic Site

LOCATED IN LAFAYETTE County not far from the Missouri River, in the heartland of Missouri Southern sentiment, Confederate Memorial State Historic Site commemorates the more than forty thousand Missouri soldiers who fought for the Stars and Bars. It is a testimonial also to their wives and daughters, who bore the brunt of the war at home and who a generation or so later took the lead in establishing the home, grounds, and cemetery where so many of the aging Confederate veterans came to live out their last years and be buried. Wandering among the more than eight hundred graves in the cemetery one may experience a whole gamut of emotions, strongest among them a renewed sense of what it meant to be a Missourian and a Southerner in 1861.

It required nearly a generation after the debacle of 1865, while Confederate veterans and their families sought to deal with the trauma of defeat and began to rebuild their lives, before they felt inclined to remember and even celebrate their lost cause. Then, in an era of annual encampments beginning in the 1880s, veterans organized as the Ex-Confederate Association of Missouri came together to relive old times and to consider the plight of the less fortunate among them. At their encampment at Higginsville in 1889, they incorporated a Confederate Home Association to select a site and seek funding for a home for their destitute brethren. The following year they purchased a three-hundred-and-sixty-acre farm north of Higginsville, aided by donations from citizens of Lafayette County.

Missouri was not alone in establishing a home for Confederate veterans—practically every state that furnished organized troops for the Confederacy had one—but Missouri was unique in building and furnishing its home solely through voluntary contributions. This is where the women entered the picture. Seeking a way to aid the cause of the Confederate Home, Mrs. Abner Cassidy of St. Louis invited nearly one hundred women to the Southern Hotel in January 1891 to organize the Daughters of the Confederacy and to promote a plan for selling tickets at ten cents apiece, each representing a "brick in the Confederate Home." The idea caught on, and soon there were Daughters of the Confederacy chapters in many Missouri communities and then in other states, leading in 1894 to the establishment of a national organization, the United Daughters of the Confederacy. In Missouri, the women held dinners, balls, ice-cream socials, and a strawberry festival, raising money in any way they could to provide cottages and furnishings and then a spacious, Colonial style main building for the Confederate Home. The home was dedicated in 1893 and six months later had 115 residents. The Daughters of the Confederacy subsequently built a hospital, a chapel, and several other buildings, in addition to commissioning a handsome granite Lion of Lucerne monument for the cemetery, erected in 1906.

In 1897, with costs outstripping income, the state of Missouri accepted the home and all the other buildings and farmland into the state hospital system, but a board of trustees made up of Confederate veterans continued to oversee the home, including a small endowment fund. In 1925 the board proposed development of a memorial park. About ninety acres of "waste land" at the southern end of the property were landscaped and thousands of trees and shrubs

The Daughters of the Confederacy, an organization founded in Missouri to support a home for aging Confederate veterans, commissioned a granite memorial for the cemetery. NICK DECKER

planted, again courtesy of the Daughters of the Confederacy, plus local schoolchildren and others. Seven lakes were built and stocked with fish for the veterans; a footbridge, gazebo, and bandstand were constructed, and rocks were even hauled in for a rock garden, all at no expense to the state. This Confederate Memorial Park, on state land, was in effect one of Missouri's earliest state parks, though it was not deeded over to the state park board until 1949.

Over the years, nearly fifteen hundred residents, including some wives and widows and even a few children of veterans, lived in the home or in the fourteen cottages on the grounds. With gardens behind the cottages, ample cropland, and cattle and other domestic livestock, the place operated fairly self-sufficiently. It was a dynamic and impressive institution, and many thought it the finest such home in the country. More than a

few Missourians remember visiting the home when the last old veterans sat fishing from the bank of the lake on a warm afternoon, spinning stories of past glory, until the clanging of the commissary bell called them back for supper. But veterans eventually die, and during the 1930s and 1940s several attempts were made to close the home or to move in mental patients or crippled children or World War II casualties.

On May 9, 1950, a chapter of the state's history came to a close when John Graves, the last Missouri Confederate veteran, who had fought with the legendary general Joseph O. Shelby, passed away at the home at the age of 107. The following

The Confederate Memorial chapel is one of only two such chapels remaining in the United States.
NICK DECKER

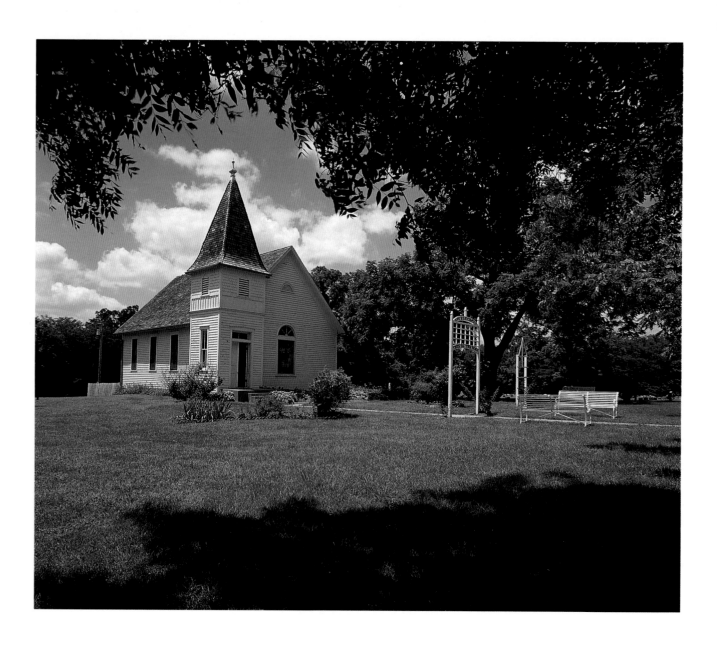

year, the Missouri legislature voted to abolish the home, and the few remaining residents, all widows of veterans, were transferred to a nursing facility in Columbia. Most of the old buildings were demolished in 1954, despite local efforts to preserve them, and the northern part of the grounds, including what was left of the building complex, is now occupied by the Higginsville Habilitation Center administered by the Missouri Department of Mental Health. The cemetery was given to the state park board by the United Daughters of the Confederacy in 1952, to be managed in conjunction with the memorial park that had been accepted three years earlier. In 1978 the chapel, threatened with demolition on its current site, was saved by the Higginsville chapter of the Beta Sigma Phi sorority, who paid to move it back near its original site next to the cemetery on state park land.

Today, Confederate Memorial Park is administered as a historic site. The simple, one-room frame chapel, one of only two such Confederate memorial chapels still standing (the other is in Richmond, Virginia), has been restored and furnished, and a small museum in the basement interprets the history of the home and the Confederate cause in Missouri. Some of this has been funded through the Confederate Memorial Park Endowment Fund, a legacy of private fund-raising

a century ago. The lake area, ever popular for fishing and picnicking, has been restored to look as it did when built by the Daughters of the Confederacy. The fishing is still good, and the grounds are still peaceful.

But most impressive is the carefully manicured cemetery, its more than eight hundred graves of veterans and widows a solemn reminder of loyalty and pride. The simple epitaph on the last old warrior's headstone is itself a lesson in history, and none who see it leave unmindful of the Southern cause in Missouri, or unmoved by the devotion of its followers:

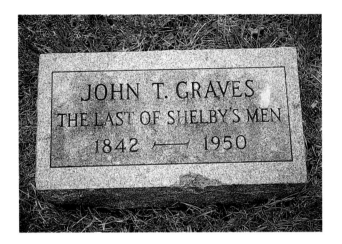

Thomas Hart Benton Home and Studio State Historic Site

IN THE DEEP WINTER OF 1936–1937, the cold weather was heated suddenly by a controversy that played loudly across the pages of Missouri's newspapers. The subject of this particular controversy did not concern the ominous situation in Europe, or even the national struggle against economic depression. Instead, a war of words was waged over a painting, a mural in the house lounge of the state capitol. This mural, officially titled *A Social History of the State of Missouri*, was a spacious work in a distinguished place by a Missourian of eminent background. It was painted by Thomas Hart Benton, namesake grandnephew of Missouri's legendary first senator, "Old Bullion," and son of Maecenas E. Benton, a four-term congressman and Confederate war veteran from the town of Neosho in southwest Missouri.

The august setting for Benton's mural fueled the passion of those who felt that it did disservice to the state of Missouri: "Whitewash the murals! They're vulgar! Look at those half-naked dancers!" "Where are Missouri's favorite sons?" ". . . nothing but honky tonk, hillbillies, and robbers. We're more than a 'coon dog state!"

By the mid-1930s, Tom Benton was no stranger to controversy, and he responded with vigor to his critics. Benton in his mural depicted a people and a state that he knew intimately and loved fiercely, but whom he was determined not to falsely romanticize or idealize. He painted real folks, doing the things that real folks do, along with some of the state's most characteristic folk legends, and he captured for all time much of the pungent flavor of the state's history. Today, the Benton mural in the state capitol is one of the most treasured artworks in the state. Every year

it inspires thousands of visitors. It has recently been restored to fine condition and enjoys a climate-controlled setting. Visit this broad expanse of vivid color and form, and you will feel its power. Then you will surely also want to visit the home and studio of the artist who produced not only that mural but hundreds of other important works and who came to be recognized as a preeminent representative of the regionalist tradition in American art.

Moving to Kansas City in the 1930s was a homecoming for Tom Benton. Born in Neosho in 1889, Benton left home in his teens to pursue an art career; he lived for varying periods in Chicago, Paris, and New York. In the course of his travels, Benton became a recognized painter, though from almost the beginning a combative and controversial one. Benton gradually became disillusioned with much of the artistic establishment and the aura of big-city life. When the Missouri General Assembly in 1935 authorized the capitol mural and the Kansas City Art Institute offered a teaching position, Tom Benton was happy to come home to Missouri with his wife and child and begin the long, colorful, and productive final phase of his career.

If Tom Benton had produced no other work than the capitol mural, he would deserve a place in Missouri and American history; but he produced thousands of illustrations, paintings, and sketches, as well as other murals, including one at the Truman Memorial Library in Independence. And, shortly after coming home, he published the first edition of his autobiography, *An Artist in America*, which detailed his reactions to the world of art and the world of life and left no question of his love for "the real Missouri."

Tom and Rita Benton's comfortable Kansas City home still welcomes guests as it did when it was the family residence. NICK DECKER

Thomas Hart Benton's studio in the carriage house behind his home looks just as it did the day he died there in 1975, except that the mural he had just completed is now in the Country Music Hall of Fame in Nashville. NICK DECKER

Missourians love Benton best for his true rendering of the common people and the land—especially, perhaps, the Ozark region of his birth.

The home to which Tom and Rita Benton moved in 1939 and where they remained until his death in 1975 is located in south Kansas City in a fashionable though not exclusive neighborhood in the Westport area. The two-and-a-half-story late Victorian style house at 3616 Belleview is of stone and frame construction. The home is spacious and comfortable and sits amid towering trees and pleasant shrubs and plants.

The rear carriage house served as a garage, and part of it was converted in the 1940s to an art studio. Here in the studio where he spent so many hours, we find today a lingering presence of the artist. Benton was working in this studio the day he died, January 19, 1975, death having taken him as he was applying the finishing touches to another of his large, dynamic murals, *The Sources of Country Music*, for the Country Music Hall of Fame in Nashville.

Partly through the care and generosity of Benton's wife, who soon also passed away, and his friends, the artist's studio and home are almost perfectly preserved. They were purchased by the state in 1977 and opened to the public on April 15, 1983, the anniversary of his birth. In the studio, the furniture, paints, sketches, brushes, even spectacles and pipe, lie about in perfectly natural clutter the way he left them. But if there is a haunting presence here, it is far from morbid. Benton was a vital man of great creativity, and that creative energy is what we feel.

In the home itself, almost all of the Bentons' personal possessions are also left in place. The most common and ordinary of family objects are as casual and available as if Tom or Rita were to walk in and offer us refreshment. In fact, entertaining friends from all over Missouri, and well beyond, was one of the great joys of household life for the Bentons. Tom and Rita were hosts to a nearly continual stream of guests, and their home had the warm and casual atmosphere that encouraged visitors to return. It still does.

Weston Bend State Park

NOT MANY PEOPLE are aware that for several years Missouri was the largest state in the Union. While in this enviable position, the state's general assembly had the temerity in 1831 to petition Congress to expand her boundaries further. Had this not occurred, Missouri would now be lacking six large and productive counties.

When the state was first laid out, the northwest boundary was a line straight north from the mouth of the Kansas River to the Iowa territory. The land west of that line to the Missouri River had been promised by treaty to the Indians in perpetuity. The Indian people of this region, the Sac, Fox, and Potawatomi, endured repeated violations of their territory owing to the remorseless advance of American pioneers, who boldly settled illegally on the rich Indian lands. The natives received little or no assistance from the U.S. army stationed by 1827 at Fort Leavenworth across the river.

By 1831 the future of this land was clear, at least to Missourians, and they petitioned Congress to add all of these two million fertile acres to the state. Missouri's powerful senators, Lewis Linn and Thomas Hart Benton, worked for congressional approval, and in 1837 the Indians were removed and the land annexed. Out of these lands, known as the Platte Purchase, were eventually carved the counties of Platte, Buchanan, Andrew, Holt, Atchison, and Nodaway.

Platte was the first of these counties to be organized, and it immediately became a lively scene of settlement and commerce along the Missouri River. The first community to rise was the town of Weston, named for one of its cofounders, Thomas Weston. The town, in turn, provided a name for the great bend of the Missouri River immediately downstream and, much later, for one of Missouri's most exciting new state parks, Weston Bend.

In the 1830s and 1840s Weston grew rapidly; very quickly the deep loess soils of the surrounding river hills were recognized as ideal for the cultivation of burly tobacco and hemp, the two main plantation crops of the antebellum upper South. Weston thrived on the tobacco and hemp trade, plus general river traffic and transportation. The commercial boom raged for several decades, with steamboats calling frequently and enterprising citizens building their fortunes. During this period, two brothers, Benjamin and David Holladay, developed a whiskey distillery just south of town. Then, in 1858, the great river that had brought prosperity abruptly changed its course. This left Weston no longer a port, and, without rail connections, the town fell into a gradual decline.

Around 1980 the state was encouraged to consider creating a state park in the hills downstream from Weston. The site combined to a rare degree the potential for fulfilling all three goals of the state park system—natural, cultural, and recreational excellence. The park site includes a superb example of Missouri River loess hills and low bluffs. From several points one can view almost the same Missouri valley scene that greeted Lewis and Clark in 1804, thanks in part to a large natural forest preserved on the lands of Fort Leavenworth across the river. With the explosion of population in the greater Kansas City region, this Platte County hill country also offers excellent promise for outdoor recreation. Perhaps the most exciting aspect of this potential is the eventual

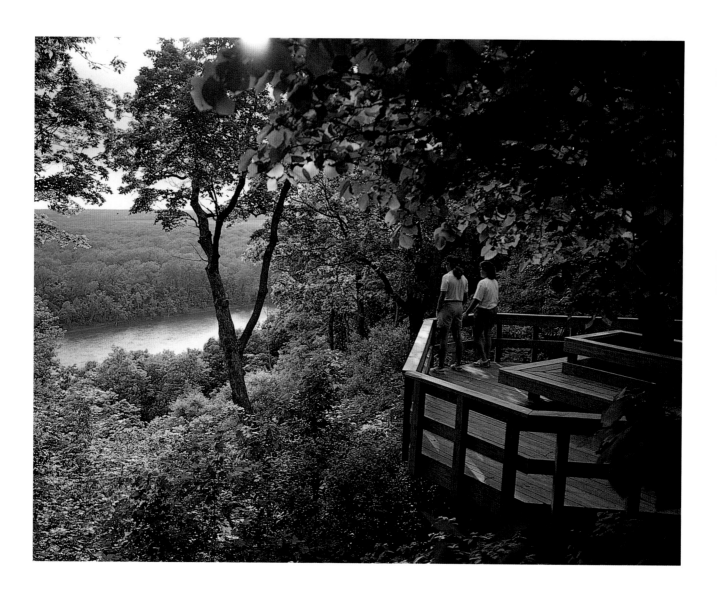

The view of the Missouri from the overlook at Weston Bend is one of the most expansive in the state.
TOM NAGEL

opportunity for direct access to the Missouri River, a resource that Missourians are learning anew to appreciate.

Finally, the cultural heritage of western Platte County will fascinate visitors. The town of Weston might have boomed on had the river stayed put in 1858; but then it would have been unlikely that so many of her beautiful antebellum buildings would have survived the progress that changed so many other towns. At Weston, the atmosphere of the old South lives on. The hemp business died when slavery was abolished and world competition increased, but the tobacco economy still flourishes. Two large tobacco warehouses are the marketplaces for millions of pounds of the fine-grade white burley that is

grown in the region, making Weston the largest tobacco market west of the Mississippi. The telltale elongate drying barns of real tobacco country still dot the ridges of the region. Four of these barns and several old tobacco fields were included in the lands making up the new park. One of the park's objectives is to preserve these sites and interpret Missouri's tobacco heritage to visitors.

The park boundary is also directly adjacent to grounds of the McCormick distillery, a direct descendent of the enterprise developed in 1857–1858 by the Holladay brothers. Benjamin (1819–1887) was a leading entrepreneur of the pioneer community. He ran a hotel and a store in Weston and became a leading operator in the overland freight and stagecoach business during and after the Mexican War. Like many of their neighbors, the Holladays were former Kentuckians who brought with them a knowledge not only of tobacco culture but also of bourbon whiskey.

David, a retired army officer, is said to have discovered in local springs a source of "sweet" limestone water considered ideal for use in a distillery like those that dot Kentucky. With Benjamin's backing, he built and opened the Holladay Distillery, which operated continuously, although later under different owners, until closed by Prohibition in 1919. It was revived under new management in 1937. "Sipping whiskey," like tobacco, represents a social priority (or vice) that, fortunately or unfortunately, has endured since Europeans brought whiskey to America and, in turn, were introduced to tobacco by the Indians.

The 1,050-acre Weston Bend State Park was assembled by the department of natural resources through the acquisition of contiguous farms beginning in 1980. Even before it was officially dedicated in the summer of 1990, the park attracted eighty thousand visitors in 1988 and more than a hundred thousand in 1989.

Entering visitors are welcomed at a kiosk designed, like other new structures in the park, to reflect the tobacco-barn motif. The main entrance road leads past scenic areas, a park office, and, just across the road, a large, well-preserved tobacco-curing barn that is used to demonstrate the techniques of tobacco production. Through

Fine burley tobacco produced in the thick loess soils along the Missouri River at Weston Bend is dried in well-ventilated tobacco barns that dot the countryside. TOM NAGEL

arrangements with local growers, the barn is still actively used, and park visitors are invited to come in and see the curing process. A small plot of tobacco is grown near the barn so that visitors may watch the entire process unfold by returning at different seasons. An outdoor exhibit displays the history of both tobacco and the Weston area.

The park also features campsites and a large picnic shelter equipped with siding that resembles—and functions like—the ventilating flaps on the tobacco-drying barns. And there is a handicapped-accessible scenic overlook of unusually pleasant design. From it one can enjoy a sweeping view upriver and downriver, across to the wild bottomland forest of Fort Leavenworth, and six to eight miles westward to distant ridges in Kansas—perhaps the best scenic view of the Missouri River anywhere in the state. From hiking trails along the park ridges and bluffs—especially early on a quiet morning, or near dusk—the visitor is likely to see white-tailed deer, unafraid because unharried by hunters, or the more elusive wild turkey.

From time to time freight trains rumble along the Burlington Northern track at the foot of the bluff, and freight barges pass on the river, now narrowed and contained by works of the U.S. Army Corps of Engineers. Although no longer as natural and fractious as when Lewis and Clark, and even earlier explorers, passed this way, or when Weston was a booming riverport, the Missouri is still a great river, and awesome to contemplate.

Lewis and Clark State Park

July 4th *Wednesday* [1804] ussered in the day by a dis-
charge of one shot from our Bow piece, proceeded on,
passed the mouth of a Bayeau lading from a large Lake
on the S.S. [starboard, or right, side] which has the ap-
perance of being once the bed of the river & reaches
parrelel for Several Miles. . . . the before mentioned
Lake is clear and Contain great quantities of fish an
Gees & Goslings, The great quantity of those fowl in
this Lake induce me to Call it the Gosling Lake.

—William Clark, in *The Journals of the
Lewis & Clark Expedition*

ONE OF THE GREAT dramas in world
history was the explosive expansion of
Anglo-American culture westward across the
continent of North America. It is no mistake that
our nation's most imposing monument to west-
ward migration, the great arch at the Jefferson
National Expansion Memorial, is located at St.
Louis. For St. Louis, at the confluence of the two
greatest rivers of the continent, was the starting
point for the epic two-year journey of Meriwether
Lewis and William Clark and their band of some
forty-five intrepid explorers up the Missouri into
the unknown vastness of the northern Rocky
Mountains, across the Continental Divide, down
to the Pacific Ocean, and back again, pointing
the way for those who would follow.

The Lewis and Clark expedition was one of the
most successful exploratory journeys of all time;
only one member of the crew died, probably of a
ruptured appendix. Commissioned personally by
a far-seeing young president, Thomas Jefferson,
Lewis and Clark used all of their remarkable in-
telligence, experience, and personal friendship to
plan and execute the expedition. Virginians by
birth, they chose mostly young Kentuckians and
French Missourians for their crew. Also accompa-
nying the group were York, Captain Clark's stal-
wart black body servant, and Sacajewea, the
Snake Indian wife of Toussaint Charbonneau. Be-
sides strengthened claims to the Pacific North-
west and its rich maritime trade, the president—
and the nation—longed to fill in the huge blanks
on the continental maps, and to know once and
for all if the fabled water passage to the Orient,
which had spurred westering explorations ever
since Christopher Columbus, did in fact, some-
how, really exist.

It is tempting to imagine the expedition push-
ing off in May 1804 from Wood River, across the
Mississippi from St. Louis, rendezvousing at St.
Charles for a frolic with the local French, then
paddling past the last upriver white settlement of
that day, a tiny hamlet at the mouth of La Char-
ette Creek. Near there lived a towering figure of
an earlier cycle of American pioneering, Daniel
Boone. Boone's relentless westering had brought
him in his vigorous old age to settle here in the
lower Missouri valley, near his children and their
households, where he continued to hunt, trap,
trade, and explore the Missouri frontier. Did the
old pioneer watch with the other villagers of La
Charette as the expedition poled upstream into
the new great unknown? Did he wonder how this
expedition of young stalwarts would perform in
the face of their certain encounters with danger,
hardship, and privation? Did he mentally com-
pare his own exploits in pushing across the Ken-
tucky wilderness to Missouri with this new ad-
venture? It is hard to imagine a more symbolic
linkage of two great surges of America's west-

Lewis and Clark celebrated the Fourth of July at this oxbow slough they named Gosling Lake on their epic journey up the Missouri in 1804. OLIVER SCHUCHARD

ward movement.

Two years later, in September 1806, Lewis and Clark returned with their expedition intact—hardened and weathered, but intact—and full of the emotion of those who have succeeded on a mission of great peril. They had explored the mountainous West, and it could no longer intimidate Americans as it had before. Lewis and Clark had strengthened American claims to the Oregon country; they had, after hundreds of years of explorers' yearning, laid to rest the myth of a water passage to the Orient; they had recorded for science a treasure trove of information about western plants, animals, and native peoples; and, most important, they had focused attention on the great West, giving the American people added knowledge and a thirst for still more knowledge, the search for which began almost immediately upon their return.

Among the great treasures of the expedition were the detailed accounts of the trip written by the leaders and also by several of the other men. From these journals we still draw key information about geology, biology, and anthropology. We also can use the journals to locate noteworthy landmarks of the expedition and assess how they have fared over time.

In the summer of 1804, the lower Missouri valley was, as it still can be, oppressively hot and uncomfortable. Nevertheless, the journals record a landscape startling to the explorers for its richness and beauty. Enveloping the wide brown river course were rolling hills draped in lush prairies and interspersed with copses of timber. Clark and Lewis comment on the abundant wild game, deer and turkey, and also on the walnut and "paecaun" (pecan), the wild grapes and raspberries, and the colorful "Parrot queets" (Carolina parakeets) that wheeled in flocks among the towering riverside trees.

One of the notable landmarks of the lower Missouri was a beautiful large oxbow lake that the explorers encountered on the Fourth of July. In those youthful days of our national independence, it seemed appropriate to the patriotic adventurers to begin the day with a salute from the gun mounted on the bow of their keelboat. That same day they explored the lake and noted the abundance of young "goslings" on the water; they named it Gosling Lake. The goslings prob-

ably were young geese, or possibly young swans, both of which nested in those days in the Missouri valley. Although the continual shifting of the river's channel makes identification uncertain, Gosling Lake may well be the oxbow we know today as Sugar Lake in Buchanan County, out on the broad warm floodplain of the Missouri River. The lake and surrounding marsh areas are still attractive to many waterfowl, though not in the same numbers as in 1804.

In 1934 a group of Buchanan County sportsmen donated about fifty acres along the southeast shore of Sugar Lake to the state for a park. And in 1938, the centennial of William Clark's death, the park board renamed this site to honor the leaders of the expedition, both of whom continued to serve the territory that would become the state of Missouri after their return from their epic journey. Meriwether Lewis was appointed governor of the Territory of Louisiana in 1807 and served until 1809, when he died under mysterious circumstances in Tennessee on a trip back to Washington, D.C. William Clark, the "red-haired chief," settled in St. Louis, served as governor of the Territory of Missouri from 1813 to 1821, and was renowned throughout his life as a skilled, fair-minded, and trusted negotiator with the western Indian tribes. On his death in 1838 he was buried in St. Louis's Bellefontaine Cemetery.

Lewis and Clark State Park, honoring one of the longest expeditions across some of the broadest expanses of the American continent, is one of the smallest parks in Missouri, only 120 acres. The lake is smaller and less clear than it was in 1804, but it still provides good fishing for catfish and crappie. As with its sister oxbow lake park, Big Lake in Holt County, there is a tendency for the lake to fill in with silt; if it is to remain in existence, this tendency must be countered with periodic dredging. The park provides facilities for lakeside picnicking, including a CCC-era stone shelter, and a well-appointed campground fully equipped with friendly little thirteen-lined ground squirrels that scurry across the manicured grounds to the delight of campers. Lewis and Clark State Park commemorates an epic of exploration, and it offers a pleasant environment in which to enjoy a remnant landscape of that saga of discovery.

Big Lake State Park

THE BROWN AND BRAWLING Missouri River comes down to the state from the Great Plains, burdened with the silt of the high prairies and flowing with the energy of the eastern slopes of the Rocky Mountains. Formed of meltwaters from the great continental ice sheets that covered the country to the north, the river in Missouri has carved a wide valley that has supported an abundance of life ever since the glaciers' retreat. The fertile soils of the Missouri valley include not only those deposited directly by the flooding river but also, and especially in northwest Missouri, soils called loess formed from silts picked up by the winds after the glaciers retreated and deposited in thick mounds along a broad strip bordering the river. These rich but easily erodible soils give the valley its shape and form; they have also shaped and formed its human history.

In its broad floodplain, the Missouri River from time to time shifted its course across the yielding alluvium. After such a shift in course, the old channel often retained water and formed a marsh or an open-water lake. Where such an abandoned channel was the result of the river cutting off a curving loop of its own course, the lake was known as an oxbow lake. As recently as a century or two ago, the floodplain of the Missouri River in northwest Missouri was a maze of shallow riverbeds, bottomland forests, wet prairies, marshes, and oxbow lakes, all teeming with fish, waterfowl, and large game animals, and bordered on the east by high-piled mounds of savanna-covered loess. It was a lush and fertile landscape, and it can still be glimpsed in a few places in the western sections of Atchison, Holt, Andrew, and Buchanan counties.

The largest remaining oxbow lake in Missouri is Big Lake, located in Holt County. With 615 acres of open water and nearby wildlife habitat, Big Lake has been a recreation magnet for many years. Most of northwest Missouri has been devoted to agricultural production, and only relatively few areas offer opportunities for outdoor recreation. Big Lake is one such area, and much of its shoreline is dotted with weekend cabins and fishing camps. In 1932, the state acquired about 100 acres along the shore of the lake for development as a state park.

The primary attraction at Big Lake was the open water of the lake itself, and all developments have been oriented to viewing, boating, and fishing opportunities in and around this shallow, tree-lined remnant of the Missouri River channel. Facilities include a tidy campground (here in the floodplain, every site is guaranteed flat), picnic areas, a full-service restaurant with a long-standing local reputation for good Missouri valley cooking, a swimming pool, a boat launch, docks, a motel, and new lakeside rental cabins. In the spring of 1984 the Missouri River rose in fury out of its army engineer–controlled channel and swept, as of old, over its floodplain. Temporarily reclaiming ground it had roamed since the Ice Age, the swollen river washed over the park and ruined the old cabins, which had dated from the earliest days of the park. Cleaning up was a mighty struggle, but not a new one. The river had wreaked similar havoc in 1952. Very quickly new cabins were built in the same lakeshore area, this time on elevated mounds.

The federal government in 1935 acquired the 6,000-acre Squaw Creek National Wildlife Refuge near the park. Squaw Creek is developed on the

*Comfortable cabins are available for rent at Big Lake,
an oxbow cut off when the Missouri River shifted its
course.* OLIVER SCHUCHARD

floodplain and the adjacent loess hills, and despite fairly intensive development of roads, ditches, and even fields for food crops, the refuge to a great extent still preserves a sample of the primitive northwest Missouri landscape.

Big Lake marsh rests under a blanket of snow, but come spring it will be a bird-watcher's paradise. KEN MCCARTY

Then in 1990 Big Lake State Park secured a significant natural marshland with the addition of a 300-acre wetland portion of the Big Lake oxbow to the north. This makes Big Lake the park system's most important marshland park. The marsh is refuge for a variety of wetland species such as the unusual yellow-headed blackbird. With restoration of fire through prescribed burning, several endangered aquatic plants once discovered here by the noted botanist Julian Steyer-

mark may once again be found. The parks division plans boardwalks and bird observation sites in the marsh.

The park visitor will find Big Lake a pleasant, restful place. Tall cottonwood trees flutter with the breeze almost constantly when in leaf, and there always seem to be shorebirds or waterfowl out on the lake. The new marsh and a portion of the park known as "the island" are kept undeveloped except for trails, and they are fine places to walk in the mornings and evenings to become better acquainted with floodplain plants and birds, or to sit on the bank and fish for Missouri River catfish.

The fall and spring migrations of waterfowl have always been times of extraordinary excitement in the Missouri valley. Nowadays, the wildlife refuge system has tended to concentrate the birds, and visitors to the Big Lake–Squaw Creek area can expect to see spectacular displays. Squaw Creek is especially attractive to the beautiful snow goose; these birds make a thunderous

Protecting the marsh wetland at Big Lake State Park is critical for such species as the green heron.
BRUCE SCHUETTE

display when they come down from the north by the thousands in the fall, and then in spring when they gather together and head back north. These migrations attract many visitors to the region either to hunt the geese or simply to thrill to their beauty and life. Other large birds, including bald eagles, come down to the Big Lake vicinity to spend the winter.

So, in the midst of heavily farmed northwest Missouri there is an oasis of recreation, natural landscape, and wildlife. Come in the summer for a lazy camp-out and fishing trip, during spring or fall migration time, or even in winter to watch eagles from the windows of the cozy dining lodge. The only problem with Big Lake is its relatively small size; there should be more and larger such parks in the Missouri valley.

Bison were eliminated in Missouri in the nineteenth century, along with virtually all of the tallgrass prairie that once covered most of the Osage Plains, but they are back in a world of their own at Prairie State Park. PAUL W. NELSON

Introduction

TALLGRASS PRAIRIE, now one of the rarest ecosystems in Missouri, once covered more than thirty percent of the state and more than seventy percent of the Osage Plains natural division in southwestern Missouri. Like the Glaciated Plains to the north, another prairie region, the Osage Plains are underlain by shales, sandstones, and limestones of Pennsylvanian age, softer and more easily erodible than the dolomites of the Ozarks. These plains are characterized by deeper soils and gently rolling topography with broad, shallow stream valleys and many marshes and sloughs. But unlike the northern plains, the Osage Plains were not covered by the great continental glaciers; hence they are topographically older and biologically somewhat more diverse, with a greater proportion of southwestern plants and animals than can be found further north. This division, which is not subdivided into sections, grades almost imperceptibly into the adjoining Ozarks, Ozark Border, and Glaciated Plains.

We begin, fittingly, with Prairie State Park in Barton County, at about 3,000 acres the largest remaining example of native prairie in a state that has lost 99.5 percent of all the prairie that once greeted the Indians, explorers, and earliest settlers. Marvelously diverse, with over four hundred different species of grasses and wildflowers, the park ecosystem is still being studied and painstakingly restored to reveal the full drama of this stunning but greatly endangered landscape. Some thirty miles to the northeast is a hilltop site—one of a series of limestone-capped ero-

sional remnants, or monadnocks, common in the region—that was the principal village of the Osage Indians in the seventeenth century, when they were first encountered by Europeans, and into the eighteenth. Though cropped in places and grazed like the rest of the Osage Plains, the vista is open, and Osage Village State Historic Site is key to understanding the preeminent role of the Osage in the state and region. Only fifteen miles east of Prairie State Park, in Lamar, is the modest birthplace of another Missourian of major stature, Harry S Truman, reminding us that the small towns on the plains of Missouri produced more than their share of great leaders.

In Johnson and Pettis counties, where the Osage Plains grade imperceptibly into the Ozarks and the Glaciated Plains, are two parks characterized by somewhat rougher land and more woody vegetation. Knob Noster, acquired by the federal government as a recreation demonstration area in the 1930s because of its scarred and impoverished condition after a century of poor agricultural practices and some coal mining, illustrates not only the penalties of misuse but also the recuperative potential of the land under careful stewardship, especially in recent years when the parks division has been restoring the long-lost savanna landscape so characteristic of this region. Bothwell, developed by a wealthy Sedalian as a country estate with a castle-like bluff-top lodge, offers trails with stone steps along wooded slopes, a shelter, and a picnic area for the enjoyment of guests today, just like those in the past.

Prairie State Park

FALL MUST BE THE prairie's prettiest season. At least it seems so each year when it comes. For this is when the grasses, emerald green all summer, turn brilliant orange, red, bronze, and gold. They stop whispering or rustling with the wind. Instead, they rattle, and toss to and fro. This makes the land seem restless and alive, its color more intense and consuming than that of forests. Standing in a swale in the midst of this rolling sea of grass, facing the wind and knee-deep in prairie asters, you feel just a speck on land that must stretch to somewhere beyond forever. And all around you, engulfed by the open skies, the annual fall pageant of the prairie begins.

First, there are the northern harriers—prairie hawks to whom the fall prairie seems a magnet. Sometimes near, sometimes far, they like to glide low, slowly skimming over the top of the grass. Or to hover, suspended, barely cresting some windy knoll—listening. Occasionally, one dives into the grass, and a noisy flock of red-winged blackbirds or a covey of quail erupts.

Beneath them, the bison are in a world of their own. After all, it is fall, and they are in their best condition of the year. It is also breeding season, and the bulls are touchy and cantankerous. Sometimes they fight, and the ground shakes and the dust flies when two one-ton animals slam full speed into one another.

Deer seem to sprout in the prairie's openness. The early morning sun often highlights them, ornamenting ridgetops and browsing along the prairie swells and swales. Sometimes you become aware of a collection of eyes, ears, and noses— each looking your way. But since only their heads show, motionless at the surface of that tossing,

grassy sea, they look strangely suspended, almost as if the heads are what is rooted while the land moves around.

Beside them in the distance, a short-eared owl glides home from the hunt; and with the blink of an eye, two coyote heads flash up and are gone. They reappear a little further away—bouncing high for looks above the tall fall grasses. Overhead, shimmering white dots—pelicans—wing their way south.

Such is the essence of Prairie State Park, one of the very few places left where this tallgrass drama still unfolds so completely. And it happens not just in fall, but daily, with a progression of sights and sounds that become a song of the seasons—living visions of Missouri's natural past, hopefully preserved in this park well into our future.

The first act begins even before the last of winter's occasional snow, when the early sedges bring a tinge of green among the white spots on the hills. These add an upright dimension to ground cleaned by prairie fires of last year's dead grasses. Soon the green spreads and envelops the land.

Splashes of color appear: scattered bouquets of purple violets, bright sulfur-yellow puccoons, and pale yellow wild indigos. The prairie chickens begin their booming—the annual courtship dance that makes them famous. One morning the hillsides are tinted red by Indian paintbrush, and meadowlark and dickcissel songs float on the spring air. Minute grasshopper sparrows busily build nests; and briefly, to those who know the sound, the buzzing song of the rare prairie mole cricket floats out of the twilight.

By May and June, the grasses begin a growth

A bronze sea of tall prairie grasses overpowers October's sunflowers and asters at Prairie State Park.
KEN MCCARTY

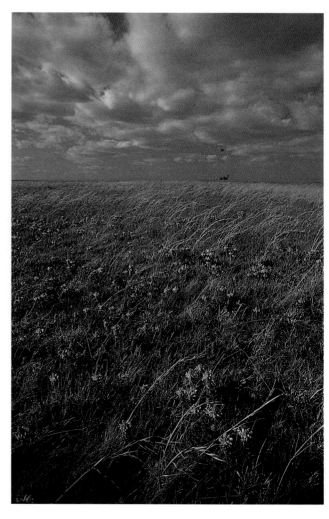

spurt that easily overtops the low flowers of spring. When knee-deep, they toss and blow in every wind, tirelessly sending waves forever rippling and racing across the hillsides—then out of sight over the far horizons. Next, a taller series of wildflowers springs through the grass, this time in mass profusion. These easily give late spring the distinction of having the most spectacular flower display of the year. Yellow coreopsis, white beard-tongue, false dragonhead, pale purple coneflower, sensitive brier, prairie phlox, scurfy pea, lead plant, and many, many more extend in all directions, to every horizon. Bison calves frolic among them in their uncommonly awkward fashion, following their mothers across the park. Northern harriers still dive, but now into blackberry thickets, where their tiny fluff-ball hatchlings are hidden and waiting to be fed.

By midsummer, as these flowers fade, the whole prairie world turns emerald. Now the grasses reign supreme, and the grassy waves still tirelessly race the breeze. When clouds drift too, the effect is almost dizzying. In fact, everything seems to move—the hawks, the songbirds, the

The prairie reflects the seasons: (clockwise from top left) monarch of the prairies, a bison bull surveys his domain on an icy winter's day (LARRY LARSON); *yellow-flowered wood betony and the remains of last year's grasses wave in an April wind above a greening prairie lawn* (PAUL W. NELSON); *changing by the week, a mid-June display features the cylindrical beard-tongue and the yellow blossoms of big-flower coreopsis* (PAUL W. NELSON); *an autumnal sun illuminates prairie grasses and the purple spikes of blazing star* (KEN McCARTY).

bison, all building during this time of plenty toward the coming winter. As big as the land seems, though, it is sometimes dwarfed by the power and fury of summer thunderstorms. And through it all, the call of the meadowlark becomes the song of the season.

By late August, these millions of grasses send up their seed stalks—four, six, eight, and, in wet places, sometimes ten feet high. Other late summer blooms, especially sunflowers, reach even higher to display their heads above the grassy sea to the hummingbirds, butterflies, and moths that

must pollinate them. By late September, the orange returns, and the fall pageant begins once again.

All this and more describes the heart and soul of Prairie State Park. It is a unique park, dedicated as a living tribute to a nearly extinguished native landscape. Missouri's sweeping prairie panoramas were almost history when this land was acquired in the late 1970s for a park. With so few fragments left, it is difficult to imagine that at least one-third of the state's land surface—thirteen million acres—once was prairie. That is, except when standing in one. Then it is much easier to appreciate the full cost of our loss—and to feel the real value of Prairie State Park. For here, on 3,000 native and restored acres, is Missouri's largest remaining prairie, and our greatest hope for preserving a sense of the scope of these wild grasslands.

Prairie State Park exists because of a happy conjunction of historical circumstance and the love of many people for the prairie landscape. It is fitting that the park is located in southwestern Missouri's Barton County, for this county had more of its land in prairie when the white settlers came than any other county in the state—some eighty-six percent. These western prairies were hunting grounds of the Osage Indians during the time of their great village on the hill along the Osage River to the north—now Osage Village State Historic Site—and the Osage continued to hunt here even after they gave up their lands further east in the cession of 1808. White settlement began in Barton County as early as the 1820s, but slowly; the lands now in the park were not taken from the public domain until the 1850s, and then as whole or half-sections under military bounty and swampland acts that tended to encourage speculative purchase by absentee owners. Surely not all the so-called swamplands were in fact perpetually untillable, but the fact is that most of the lands in the park were never tilled.

Major development in this area began in 1880 with the coming of the railroad, which provided access to markets for the region's coal and crops. Coal production centered around Mindenmines only a few miles southwest of the park; there was only limited disturbance on lands now within the park, though acid mine drainage remains a problem. More happily, a new industry began to flourish—the cutting and curing of the tall prairie grasses highly desired as fodder for mules and horses and cattle, prairie hay that could now be shipped by rail to markets near and far. The locals proudly aver that by World War I, when Mis-

souri mules were greatly sought for use in stateside crop production and even by the military overseas, the Schreiner Hay Company of Lamar had grown so successful that it had cornered the market for prairie hay. The center of the company's operations was at Prairie Center, just southeast of today's park. The need for mules began to decline with the advent of tractors, but a market still existed at stables, racetracks, and stockyards for the nutritious hay of the prairie bottoms. As recently as the 1960s, more than thirty thousand acres of native prairie remained in western Barton County, mostly on land whose owners were proud of their unbroken yet productive hay meadows. But then the chain of benign circumstance seemed to break. When the price of soybeans soared in the early 1970s and the price of land soared too, the prairies one by one were put to the plow for beans.

By the late 1970s when state park officials began to seek lands for a prairie park, they feared the best they could do would be an untilled forty or two that might in time be restored. But again came a happy conjunction of circumstance. An owner of a key undisturbed tract was suddenly willing to sell, officials of the Missouri Prairie Foundation and the Nature Conservancy simultaneously became aware of his willingness and the state's interest, and a wealthy heiress from Connecticut, who had fallen in love with the rolling prairie on a visit to Barton County in 1972, offered an interest-free loan to cover the sale price. Within days, a deal was struck for the core 1,520 acres that by 1980 would be dedicated as Prairie State Park. Katharine Ordway, the woman who put up the money, ultimately gave more than $40 million through the Nature Conservancy and other groups to preserve tallgrass prairie throughout the Midwest at a time when it would otherwise have faced annihilation.

At Prairie State Park today, some of the most spectacular wildflower shows of the state occur, more spectacular even than those that enchanted Katharine Ordway, as a result of careful clearing of brush and management by fire. The prairie is home for several rare and endangered species: the northern harrier, greater prairie chicken, prairie mole cricket, regal fritillary butterfly, Mead's milkweed, and the auriculate foxglove. A small herd of American bison was reintroduced to the park in 1985, after several units were fenced, and elk may soon follow. But, most important, the park is a place where prairie, as a landscape, can survive—expansive, dynamic, self-renewing, a living tribute to a largely extinct component of our natural past.

And Prairie State Park is for people to enjoy. A visitor center tells the prairie story, with displays, dioramas, a living prairie stream, slide programs, a greenhouse where the out-of-season plants may be seen, and more. Naturalists are there to present prairie programs, answer questions about the prairie, or lead walks across it. School groups are common by day, as are visitors on trails or along the roadways in the evening, when bison, deer, and prairie birds are most easily seen. Several foot trails, short and long, leave from the visitor center and roadside trailheads. These lace the rolling prairie, from its high, dry ridges to its rich, marshy streams. Along one prairie stream, in a small grove near the visitor center, are a picnic ground and a small, reservation-only campground. And near the juncture of two other streams, on a remote terrace with nothing but prairie in sight, is a small, reservation-only camp for backpackers. The nearby stream, East Drywood Creek, is the state's most outstanding prairie headwaters stream, and the area through which it flows is a state natural area. Prairie State

Tallgrass prairie has been maintained since time immemorial by repeated burning from fires set by lightning, Indians, or park managers.

Park is a place where those who wish to experience the great North American tallgrass prairie may readily do so.

It is a wonder that enough prairie survived to become a state park. But it did, thanks first to the many owners who valued these unbroken grasslands, and then to those who cared enough to preserve a legacy for the future. If this legacy is truly to be preserved, however, park scientists now realize that this tiny island ecosystem must be considerably enlarged—to a total of about 7,000 acres—in order to protect against changes in land use and other threats from beyond its boundaries. The hope for this park is that it can be large enough, and ecologically viable enough, that the age-old drama of the prairie may forever unfold.

Osage Village State Historic Site

WHEN FRENCH-SPEAKING explorers and traders first came to Missouri, the Indians most feared and respected by other natives were a tribe that called themselves the Ni-U-Ko'n-Ska, "Children of the Middle Waters." Among themselves, in humility before their Wah'Kon, or "Mystery Force," they said they were the "Little Ones." The first written record of these people derives from the expedition of Louis Jolliet and Father Jacques Marquette down the Mississippi River in 1673. From the Illinois Indians near the mouth of the Missouri, Father Marquette learned of a powerful tribe that lived up that river near the people called the Oumessourit, or Missouri. The Illinois Indians only knew of the more powerful tribe through the one band that had visited them, the Wah-Sha-She; this name, referring to only one group of the tribe, evolved into the name we now use for the whole people: the Osage.

The territory over which the Osage held sway was huge, including most of what is now Missouri, Arkansas, eastern Kansas, and Oklahoma. On hunting or war expeditions, they wandered far beyond even those limits. Their principal villages were at a junction of waters in western Missouri that they called the "Place-of-Many-Swans." This locale is where the streams we know today as the Marmaton, Little Osage, and Marais des Cygnes come together to form the Osage River in Vernon and Bates counties. The Osage were lords of the prairies and woodlands from the Missouri to the Arkansas rivers, and from the Mississippi to the Great Plains. It is startling to consider that this robust, warlike tribe numbering at most ten thousand people so thoroughly dominated such a large region. The

land, which they called "The Sacred One," was certainly rich, and the Osage obviously knew well how to live with it.

The Osage may have developed as a tribe in the same territory they occupied when the French encountered them. They spoke a language classed as one of the southern Siouan tongues, related to the Quapaw of northeast Arkansas. As a prairie-woodland people, the Osage used the animals and plants of both the forest and the grasslands. They planted gardens of corn, squash, and beans, but also hunted for buffalo, bear, elk, and deer. They gathered the fruits of the walnut, wild grape, pawpaw, persimmon, and American lotus or yanquapin, and fished the fertile waters of the rivers and oxbow lakes.

The Osage defended their northern frontier from the Sac and Fox, cooperated with the kindred Missouri and Kansas on the Missouri River, fought more or less continually against the Pawnees on the western plains, and thoroughly intimidated the Caddoan tribes to the south along the Arkansas and Red rivers.

Osage ceremonies, rituals, and modes of social organization were elaborately tuned to the natural environment. By almost any fair measure, the Osage had "strong medicine." And they apparently looked the part. Almost every chronicler of the early West was impressed by the physical prowess of the Osage. Washington Irving, in his *Tour on the Prairies*, paints a characteristic portrait:

> Near by there was a group of Osages: stately fellows; stern and simple in garb and aspect. They wore no ornaments; their dress consisted merely of blankets, leggings, and moccasins. Their heads

During most of the eighteenth century, Osage Indians had their principal village on a grass-covered hilltop near what they called the Place-of-Many-Swans.
K. W. Cole

The pits and grooves in this sandstone slab give mute testimony to its use by the Osage for grinding and sharpening. Arne Larsen

were bare; their hair was cropped close, excepting a bristling ridge on the top, like the crest of a helmet, with a long scalp lock hanging behind. They had fine Roman countenances, and broad deep chests; and, as they generally wore their blankets wrapped round their loins, so as to leave the bust and arms bare, they looked like so many noble bronze figures. The Osages are the finest looking Indians I have ever seen in the West.

The arrival of the earliest French traders from the east and of the first stray horses from the southwest probably did not affect the Osage as drastically as the tribes further out on the plains. Neither the French, the Spanish, nor the British could contest the power of the Osage in their domain. Instead, the Osage were prime trading partners, supplying huge quantities of furs and also captive Indian slaves. Until the nineteenth century, the Osage accounted for over half of the total trade in furs on the Missouri River. The French and Spanish profited from the trade, valued the Osage as buffers from each other or from the British, and blinked at the frequent robbing of traders or the killing of weaker Indians and even whites who strayed into confrontations with the "Imperial Osages."

For their part, the Osage tolerated the small infringements of French settlements along their largest rivers, occasionally punished offending settlers or traders, and even adopted a number of stray whites as semipermanent guests in their villages. They relished the trade that brought them metal tools and weapons, gradually becoming more and more dependent upon it.

When the new United States government bought the territory of Louisiana from France in 1803, the old Osage way of life was doomed. American settlers, much more aggressive than French villagers, more persistent and tenacious than French traders or Spanish commandants, pressed hard upon Osage lands. Starting with a treaty in 1808, the Osage began a series of dignified but repeated retreats that withdrew them step by painful step from eastern Missouri, then from western Missouri into Kansas in 1823, then into southern Kansas, and finally, after the Civil War, into Oklahoma, where they now live. The Osage domain today in Oklahoma, Osage County, is but one county—albeit an oil-rich one—of a state that once was largely Osage tribal ground.

In the vicinity of the rich prairie, river, marsh, and forest area known by the Osage as Place-of-Many-Swans in present Vernon and Bates counties, the Osage occupied several village sites over the course of the many years they lived there. During the period from about 1700, not long after they first met the French traders, until about 1775, when they moved a few miles away to the south, the Little Ones' lodges stood on a high, open hilltop that commands a broad, sweeping view of the winding Osage River valley and surrounding hills and groves. This hill is the highest in a chain of isolated, limestone-capped remnant hills that runs roughly northwest to southeast, sitting between two small tributary streams and pointing toward the Osage River to the north. It is this grass-covered hilltop site that is now preserved as Osage Village State Historic Site.

While living in this beautiful setting with their rich lands arrayed before them, the Osage first came really to know the white traders and their goods, trading for several years at Fort Orleans on the Missouri River. They met Etienne de Bourgmond, Charles du Tisné, and Bernard de la Harpe; they welcomed home their warrior who was taken along with other Indians to France to be the object of flattering attention from the Gallic nobility; they sent warriors east in alliance with France to help in the bloody ambush of the English general Edward Braddock; they came to know, though not very intimately, the Spanish commandants after Charles III took suzerainty over Louisiana; they visited the new village growing up on the Mississippi just below the Missouri which the Spanish called San Luis, but which they always referred to as "Chouteau's town" in deference to their most respected trading partner. During this time the Little Ones also continued their traditional skirmishes with the tribes who bordered Osage territory, especially the Pawnee on the west. They also carried out their immemorial ceremonies of life, hunting in the spring and fall, planting and harvesting their crops, and praying each morning in the predawn darkness as they faced the rising sun.

When the Osage left this home and eventually Missouri, they left no monuments. Soon there was little that might tell the white American settlers of Vernon County that this tall hill had once been the political and cultural center of an empire extending into four states, a domain claimed by a people who called themselves the Little Ones but whom others called "giants," an empire respected by the sovereign monarchs of Europe. The Osage themselves retained memories of the Place-of-Many-Swans but did not come back to visit except as occasional individual pilgrims. In time, domestic cattle came to graze the hill. Farm buildings and watering ponds were constructed. The old village site became, for practical purposes, lost to knowledge.

Then in 1941 a young archaeologist from the

Carl Chapman describes findings of his archaeological studies of the Osage to a tour group gathered to support inclusion of the village site in the state park system. K. W. Cole

University of Missouri surveyed the site and confirmed that this hill was indeed a principal village site of the Osage during those historic decades of the eighteenth century. In the archaeological world the village site took on the name of the Missouri farm family who owned the ground, the Browns. Eventually, further investigations were conducted at the "Brown Site"—or, even more arcanely, at 23VE3, as it was identified in the archaeological survey of Missouri. The extent of the site was more precisely defined through excavations over the years, and a wealth of recovered artifacts now document the village. Here is where the Osage were becoming more and more dependent upon European trade goods, even while maintaining their earlier style of life.

In 1971 the Brown Site was enrolled in the National Register of Historic Places. There was no other legal recognition for the land, although the Brown family knew its value and safeguarded it from pothunters. Finally, in the late 1970s, the same archaeologist who first confirmed the site, by this time the dean of Missouri archaeologists, Dr. Carl Chapman, alerted the parks division and the Archaeological Conservancy, a national preservation organization, that Mrs. Leslie Brown was interested in seeing the site permanently preserved. Mrs. Brown's death brought some urgency to the matter, and the conservancy, after signing a repurchase agreement with the department of natural resources in 1981, stepped in and purchased the hundred-acre tract. Then in 1984, thanks again largely to the efforts of Carl Chap-

man, the state legislature appropriated funds to buy the property.

In its lovely setting, with its wealth of buried knowledge, and because of its pivotal role in so much early Missouri history, Osage Village State Historic Site has a unique part to play in helping Missourians understand their state. The walking trail and excellent outdoor exhibits help the visitor not only to visualize the history of the Osage and the relationship of this place to other nearby Osage and early European sites but also to feel the vibrant life of the village.

The site also brings an unusual burden of responsibility. Even beyond the obvious charge of protecting the resource, there is the memory of the Little Ones who actually lived on this spot for most of a century to be treasured and nourished. These Missourians shaped our history, but they remain relatively little known. What we know of them from history was written largely by those who coveted their land or feared their strength. The Osage of old Missouri will never have an opportunity to tell their story in their own way, from their own point of view. We must hope that the stories that are told here would find a measure of approval in the hearts of the Little Ones, the Children of the Middle Waters.

Harry S Truman Birthplace State Historic Site

THE FIRST OF THREE children of John Anderson and Martha Ellen (Young) Truman was born May 8, 1884, in a downstairs bedroom of a neat but small frame house on the edge of Lamar, the county seat of Barton County. The house measured only twenty by twenty-eight feet. It had four small rooms downstairs and two attic rooms with low ceilings, and it had neither electricity nor indoor plumbing. Set behind it were a smokehouse, a well, and, a little distance away, an outdoor privy—all typical of the times in the rural Midwest.

Lamar, first settled and platted in the 1850s, nearly died during the Civil War when it was briefly host to Gov. Claiborne Jackson's rebel force before the battle of Carthage, then was garrisoned by the Union army, and finally was raided not once but twice by William Quantrill's guerrilla band. Wyatt Earp married a local girl and served as the town's first marshal in 1870, providing a boast for boosters of a later day, but it was not until 1880–1881, when two rail lines reached and intersected at Lamar, that prospects significantly brightened. The house that John Truman bought in 1882 had been built two years before.

But Lamar's favorable prospects could not hold the Trumans, for when Harry was only eleven months old the restless young father, a horse trader and farmer with migratory tendencies, moved his family to the area south of Kansas City where both he and his wife had grown up. After living successively near Harrisonville, Belton, and Grandview, the family moved to Independence, county seat of Jackson County, in 1890. There Harry began his formal schooling and, at age six, first met Elizabeth Virginia (Bess)

Wallace, age five. They were classmates most of the time. Harry fell behind Bess one year when he was ill a long time with diphtheria, but he caught up later by skipping a grade—he was a "bookish" rather than an athletic boy—and both were members of the Independence High School graduating class of 1901.

College was out of the question. John Truman had switched from livestock trading, which he understood, to the commodities market, which he didn't, and lost all his savings including his home in Independence. Harry had to go to work to help keep his brother and sister in school. In 1906 his father and mother returned from a brief farming venture in Henry County to take over management of Grandmother Young's substantial six-hundred-acre farm near Grandview, and they asked Harry to help. For the next eleven years farming was his work, leavened by a prolonged courtship with Bess Wallace.

Reacting to events in Europe and the Kaiser's submarine warfare against American shipping, the United States declared war against Germany on April 6, 1917. In late September a new field artillery regiment made up of Kansas City and Independence units of the National Guard arrived at Camp Doniphan in Fort Sill, Oklahoma, and was federalized. Harry Truman had been elected first lieutenant. By the next April they were in France, and shortly Lieutenant Truman, having demonstrated exceptional leadership, was promoted to captain and commander of Battery D. His outfit was in some of the fiercest fighting—in the battle of Meuse-Argonne and on the Verdun front—as the Americans helped push the German army back and into collapse. His company, Captain Truman wrote, fired more than ten

Harry Truman was born in a downstairs bedroom of this little house in the up-and-coming railroad and county-seat town of Lamar in 1884.
OLIVER SCHUCHARD

thousand rounds at "the Hun" and never lost a man and only one gun, and that because a shell stuck in it.

Upon Truman's return from overseas in April 1919, he and Bess Wallace lost little time making plans for their marriage in June, and then Truman and his former canteen sergeant at Camp Doniphan opened a men's clothing store in Kansas City. The business did well at first but failed in 1922 during a period of postwar deflation. Another army friend was Lt. James Pendergast, nephew of the Kansas City political boss, Tom Pendergast. They persuaded Harry to run for eastern judge of the Jackson County Court (a position

now called commissioner). He won, was defeated for a second term, but then was elected for successive terms, eight years in all, as presiding judge of the county. He developed a good record and established a reputation for honesty.

In 1934, with Pendergast backing, Truman won a three-way contest for the Democratic nomination and was elected to the U.S. Senate, demonstrating a surprising appeal in outstate Missouri—thanks no doubt to his small-town and farm roots. Despite his continued loyalty to Pendergast, even after the Boss was indicted for bribe-taking and sent to prison in 1939 for income tax evasion, Truman was reelected to the senate in 1940—again appealing to rural Missouri and also to labor.

In his second term he built a national reputation as chairman of the "Truman committee," a special panel set up to monitor World War II contracts and to investigate and expose graft and profiteering. This led President Franklin D. Roose-

velt, as he prepared in 1944 to run for a fourth term, to choose the popular and dependable Senator Truman to be his running mate.

Mindful of the support he had received from outstate Missouri, Truman returned to the place of his birth and stood in the town square of Lamar to accept the nomination as candidate for vice president of the United States. Citizens of the little Osage prairie town, population 3,223, swelled with pride. For not only could they cheer one of their own as candidate for vice president, but by this time in the midst of the greatest military conflagration the world had ever seen they could also number among their native sons and daughters three rear admirals and the lieutenant commander of the coast guard women's reserve. Eight months later little landlocked Lamar would be able to boast the president and commander in chief.

The man from Missouri became the thirty-third president when Franklin Roosevelt, only eighty-two days into his new term, died of a massive stroke on April 12, 1945. In 1948 Harry Truman was elected to a full term, upsetting Republican candidate Thomas E. Dewey of New York, whom pollsters had picked as a sure winner.

The seven-plus years of the Truman presidency were marked by events and decisions of worldwide as well as national significance: the dropping of the first atomic bombs to end the war with Japan, the signing of the United Nations charter, the development of the Marshall Plan to rebuild war-ravaged Europe, the formation of the North Atlantic Treaty Organization, the beginning of the "police action" in Korea and other moves to check communist aggression, and, at home, the evolution of the Fair Deal program of social and economic reform.

Choosing not to run for another term in 1952, Truman returned to live in retirement with Bess in Independence, but for many years he kept up a vigorous life, working daily and writing his memoirs in the Harry S Truman Library and Museum. He died December 26, 1972, at the age of eighty-eight. Bess outlived him by nearly ten years. Both are buried on the grounds of the Truman Library

Truman attended the dedication of his birthplace in 1959, after it was purchased and donated to the state by the United Auto Workers. STATE PARK ARCHIVES

in Independence. Thus concluded a notable public life that began humbly in the little house on Kentucky (now Truman) Avenue in Lamar.

Throughout his political life Harry Truman had been a strong supporter of organized labor. In appreciation, the United Auto Workers of America bought the birthplace in 1957 from descendants of Wyatt Earp, had it restored, and donated it to the state in 1959 for preservation as a historic site. Harry Truman came down from Independence for the dedication on April 19, 1959, along with Gov. James T. Blair, Sen. Stuart Symington, and other dignitaries. "I feel like I've been buried and dug up while I'm still alive," Truman said, "and I'm glad they've done it to me today." He signed the guest book as a "retired farmer."

The parks division has furnished the house appropriately for the time of Harry's birth and provided period landscaping as well. A monument to our thirty-third president, erected by the UAW, stands at the front. Otherwise, the place remains very much as it was when John and Martha Ellen Truman lived there and their first child was born, May 8, 1884.

Knob Noster State Park

THERE IS AN OLD and haunting photograph in the state park archives in Jefferson City—a scene at Knob Noster sometime during the 1930s. In the eerie glow of a night campfire, a young woman in a white costume stands ceremonially surrounded by her fellow campers. If you have had the good fortune in your own youth to partake in a similar ceremony—this one was probably the allegorical closing ceremony of a youth camp session—you may be able to call up memories of such an evening. With excitement and anticipation in the air you would have listened to whippoorwills and an occasional screech owl calling from the gloom beyond the circle of light, a gloom punctuated by thousands of tiny fireflies, the darkness only intensified by the magic of the light and warmth, where ceremonies and songs wove you and your friends together. If all of this is unknown to you, you may just have to take it on faith that some of life's most enduring memories can emerge from such circles of summer firelight. Among those whose moment was captured in the old Knob Noster photo, the memories must still be glowing.

The group camps of the Missouri state parks were conceived during the Great Depression to provide the opportunity for just such experiences for youngsters who would not otherwise be able to enjoy them in a privately run camp. These camps, built mostly by the Civilian Conservation Corps and the Works Progress Administration, are for the most part still functioning today, including two—Camp Shawnee and Camp Bobwhite—at Knob Noster State Park.

Knob Noster was named for a nearby Johnson County town, which in turn was named in the 1850s for two hillocks, or knobs, near the town, plus some wag's addition of the Latin word for "our," *noster:* thus "our knobs." The park only became Knob Noster in 1946 when it was transferred to the state by the National Park Service. From 1936 to 1946 it was administered by the federal park service under the name *Montserrat* as one of its recreation demonstration areas, submarginal lands restored and developed for recreation near population centers. Montserrat was one of three such RDAs that have become state parks, Lake of the Ozarks and Cuivre River being the other two. The name *Montserrat* derived from another adjoining village, smaller than Knob Noster, located north of the park.

With labor provided through the work-relief program of the WPA, the federal government between 1938 and 1941 built Shawnee and Bobwhite youth camps, as well as a campground and picnic area, several small lakes, and various bridges and service buildings. Many of these buildings and other structures are still intact today and are listed on the National Register of Historic Places.

Since Johnson County is widely known as an agricultural and ranching county, how did this 3,500-acre tract come to be a candidate for a New Deal program aimed at poor and worn-out lands? While much of the county is indeed rolling prairie now under productive cultivation, a region along the Clearfork Creek tributary of the Blackwater River is fairly rough, centered on a high, limestone-capped erosional remnant known as Bristle Ridge. The shaley sedimentary rocks in this area contained coal deposits. Because of overgrazing and poor farming practices on the thin soils of these rolling ridges, coupled with coal mining in places, this vicinity had by the

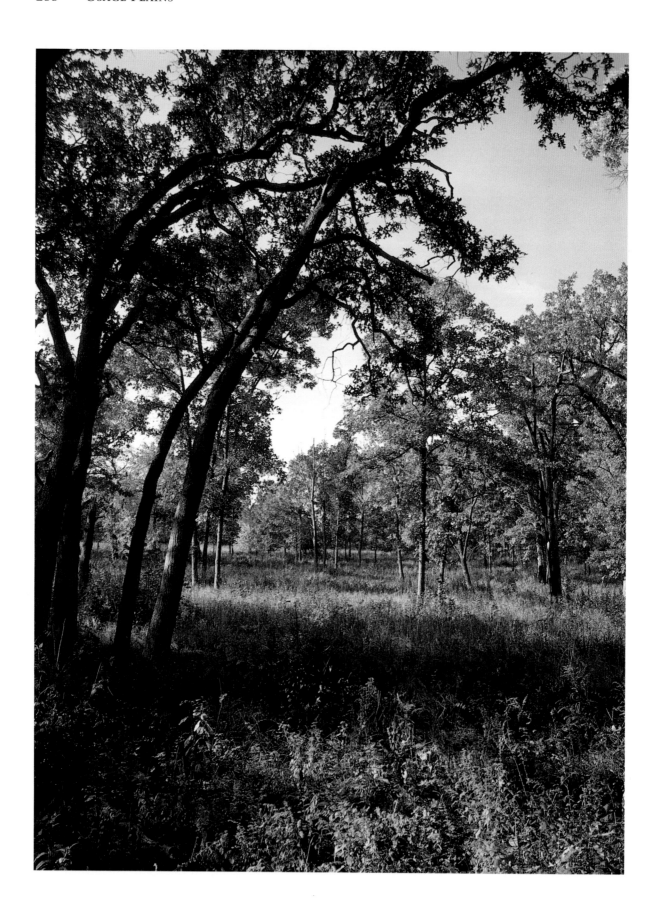

1930s become scarred and impoverished. With federal acquisition and development, the Montserrat Recreational Demonstration Area in fact began a useful second life. The effects of erosion were largely reversed, and a somewhat brushy forest reclaimed parts of the area.

But neither the barrenness of the early 1930s nor the more recent brushy aspect accurately represent the original landscape in this area. Knob Noster lies along the eastern fringe of the Osage Plains natural division, and amid the dissected lands along such sizable streams as Clearfork Creek there originally was a broad zone of transition between forest and prairie. An interesting eyewitness description of this now-vanished savanna landscape has come down to us in the form of a narrative written by a young Missouri Confederate soldier, Ephraim McDowell Anderson, who marched with his companions through the Knob Noster vicinity in 1861: "The country was prairie, but not quite so rich as that we had left behind. . . . The view opens upon boundless and beautiful prairies, dotted with clumps of trees. . . . Clumps of trees, away from any stream or water, is another peculiar feature of this region."

The savannas described by Anderson, and much besides, were gone by the 1930s and have largely been replaced by second- and third-growth timber. In recent years, the parks division has attempted to restore portions of this presettlement landscape. Progress has been steady and gratifying. The park's visitor center contains exhibits that explain the dynamic forces, including fire, that created and can eventually restore the Knob Noster savannas, and informational signs are located near some of the burn areas as well. This park, long in the process of rehabilitation, is now encountering new challenges posed by expansion of nearby Whiteman Air Force Base and rapid growth in neighboring towns—challenges that will require continued creativity and commitment if the park is to endure as a natural retreat in an urbanizing world.

If you are no longer able to enjoy Knob Noster

In a park carved from abused lands in the 1930s to demonstrate the possibilities of rehabilitation, park scientists are now restoring a long-lost savanna ecosystem. SHEILA LARRABEE

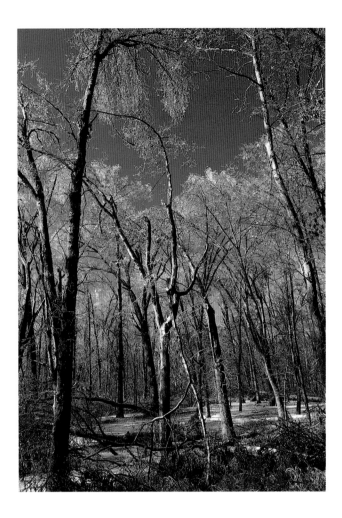

Ice coats the trees at Pin Oak Slough Natural Area.
TOM NAGEL

as a group camper at Shawnee or Bobwhite, come anyway and set up your own campsite in the shady public campground. Enjoy some quiet fishing in Clearfork Lake. Visit the Pin Oak Slough Natural Area, an old oxbow of Clearfork Creek now home to pin oak, swamp white oak, silver maple, and many other species. Hike out to one of the savannas, listen to the dickcissels calling in the tall bluestem, and imagine the old Missouri landscape as Ephraim Anderson saw it. In the evening, you can enjoy your own little campfire. The dark summer night still resounds with whippoorwills and screech owls, the fireflies still flicker like tiny stars, and the glow of a circle of friends or family can still create magic memories.

Bothwell State Park

THE MISSOURI TOWN of Sedalia is probably best known to the world at large as the temporary home of ragtime genius Scott Joplin, the place where he wrote the "Maple Leaf Rag," named after Sedalia's Maple Leaf Club, an old-time nightclub. Missourians themselves probably know Sedalia best as the home of the Missouri State Fair.

Thousands of Missouri families over the years have traveled north from Sedalia along Highway 65 after a visit to the fair and noted the large, stone, castle-like building standing prominently on a bluff just a few miles north of town. Many, no doubt, have wondered what this building was, and who owned it. Any Pettis Countian could have told them.

In 1979 the old stone lodge and the surrounding 180 acres—now 250—were dedicated as Bothwell State Park. Now the state park system is the caretaker and storyteller for this intriguing old estate. John Homer Bothwell was a Pettis County attorney and businessman who had moved to Missouri in 1871. He married the daughter of a prominent Sedalia family, Hattie Ellen Jaynes, in 1884, but she died after a brief illness only a few years later, and he never remarried. Bothwell was active in local politics and served Pettis County in the Missouri General Assembly for four terms, running for governor in 1904. He helped to make Sedalia the permanent seat of the state fair.

John Homer Bothwell's Stonyridge estate north of Sedalia, accepted as a state park in 1974, has been intriguing guests since the turn of the century.
OLIVER SCHUCHARD

In 1897 he began construction of the home that he called Stonyridge. He used native rock from the estate grounds, and the house grew in a rambling fashion—actually three independent sections tied together. The house is built over a natural cave and has a connecting shaft into it. In the room below the library—a workroom and storage pantry—a wooden "well kerb" device covers an opening that drops directly into the cave. The shaft may have been dug for a sort of refrigerator, like a springhouse, into which food could be lowered. This shaft also links the cave to an adjacent stairwell that goes up through the house. Some rooms have doors or windows that can be opened onto the stairwell to provide a draft to draw cool cave air up into the house, room by room.

As a bachelor of means, Bothwell enjoyed both traveling afar and entertaining numerous guests at home. Stonyridge reflected all of this in its informal atmosphere and eclectic furnishings— from mission style to wicker, with an occasional stuffed animal or fish thrown in. Bothwell appreciated the natural world, and he grieved that much of the timber atop the ridge had been cut just before he acquired the property. He spent years restoring the native vegetation, and he constructed a trail along the wooded slope surrounding the lodge. This charming trail was popular with his guests, providing stone steps in steep spots, resting benches, and a small picnic shelter.

Bothwell prospered on into his old age, continuing to provide easygoing hospitality until his death in 1929—and even after, because his will provided that the estate should continue to serve as a recreational retreat for his friends, and ultimately for the people of Missouri. So Bothwell

The handsomely appointed library of Bothwell's bachelor aerie. TOM NAGEL

Lodge, accepted by the state in 1974, today continues to entertain and refresh visitors from far and near.

A trip to this park properly begins with a visit to the lodge itself, which could be described as an overgrown English style cottage. It has three levels and twenty rooms. If Hattie Bothwell had lived, she might have brought a more delicate touch to the decor, but the furnishings are of good quality and comfortable. A favorite room is the library; when one visits here, it is easy to imagine the widely read and curious-minded Bothwell enjoying the fine woodwork and extensive collection of handsomely housed books, as well as the lovely view of the valley below his estate. The cozy fireplace must have made this a favorite retreat in the wintertime too.

Bothwell's Stonyridge trail has been refurbished and still offers a pleasant walk. Many of the trees along this forested slope are sugar maples, so fall walks can be especially beautiful among the golden and orange leaves.

Blazing star graces Little Chariton Prairie at Long Branch State Park, a tiny remnant of the tallgrass prairie that once was common on the Glaciated Plains. KEN MCCARTY

Introduction

THE CONTINENTAL ICE sheets covered the northern third of the state approximately to the Missouri River, which was largely formed by outwash from the melting glaciers. Thus the land surface of the Glaciated Plains natural division is younger than that of the Osage Plains and other unglaciated portions of the state, with deep soils formed primarily from glacial till and windblown silts or from alluvium. Prairies covered about forty-five percent of the area, primarily on the more level uplands but with wet prairies along some of the major streams, while savannas and woodlands characterized the slopes and many bottomlands. The topography, soils, and vegetation vary considerably within the Glaciated Plains division, which is divided into four sections.

We begin in the east in the Lincoln Hills section along the Mississippi River, an area of steep topography with bedrock exposures of Mississippian and Ordovician age. This rugged area was a mosaic of oak woodlands, savanna, and a little open prairie in presettlement times. In addition, bluffs, glades, and karst features like caves and sinkholes have resulted in a biota similar to that of the Ozarks. The section is represented at its southern fringe by its only state park, Cuivre River, with its limestone bluffs, wooded valleys, remnant and restored prairies, and a richly diverse flora and fauna.

Immediately to the west is the Eastern section of the glaciated plains, drained by streams that flow eastward to the Mississippi River or southward to the lower Missouri, but excluding the Lincoln Hills. Originally this was a region of glacial till prairies and savanna (now farmland or, in places, mined land) and fairly rugged wooded river breaks. Fittingly for an area early settled by migrants pushing upstream from the Mississippi, the region is represented by two historic sites and a related park. Far and away the best-known denizen of the Salt River hills is Samuel Langhorne Clemens, born in 1835 in Florida, Missouri, in a two-room cabin now enshrined about a quarter-mile away in a modernesque museum at Mark Twain Birthplace State Historic Site. Mark Twain State Park, which surrounds the birthplace and museum, was assembled in 1924 to preserve Clemens's Salt River valley haunts; but in an irony of fate symptomatic of our times the valley is now drowned by a huge Army Corps of Engineers reservoir named Mark Twain Lake, and progress has come to Mark Twain Country. Fifteen miles west on the Elk Fork of the Salt River is Union Covered Bridge, which preserves a remnant scene from earlier times.

The central section of the Glaciated Plains, the Grand River section, embraces lands drained by the Grand and Chariton rivers and their tributaries. This region was originally about half savanna and half woodland and prairie, wooded in the breaks along the stream drainages but with wet prairies and marshes along the broad floodplains of the major rivers and dry prairie on the rolling hills. Moving generally westward, we begin with Long Branch State Park, a tract on the shores of a corps reservoir in the Chariton drainage that preserves remnants of the savanna and prairie landscape that greeted the early settlers. To the north at Thousand Hills State Park west of Kirksville is a rugged belt of hills that shelters Indian petroglyphs and rare occurrences of the large-toothed aspen, a plant usually found much further north.

In Linn County, near Locust Creek in the Grand River drainage, is a cluster of sites associated with the highest-ranking military officer in United States history, Gen. John J. Pershing. The Pershing boyhood home in Laclede includes the one-room Prairie Mound School where Pershing once taught, as well as the home and its outbuildings. Pershing State Park preserves childhood haunts of the general, including superb wet prairie and forested bottomlands along Locust Creek, one of the last sizable stream segments in northern Missouri that has not been channelized. Locust Creek Covered Bridge north of the park, through which Pershing traveled as a boy, sits mired in silt eight hundred feet away from the "improved" channel of Locust Creek, a monument to the epidemic of stream straightening that afflicted north Missouri from the 1920s to the 1950s.

In Grundy County northwest of the Pershing sites is a scenic memorial to another noted Missouri general, Enoch Crowder, founder of the selective service system. Crowder State Park preserves boyhood haunts along the rough, wooded drainages of the Big Thompson, tributary to the upper Grand River. And in Clinton County, closer to Kansas City, is Wallace State Park, a wooded oasis amid fertile farmlands that includes a superb example of old-growth north Missouri upland forest.

The western section of the Glaciated Plains natural division is characterized by thick mounds and bluffs of loess along the Missouri River and extending back from it. This region has the driest climate in the state and originally was mostly prairie, with some hill prairies exhibiting species typical of the Great Plains. Because this is some of the richest (though highly erodible) agricultural land in the state, little prairie remains. Watkins Woolen Mill State Historic Site and the adjoining Watkins Mill State Park in Clay County near Kansas City provide a fine introduction to the riches of the area. A prosperous agricultural plantation since its settlement by Waltus Watkins in the 1830s, the operation by the 1860s included a major woolen mill with three floors filled with machinery. It is today the nation's only nineteenth-century textile factory with its original machinery still intact, and it has been designated a national historic landmark.

Cuivre River State Park

THE CUIVRE RIVER barely touches the southwestern edge of the state park in Lincoln County that bears its name. But the juxtaposition is dramatic: a high cliff of Mississippian limestone known locally as Frenchman's Bluff drops off sheer to the river. From the vantage point of the park, one can take in a sweeping view of the rich, alluvial farmland stretching along the valley.

Such striking topography may, at first, seem out of place in northern Missouri. The rugged landscape, the rich woodlands, the limestone glades, the upland sinkhole ponds: all seem more representative of the Ozarks region south of the Missouri River. But Cuivre River State Park is located at the southern end of a sixty-mile stretch of uplifted bedrock known as the Lincoln Hills. While the rest of northern Missouri was scoured and buried by debris carried by the continental glaciation, the Lincoln Hills somehow escaped its more dramatic effects. Glacial erratics are found throughout the hills, yet today the hills remain a kind of biological island with an assemblage of plants and animals not usually found on the glaciated plains of northern Missouri.

The state park consists of over 6,200 acres centered on Big Sugar Creek, a tributary of Cuivre River. The creek has carved a lovely valley through limestones formed from warm-sea sediments laid down more than three hundred million years ago. That ancient sea was home to millions of animals called crinoids or sea lilies. Related to starfish and sea urchins, the crinoids once carpeted the sea bottom, and their fossil remains are plentiful in the Mississippian-age rocks exposed in the park. In fact, the crinoid is now the official state fossil.

Long after the last crinoid died on the sea floor and turned to stone, and long after the resulting rock formations were uplifted, folded, and eroded, the Cuivre River area was home to native Americans. Indians inhabited the area as early as ten thousand years ago, and many remains—campsites, burial mounds, villages, and ceremonial areas—have been identified by archaeologists in and around the park. One burial mound in the park was carefully excavated in 1937, shortly after the land was acquired by the National Park Service as a recreation demonstration area.

Most of the land acquired during the New Deal as demonstration areas had been badly abused; one of the motives for federal ownership was to demonstrate good land use practices. Another was to demonstrate the benefits of outdoor recreation, especially in areas close to population centers. Two of President Franklin Roosevelt's "alphabet-soup" agencies, the CCC (Civilian Conservation Corps) and the WPA (Works Progress Administration), built many of the park's facilities: the roads, bridges, picnic shelter, group camps, and shelters. In 1946, the Cuivre River lands, along with similar demonstration areas at Lake of the Ozarks and Knob Noster, were transferred to the state.

Camp Sherwood Forest, Camp Derricotte, Camp Cuivre: group camps are a special feature of the park. Generations of eastern Missouri schoolchildren first encountered wild nature through one of the organized school, church, or other group camp sessions at Cuivre River State Park. One of the old guidebooks for counselors tried to define a camp: "What makes a camp a camp? Not the tents, the buildings, not the campers, although of course there must be camp-

ers. It is the warm sun, white clouds, the rain, the grass, trees, shrubs, flowers, the pond and brook. It is the fish, frogs, turtles, birds, rabbits, squirrels, foxes, butterflies, crickets and many others. It is the stars at night." The counselor's job was—and still is—to introduce young campers from the city to these wonders. Most of the campers come straight from the world of asphalt, concrete, and TV sets. They are not tuned to the out-of-doors.

Just as the New Deal was attempting to rehabilitate the lands of the park, so too were the group camps an effort to reinvigorate the health and character of the young campers. Intended primarily for disadvantaged children from the cities who did not have much access to wild nature, the camps aimed to immerse the youngsters in wholesome activities in a primitive setting. The rustic stone and wood construction of the CCC and WPA structures was a perfect accompaniment to the developmental education philosophy underlying the camps.

Nowhere may one get a better sense of the traditional New Deal group camp than at Camp Sherwood Forest, where fifty-three CCC buildings and other structures still remain, most now beautifully restored for use into the future. Evoking the Robin Hood theme, the camp consists of four "villages"—named Ancaster, Locksley Chase, Nottingham, and Fountaindale—each with five cabins for four to eight campers, two counselors' cabins, and a unit lodge, outdoor kitchen, and latrine, accessible from the rest of the camp only by foot trails through the forest. Other buildings include a central dining lodge, recreation hall, pool house, infirmary, other administrative buildings, and an amphitheater and council circle with a flagstone campfire area and split-log seats. Originally operated under the supervision of the St. Louis Park and Playground Association with assistance from various social agencies and charities, the camp developed a ritualized program intended to instill the spirit of "friendship, cooperation, and learning" and, even more, an appreciation of the workings and values of democracy in children from the inner city.

In recent years, the camps have been available for rental by a wide range of organizations for everything from religious retreats and group and family reunions to music camps, storytelling workshops, and orienteering championships, and

Frenchman's Bluff brings a touch of the Ozarks to the Lincoln Hills of northeastern Missouri, contrasting with the alluvial farmland of the Cuivre River valley.
TOM NAGEL

Campers from the city while away a few idle moments outside the dining lodge during a break from the busy camp routine at Camp Sherwood Forest.
BRUCE SCHUETTE

of course 4-H, scouting, and school activities. For many groups, especially scout and school programs, the emphasis has been not only on socializing in the out-of-doors but on becoming aware of the natural world. From awareness and knowledge come appreciation, an understanding of one's relationship to and dependence on soil, water, plants, and animals—and of one's power to destroy a habitat, and to help restore it.

Cuivre River State Park, itself an assemblage of preserved and restored natural communities, is an ideal setting in which to learn the meaning of land stewardship. One might begin with a trip along the main park road, where the New Deal relief workers in the 1930s painstakingly constructed masonry check dams, curbing, guttering, and culverts to keep roadside ditches from washing and to direct the flow from one side of the road to the other—all of this conscientious engineering now enrolled, along with Camp Sherwood Forest and various other structures, on the National Register of Historic Places.

The natural environment has recovered to such a degree that the park now boasts three state natural areas—Big Sugar Creek, Pickerelweed Pond, and Hamilton Hollow—and two state wild areas totaling nearly 3,000 acres. Both wild areas straddle Big Sugar Creek—Northwoods is north of Route KK, while Big Sugar Creek is south of Camp Derricotte—and both feature a forest canopy dominated by sturdy white oak.

The Big Sugar Creek Natural Area encompasses part of the northernmost segment of Big Sugar Creek. The creek has a gravel or limestone bottom and is spring-fed, like an Ozark stream,

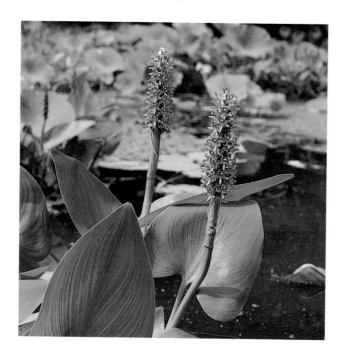

Only a few natural upland sinkhole ponds remain in northern Missouri. The rare pickerelweed still survives at its namesake Pickerelweed Pond Natural Area. PAUL W. NELSON

blazing star.

This largely restored, marvelously diverse park offers excellent naturalist programs headquartered at a new visitor center with exhibits on the natural and cultural history of the park and the Lincoln Hills. At least eight different hiking, backpacking, and horseback-riding trails total some thirty miles. The eighty-eight-acre Lake Lincoln is fine for swimming and fishing, and there are numerous campsites and picnic areas.

Even the entrance to Cuivre River State Park is special. Following a narrow corridor of public land north from State Route 47, you are gently removed from the asphalt and concrete of the workaday world and drawn into the peaceful forest of Cuivre. When you cross the charming triple-arched stone bridge over Little Sugar Creek, all cares are left behind and you feel somehow reborn. Cuivre River is a park of hope, where nature has regenerated and man may too.

but the springs are intermittent in summer, giving rise to warmer water in the pools. Thus its assemblage of eighteen or more fish species and other aquatic life shows the transition between Ozark and prairie streams. Big Sugar Creek is probably the finest undisturbed stream in northeastern Missouri. Along its banks grows a bottomland forest of sycamore, cottonwood, black walnut, box elder, hackberry, and Ohio buckeye. Pickerelweed Pond and other sinkhole ponds in the park are karst topographic features, like the springs in the Ozarks, but their water levels fluctuate as a result of periodic droughts, again resulting in a transitional flora and fauna. The ponds provide breeding areas for various salamanders and other amphibians, several of which occur here at the northern limit of their range.

Just as the stream and ponds show elements of both the Ozark and the prairie regions, so too do the upland areas. Much of the park uplands was originally grassland: savanna, prairie, and glades. The glades especially show affinities to the Ozarks and regions to the south and west. Many of these grassland areas are being restored and preserved through brush clearing and prescribed burning. Sac Prairie just south of the road to Camp Sherwood Forest, for example, displays such species as big bluestem grass, Indian grass, rattlesnake master, butterfly weed, and prairie

The triple-arched bridge over Little Sugar Creek at the entrance to the park invites visitors to leave all their cares behind. BRUCE SCHUETTE

Mark Twain Birthplace State Historic Site

ON ANY LIST OF MISSOURIANS who have contributed to our national culture, indeed to world heritage, the name of Samuel Langhorne Clemens, better known as Mark Twain, ranks preeminently. As creator of such masterpieces as *Adventures of Huckleberry Finn*, *The Adventures of Tom Sawyer*, and *Life on the Mississippi*, he is one of America's foremost storytellers, humorists, and masters of the language. While providing the world with enduring wit and insight, Mark Twain's imagination remained deeply rooted in his home state. Twain's genius enriches the world, but he remains also the keenest observer and literary interpreter of Missouri.

Huckleberry Finn and Tom Sawyer are not only for all time the quintessential all-American boys, they are also the best portraits ever penned of nineteenth-century Missouri youth. Jim is not only the symbol for a whole class of long-suffering black Americans, he is also an exemplar of their human aspirations. Huck and Jim's journey down the river into humanity has become a classic of world literature.

It is said that a great artist portrays individual experience so well that universal human experiences are illuminated. No literary artist performed this magic more successfully than Mark Twain. And the specific, individual world of experience that Mark Twain drew upon centered around his boyhood in the Missouri countryside and along the Mississippi River. To a degree, the land and people that shaped his life can still be found in northeast Missouri. And the story of his birth and early childhood are told at one of Missouri's most important shrines, Mark Twain Birthplace State Historic Site at Florida, Missouri.

In 1835 the Clemens family moved from Tennessee to Monroe County, Missouri, at the suggestion of relatives who had already made the trip. The Clemenses settled in the four-year-old village of Florida, between the North and Middle forks of the Salt River in a region of rolling hills, oak forests, and small prairies. As Twain recalled in his autobiography, the village "had two streets, each a couple of hundred yards long; the rest of the avenues mere lanes, with rail fences and cornfields on either side. Both the streets and the lanes were paved with the same material—tough black mud in wet times, deep dust in dry." In this tiny frontier village, on November 30, 1835, in a rented two-room clapboard cabin, Samuel Langhorne Clemens was born, sixth child of John and Jane Clemens. That cabin still stands, though its setting has changed dramatically. On seeing a picture of the cabin years later, Clemens wrote, "Heretofore I have always stated that it was a palace, but I shall be more guarded now."

In 1839, the Clemens family moved to Hannibal, in Marion County, on the Mississippi River. Even after this move of some thirty miles, young Samuel returned to Florida almost every summer to visit his uncle John Quarles's thirty-slave "plantation." This was the countryside that Sam Clemens roamed, as biographer A. B. Paine recalled, "hunting berries and nuts, drinking sugar-water, tying love knots in love-vine, picking the petals from daisies."

Sam Clemens's world expanded after he left school at the age of twelve, especially as he earned his living working on the broad waters of the Mississippi River. But again Clemens returned to the village of Florida. After the Civil War broke out, in response to the governor's call

The Mark Twain shrine, its roof in the shape of a hyperbolic paraboloid, was dedicated in 1960 as the first of the modern visitor centers and museums in the parks. OLIVER SCHUCHARD

The birthplace cabin sits on the red tile floor of the shrine, safe from the elements. OLIVER SCHUCHARD

to activate the state militia and along with thousands of fellow Missourians, Clemens volunteered to help defend the state against the Yankees. He and some companions formed the short-lived Marion County Rangers. As lieutenant of this company, Sam Clemens spent several weeks in the summer of 1861 retreating from Union army patrols under the command of Col. Ulysses S. Grant of the Twenty-first Illinois Infantry. The hills and draws around Florida provided hideouts for the rangers.

Clemens quickly abandoned the war and "lit out for the territories." In leaving Missouri, he commenced a remarkable set of adventures and launched his career as a writer, under the name *Mark Twain*, a term he borrowed from his days as a river pilot meaning two fathoms (twelve feet) of river depth.

Many who read Mark Twain's works find, in addition to wit, humor, and good-natured insight, an underlying tension of competing values. Some credit part of Mark Twain's creative genius to the artist's conflicting loves for rural simplicity and urban progress, for the southern flavor of his boyhood and the Yankee respectability he later craved. Could there be a more likely home for such a genius than Missouri?

So, how do we acknowledge the legend? More specifically, how should the state honor this extraordinary son? Not all could agree on an answer. Shortly after Mark Twain died in 1910 at his home in Redding, Connecticut, groups formed to seek appropriate commemoration. The Missouri General Assembly in 1911 authorized a bust and a monument. The bronze bust, created by R. P. Bringhurst, and the monument were erected in 1914 at the corner of Main and Mill streets in Florida. In addition, Merritt Alexander "Dad" Violette, whose mother had known the Clemens family in Florida, bought the seriously deteriorated birthplace cabin in 1915, moved it across the street to property he owned, rehabilitated it, furnished it in a nineteenth-century manner, and opened it to the public. He also ran a girls camp to bring youngsters to Twain's Salt River country. In 1923, at the suggestion of one of the campers, Ruth Lamson, whose father was a newspaperman in Moberly, a group of northeast Missouri country newspaper editors, backed by Violette, organized the Mark Twain Memorial Park Association and within a year raised $15,000 to purchase the core tract for a state park adjacent to Florida that could memorialize Mark

Twain. Violette presented the cabin to the park association in August 1924, and in December the association transferred both the park and the cabin to the state. This was one of the first parks in the system and the very first north of the Missouri River.

The birthplace cabin itself was moved in 1930 from Florida to the new park, where it was placed on the highest point of Violette's old Hilltop Camp, underneath a primitive frame shelter built to protect it from the weather. In 1960, this inadequate arrangement was abandoned with the dedication of an ultramodern museum building, the "shrine," complete with a hyperbolic paraboloid roof under which the simple two-room cabin now sits. The contrast between the soaring roof and the little cabin on the red tile floor is striking. One pauses as if in anticipation of a crack of hilarity from the mind that it honors. Perhaps, however, this very contrast helps us to see more starkly the simplicity, almost poverty, into which this exemplary man of letters was born. It also tells us something about how we sometimes choose to honor our legends. Twain's daughter Clara had a hand in selecting the design.

An honor of a different sort was the dedication in 1983 of the huge Clarence Cannon Dam and the reservoir named for Mark Twain that drowns nearly all of the Salt River valley that Sam Clemens came to know as a boy. This 18,600-acre reservoir with the ghosts of forests past still standing in the shallows is, of course, Mark Twain Lake, constructed and operated by the U.S. Army Corps of Engineers. Maybe this is the ironic and ultimate revenge of the federal army for Sam's brief Confederate service.

The museum in the shrine contains a wealth of artifacts, exhibits, and Clemens belongings. An original, handwritten manuscript of *Tom Sawyer* is on view, and a public reading room houses an excellent collection of Twain first editions and foreign-language versions of his works. The Bringhurst bust of Mark Twain originally erected in Florida was moved to the shrine in 1964, and in 1966 the monument was moved from the corner of Main and Mill streets to the spot in Florida where the birthplace cabin originally stood.

Mark Twain Birthplace State Historic Site is a place to ponder the origins of authentic homespun genius. It is also a place to contemplate how we as a society choose to honor our legends, and how our choices change over time.

Mark Twain State Park

AFTER THE MARK TWAIN Memorial Park Association formally dedicated its new park in honor of Monroe County's native son in August 1924, it transferred the land to the state. Mark Twain State Park was one of the first parks in the state's new park system and for years the only one north of the Missouri River. The 100-acre park, some of it formerly a girls' camp operated by M. E. "Dad" Violette of Florida, one of the founders of the memorial park association, eventually provided a hilltop setting for the relocated birthplace cabin of Mark Twain, which Violette had saved from destruction. Mark Twain—Samuel Clemens—was born in 1835 in Florida, a tiny settlement now surrounded by the park and, since 1983, by the huge new Mark Twain Lake.

With the help of the memorial park association and people from the neighborhood, the state improved the road access, provided camping and picnic grounds, and constructed a large pen for two bison on loan from the state fair board for the edification of visitors. There was some thought by the late 1930s that the park ought to be enlarged and turned over to the federal government as a national park for north Missouri. During 1938–1939, the state acquired more than 1,000 acres in eight separate tracts, but the area was destined to remain a state park.

Much of the early development in the park occurred during 1939–1942, when Civilian Conservation Corps Company 1743, an all-black company that had done superb work at Washington State Park, was transferred to Mark Twain. A group of Monroe Countians, obviously not remembering the lessons of Huck and Jim as portrayed by their native son, circulated petitions protesting the assignment of blacks to the park;

but other citizens, who did remember, circulated counterpetitions and carried the day. The company cleared large tracts of land, laid out trails, installed a water system, and developed a beautiful picnic area amid generous shade trees at Buzzard's Roost, a promontory overlooking the Salt River valley—today, Mark Twain Lake. The picnic ground features a handsome T-shaped open shelter, built of native limestone, with a large stone fireplace flanked by built-in stone benches with wood seats.

For decades, Mark Twain State Park consisted of rugged, timbered hills surrounding and overlooking the North and Middle forks of the scenic Salt River. In these valleys and along these streams Missourians were invited to play and explore, just as a young Sam Clemens had done. In fact, the park board built a group camp named Camp Clemens there after World War II, using some of the buildings from Camp Tom Sawyer, the CCC's barracks.

But in 1983, Mark Twain Lake was completed by the U.S. Army Corps of Engineers, and it has totally changed the character of the park. Enlarged to nearly 2,800 acres by the addition of land leased from the corps, the park is now reservoir-based and provides facilities geared toward recreation on the water, including boat ramps, picnic areas, and modern camping sites. The most attractive picnicking spot in the park, however, is still the old Buzzard's Roost. Camp Clemens has been closed, and an all-new $1 million group camp, the largest in the system, has been constructed on land acquired from the corps. The camp is named Camp Colborn, after R. I. "Si" Colborn, the longtime editor of the *Monroe County Appeal*, a state park board member dur-

*Buzzard's Roost, which once looked across the Salt
River valley Sam Clemens loved to roam as a boy,
now crowns the shore of Mark Twain Lake.*
NICK DECKER

ing the 1950s and 1960s, and the leader of the
counterpetition effort to bring the black CCC
company to the park back in 1939.

After several efforts to interest some private en-
terprise in building a resort-type development at
one of the reservoir parks, most recently at Tru-
man Lake, the department of natural resources in
January 1991 announced that it had accepted a
$14 million proposal from the C. F. Vatterott Co.
of St. Ann to design, develop, and operate a resort
in Mark Twain State Park. The resort, including a
lodge with a hundred and sixty rooms and confer-
ence facilities, twenty cabins, an eighteen-hole

golf course, and a large marina, will be a first for
the state park system, and many people will be
watching to see how it turns out.

Away from the developments, there is still a
large area of fairly wild land. Because of the deep
valleys carved by the Salt River and its tribu-
taries, the park has an Ozark-like quality, in con-
trast to most of the rolling glaciated plains of ag-
ricultural north Missouri. The extent of the
park's forests, coupled with those owned by the
corps of engineers around virtually the entire
lake, make this area one of the most significant
examples of a north-central Missouri forested
landscape. Beyond the reservoir and its forested
fringe, the lovely rolling fields and farms and the
friendly, down-home people of Monroe County
are still there, and the country still offers the per-
fect setting for a lazy summer of fishing, swim-
ming, and dreaming.

Union Covered Bridge
State Historic Site

I like a bridge that sports a roof
Well thatched with cedar shingle:
They're just as good for married folks
And better for the single.

For where may country lad and lass,
Their work-day world forgetting,
Have better chance for holding hands
And altruistic petting.

THUS, POET DANIEL L. CADY explained one reason for the popularity of covered bridges in nineteenth-century America. Such "kissing bridges" provided a refuge for lovers, but they also sheltered weary travelers seeking some shade as well as highwaymen ready to relieve the unsuspecting of their valuables. Even today, a variety of birds and other animals often take up home within the clapboarding. And every covered bridge has been the source of local superstitions, a residence of ghosts, goblins, and trolls.

Covered bridges, for all the romantic images they continue to inspire, were in fact very utilitarian. Their roofs providing shelter against the weather, these bridges proved structurally sound for years; without the covers, moisture would quickly have rotted the joints where the large timbers intersect. Union Covered Bridge, one of the four remaining in Missouri, clearly shows the care and planning that went into its construction.

On September 17, 1871, officials of the Monroe County Court opened the Union Covered Bridge to traffic. The new bridge replaced a dilapidated, uncovered structure spanning the Elk Fork of the Salt River near Union Church, where the Paris–Fayette road crossed the stream. The bridge continued to carry vehicles for almost one hundred years.

Joseph C. Elliott from Payson, Illinois, won the county contract for construction of the bridge in 1870. Elliott eventually built five bridges in Monroe County, crossing the North, Middle, South, and Elk forks of the Salt River. All five were constructed in similar fashion using a support system called the Burr arch truss. Only Union remains.

The Burr arch truss, patented by Theodore Burr of Torringford, Connecticut, produced bridges of great structural strength. In addition to the more typical vertical and diagonal beams, the Burr arch truss added a curved beam on each side. This has been likened to wearing both a belt and suspenders, and the combination of beam systems created a bridge as handsome as it was strong. But Elliott went even further. His bridges featured double arches on each side.

The beams and timbers, cut from local oak, were braced against stone abutments. To form the arches, Elliott fitted multiple timbers together with bolts; the timbers were sawed on two sides and then shaped to the necessary curve with an adze. The careful observer can still see the blade marks left by the builders. The bridge structure was held together with wooden pegs known as "treenails" or "trunnels." For siding, Elliott used narrow clapboard instead of the more common vertical batten strips. The roof had wooden shingles. Records at the courthouse show $5,000 allocated for two bridges.

In 1961, a study was made to consider the soundness of the county's two remaining covered

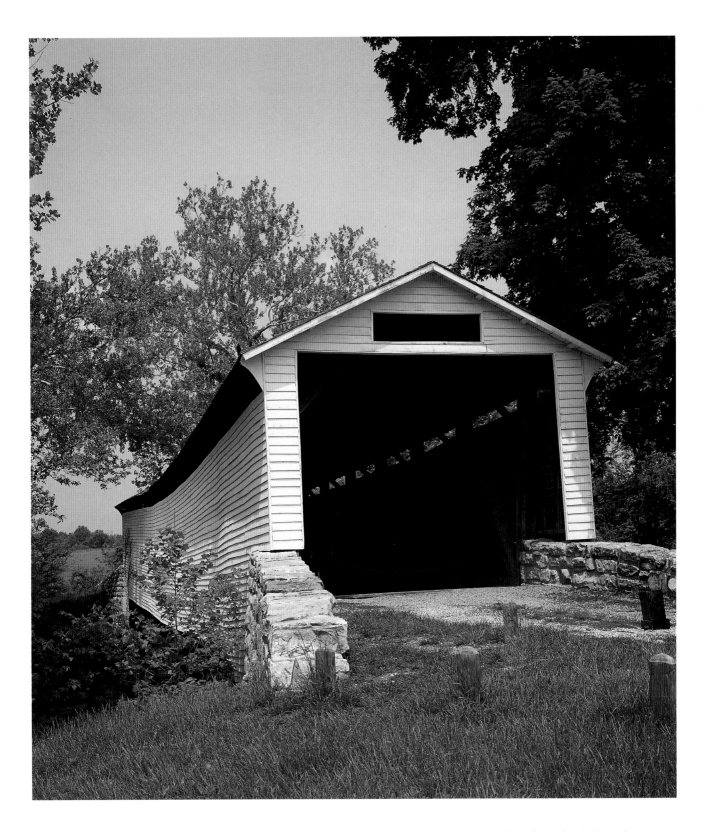

bridges, Union and Mexico. On July 9, 1967, the Mexico bridge five miles downstream from Union was destroyed by floodwaters—only days before it would have been transferred to the state along with the Union bridge on July 11. Some of its timbers were salvaged, however, and used on Union bridge a year later when it was partially re-

The Union bridge over the Elk Fork of the Salt River is the only one of Missouri's four remaining covered bridges to feature the Burr arch truss.
OLIVER SCHUCHARD

stored by state park authorities. A full restoration was completed in 1988.

Long Branch State Park

I N THE EARLY 1800s pioneers from the Appalachian hills and valleys of North Carolina and Kentucky followed Daniel Boone into Missouri, and some of them continued on into the area north of the Missouri River. Traveling westward along the Salt River, a Mississippi River tributary, or northward from the Missouri River via the Chariton, they converged on an ancient Indian trade route that followed high ground marking the geographical divide between the Mississippi and Missouri drainages. Thus they found the land that is now Randolph, Macon, and Adair counties, and it reminded them of home. Skilled woodsmen as well as farmers, they settled first in the timbered valleys of the rivers and creeks, felling logs to build houses and barns and clearing the bottomlands for crops.

On the Grand Divide east of the East Fork Little Chariton River and its sizable tributary, Long Branch, they discovered open woodlands well populated with hollow trees that provided nesting places—natural hives—for the naturalized American honeybee. A road through the woods became known as the Bee Trace, a beaten path or trail being the original meaning of the noun *trace*. The settlers came here in the autumn to fell the bee trees and chop them open to harvest the honey. Before the culture and processing of sorghum cane became common, the delectable product of the bee was the sweetening agent most accessible to the pioneers. Of course, if they chopped the tree to get the honey they de-

The Bee Trace area at Long Branch State Park features a remnant of the north Missouri savanna prevalent when the early settlers arrived. KEN MCCARTY

stroyed the tree and often its colony of bees.

Bee trees are scarce if not totally absent now, but portions of the Bee Trace area are still preserved in Long Branch State Park, which surrounds the lower reaches of a reservoir built by the U.S. Army Corps of Engineers. The dam, a multipurpose project authorized by the U.S. Congress for flood control, water supply, and recreation, was actually constructed on the East Fork Little Chariton a few miles south of the point where the waters of Long Branch joined its flow. But in the annals of federal public works it was Long Branch Dam; thus, the 2,450-acre reservoir it formed is Long Branch Lake, and the park is Long Branch State Park.

As the dam was completed in 1980 the corps leased 550 acres of the shoreline area to Missouri for administration as a state park. The federal agency also signed an agreement with the Missouri Department of Natural Resources to share equally the cost of developing and operating recreational facilities. Among the facilities are picnic areas and campgrounds, a swimming beach, several boat ramps, and a marina operated by a private concessionaire.

In 1987 the state park grew to more than 1,800 acres through the transfer by lease of additional army-owned land. The new acreage includes the southern part of the Bee Trace area between the two arms of the reservoir and additional lands on the eastern side, the so-called Macon area. The dam and park lie off Highway 36 scarcely outside the city limits of Macon.

The Bee Trace area, some 640 acres of it within the park, is mostly woods; these are interspersed, however, with old farm pastures that reveal some native prairie species. A special feature is about

six acres of surviving savanna, a landscape now rare in northern Missouri. Here, over an open floor of prairie grasses and forbs, stand great old white oaks that were saplings when the first settlers came in search of honey. One, core drillings have shown, has stood for more than 250 years, and several range from a century to nearly two centuries in age. It was the white and bur oaks, no doubt, with their tendency to hollow trunks and limbs—log-size limbs—that provided homes for the wild honeybee.

Paradoxically, the construction of the dam came none too soon to save remnants of northern Missouri's once vast tallgrass prairie and oak savanna. Now that the Bee Trace area is within a state park, prescribed fires and removal of scrub brush will restore its health and species diversity, making it northeastern Missouri's most important prairie-savanna landscape.

Long Branch State Park also reveals considerable evidence of occupation by Indians. The drainages are so narrow and steep-sided that there are sites on almost every hill. Just as the environment of northern Missouri was highly structured, with narrow fingers of woodland extending along the streams and the broad sweep of prairie beyond, so too was the location of Indian sites. From the Early Archaic period through the Middle Woodland, about nine thousand to fifteen hundred years ago, most sites were occupied seasonally in late summer and fall for large-scale processing of nuts, as indicated by unusually high concentrations of nutting stones in proportion to projectile points. During the Late Woodland period the Indians congregated in larger communities along the Missouri River in the summer and fall, and they used the Long Branch area in the winter when they broke up into smaller groups. Then, during the period of the larger, more permanent Mississippian towns around St. Louis and Cahokia, about A.D. 900–1400, Long Branch seems to have been used only for small hunting camps. Of course, there was fishing too. On the Chariton River not far from the park, archaeologists have investigated a stone dam and weir that served as a fish trap—possibly built by Missouri or Osage Indians.

Pioneer families, like the Indians before them, hunted the abundant native game and exploited the rivers for fish and fur. For a century or more the waters were productive, but by the end of World War II the streams of northern Missouri were all but ruined for subsistence or recreation.

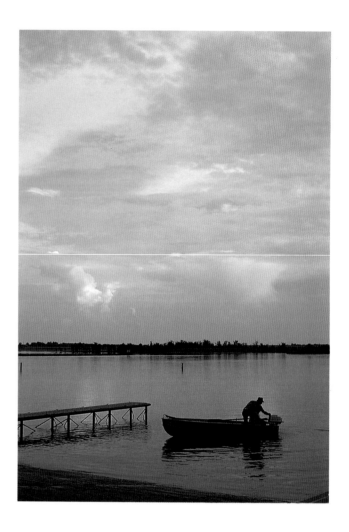

Missourians harbor an ancestral hunger for a good fishing hole. TOM NAGEL

Intensive farming had turned them into heavily silted waterways, and drainage from coal mines helped sour their waters. (By 1900 the nearby town of Bevier had become the leading coal-mining center in northern Missouri, adding Welsh and Italian miners to the local mix of Boone-type pioneers and a sprinkling of the Irish who built the Hannibal and St. Joseph Railroad that carried the coal to market.)

Thus the army engineers' project was welcomed by the locals. Long Branch Lake with its sparkling blue water satisfied an ancestral hunger for a good fishing hole. It has become famous for "lunker" black bass, walleye, and catfish; with more than just good fishing, it is popular also for boating, water-skiing, and swimming. A visit to Long Branch can help one appreciate the environment that is north Missouri.

Thousand Hills State Park

I N THE YEARS FOLLOWING World War II, the northeast Missouri community of Kirksville faced a number of challenges. Two seemed to be related: how to provide fresh clean water for a population that had more than doubled since 1900, and how to provide outdoor recreation opportunities for that same population, which included the growing ranks of students at Northeast Missouri State Teachers College. The town fathers knew that they had some advantages. There was a large stream west of town, Big Creek, that flowed through wooded, hilly land. There was lively interest in the region in bringing some of the benefits of outdoor recreation to this portion of the state. And there was the legacy of Dr. George Mark Laughlin.

George Laughlin had been born in nearby Ralls County in 1872. He moved to Kirksville in Adair County as a young man to study osteopathic medicine with the founder of this new branch of medicine, Dr. A. T. Still. Laughlin flourished in his endeavors, married Still's daughter, and built a remarkable career as an administrator of hospitals, medical schools, and clinics. In addition to medicine, Laughlin had an interest in land, and he eventually developed a large farm west of town that he called Thousand Hills Farm.

The land west of Kirksville includes a rugged belt of hills that runs north and south between rolling expanses of Missouri prairie lands. This belt is located west of the Grand Divide between the Salt River drainage to the Mississippi and the Chariton drainage to the Missouri, and it has always been a refuge for wildlife, plants, and humans. The hills surrounding Big Creek valley supported a natural vegetation of mixed oak-hickory woodland, savanna, and tallgrass prairie openings.

The Indians who used this area left behind highly realistic rock carvings of deer, opossums, snakes, lizards, at least four different kinds of birds, arrows, and other figures on a prominent rock outcrop overlooking the valley. Because these carvings lack the stylization and the symbols of status and power that distinguish Mississippian petroglyphs such as those found at Washington State Park, archaeologists believe they may have been made by people of the earlier Late Woodland period, around A.D. 400–900.

Most of the ambitious early American settlers tended to bypass this land at first in favor of less rugged terrain, but some folks did call the hills home. Later, they also exploited the valley for its clay deposits and coal reserves. The little town of Novinger, just northwest of the hills, still bears the stamp of its heritage in its turn-of-the-century mail-order miners' cabins. About the same time, Laughlin's Thousand Hills Farm brought quality livestock, including Aberdeen Angus cattle and Berkshire hogs, to the area.

Laughlin died in 1948, and the following year Kirksville leaders conceived of a solution to their problems of water supply and recreation—a large freshwater lake on Big Creek in the rugged Thousand Hills country. The groundwater from the Pennsylvanian bedrock of northern Missouri is unfit for most municipal and agricultural uses, and the water in the glacial drift is often too saline as well, so that most water must come from surface sources—hence the need for impoundments, especially near urban areas. The Laughlin heirs concurred in the plan and donated 1,000 acres of the old farm. The city raised funds and purchased another 1,500 acres. By 1952 a 600-

*Wiry spike rush and other marsh plants line the shore of
Forest Lake in Thousand Hills Lake State Park.*
OLIVER SCHUCHARD

A park naturalist welcomes new recruits to the junior naturalist program. TOM NAGEL

acre reservoir named Forest Lake was completed, using an abandoned coal mine and rock quarry. Then the whole tract was turned over to the state, and in 1953 Thousand Hills State Park was dedicated. The city retained ownership of the lake proper to insure that its function as a water-supply reservoir would continue.

Most of the original facilities at the park were built between 1955 and 1964, and they generally reflect the "modern" park style of that era. During the same period the park also gradually grew to over 3,200 acres. Among the 1970s additions to the park was a dining lodge on a lovely spot overlooking Forest Lake. Over the years this lodge has developed into one of the finest eating places in northeast Missouri, with a reputation for excellent Missouri food, at reasonable cost, in a beautiful setting.

The park is, naturally, centered around Forest Lake with its seventeen miles of shoreline, and many of the activities here are on or in the water. A new marina provides boat rentals and supplies. Fishing and swimming are good, and so is bird-watching along the shore. Fully furnished cabins are available, if you are not in the mood to camp.

Don't neglect to walk the trails and visit the petroglyphs. The glyphs are now enclosed in a shelter for protection against the elements and vandalism, but windows along an outside ramp allow you to view them even when the building is not open. If you are adventurous, take the rugged, five-mile Thousand Hills Trail, which courses through oak-hickory forest, savanna, and grasslands being restored to prairie and takes you into an isolated little valley where a very rare tree grows. The large-toothed aspen is a northern species, and most of its range is far away, but a small colony of this beautiful and delicate visitor grows in protected seclusion down here in Missouri at Thousand Hills. Wildlife abounds in the park. Deer, turkey, red fox, coyotes, barred and great-horned owls, and various ducks are fairly easy to see if you know when to expect them, and other rarer species like bald eagles and ospreys occasionally appear. The full-time park naturalist can help to make your visit really special.

Thousand Hills is a unique state park with its mission shared between Kirksville and the state. The arrangement seems to be working to the benefit of both the city and the people of Missouri. Come and see for yourself.

Petroglyphs perhaps carved by people of the Late Woodland cultural tradition are protected from the elements within an interpretive shelter.
OLIVER SCHUCHARD

General John J. Pershing Boyhood Home State Historic Site

The place seems like home to me and it always will. I've been away a long time and there have been many changes, but this is home.

—Gen. John J. Pershing,
upon visiting his hometown
of Laclede late in his life

I T REQUIRES A REAL effort of our modern-day imaginations to appreciate the thunderous impact of America's arrival in Europe in June 1917 as a participant in World War I. Isolationist America had at last decided to enter the great war against the Kaiser and his allies. President Woodrow Wilson knew that his choice of leader for the American Expeditionary Force was crucial: he appointed "Black Jack" Pershing from Missouri.

General Pershing was a soldier's soldier, and definitely not given to fanfare, but he understood the importance of symbolism, and his arrival in Europe was a triumph of international diplomacy. The single most powerful moment took place at a small ceremony in a Parisian cemetery. After accepting an official welcome to Paris, the American general and his first small contingent of combat troops marched to the resting place of the French officer who had fought with the United States during the American Revolution. On America's Independence Day, July Fourth, descendants of the Marquis de Lafayette met the general and his party at the Picpus Cemetery and led them to the grave site. There, in a simple gesture, the leader of the American army that had come across the ocean to help France in her hour of need placed a wreath of roses upon the tomb of the gallant French soldier, with the words: "Lafayette, we are here." (The striking utterance was widely attributed to Pershing, though he himself credited a colonel on his staff.) All of France erupted in an outpouring of emotion for America and her general.

General Pershing was astute in public ceremony; he was also astute in conducting warfare. Most historians credit Pershing with masterful handling of the American army in France, which tilted the tide of war against the Germans. He was lionized at the time, and upon completion of his European assignment, the U.S. Congress conferred upon him the rank of general of the armies, a rank higher than that of any other American general. Some years later, George Washington was accorded the title posthumously.

The nation's highest ranking military officer was a fighting soldier. Graduating from West Point in 1886, he built a career that stretched from the time of the Indian wars in his youth to his death at the dawn of the nuclear age. He began his career leading cavalry against the Apache chief Geronimo and accepted a congratulatory letter in retirement from Gen. Dwight Eisenhower following the defeat of the Nazis in World War II. During that remarkable span of service, Pershing led the black soldiers of the Tenth Cavalry—the source of his nickname "Black Jack"—against Indians and bandits in Montana and against Spaniards at San Juan Hill; he fought against Emilio Aguinaldo in the Philippines and served as a military observer with the Japanese during the Russo-Japanese War; he commanded the Mexican border operations against Pancho Villa, was promoted directly from captain to brigadier general over 862 more senior officers,

John J. Pershing, the highest-ranking military officer in American history, spent his youth during the 1860s and 1870s in this home in the small north Missouri town of Laclede. OLIVER SCHUCHARD

led American troops in the Great War, served as army chief of staff, and in 1932 won the Pulitzer Prize for his memoirs. He also married and had four children, three of whom died with their mother in a tragic fire at the Presidio in San Francisco in 1915 on the eve of his greatest achievements. Through all his remarkable exploits, John Pershing always remembered the north Missouri countryside from which he came, and he returned to his hometown of Laclede when he could.

John Joseph Pershing was the firstborn son of a northern father, John Fletcher Pershing of Pennsylvania, and a southern mother, Ann Elizabeth Thompson of Tennessee. Born in 1860 near Laclede in Linn County, young John Pershing's earliest memory was of the cruel violence of the Civil War that divided the people of Linn County. There was a Confederate raid on Laclede when he was four years old. Pershing's father was a strong Union man. His mother's brother was a Confederate soldier.

After the war, the growing Pershing family continued farming but moved into town to live. The comfortable frame house at the corner of State (now Pershing Drive) and Warlow streets was home during "Johnny" Pershing's boyhood, and he called it his "real home" for the rest of his life. Johnny Pershing grew into Jack Pershing and was a great favorite among the boys of the vicinity for his high spirits and friendly ways, yet he also won over adults because he was hardworking and trustworthy.

While still in his teens Jack Pershing took on the responsibility of teaching at the Prairie

Mound School eight miles south of town. He also attended the Kirksville Normal School and might have become a Missouri lawyer if he had not in 1881 noticed an opportunity to take an examination for entrance into the United States Military Academy at West Point. After entering the army, Pershing would be only a visitor in his hometown. His career became the heritage of the whole nation; he died in 1948 and is buried in Arlington National Cemetery amid his World War I soldiers and comrades.

Back in Laclede, the Pershing family eventually moved out of its old home on State Street. Other families lived in the house, and it had fallen into a state of disrepair by 1952, when it was purchased by the state through the good offices of the Pershing Memorial Park Association as a shrine to the memory of General Pershing and the American soldiers of World War I. The house was restored under the direction of John Albury Bryan, an architect and longtime "guru" of historic preservation in Missouri. It was dedicated on September 13, 1960, the one-hundredth anniversary of Pershing's birth, with the United States Army Band—"Pershing's Own"—and numerous dignitaries in attendance. In 1977 it was designated a national historic landmark.

Today, the Pershing home, which is described as "carpenter gothic" in design, has been furnished in an effort to recapture the era of Pershing's youth in the 1870s. A small gallery houses exhibits relating to the general's career and to local history. Around the house, original features of the grounds have been restored, including the smokehouse, root cellar, well, privy, and garden.

To preserve the character of the neighborhood, the state has acquired adjoining property and expanded the scope of the site. Just north of the home is a bronze statue of Pershing by sculptor Carl Mose. Originally created for the capitol grounds, it was legislatively transferred and moved to the Pershing home in 1968. Flanking the statue are granite tablets naming war veterans who served under General Pershing. Further

north, the old Prairie Mound School where young Pershing taught has been relocated and restored, after it had faced demolition in its original location south of town.

Laclede itself has barely survived as a town in the years since Pershing's father served as postmaster and community leader. Like many small farmbelt towns, it has been a victim of changing economies and transportation patterns. But the little village seems determined not to perish utterly. The residents love their community, and they love to honor the memory of their most famous son. For all those who recall or imagine small-town life with fondness, and for those who are curious about the sort of place where a very great American soldier was nurtured, a trip to the Pershing home in Laclede is a must.

Carl Mose's heroic-scale bronze of General Pershing was originally commissioned for the grounds of the state capitol. NICK DECKER

Pershing State Park

YEARS LATER, a childhood friend of Gen. John J. Pershing remembered, "He knew the best places to shoot squirrels or quail, knew where to find the hazel or hickory nuts. He knew where the coolest and deepest swimming pools in the Locust, Muddy or Turkey Creeks were." Thus, when the patriotic members of the General John J. Pershing State and National Park Association pondered in 1930 how to commemorate the still-living World War I hero from Missouri, they quickly resolved that the most suitable memorial would be a park amid the wilds that young Jack Pershing had loved to roam as a boy.

For the young people of Laclede in the 1870s, there was no better place for outdoor adventure than the old Canfield Ranch just west and south of town. This sprawling Linn County ranch bordered the winding Locust Creek with its swimming and fishing holes, and it included the low ridges, tall forests, and open prairies typical of old-time north Missouri. In 1930 this "Jack Pershing Country" still boasted its wild streams and forests, so Canfield Ranch was chosen as the core of the proposed memorial park.

The association originally had hoped to establish a national military park at the site, but this was not to be—in part because National Park Service policy prevented commemoration of living people—so the focus shifted to the state. The members of the association envisioned a recreation ground for legionnaires as well as the general public, a place with a good-size lake, a golf course, a landing strip, a large auditorium, and other facilities suitable for encampments of ex-soldiers, whom they believed would flock from across the nation to Pershing Park, which would

thus attract more than a million visitors a year. Enthusiastic support for the park idea spread across Missouri, and in 1937 the state general assembly approved funds. Later that year the state purchased the first of what now amounts to more than 2,300 acres of land, though apparently without the intention or funds to develop the site to the extent envisioned by the promoters.

As it is, it is difficult to imagine a more fitting memorial to the spirit of Gen. John J. Pershing than to preserve a portion of the environment that shaped him in his youth. In the 1870s this tract hallowed by Pershing's boyhood play would in most respects have been classed as typical north-Missouri wildland. However, the march of agricultural progress across northern Missouri has now rendered it a rare jewel, surrounded by miles and miles of row crops and clipped pastures.

Locust Creek runs through the heart of the park. The creek is actually a small river that originates far to the north and flows southward through north-central Missouri until it joins the Grand River, a tributary to the Missouri. Along most of its length today, Locust Creek, like most north Missouri streams, has been channelized and straightened, deprived of its wildlife habitat and natural beauty. But here in Pershing State Park the winding stream still flows lazily across its broad and level floodplain. In the process of these meanderings, the creek forms and reforms oxbow lakes, sloughs, and small ponds. Along its shores, one of the last virgin forests in north Missouri towers over the creek and adjacent low ridges. Early promotional literature for the memorial park boasted of a gigantic national champion cottonwood tree. That specimen tree died years ago, but the even more significant bottom-

land forest of which it was a part still stands.

Away from the forest corridor along Locust Creek, an even rarer scene awaits the Pershing park explorer. Out on the wide floodplain of Locust Creek are hundreds of acres of remnant lowlands covered not in forest but in wetland prairie and marsh. Wetland prairies were once abundant along the broad river valleys of Missouri. Because their soggy soils and tendency to flood discouraged farming, large expanses of such prairies persisted even after most of the upland prairies had been plowed under. In this realm of slough grass, southern blue flag, and yellow giant hyssop, a whole community of life flourished under the Missouri sun. Marsh wrens and red-winged blackbirds nested in the tall grasses and reeds. Ducks, geese, and shorebirds by the thousands congregated around the ponds and sloughs. On low rises in the floodplain, upland prairie com-

A one-and-one-half-mile boardwalk leads park visitors through backwater sloughs, wet prairie, bottomland hardwood forest, marsh, and the sandbanks of Locust Creek. PAUL W. NELSON

munities harbored greater prairie chickens and upland sandpipers. Deer—and, in an earlier age, bison and elk—wandered amid grasses shoulder-high or taller. Close to the ground, fox snakes and massasauga rattlesnakes hunted for mice. And every year, the rains would bring the streams up and out to replenish the moisture in the soils.

Eventually, north Missouri farmers mastered the arts of ditching, draining, and plowing these wet prairies, and a whole world passed away. One of the largest wet prairies left in northern Missouri, and the only one along an unaltered meandering stream, is at Pershing State Park. Although some park advocates in the 1930s proposed draining the creek, or damming it for a lake, park officials in the late 1930s sensed the special value of the natural stream and the virgin prairie. By the 1950s, however, pressure mounted from local farmers to plow part of the Locust

Marsh marigolds and false asters blossom on the broad expanse of wetland prairie at Pershing State Park. Bottomland wet prairie, once prevalent in north Missouri, has disappeared nearly everywhere. KEN McCARTY

Creek bottoms for soybeans, and park officials, in a weak moment, relented. Fortunately, the farming episode was short-lived owing to the gumbo soil, and many prairie plants reestablished themselves naturally. But the wet prairie and bottomland forest at Pershing, today more rare and precious than ever, are still threatened, their annual renewal by floodwaters impeded by agricultural levees, drainage, and heavy erosion and siltation from beyond the borders of the park. It will require careful attention and a major commitment by park officials and the public to maintain the special qualities of Pershing Park.

For now, most of the wet prairie world survives at Pershing. Teal and blue geese circle the prairie in spring and fall, and snow-white flocks of pelicans rest on hidden ponds. Amid the heavy dark green growth of early summer, there can still be clouds of mosquitoes and biting flies. But then in September much friendlier clouds of thousands of orange monarch butterflies migrate languidly across the sunny prairie, drifting and dallying above nodding ranks of butter-yellow compass plant and marsh marigold.

Space, broad and flat across the waving grasses, is one of the great sensations of this prairie. An old wood-decked iron bridge leads park visitors across Locust Creek and then along the edge of the bottomland forest on a dry boardwalk to an overlook where one can see and feel this space. This is the best place we know to touch the long-lost world of north Missouri wilderness.

The Civilian Conservation Corps helped Missouri develop this park, and it opened in the summer of 1940. At the same time, a year after a second great twentieth-century conflict had erupted and a year before American youth would again be drawn into the maelstrom, the American War Mothers of Missouri dedicated a monument in the center of the park's recreation area to American mothers like Pershing's who gave sons to the war. Sculpted of white marble by John Slitz, a federal prisoner at Fort Leavenworth, the War Angel carries a torch of liberty, wears a laurel wreath, and has an American flag draped about her shoulders.

Today Pershing State Park offers plentiful picnic sites on the breezy uplands above the creek as well as a shady campground. The well-manicured recreation area with the War Angel statue includes also a Woodland Indian mound and a superb display of pink redbud in the spring, as well as two small swimming and fishing ponds. Along Locust Creek are the remains of an old gristmill that once attracted folks to the area; the opposite bank provided camping sites, and the millpond was a favorite swimming hole for the young people, including Jack Pershing. The dam and millpond are gone, but the creek is still there, as is the forest, and as is the prairie. Pershing the general was one of a kind, and so also is the park that commemorates him.

Locust Creek Covered Bridge State Historic Site

W E FOUND THE OLD BRIDGE sitting flat on the ground in a swamp forest, looking like an elongated house with no windows and a gable roof, open at each end. What were once rising approaches to either end could no longer be discerned, nor could the stone abutments that excavations proved were there, nor any road leading to the structure, nor any trace of what was once the Locust Creek channel. All had been buried in silt swept down the waterway from carelessly cultivated corn and soybean fields and overgrazed pastures, all the way from southern Iowa and the northern Missouri counties of Putnam, Sullivan, and Linn.

The superstructure is remarkably well preserved to have been erected in 1868. The Locust Creek span, longest of the four covered bridges surviving in Missouri (all now state historic sites), is 151 feet from end to end, 16 feet wide, and 20 feet to the gable. It was built of white pine using the Howe truss method, as were most of the covered bridges in Missouri, once numerous. The Howe truss, deriving its strength from a triangular arrangement of massive beams, is said to have been used in more railroad bridges in the United States than any other design. According to old Linn County records, the construction cost was "not to exceed $5,000."

Remnants of advertising signs can still be seen on the crossbeams and end timbers. Once they were read by travelers on the Pike's Peak Ocean to Ocean Highway, laid out before World War I as Route 8, the first transcontinental highway. Model T's, then Model A's, rattled across the plank floor in the late 1910s and 1920s, beginning to outnumber the horse-drawn wagons and buggies. The highway was replaced in 1930 by U.S. Highway 36, built one mile to the south, and the venerable covered span was on its way to relic-hood.

More of man's engineering enterprises contributed to its present strange setting. From the 1920s and into the 1950s stream-straightening fever afflicted the Grand River valley, of which Locust Creek is a part. Through most of its northern reaches Locust Creek was stripped of its meanders and turned into a long drainage ditch. The "improved channel" was located eight hundred feet east of the covered bridge, leaving the bridge to span a dry bed or, in wet times, an unnatural oxbow lake.

Channelization extended as far as the railroad a half-mile south, though it skipped the creek course through Pershing State Park south of Highway 36. The silt-laden floodwaters, rushing down the "improved" Locust Creek chute, piled up north of the tracks, spread over the floodplain, submerged the old road, crept up the side of the old bridge, and dropped the topsoil they had carried from eroded farmlands up north. The silt buildup was so dramatic that one could scarcely imagine the earthen ramps that were once necessary to provide access to the bridge, or that once a dozen or more feet separated the bottom of the bridge from the surface of the stream below.

The Linn County government gave up trying to maintain the road to the bridge in 1960. Trees now growing on the old right-of-way and in the former creek channel are thirty to fifty years old. The bridge was deeded to the state for preservation as a historic site in 1968, one hundred years after its completion. After restoration, it was added to the National Register of Historic Places in 1970.

A new approach route from the west was completed and dedicated in 1989. It includes a sturdy footbridge across Higgins Ditch—another of man's "improvements"—about four hundred yards to the west. A kiosk sheltering interpretive panels also was completed in 1989. Then in 1991 the parks division raised the structure six feet, rebuilt the abutments, and constructed new approaches, so the bridge again looks more like a bridge.

At one time there was talk of moving the abandoned and isolated bridge to Pershing State Park, several miles to the south. But it's best that it stay where it was built—because here is where memories were made of square dances and weddings held in it, of picnics enjoyed nearby, and here small boys including Jack Pershing and his brothers played and fished in Locust Creek. Here

The Locust Creek bridge sat flat on the ground—the former creek channel obliterated by some fourteen feet of silt, a sad monument to careless land use—before it was raised six feet in 1991 to more nearly resemble its original setting. NICK DECKER

was the nation's first transcontinental highway. And here, some say, even before the Civil War and therefore before the covered bridge, ran the route of the "underground" that transported fleeing slaves from Hannibal to St. Joseph and to freedom in Kansas. Here the bridge should remain, with over fourteen feet of accumulated silt obliterating the creek bed, as dramatic testimony to man's past misuse of the land and to his frequent folly in trying to improve on nature's drainage patterns.

Crowder State Park

A Military Man Who Understood
the Civic Spirit of a Free People

—Epitaph on the gravestone of
Gen. Enoch Herbert Crowder at
Arlington National Cemetery

THERE ARE CYCLES in popular culture, and it may be that Gen. Enoch Crowder's achievements would be viewed by some as out of season in the late twentieth century. This native north Missourian, who was born just before the Civil War near the small town of Edinburg in Grundy County, developed into a highly intelligent though rather severe military man who is remembered primarily as the "father of the selective service." As judge advocate general, Crowder drafted the Selective Service Act of 1917, and as provost marshall general he directed its implementation. Many of General Crowder's other exploits—his participation in the efforts to corral Geronimo's Apaches in the 1880s, his indirect role in the arrest and subsequent death of Sitting Bull in 1890, his service as head of the military government of the Philippines, and his vigorous involvement in the affairs of America's Latin neighbors, especially Cuba would be regarded by some today as unfashionable, but they were popular causes at the time. General Crowder was also held in extremely high regard in his day for his legal erudition, his devotion to duty, and his principled dedication to fairness as he saw it.

There is general consensus that the selective service system was a key factor in helping the United States play a winning role in World War I.

The draft law, an extension of the idea of the citizen soldier of which the nation has been fond, inspired one waggish county clerk to versify when, along with his local sheriff named Burke, he was "drafted" into helping to implement it:

> Who was it built up this army,
> that set the whole world free?
> Who inducted them into service?
> It was Crowder, and Burke, and me.

The leader of American forces in World War I and a fellow north Missourian, Gen. John J. Pershing, commented following Crowder's death in 1932: "Professionally his exceptional record speaks for itself. . . . I had a high regard for him, both as a man and an officer." So, besides the army's Camp Crowder near Neosho—now Crowder College—and the University of Missouri's Crowder Hall on its Columbia campus (after graduating from West Point, Crowder taught military tactics there while attending law school), there is also Crowder State Park in Grundy County near Edinburg.

The original 640-acre memorial park honoring Enoch Crowder was purchased with a $10,000 legislative appropriation in 1938, just a few years after the general's death. It includes a wonderfully representative tract of northern Missouri hills formed through dissection of glacial till plains. Located just a few miles from the old Crowder homestead, the park adjoins the Big Thompson, a major tributary of the Grand River, and it is generally forested owing to the fairly rugged drainages near the river. Most of the surrounding region is rich farmland, but within the refuge of the park are impressive stands of hard-

wood forest. Although the river apparently was channelized early on, like most streams in north Missouri, it has begun to reassert its natural right to meander, and the stretch of it in the park once again sports twists and bends with sandbars and gnarled driftwood snags. All along its banks a rich bottomland forest of silver maple, cottonwood, and green ash shades a valley floor where the rare ostrich fern spreads its delicate lime green foliage.

The Crowders, who arrived from Ohio by way of Iowa just before Enoch Crowder's birth, were not among the first residents of the area. There are several prehistoric Indian mounds in the park, probably of the Woodland period, and at the time of white contact the area was utilized by the Sac and Fox tribes. In an extension to Crowder Park of more than 1,200 acres acquired in 1991 is the old brick home of the first white settler of Grundy County, Dr. William Preston Thompson, who gave his name to the river on which the park is located. Thompson was a Virginia-born physician who was a brigadier general during the War of 1812 and a member of the Virginia legislature and the U.S. Congress before coming in 1821 to Ray County, Missouri, where he continued to play a prominent role in public affairs. He moved to this northern hinterland in 1833, and his house was built soon thereafter by his slaves from clay dug on the site and molded into bricks. Hand-carved walnut sunburst corner blocks can still be seen on the door and window frames, and other fragments of woodwork offer mute testimony that this once must have been the showplace of the whole region. In building this house, Thompson succeeded in extending southern culture to a frontier region well removed from the prevalent centers of Missouri's southern settlement. One of his sons died fighting for the Union in the Civil War, as did Enoch Crowder's namesake uncle.

The recreational facilities at Crowder, begun by the Civilian Conservation Corps and continued after the war by contract labor, are centered upon a twenty-acre man-made lake that offers fishing

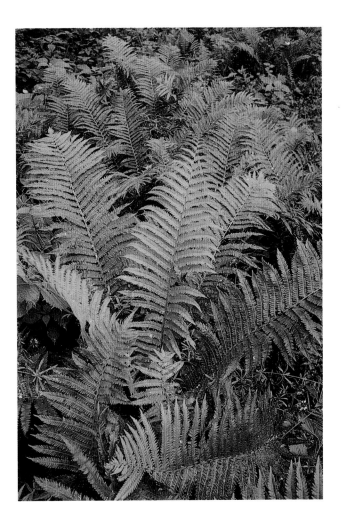

The rare ostrich fern may be found in the forest at Crowder State Park. TOM NAGEL

and a lovely setting for picnics. A campground sits on the hill above the lake, and one of the park system's fine group camps—Camp Grand River—is situated on a broad ridge above the Big Thompson tributary of the Grand.

Perhaps one of the values of commemorative parks such as Crowder is that they preserve a collective memory of our shared ideals and of the leaders who have embodied them. It is good for us to know whom we have honored in earlier times, and why. This is important to us as we lurch from one set of fashionable ideas to another down the path of history. We do well to interpret the character and deeds of those we have so commemorated accurately and with appreciation for their role in their time and place.

The entrance road at Crowder leads the visitor through a classic park landscape, a fitting memorial to the north Missouri farm boy who oversaw the establishment of the selective service system.
OLIVER SCHUCHARD

Wallace State Park

I F YOU FIND YOURSELF traveling in northwest Missouri, you will no doubt be impressed by the fertile farmlands there. Scattered throughout the region, however, are also areas of rough hilly land, especially near some of the streams. One of the most lovely of these forested oases of natural land is preserved in Wallace State Park near the little town of Cameron in Clinton County, not far northeast of Kansas City.

Wallace was one of our "second-generation" parks, and only the second after Mark Twain to be acquired north of the Missouri River, where land was considerably more expensive than in the Ozarks. Its initial 120 acres were purchased in 1932 for a state recreation area from William J. Wallace and other family members and neighbors. Now about 500 acres, it includes some very lovely forested hills, as well as over a mile of the valley of Deer Creek. This was Mormon country in the 1830s, and some historians believe one of the Mormon trails crossed the creek in what is now the park.

William Wallace's father, James, a native of Tennessee, had fought as a young man in the Black Hawk War of 1832 and subsequently migrated to Missouri, settling in extreme western Caldwell County. Caldwell County was carved out of the sparsely settled northern reaches of Ray County in December 1836 as a haven for the Mormons, who had already been driven out of Independence into Clay County, where non-Mormon settlers were now agitating for them to leave. Mormons flooded by the thousands into the new county, especially after Joseph Smith arrived in March 1838 and proclaimed their principal settlement, Far West, the new gathering place of the Saints. Far West, only four miles east of

the Wallace farm, quickly became second in population only to Liberty among western Missouri cities. But during the fall of 1838, Missourians fearful of the influx of Mormons, who were spilling beyond the bounds of Caldwell County, united in a sorry episode of vigilante and militia action to drive them from the state. The Mormons fled to Nauvoo, Illinois, and then in 1846 began their trek to the valley of the Great Salt Lake.

Wallace family tradition holds that James Wallace arrived in the area before the dramatic migration of the Mormons and took part in anti-Mormon activity, though no evidence has been found to substantiate this, records at Far West having been destroyed during the Mormon War and those in the new courthouse at Kingston having been lost to fire in 1860. We do know that his family was established in Caldwell County by the census of 1850, and that he, his brother David, and his four sons eventually acquired some six hundred acres on both sides of the Caldwell-Clinton county line, a portion of which (in Clinton County) became the state park.

The early facilities in Wallace State Park—roads and trails, picnic area, landscaping, and the like—were developed with the assistance of the Works Progress Administration and the National Youth Administration. Later, a small lake was constructed along a tributary of Deer Creek. This lake, which nestles attractively in its little valley, is known as Lake Allaman after a former park board member. It has been a favorite with park visitors and offers swimming, boating (electric motors only), and fishing. But it is also subject to heavy siltation, a common malady on the glaciated plains of north Missouri with their erodi-

Wallace State Park offers a lovely forested oasis in the rolling farmlands of north Missouri.
OLIVER SCHUCHARD

ble soils, and it requires periodic renovation.

Several miles of trails at Wallace can help you explore the lake, the gentle hills, and the Deer Creek valley. You may be lucky enough some summer morning to find a mother whitetail and her fawn drinking from the waters of Deer Creek. The park also offers numerous picnic sites and several campgrounds, including an area for group camping and a semiprimitive area for youth groups.

Some miles southwest of Wallace State Park a sixty-acre tract of land exhibits an outstanding example of northern Missouri's original hardwood forest. Known as Trice-Dedman Memorial Woods in honor of its previous owners, it was preserved through the research efforts of the University of Missouri, the generosity of the owners,

and the assistance of the Missouri Chapter of the Nature Conservancy, which has leased it to the parks division since 1981.

The memorial woods features a mature forest dominated by uncut white oak, a very unusual remnant of northern Missouri's heritage. These oaks are perhaps the original trees of the open white oak forests early naturalists described in the northern prairies. Shagbark hickory and northern red oak may also be found on the uplands, with hackberry, box elder, and Ohio buckeye in lower areas. In the spring you may find an abundance of Jacob's ladder, Dutchman's breeches, and other wildflowers. In many places, the low green umbrella leaves of the may apple nearly carpet the soft ground. Here is a place for nature education, for research, and for interpretation. But here also is a place for simple contemplation of nature in a peaceful setting. Don't deprive yourself of this joy during your visit to Wallace State Park.

Watkins Mill State Park

THE VERY POPULAR Watkins Mill State Park in northeastern Clay County shares a portion of the original 1,800-acre Waltus Watkins farm with the adjacent state historic site. Donated to the state by the citizens of Clay County in 1963, the units interact closely to provide a full range of park and museum experiences for visitors. Because recreational resources and historic resources have different management strategies, the state has divided these functions administratively into two separate but complementary facilities.

The park incorporates about 800 acres of the south end of the original Watkins farm, including the original 80-acre tract upon which Watkins settled with his family in 1839. The actual site of the log house within this 80 acres has never been precisely located, but it is thought to have been somewhere along the park road just southwest of the boat-launching ramp at the lake.

This part of the estate was the most hilly of all the land that Watkins owned. It generally supported little crop activity and probably no residences once the family had moved to the location of the big brick house to the north. The landscape remains today much as it was when Watkins settled here, mainly grassy on the ridge-tops and timbered in the lower-lying areas.

The most rugged portion of this tract was created by the cutting action of Williams Creek, and the resulting small valley lent itself logically to the creation of the Williams Creek Lake. This lake, which now basks in universal popularity, was once the subject of controversy among Watkins Mill supporters. Williams Creek ravine, because of its steepness, had seemingly never been farmed or logged during its long ownership by the Watkins family. As a result, it stood full of huge and ancient oaks, some more than three feet through, with sycamores and cottonwoods twice that diameter interspersed. The Watkins Mill Association had used a "save the oaks" motif as one element in its campaign for the bond issue that purchased the acreage for the park. But park officials favored a lake—the 1960s was an era of lake building in the parks—and the ravine seemed an obvious place. A conservation department forester called in for advice pronounced the oaks "overmature," and down they came, aided by a $100,000 grant from the Soil Conservation Service. A final shot was fired by a Watkins Mill Association trustee who requested in a terse memo that the resultant body of water be named "Submerged Oak Lake." Swimmers today frolic in the sparkling water and sun themselves on the beautiful sand beach, unaware of the old argument. But in controversy the differences in philosophy within agencies—and among agencies—may be revealed.

Probably the most popular single feature of the park is its bicycle path, a hard-surfaced five-mile track that completely encircles the lake. It provides pretty views of water, woods, and grasslands and is popular with walkers as well as bicyclists. Automobiles with bike carriers are a common sight on rural roads leading to Watkins Mill.

The park has a lovely wooded campground with one hundred units, two of which are specially designed to accommodate handicapped campers. The campground was designed for maximum retention of an existing woods, and individual units are widely spaced among the trees.

A weekend camping trip here will provide few reminders that downtown Kansas City lies only

The campground amid a remnant mature forest on the Watkins farm is one of the most pleasant in the park system. B. H. RUCKER

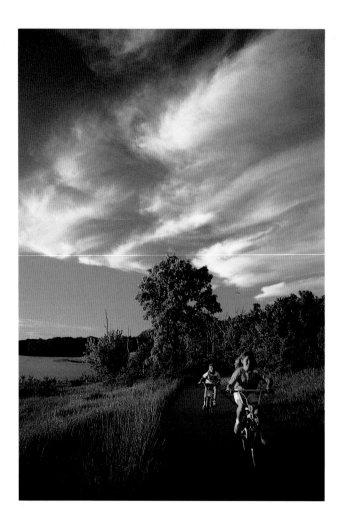

The bicycle path around Williams Creek Lake is the most popular single feature of the park. TOM NAGEL

camp life. The two units together total some 1,440 acres.

Camping is an appropriate use for Watkins Mill State Park—more so than we may realize. As busy as the campground seems on a Saturday night in August now, it was once busier. For that peak we must go back some seventy-five years to the days when the Watkins farm, still serving as the community center it became during the nineteenth-century heyday of the mill, hosted the Missouri Valley Foxhunters Association for its annual hunt. In those days a tent city was erected, complete with barbershop and movie theater, and several thousand people spent the night. In fact, two weeks' worth of nights, listening to the baying of hounds and telling tall tales.

A marker has been placed at the site of the old foxhound barn, not far from where the modern swimming beach is today, to remind us of that time. Take a moment out of your camping evening, perhaps on a full-moon night, and step out of the circle of light from your campfire. Can you still hear the ghostly baying of long-gone hounds echoing from the distant hills?

Fishing into the twilight. TOM NAGEL

twenty-five miles to the south. In fact, for being so close to the city, and in the midst of a generally agricultural landscape, the variety of plant and animal life is quite a surprise. Avian activity is abundant, and birders have reported species from here that have not been seen for years in other areas of northwestern Missouri. White-tailed deer are sure to be seen, and raccoons, opossums, and even beaver in Williams Creek are possible delights for the careful observer.

The park, which provides a full day-use environment of picnic areas, including an open shelter overlooking the lake, serves a dual role. It is a full-fledged park and a recreational magnet in its own right, but it also offers a nice adjunct to the state historic site—a place for a picnic or a shady bit of relaxation following a day of living history. The juxtaposition also works in reverse, and those camped for the weekend will find a Saturday afternoon trip through the historic old Watkins Woolen Mill an interesting diversion from

Watkins Woolen Mill State Historic Site

"GOING . . . GOING . . . GONE! Sold to the man for six hundred dollars." When the auctioneer's hammer fell on that warm, late spring afternoon in May 1958 it was both an end and a new beginning for what would soon become one of Missouri's outstanding national historic landmarks: the Watkins Woolen Mill. This auction sale of the Watkins farm and its famous woolen mill was the breaking up of the last intact piece of one of Missouri's best-known antebellum land holdings. Thus ended the passing of an undiminished title to this estate that had been begun by Waltus L. Watkins in 1839. At the same time this sale presaged a new beginning for the Watkins property, once known as Bethany Plantation, soon to become one of Missouri's premier state historic sites, with its adjacent state park growing increasingly popular as a recreational attraction.

The Watkins story in Clay County had begun in 1830, when a young Waltus Watkins immigrated to Liberty from his beloved Kentucky and opened the business of his dreams. In his youth he had been an apprentice in the mechanical trades, and now he had in mind to operate a cotton spinning mill of his own and perhaps, in addition, small plants for the milling of grain and the sawing of lumber. These enterprising plans went awry owing to the inability of the northern Missouri climate to sustain a cotton crop and the impossible expense of shipping in baled cotton. The mill was converted to wool carding and spinning and operated for a number of years until stilled by a fire.

Whatever his original intent, in 1839 Watkins changed direction and moved his growing family from Liberty to northeast Clay County. This re-gion seemed from the start to have a strong attraction for Kentuckians, and they settled there in great numbers. The countryside likely seemed a good fit to these former bluegrass natives. It still does.

The state historic site encompasses several hundred acres of this nineteenth-century world and preserves it nicely for our enjoyment as a historic farmstead. Although the aim of the site is to present the farm at about the level it achieved in the 1870s, the essential look of the land remains as it has for eons: high and rolling—hilly, but gently so. The hilltops and ridges are today largely pasture, still open land, just as they probably were in 1839, although no longer covered with native grasses. The slopes, deeper ravines, and lower elevations still have nice stands of trees, now second growth instead of the occasional giant oaks and huge walnuts that once towered above the general forest canopy. It was this mosaic world of rich-loamed prairie ready for the plow, braided with large-logged forests for cabins and lumber, and all well watered to boot, that drew settlers like a lodestone. And not only was it just as good as Kentucky, by comparison it was practically free.

Today a visitor arriving at Watkins Woolen Mill sees first the handsome new visitor center. Representing a million-dollar investment by the state, this structure not only provides a welcome introduction to the site through exhibits, artifacts, and audiovisual programs but also houses administrative offices and museum-quality storage for a large collection of original Watkins family manuscripts and artifacts.

Probably the most surprising exhibit in the center is a fully operational loom upon which

Watkins Woolen Mill, constructed in 1860 on the eve of Civil War, is now a national historic landmark, un-surpassed in the integrity of its structure and machin-ery. OLIVER SCHUCHARD

The belt-driven looms on the second floor of the woolen mill were marvels of the industrial age. OLIVER SCHUCHARD

one may be able to see cloth being woven. This loom will be the first clue for many visitors that the Watkins Mill is not the quaint, streamside gristmill of their imaginations. In the rattle, clatter, and snap of this mechanized marvel, all thoughts of a slow-turning, moss-covered waterwheel quickly dissipate. Watkins Mill is the industrial revolution made manifest—all steam, speed, and cast iron, the best example in the world of a nineteenth-century textile factory, with three whole floors of antique machinery remaining intact. And yes, oddly enough, it is a factory on a farm.

That it is a farm becomes apparent when one leaves the center by the rear door, having finished with the exhibits, one's appetite whetted for the real thing. A sense is created of the visitor center as a time machine, the rear door being a portal opening into, say, 1876. Go through it and you find yourself in a narrow country lane, lined with split-rail fences and baaing sheep. This is the bucolic world Waltus Watkins moved his family to in 1839, settling on his first purchase of 80 acres just a little south of here. By 1846 the 80 acres had grown to 640, of which 450 acres were under cultivation, and Watkins had just moved to a new and larger cabin located on the hill you can see just ahead. By his death in 1884, this home place had grown to about 1,800 acres, and it was the centerpiece of a holding that totaled over 3,600 acres in several counties. Watkins called this place Bethany, and for a while he held a U.S. Government appointment as postmaster for it.

It isn't clear whether he was thinking of Bethany as a plantation in the southern mode, or whether the establishment of the post office reveals even larger thoughts about town founding. It is true that he once referred to "my plantation." And, yes, there were slaves here, in small numbers, to serve as domestics. But by most modern definitions, this place would be best described as having been a very large, diversified farm.

Coming into view ahead is the house that Watkins began in 1850 to replace his second log home. Even on first sight from a distance, this third house bears the unmistakable earmarks of that first generation of southern immigrants— handmade red brick, green shutters, white trim, a wood shingle roof, and the whole composition encompassed by a whitewashed fence. Long straight rows of hard maples and red cedars running from the house to the lane express a sense of formality that prevailed in this nineteenth-century world. Almost everyone who visits comes away satisfied with a fundamental notion of this building: it was a comfortable, beautiful

Waltus Watkins built his family a substantial brick home in 1850, after they had lived in two previous log homes on the property. OLIVER SCHUCHARD

house, not a mansion, but a home.

Upon entering the house, you can see its most striking feature there at the front door—the sweeping circular staircase that rises in a 180-degree arc to the second-floor landing. Constructed with oak treads and walnut trim, the staircase is itself a definition of the beauty that may lie in simplicity. The balusters are only plain, lathe-turned sticks, set into a smooth railing that terminates in a massive newel, carved in a sweeping curve from one solid block of walnut. Further exploration reveals the consistency of this motif: the whole house is trimmed in walnut boards, with few moldings and little ornamentation, the stark white plaster everywhere setting off the beauty of this warm, mellow, hundred-and-forty-year-old wood. Family letters indicate that the windows and possibly other millwork for the house were contracted for by a brother-in-law in Kentucky and shipped to Clay County by steamboat.

Exploring this house further provides several surprises. In a day of large families—Waltus had eleven children—and long visits by relatives and friends, houses had to accommodate an amazing variety of living arrangements. To a modern visitor it seems very unhandy that the two large bedrooms at the front of the house, at the top of the circular stairway, do not connect with the three small rooms at the back of the house. In addition, two of these small back bedrooms do not have a connection with the third. From the dining room a very narrow stairway leads, by steps with risers so high the knees creak, past this third bedroom to a large dormitory room at the top of the house

where the many boys of the family—and perhaps some hired hands—slept. These arrangements, which seem so inconvenient to us, were a nineteenth-century concession to modesty and privacy whereby family and guests, and boys and girls, were easily segregated.

A second, quite pleasant surprise about this house is that it is furnished almost entirely with original family pieces spanning the full period of Watkins occupancy. This site has been blessed by having been acquired with many furnishings intact, and by the assistance of family and friends who returned many original Watkins furnishings for the home.

From the door to the balcony over the front porch, you may look out over a large portion of the Watkins farm. Our enormous good fortune in having so much of this world survive is the predominant sensation. Fully ninety-five percent of everything we see here is original to the place. The parks division has wisely reconstructed only minor features of the site—outbuildings, sheds, fences, all determined by archaeological research—so that a more understandable context is created for the major buildings that survived. The addition of livestock and costumed guides adds vitality and enables us to better visualize this world of another era.

From the upstairs vantage point, when the leaves are off the trees, the Franklin School, an interesting 1856 octagonal structure, and the Mount Vernon Church, built in 1871, are barely visible on a hill a half-mile to the east. Neither building was a part of the Watkins farm, but both were intimately connected with the Watkins family. Waltus was a leader in his community, and he strongly supported both religious and educational endeavors. He served as building commissioner for the construction of both buildings and personally underwrote a major portion of their cost. Although originally located on adjacent property, both buildings were later added to the Watkins holdings after their ownership organizations had become defunct. Both of these buildings have been fully restored and present important elements of everyday life in old Missouri. Modern students sometimes spend an 1870s day in the old academy, learning lessons now antique, as part of a school field trip to the site. Likewise, from time to time, the organ peals and modern couples come to say their vows in the church, just as in the old days.

Standing here in this doorway of the brick house on the hill, you are probably looking at the very view that Waltus Watkins himself most liked to savor. It is absolutely the best place from which to look down into the swale where the

Franklin School, a private academy built in 1856 with Waltus Watkins's support, was later added to his holdings. NICK DECKER

centerpiece of this nineteenth-century world stands. Here is the Watkins woolen mill itself, its bright red metal roof, pinkish brick walls, and white woodwork gleaming anew, the required restoration treatment having given it a preternaturally bright look that belies its hundred and thirty years.

This first impression of bright newness is struck from your consciousness the instant you enter the mill's front door. Here all of the senses immediately convey a massive impression of great age. The eyes register the slightly edge-softened contours of old brick and wood, and even the iron machinery bears witness to the erosion of time. The skin conveys a sensation of coolness, for it always seems cooler just inside the mill door than out, no matter what the season. The slightly acrid odor of damp brick and old wood mingles with the unmistakably oleaginous scent of lanolin, soaked deeply into the wooden floors and machinery for all time. A few century-old graffiti are daubed here and there, and an antique sign tacked by the stairwell proclaims: DON'T GO UPSTAIRS—GO TO THE OFFICE IF YOU WANT ANYTHING. One glances about guiltily; does this mean us?

It was in this very room, crowded with potential buyers and curious spectators, that the 1958 auction was held that led to the creation of this state historic site. As early as 1938, after the

death of the last of Waltus Watkins's sons, the Clay County Historical Society had urged the state to acquire the farm. Then in 1945 the Watkins heirs had sold the homeplace in a block of some 1,800 acres to ranching interests from Texas, and for thirteen more years it remained intact. The owners were sympathetic to the idea of creating a historic site, but no source of funding had come forward. So, at this auction sale, the possibility existed that for the first time in over a century the estate would be broken up. Among those intrigued by the announcement of the sale of this major engineering enterprise—the Watkins Woolen Mill—were three employees of a similarly industrial concern, the Allis-Chalmers gleaner combine works in Independence. They decided to satisfy their curiosity by attending the sale, and it was thus that on a spring day in 1958 an important public enterprise began with a bit of luck.

Because of a last-minute intervention, one of the three, George Reuland, was unable to make the trip to Clay County. The other two, Lee Oberholtz and Forest Ingram, went on, carrying with them his casual request to "buy a souvenir for me." When the afternoon ended, and the two returned home, the request was more than satisfied—in a burst of enthusiasm, and for a little over six hundred dollars, they had bought the entire contents of the mill, four floors loaded with rare, century-old textile equipment and machinery. The next day, the three formed the Watkins Mill Association, a nonprofit corporation, to try to deal with this embarrassment of riches.

They faced an immediate problem of removing all the machinery within thirty days, the parcel with the mill building on it having been sold to another bidder. A failed fiscal instrument solved that problem, and the second-place bidder proved more sympathetic—in fact, downright supportive. It was at this point that it became possible not just to save some of the old machines, but perhaps to save the world that had contained them.

For decades attempts had been made to convert the Watkins estate into a state park, but to no effect. Now with the leadership of the Watkins Mill Association, the job moved toward accomplishment. It was not easy. It required five years of effort and the help of hundreds of volunteers. Finally, following a successful Clay County bond issue, the Watkins Mill and most of the original farm became a state park and historic site on the first day of January 1964. Today, more than thirty years after the story began, the Watkins Mill Association remains an active partner in the Watkins endeavor, supporting the state's efforts to

make this magnificent resource available for public enjoyment.

If we follow the instructions on the old sign, and go to the office as told, we enter a mercantile world, complete with the store counter and walnut yardstick used for measuring yard goods, deep bins to hold bolts of finished cloth, and a hanging shelf above for displaying the other sundry items for sale. Overhead hanging on nails are items of original store stock, awaiting customers. A letterpress and a tall bookkeeper's desk tell us that this was indeed the "office and sales room at the mill" that Watkins's advertisements proclaimed.

With or without our pass from the office, a trip upstairs immerses us in mechanical engineering of the 1870s. On the second floor, the weaving trade predominated. Whitewashed walls—to enhance visibility with more light—frame lines of looms, from narrow simple looms of 1860 vintage, through wide looms for the weaving of blankets, to the most modern machines in the mill, fancy looms of the 1880s, set to weave patterned cloth and all the while automatically controlled by roller-chain versions of computer punch cards. In the corner of this room sit two unimposing machines, tongue-twistingly known as "ring frame ply twisters." These particular ones are thought to be the only examples of their once-common type left in the entire world.

The third floor is devoted to carding and spinning. A long row of carding machines—a vast array of rotating cylinders, covered with sharp wire teeth—served for the brushing and straightening of fleece as a preparation for its transformation into yarn and ultimately cloth. Across the room two rows of spinning machines acquaint us with a midpoint of industrial evolution. Known as spinning jacks, they spin 216 threads at a time, a step forward from Richard Arkwright's famous spinning jenny, which prepared 16 threads simultaneously.

The fourth floor is not open to visitors, being a low-ceilinged attic only accessible by narrow stairs, but it contains long racks used for the drying of cloth. All of the wet processes needed to convert the raw cloth into the fine, salable product we are used to seeing in stores are confined to the ground floor of the mill. Here is a zone of mainly wooden machines for fulling, washing, dyeing, pressing, and napping. The nature of their construction gives them a homemade look and an antique air that belies their having been state of the art for their time.

There are homemade things in the mill, and packing-crate lumber played its part, Watkins not being one to waste things. Not only are the win-

dowsills made from the packing crates in which the looms were shipped, but the boards that form the wooden enclosure surrounding the main power sheave clearly show the legend *Not Contraband*. Thus they display their origin as crating lumber that once enclosed mill machinery being shipped into a not-so-peaceful, wartime Missouri in the 1860s.

Behind this board enclosure can be seen the huge ten-foot-diameter main power sheave for the entire factory. This cast-iron wheel drove a belt of twenty-inch-wide leather that was connected to a power-distribution center on the second floor, from which in turn every machine in the building was driven. The sheave is mounted on an iron axle that passes through the brick wall and into the engine room immediately outside.

Perhaps it is fitting that our tour of the mill concludes at the back of the building with the power plant. There, thoughts of motive force—both human and mechanical—are most appropriate. From here the huge steam engine, powered by a thirty-foot iron boiler salvaged from a sunken steamboat, provided the power to run all

three floors of machinery. The shaft piercing the wall into the mill is surmounted by a sixteen-foot-diameter flywheel weighing 8,000 pounds. The many scars in the brick are a lasting memorial to those who turned it by hand with pry bars when the engine would occasionally stop on dead center and need to be rotated off-center before it could be restarted with steam.

This whole area of the mill calls to mind thoughts of power, and of the ingenuity and pragmatism of nineteenth-century American industrialism. We led the world in the solution of large, heavy tasks through a corresponding strength of ideas, designs, and materials. Perhaps ideas were our greatest capital, for all the cast-iron-generated motive force in this powerhouse was scarcely a match for the motivation of the man who built this mill.

In our time when early retirement may begin at fifty-five, it is not easy for us to understand the determination of a man who would begin the largest undertaking of his life at that age, risking all the accumulated wealth of his lifetime when cash was hard, credit practically nonexistent, and the outbreak of civil war at any moment a virtual certainty. This magnificent and amazing survival of nineteenth-century industrial America is a fitting memorial to the determination and strength of the man who willed it into existence.

Watkins Mill is quiet now in the hush of winter, but it was not always so. CINDY BROWN

Bibliographical Essay

MATERIAL FOR THE essays in this book has been drawn from a wide array of sources both documentary and secondary, as well as from personal observations and interviews. Authors have visited each park once or several times in the course of preparing these essays, and talked with park staff and other knowledgeable persons.

The parks division made available its archival and current files on the individual parks, including correspondence, reports, plans, clippings, and national register nominations. This material has been supplemented by ancillary research for a history of the system as a whole, utilizing annual agency reports, minutes, correspondence, land acquisition records, and other data. For the earlier years of the system, when park archives are thin, the papers of several Missouri governors and other materials in the joint holdings of the University of Missouri Western Historical Manuscript Collection and the State Historical Society of Missouri are quite rich. These have been supplemented with newspapers available at the state historical society and, for the period after 1945, with clippings from the files at the Missouri State Library, as well as with census records, county histories, and other materials. To list all these resources individually is beyond the scope of this book, but many of them are specifically cited in a fully documented history of the state park system that will be published separately. This bibliographical essay, instead, offers a brief indication of some of the published sources used and suggestions for further reading on a variety of topics addressed in this book and on many of the parks and historic sites.

Perhaps the most suggestive work on the intellectual context of the movement for public parks is Norman T. Newton, *Design on the Land: The Development of Landscape Architecture* (Cambridge: Harvard University Press, 1971). The best approach to urban parks in Missouri is through Caroline Loughlin and Catherine Anderson, *Forest Park* (Columbia: Junior League of St. Louis and University of Missouri Press, 1986); William H. Wilson, *The City Beautiful Movement in Kansas City* (Columbia: University of Missouri Press, 1964); and Edward C. Rafferty, "Orderly City, Orderly Lives: The City Beautiful Movement in St. Louis," *Gateway Heritage* 11:4 (Spring 1991): 40–65. The National Conference on State Parks published several comprehensive reports on state park systems: Raymond H. Torrey, *State Parks and Recreational Uses of State Forests in the United States* (Washington, D.C., 1926); and Beatrice Ward Nelson, *State Recreation: Parks, Forests and Game Preserves* (Washington, D.C., 1928). For a personal interpretation with essays on parks in many states see Freeman Tilden, *The State Parks: Their Meaning in American Life* (New York: Alfred A. Knopf, 1962). And for an excellent analysis of contemporary issues see Phyllis Myers, *State Parks in a New Era*, 3 vols. (Washington, D.C.: The Conservation Foundation, 1989). One of the better historical analyses of management philosophies and issues in the national park system is by Ronald A. Foresta in *America's National Parks and Their Keepers* (Washington, D.C.: Resources for the Future, 1984).

Michael Kammen probes the cultural significance of historical commemoration in *Mystic Chords of Memory: The Transformation of Tradition in America* (New York: Alfred A. Knopf,

1991), while the national movement for historic sites is traced in Charles B. Hosmer, Jr., *Presence of the Past: A History of the Preservation Movement in the United States before Williamsburg* (New York: Putnam, 1965) and *Preservation Comes of Age: From Williamsburg to the National Trust, 1926–1949*, 2 vols. (Charlottesville: University Press of Virginia, 1981). For an overview of recreation issues see the reports of two major national commissions: Outdoor Recreation Resources Review Commission, *Outdoor Recreation for America* (Washington, D.C.: USGPO, 1962), and President's Commission on Americans Outdoors, *Americans Outdoors: The Legacy, the Challenge* (Washington, D.C.: Island Press, 1987). Stephen Fox provides the most accessible one-volume survey of the twentieth-century conservation movement in *John Muir and His Legacy: The American Conservation Movement* (Boston: Little, Brown and Company, 1981), but for multiple insights on the transformation of values in the postwar era see also Samuel P. Hays, *Beauty, Health, and Permanence: Environmental Politics in the United States, 1955–1985* (New York: Cambridge University Press, 1987).

Numerous articles published in magazines and newspapers over the years have discussed individual Missouri parks, but few have dealt with the system as a whole. The periodicals that have carried articles about parks and related themes include *Bulletin of the Missouri Historical Society, Gateway Heritage, Grassroots, Missouri Archaeological Society Quarterly, Missouri Archaeologist, Missouri Game and Fish News, Missouri Conservationist, Missouri Historical Review, Missouri Life, Missouri Magazine* (1928–1938), *Missouri Magazine* (1989–), *Missouri Preservation News,* and *OzarksWatch. Missouri Resource Review,* published since 1982 by the Missouri Department of Natural Resources (DNR), features a park or park theme in each issue, while *Heritage,* the newsletter of the Missouri Parks Association (1982–), is the best source for news about the park system. The book-length work that has heretofore done the most justice to Missouri state parks—or, at least, historic sites—is Suzanne Winckler, *The Smithsonian Guide to Historic America: The Plains States* (Washington, D.C.: Smithsonian Books, 1990). Carl Chapman traced the history of archaeological research in Missouri, much of which was at sites now in the park system, in "Digging Up Missouri's Past," *Missouri Historical Review* 61:3 (April 1967): 348–63, while Ronald W. Johnson discussed the park division's involvement in preservation of historic sites in two articles, "Historic Preservation in Missouri: Origins and

Development through the Second World War," *Bulletin of the Missouri Historical Society* 32:4 (July 1976): 222–46, and "Historic Preservation in Missouri: A Recent View," *Midwest Quarterly* 18:1 (October 1976): 64–77. John Karel briefly described the history of the state park system and the values at stake in the parks in a two-part article, "Missouri State Parks: A Natural Treasure House," *Ozark Sierran* 12:6 (December 1980–January 1981):4 and 13:1 (February–March 1981):4, and in the latter issue Greg F. Iffrig added "A Review of the Missouri Wild Area System, 4–5." Greg Iffrig and Paul Nelson discussed a new approach to resource management in "Savannah Stewardship in Missouri State Parks," *Missouri Prairie Journal* 5:1–2 (October 1983): 3–12. Recent approaches to park philosophy and issues are explored in *First Missouri Conference on State Parks, June 15–17, 1984: Proceedings,* edited by Susan L. Flader and issued by the Missouri Parks Association in 1984, and two articles prepared by Sue Holst for *Missouri Resource Review,* "Question of Balance," 7:2 (Summer 1990): 6–11, and "Parks in Peril," 8:3 (Fall 1991): 2–7.

Paul W. Nelson prepared a "Natural Heritage Inventory of Missouri State Parks" (report, DNR, 1980), which categorized and listed sites for natural areas, rare and endangered species, and special ecological management areas. Richard H. Thom and Greg Iffrig followed in 1985 with *Directory of Missouri Natural Areas* (many of which are in state parks), issued by the Missouri Natural Areas Committee. These works are in turn based on three sets of natural area inventories initiated by Dr. William Elder of the University of Missouri–Columbia in the 1970s, extended to the entire state by the L-A-D Foundation under the general direction of R. Roger Pryor, and further refined through an ongoing computerized methodology developed by the Nature Conservancy under sponsorship first by the department of natural resources and then by the conservation department. For the world underground see James and Treva Gardner, "An Inventory and Evaluation of Missouri State Park Cave Resources" (report, DNR, 1982). And for a framework see Paul W. Nelson's "Natural History Themes for the Missouri State Park System" (report, DNR, 1985).

There is no comprehensive inventory of cultural resources in the parks, but a major survey of CCC and WPA architecture in the parks resulted in the nomination of nearly 350 structures to the National Register of Historic Places; see James M. Denny and Bonita Marie Wright, "Emergency Conservation Work (E.C.W.) Architecture in Missouri State Parks, 1933–1942, Thematic Resources" (National Register of Historic Places

Nomination, November 7, 1984). A sobering park-by-park assessment of internal and external threats has been issued under the title "Challenge of the '90s: Our Threatened State Parks," 2 vols. (report, DNR, 1991). The DNR in 1991 also issued a draft version of a "Missouri State Park and Historic Site System Expansion Plan," containing an analysis of the system and suggested criteria for expansion.

Several bibliographies now regrettably out of date include research about the parks: Randy L. Cottier et al., *A Selected Bibliography of Missouri Archeology* (Columbia: Missouri Archaeological Society Research Series Number 10, 1973); and Greg F. Iffrig and John A. Karel, "Natural History Research in Missouri State Parks," *Transactions, Missouri Academy of Science* 13 (1979): 147–58. In addition, the DNR Division of Parks, Recreation, and Historic Preservation maintains computerized inventories of archaeological sites, historic sites, and unpublished reports and studies prepared by or for the division. The best single bibliography of research on the natural resources and cultural geography of Missouri is Walter A. Schroeder's *Bibliography of Missouri Geography: A Guide to Written Material on Places and Regions of Missouri* (Columbia: University of Missouri Extension Division, 1977).

Characteristic landforms of Missouri are discussed in several classic works: Carl O. Sauer, *The Geography of the Ozark Highland of Missouri,* The Geographic Society of Chicago, Bulletin No. 7 (1920; reprint New York: Greenwood Press, 1968); Edwin Bayer Branson, *The Geology of Missouri,* University of Missouri Studies, 19:3 (Columbia, 1944); J. Harlen Bretz, *Caves of Missouri* (Rolla: Division of Geological Survey and Water Resources, 1956); H. Dwight Weaver and Paul A. Johnson, *Missouri: The Cave State* (Jefferson City: Discovery Enterprises, 1980); Jerry D. Vineyard and Gerald L. Feder, *Springs of Missouri* (Rolla: Missouri Division of Geological Survey and Water Resources, 1974); and Thomas R. Beveridge, *Geologic Wonders and Curiosities of Missouri* (1978), Educational Series No. 4, 2d ed., revised by Jerry D. Vineyard (Rolla: Missouri Division of Geology and Land Survey, 1990). Supplementing these are two works published in 1992 by the University of Missouri Press: A. G. Unklesbay and Jerry D. Vineyard, *Missouri Geology: Three Billion Years of Volcanoes, Seas, Sediments, and Erosion,* and H. Dwight Weaver, James N. Huckins, and Rickard L. Walk, *The Wilderness Underground: Caves of the Ozark Plateau.* For an overview of water resources see Walter A. Schroeder, *Missouri Water Atlas 1982*

(Jefferson City: Missouri Department of Natural Resources, 1982). See also Betty Flanders Thomson, *The Shaping of America's Heartland* (New York: Houghton-Mifflin, 1977). Two good handbooks are W. D. Keller, *The Common Rocks and Minerals of Missouri,* rev. ed. (Columbia: University of Missouri Press, 1961); and A. G. Unklesbay, *The Common Fossils of Missouri,* rev. ed. (Columbia: University of Missouri Press, 1955).

The dean of botanical studies in Missouri was Julian Steyermark, whose key works are *Studies of the Vegetation of Missouri: I. Natural Plant Association and Succession in the Ozarks of Missouri,* Field Museum of Natural History, Botanical Series 9:5, Publication 485 (Chicago, 1940); *Vegetational History of the Ozark Forest,* University of Missouri Studies, 31 (Columbia, 1959); and *Flora of Missouri* (Ames: Iowa State University Press, 1963). See also A. P. Beilmann and L. G. Brenner, "The Recent Intrusion of Forests in the Ozarks," *Annals of the Missouri Botanical Garden* 38 (1951): 261–82; and Douglas Ladd, "Re-examination of the Role of Fire in Missouri Oak Woodlands," in *Proceedings of the Oak Woods Management Workshop* (Charleston: Eastern Illinois University, 1991), 67–80. The occurrence of prairie in the state has been expertly mapped and analyzed by Walter A. Schroeder in *Presettlement Prairie of Missouri,* Natural History Series No. 2 (Jefferson City: Missouri Department of Conservation, 1982); for glades see Paul W. Nelson and Douglas Ladd, "Preliminary Report on the Identification, Distribution and Classification of Missouri Glades," in *Proceedings of the Seventh North American Prairie Conference,* ed. Clair L. Kucera (Springfield: Southwest Missouri State University, 1983), 59–76. Paul W. Nelson's *The Terrestrial Natural Communities of Missouri* (Jefferson City: Missouri Natural Areas Committee, 1985) characterizes eighty-nine distinct communities and includes many examples from state parks. Several handy guides to trees, wildflowers, ferns, orchids, aquatic plants, and other flora have been published by the Missouri Department of Conservation.

The best guide to Missouri mammals is by Charles W. Schwartz and Elizabeth R. Schwartz, *The Wild Mammals of Missouri* (1959), rev. ed. (Columbia: University of Missouri Press, 1981). For birds see Mark B. Robbins and David A. Easterla, *Birds of Missouri: Their Distribution and Abundance* (Columbia: University of Missouri Press, 1992). See also Francis T. Holt et al., *Rare and Endangered Species of Missouri,* rev. ed. (Jefferson City: Missouri Department of Conservation, 1984) and conservation department guides

to fishes, naiads, reptiles and amphibians, butterflies, and other fauna.

The leading student of Missouri archaeology was Carl H. Chapman, whose two-volume *The Archaeology of Missouri* was published by the University of Missouri Press in 1975 and 1980. More accessible for the general reader is Carl H. Chapman and Eleanor F. Chapman, *Indians and Archaeology of Missouri* (1964), rev. ed. (Columbia: University of Missouri Press, 1983).

Among the numerous surveys of Missouri history, the most consistently helpful is David D. March, *The History of Missouri*, 4 vols. (New York: Lewis Historical Publishing Company, 1967). David Thelen's *Paths of Resistance: Tradition and Dignity in Industrializing Missouri* (New York: Oxford University Press, 1986; reprint Columbia: University of Missouri Press, 1991) offers the greatest insight on the political culture of the state. The several volumes of the University of Missouri Press series *A History of Missouri*, by William E. Foley, Perry McCandless, William E. Parrish, and Richard S. Kirkendall, are also useful, as are one-volume surveys by Duane G. Meyer, Paul C. Nagel, and William E. Parrish et al. For those interested in parks and historic sites, the outstanding WPA guide, *Missouri: A Guide to the "Show Me" State* (1941), supervised by Charles van Ravenswaay, is still indispensable; it was reissued in 1986 by the University Press of Kansas as *WPA Guide to 1930s Missouri*.

The history of Missourians' relationship to their natural resources can be approached through Noel P. Gist et al., eds., *Missouri: Its Resources, People, and Institutions* (Columbia: Curators of the University of Missouri, 1950); Charles Callison, *Man and Wildlife in Missouri: The History of One State's Treatment of Its Natural Resources* (Harrisburg, Pa.: Stackpole, 1953; reprint Jefferson City: Missouri Department of Conservation, 1981); and James F. Keefe, *The First 50 Years* (Jefferson City: Missouri Department of Conservation, 1987). In retrospect, all are notably limited in their attention to the state park system.

The regionalization scheme of six natural divisions and nineteen sections that provides the organizational basis for this book was developed by the Missouri Natural Areas Committee; see Richard H. Thom and James H. Wilson, "The Natural Divisions of Missouri," *Transactions, Missouri Academy of Science* 14 (1980): 9–23. This regionalization is in turn based on schemes developed in Sauer, *Geography of the Ozark Highland of Missouri*; Arthur B. Cozzens, "Analyzing and Mapping Natural Landscape Factors of the Ozarks Province," *Academy of Science of St.*

Louis Transactions 30:2 (1939): 37–63; James E. Collier, "Geographic Regions of Missouri," *Annals of the Association of American Geographers* 45 (December 1955): 368–92; and other regional studies in the fields of soils, vegetation, zoogeography, and so forth. Although there is no comparable widely accepted division of the state based on history and culture, Walter A. Schroeder developed a map of cultural regions of Missouri for the University Press of Kansas reissue of the *WPA Guide to 1930s Missouri* that overlaps in significant respects with the natural divisions used in this book. Both the natural divisions and the natural communities classification developed by Paul Nelson and others have served for a decade as the basis for the parks' natural history program.

The best place to start reading about the Ozarks and the Ozark Border is with the trenchant observations of the early nineteenth-century traveler Henry Rowe Schoolcraft, published in several volumes: *A View of the Lead Mines of Missouri* (New York: Charles Wiley & Company, 1819); and *Journal of a Tour into the Interior of Missouri and Arkansaw from Potosi, or Mine a Burton, in Missouri Territory, in a Southwest Direction, Toward the Rocky Mountains, Performed in the Years 1818 and 1819* (London: Richard Phillips and Co., 1821). The latter was reissued as *Schoolcraft in the Ozarks*, ed. Hugh Park (Van Buren, Ark.: Press-Argus Printers, 1955). Other key works offering insight on the Ozarks include Sauer's *Geography of the Ozark Highland*; Vance Randolph, *The Ozarks: An American Survival of Primitive Society* (New York: Vanguard Society, 1931); Otto Ernst Rayburn, *Ozark Country* (New York: Duell, Sloan and Pearce, 1941); Russel L. Gerlach, *Immigrants in the Ozarks: A Study in Ethnic Geography* (Columbia: University of Missouri Press, 1976); and Milton D. Rafferty, *The Ozarks: Land and Life* (Norman: University of Oklahoma Press, 1980).

For more information on the diverse flora of the parks at the core of the Ozarks in the St. Francois Mountains see Paul W. Nelson, "Flora of Johnson's Shut-Ins State Park, Reynolds County, Missouri" (M.S. thesis, Southern Illinois University, Carbondale, 1977). Theodore Pease Russell wrote regular columns of historical vignettes and personal observations on this part of the Ozarks in the nineteenth century; these have been edited and annotated by James F. Keefe and Lynn Morrow as *A Connecticut Yankee in the Frontier Ozarks: The Writings of Theodore Pease Russell* (Columbia: University of Missouri Press, 1988).

For a historical account of the Meramec River, along which there are four parks (Onondaga, Meramec, Robertsville, and Castlewood), see James P. Jackson, *Passages of a Stream: A Chronicle of the Meramec* (Columbia: University of Missouri Press, 1984). George C. Suggs, Jr., offers brief essays on Dillard and Bollinger mills in *Water Mills of the Missouri Ozarks* (Norman: University of Oklahoma Press, 1990), and Priscilla Evans puts the mills in historical context in "Merchant Gristmills and Communities, 1820–1880: An Economic Relationship," *Missouri Historical Review* 68 (April 1974): 317–26. Ralph McCanse has written a beautifully evocative narrative poem, *Waters over Linn Creek Town* (New York: Bookman Associates, 1951), on the country that is now inundated by Lake of the Ozarks.

Montauk State Park and the character of the Current River country in the lower Ozarks are depicted in Leonard Hall's classic *Stars Upstream: Life along an Ozark River* (Chicago: University of Chicago Press, 1958; rev. ed., University of Missouri Press, 1969), and in *Two Ozark Rivers: The Current and the Jacks Fork*, with photographs by Oliver Schuchard and text by Steve Kohler (Columbia: University of Missouri Press, 1984). Carol A. Fuller, Gordon Todd Maupin, Theresa L. Hilton, and Kathleen Lee Hornberger have written master's theses at Southwest Missouri State University on aspects of the vegetation of several state parks, respectively Ha Ha Tonka (1986), Montauk (1975), and Roaring River (1979, 1980). "Tourism in the White River Valley," where Roaring River and Table Rock state parks are located, was the subject of a special issue of *OzarksWatch* 3:4 (Spring 1990). The prehistory of the Springfield Plateau area represented by Stockton, Pomme de Terre, and Harry S Truman parks was the subject of an intensive interdisciplinary study reported in *Prehistoric Man and His Environments: A Case Study in the Ozark Highland*, ed. W. Raymond Wood and R. Bruce McMillan (New York: Academic Press, 1977); see also a two-volume draft report by Curtis H. Synhorst prepared for this study—the Cultural Resources Survey of the Harry S Truman Dam and Reservoir Project—and issued in 1977.

The Civil War in the Ozarks, commemorated at Fort Davidson and Battle of Carthage historic sites, is the subject of a special double issue of *OzarksWatch*, 4:4 and 5:1 (Spring–Summer 1991). Studies of the battle of Pilot Knob (Fort Davidson) include Cyrus A. Peterson and Joseph M. Hanson, *Pilot Knob: The Thermopylae of the West* (New York: Neale Publishing Co., 1914); Richard S. Brownlee, "The Battle of Pilot Knob,

Iron County, Missouri, September 27, 1864," *Missouri Historical Review* 59 (1964): 1–30; and Bryce A. Suderow, *Thunder in Arcadia Valley: Price's Defeat, September 27, 1864* (Cape Girardeau: Center for Regional History and Cultural Heritage, Southeast Missouri State University, 1986). Among the biographies of Sterling Price is Robert E. Shalhope's *Sterling Price: Portrait of a Southerner* (Columbia: University of Missouri Press, 1971). Michael Fellman explores the "unofficial" war that plagued the state in *Inside War: The Guerrilla Conflict in Missouri during the American Civil War* (New York: Oxford University Press, 1989). Carole Bills has compiled materials about Nathan Boone in *Nathan Boone: The Neglected Hero* (Republic, Mo.: Western Printing Co., 1984).

For an indication of some of the special features of Hawn and St. Francois parks in the eastern Ozark Border see John A. Karel and William H. Elder, "A Natural Area Survey of the Southeast Missouri Regional Planning District," final report to the State Interagency Council for Outdoor Recreation (University of Missouri Cooperative Wildlife Research Unit, Columbia, 1976); and Mary Kay Solecki, "The Vegetation and Floristics of Hawn State Park, Ste. Genevieve County, Missouri" (M.S. thesis, Southern Illinois University, Carbondale, 1981). Early excavations at Mastodon State Park are discussed in M. G. Mehl, *Missouri's Ice Age Animals*, Education Series No. 1 (Rolla: Missouri Division of Geological Survey and Water Resources, 1962), and recent excavations in Russell W. Graham, "Final Report on Paleontological and Archaeological Excavations and Surface Surveys at Mastodon State Park" (Illinois State Museum, Springfield, 1981). For the excavations at Graham Cave see Walter E. Klippel, "Graham Cave Revisited: A Reevaluation of Its Cultural Position during the Archaic Period," *Missouri Archaeological Society, Memoir No. 9* (October 1971); and for the petroglyphs at Washington State Park see Ronald J. Wyatt, "A Study of Three Petroglyph Sites along Big River in the Eastern Ozark Highland of Missouri" (paper, Harvard University, 1959). Missouri's mining history, represented at Missouri Mines, St. Joe, and Finger Lakes, is summarized by Jo Burford in "Underground Treasures: The Story of Mining in Missouri," *Official Manual, State of Missouri, 1977–1978*, 1–33. See also Henry C. Thompson, *Our Lead Belt Heritage* (Flat River, Mo.: News-Sun, 1955).

The best overview of the history of the Mississippi Lowlands is Leon Parker Ogilvie, "The Development of the Southeast Missouri Lowlands" (Ph.D. dissertation, University of Missouri–Co-

lumbia, 1967). Paul A. Korte and Leigh H. Fredrickson have traced the "Loss of Missouri's Lowland Hardwood Ecosystem" in *Transactions of the 42nd North American Wildlife and Natural Resources Conference* (March 1977): 31–41. For an account of the champion trees at Big Oak Tree see James P. Jackson, "A Park of Champions," *American Forests*, 69:5 (May 1963): 9, 62–63; and for an analysis of the vegetation see Wanda S. Oskins Doolen, "The Vascular Flora of Big Oak Tree State Park, Mississippi County, Missouri" (M.S. thesis, Central Missouri State University, 1984). Indian use of the lowland environment is considered in R. Barry Lewis, *Mississippian Exploitative Strategies: A Southeast Missouri Example* (Columbia: Missouri Archaeological Society Research Series No. 11, 1974), while recent excavations at Towosahgy are reported in James E. Price et al., "Archaeological Investigations in Three Areas of the Towosahgy State Historic Site, 23MI2, Mississippi County, Missouri, 1989" (University of Missouri, American Archaeology Division, June 1990). Robert A. Shaddy studied "The Hunter and Dawson Families in Southeast Missouri" in a University of Missouri-Columbia paper in 1987.

The best starting points for the Big Rivers are undoubtedly Mark Twain's *Life on the Mississippi* (1883) and, for the Missouri River, *The Journals of the Lewis and Clark Expedition* (1803–1806), both of which are available in several editions; the definitive edition of the journals is being edited by Gary E. Moulton and published by the University of Nebraska Press, 1983–. The Mississippi as far north as St. Louis and parts of the Missouri are also admirably described in *An Account of Upper Louisiana*, written by Nicholas de Finiels in 1803 and edited by Carl J. Ekberg and William E. Foley (Columbia: University of Missouri Press, 1989), and in *Recollections of the Last Ten Years* by Timothy Flint (1826; reprint New York: Da Capo Press, 1968). See also Philip V. Scarpino, *Great River: An Environmental History of the Upper Mississippi, 1890–1950* (Columbia: University of Missouri Press, 1985); Norah Deakin Davis, *The Father of Waters: A Mississippi River Chronicle* (San Francisco: Sierra Club Books, 1982); Don Pierce, *Exploring Missouri River Country* (Jefferson City: Missouri Department of Natural Resources, ca. 1982); and John L. Funk and John W. Robinson, *Changes in the Channel of the Lower Missouri River and Effects on Fish and Wildlife*, Aquatic Series No. 11 (Jefferson City: Missouri Department of Conservation, 1974).

For an account of the tragedy commemorated at Trail of Tears see Grant Foreman, *Indian Re-moval* (1932; rev. ed. Norman: University of Oklahoma Press, 1986). Carl J. Ekberg has dealt with *Colonial Ste. Genevieve: An Adventure on the Mississippi Frontier* (Gerald, Mo.: Patrice Press, 1985), while James Baker examined "Menard & Valle and Ste. Genevieve's Early 19th Century Merchants" in a paper delivered at the third annual Fur Trade Symposium in 1989. The Ste. Genevieve project at the University of Missouri–Columbia is resulting in a series of theses and articles on the area; see, for example, Mary Susan Green, "The Material Culture of a Pre-Enclosure Village in Upper Louisiana: Open Fields, Houses, and Cabinetry in Colonial Ste. Genevieve, 1750–1804" (M.A. thesis, 1983), and Susan C. Boyle, "Did She Generally Decide? Women in Ste. Genevieve, 1750–1805," *William and Mary Quarterly*, 3d series, 44 (October 1987): 775–89.

They All Played Ragtime by Rudi Blesh and Harriet Janis (New York: Alfred A. Knopf, 1950), *Scott Joplin and the Ragtime Era* by Peter Gammond (New York: St. Martin's Press, 1975), and *Scott Joplin* by James Haskins with Kathleen Benson (New York: Doubleday and Co., 1978) provide background on Scott Joplin and his musical tradition. For Battle of Athens see Leslie Anders, *The Twenty-First Missouri: From Home Ground to Union Regiment* (Westport, Conn.: Greenwood Press, 1975), and Ben F. Dixon, *The Battle of Athens*, a 1991 reprint by the *Hometown Journal* of Kahoka, Missouri, of a local historian's articles about the battle.

The Katy Railroad and the Last Frontier by V. V. Masterson (1952; Columbia: University of Missouri Press, 1988) offers an account of the railroad that once ran along the Missouri River on what is now the Katy Trail, while James M. Denny et al. prepared an extensive report on "Cultural Resources along the Missouri, Kansas and Texas (Katy Trail) Railroad Route, Sedalia to Machens, Missouri" (DNR, 1986). The German culture celebrated at Deutschheim may be approached through Charles van Ravenswaay's monumental *Arts and Architecture of German Settlements in Missouri: A Survey of a Vanishing Culture* (Columbia: University of Missouri Press, 1977). But see also Gottfried Duden, *Report on a Journey to the Western States of North America*, ed. James W. Goodrich et al. (Columbia: State Historical Society of Missouri and University of Missouri Press, 1980), and *Hold Dear, As Always: Jette, A German Immigrant Life in Letters*, ed. Adolf E. Schroeder and Carla Schulz-Geisberg (Columbia: University of Missouri Press, 1988). Eldon Hattervig has written the history of "Jefferson Landing: A Commercial Center of the Steamboat Era," *Missouri Historical Review* 74:3

(April 1980): 277–99. For an account of the successive structures that have served as Missouri's capitol, including the first state capitol in St. Charles, see Marian Ohman, *The History of Missouri Capitols* (Columbia: University of Missouri Extension Division, 1982); and for the magnificent public art in the current building be sure to look at John Pickard, *Report of the Capitol Decoration Commission, 1917–1928* (Jefferson City, 1928), and Nancy Edelman, *The Thomas Hart Benton Murals in the Missouri State Capitol* (Jefferson City: Missouri State Council on the Arts, 1975).

Robert T. Bray has reviewed the history and archaeology of the "Boone's Lick Salt Works, 1805–33" in *Missouri Archaeologist* 48 (December 1987): 1–65. For Arrow Rock see especially Charles van Ravenswaay, "Arrow Rock, Missouri," *Bulletin of the Missouri Historical Society* 15:3 (April 1959): 203–23. Studies of leading residents of the area include E. Maurice Bloch, *George Caleb Bingham: Evolution of an Artist* (Berkeley and Los Angeles: University of California Press, 1967); Lynn Morrow, "John Sappington: Southern Patriarch in the New West" (paper, University of Missouri-Columbia, 1985); and William H. Lyon, "Claiborne Fox Jackson and the Secession Crisis in Missouri," *Missouri Historical Review* 58 (July 1964): 422–41. On Van Meter see Jean Tyree Hamilton, "Abel J. Vanmeter, His Park and His Diary," *Bulletin of the Missouri Historical Society* 28:1 (October 1971): 3–37; Robert T. Bray, "The Missouri Indian Tribe in Archaeology and History," *Missouri Historical Review* 55:3 (1961): 213–25; and Dale R. Henning, "Development and Interrelationships of Oneota Culture in the Lower Missouri River Valley," *Missouri Archaeologist* 32 (1970): iii–180. For a discussion of vernacular architecture see Howard Wight Marshall, *Folk Architecture in Little Dixie: A Regional Culture in Missouri* (Columbia: University of Missouri Press, 1981).

One approach to the Battle of Lexington is through the eyes of a participant, Ephraim McDowell Anderson, whose *Memoirs: Historical and Personal; Including the Campaigns of the First Missouri Confederate Brigade* (1868) was reissued by Morningside Press in 1972 with extensive annotations by Edwin Bearss. See also Neil Haddock, "Embattled Mansion," *Missouri Life* 5:1 (1977): 19–23. Regarding Confederate Memorial see Elizabeth Ustick McKinney, "The Confederate Home: Its Origin and Objects," in *The Confederate Mail Carrier* by James Bradley (Mexico, Mo., 1894), 231–61. The best place to start among the numerous biographies and studies of Thomas Hart Benton is certainly with his own

autobiography, *An Artist in America* (1937), the fourth edition of which was issued by the University of Missouri Press in 1983. For a haunting account of his life and work see Karen Ann Marling, *Tom Benton and His Drawings: A Biographical Essay and a Collection of His Sketches, Studies, and Mural Cartoons* (Columbia: University of Missouri Press, 1985).

The prairie plains of western and northern Missouri have been relatively little celebrated, but see Walter Schroeder's fine *Presettlement Prairie of Missouri* (Jefferson City: Missouri Department of Conservation, 1981) for a discussion of early travelers who described the prairie landscape, notably Victor Tixier, who visited the Osage prairies, and Edwin James, who described northern Missouri in his account of the Stephen Long expedition. Denyse K. Sturges has traced the beginnings of the lands that became a park in "Prairie State Park: A Public Land History" (paper, University of Missouri–Columbia, 1985), while James H. Shortridge provides insights into the business that kept the lands in prairie in "Prairie Hay in Woodson County, Kansas: A Crop Anomaly," *Geographic Review* 63:4 (October 1973): 533–52. The finest account of the Indians who roamed the western prairies is *The Osage: Children of the Middle Waters* by John Joseph Mathews (Norman: University of Oklahoma Press, 1961). Washington Irving described his 1982 encounters with them in *A Tour of the Prairies* (1835), ed. John Francis McDermott (Norman: University of Oklahoma Press, 1956). See also Carl H. Chapman, "The Origin of the Osage Indian Tribe: An Ethnographic, Historical and Archaeological Study" (Ph.D. dissertation, University of Michigan, 1959).

Of the many works on Truman, one place to start is with *The Autobiography of Harry S. Truman*, ed. Robert H. Ferrell (Boulder: Colorado Associated University Press, 1980); see also Ferrell's edition of Truman's letters to his wife, *Dear Bess: The Letters from Harry to Bess Truman, 1910–1959* (New York: Norton, 1983), and biographies by Margaret Truman, *Harry S. Truman* (New York: William Morrow, 1973), and Alfred Steinberg, *The Man from Missouri: The Life and Times of Harry S. Truman* (New York: Putnam, 1962). Bonnie Stepenoff has written about youth camps, a key aspect of Knob Noster and Cuivre River state parks in "The New Deal's Camp Sherwood Forest: An Incubator of Democracy," *Gateway Heritage* 11:3 (Winter 1990–1991): 52–59.

The most obvious place to start on Mark Twain is with *Adventures of Huckleberry Finn* (1885), but don't neglect *The Gilded Age: A Tale of To-Day* (1873–1874), written with Charles

Dudley Warner and set in part in Sam Clemens's Salt River country. See also his posthumously published *Mark Twain: Autobiography*, 2 vols. (New York: Harper and Brothers, 1924). For a critical reassessment see *One Hundred Years of* Huckleberry Finn*: The Boy, His Book, and American Culture*, ed. Robert Sattelmeyer and J. Donald Crowley (Columbia: University of Missouri Press, 1985). Albert Bigelow Paine reported on his effort to find the birthplace cabin in Florida in *Mark Twain: A Biography*, 3 vols. (New York: Harper & Brothers, 1912). Concerning the saga of the cabin and the park, see Ralph Gregory, *M. A. "Dad" Violette: A Life Sketch*, a pamphlet printed in Perry, Missouri, in 1969. The Salt River country has been the subject of a major multidisciplinary study sponsored by the U.S. Army Corps of Engineers, summarized in Michael J. O'Brien, ed., *Grassland, Forest, and Historical Settlement: An Analysis of Dynamics in Northeast Missouri* (Lincoln: University of Nebraska Press, 1984). For the history of the dam see Michael D. Shulse, "The History and Development of the Clarence Cannon Dam and Reservoir, 1957–1968" (M.A. thesis, Northeast Missouri State University, 1975), and for the efforts of local folks to come to terms with the Mark Twain legend see Ron Powers, *White Town Drowsing* (Boston: Atlantic Monthly Press, 1986).

The military men honored by north Missouri parks are the subjects of a number of biographies, including Everett T. Tomlinson, *The Story of General Pershing* (New York: D. Appleton and Company, 1920); Donald Smythe, *Pershing: General of the Armies* (Bloomington: Indiana University Press, 1986); and David A. Lockmiller, *Enoch H. Crowder: Soldier, Lawyer and Statesman*, University of Missouri Studies 27 (Columbia, 1955). Pershing's autobiography, *My Experience in the World War*, 2 vols. (New York: Frederick A. Stokes Co., 1931), won the Pulitzer Prize. For the trauma of the Mormons near what is now Wallace State Park see Stephen C. LeSueur, *The 1838 Mormon War in Missouri* (Columbia: University of Missouri Press, 1987). Dorothy Caldwell has written about Watkins Mill in "Missouri National Historical Landmarks, Part III: Watkins Mill," *Missouri Historical Review* 63:3 (April 1969): 364–77, as has B. H. Rucker in "Watkins Mill," *The Harbinger* 3:5 (December–January, 1970–1971): 15–19.

Current brochures on individual parks or on the system as a whole may be secured by writing to the Missouri Department of Natural Resources, Division of Parks, Recreation, and Historic Preservation, P.O. Box 176, Jefferson City, MO 65102.

Index

Miller Co., 75
Mills: lead-processing, 139–41, 143;
 steam-powered, 183, 336; textile, iv,
 331–36; water-powered, 6, 13, 26, 57,
 60–62, 63, 65, 66, 70, 80, 83, 90, 115,
 134–36, 211, 320
Mina Sauk Falls, 35, 36
Mincher, Andrew and Jesse, 62
Mine Creek (Kans.), battle of, 44
Mine La Motte, 121
Mineola, 157
Mingo National Wildlife Refuge, 86
Mining and mineral industry: cave onyx,
 57; coal, 116, 142, 168, 169, 278, 287,
 310, 311, 313; copper, 53; granite, 29,
 32; gravel, 148, 149, 204–7 passim;
 iron, 51, 53, 62, 196, 197; lead, 53, 115–
 16, 121, 129, 131, 139–42, 143, 144,
 145, 199; marble, 231; salt, 233–36;
 saltpeter, 157; zinc, 142
Mink, 54
Mischke, Emil and Mary, 60, 62
Mississippian period, 295, 297
Mississippi Co., 173, 175
Mississippi Embayment, 173, 177
Mississippi Lowlands, 47, 84, 86, 173–74
Mississippi Valley Hardwood Company,
 175, 177
Missouri Act of Secession, 92
Missouri Archaeological Society, 157, 159,
 247
Missouri Bicentennial Commission, 227
Missouri Caverns, 57
Missouri Compromise, 218
Missouri Conservation Commission (De-
 partment), 9, 10, 11, 15, 17, 18, 19, 47,
 66, 81, 97, 119, 177, 187, 328
Missouri Constitutional Convention
 (1820), 100, 184, 229
Missouri Department of Natural Re-
 sources, x, 101, 143, 145, 187, 309; es-
 tablishment of, 16; Division of Geology
 and Land Survey, 142; Division of
 Parks, Recreation, and Historic Preser-
 vation, x, 16. See also State park system
 (Missouri)
Missouri Farm Bureau, 214
Missouri General Assembly, 1, 2, 4, 9, 12,
 16, 18, 19, 20, 23, 33, 68, 104, 127, 134,
 137, 143, 166, 184, 199, 218–20 passim,
 229, 240, 258, 291, 303
Missouri Indians. See Indians: Missouri
Missouri-Kansas-Texas Railway Company
 (M-K-T), 212–17
Missouri Mines SHS, 115, 139–42, 143
Missouri Pacific Railroad, 212, 217, 225
Missouri Parks Association, xi, 19, 22,
 214
Missouri Prairie Foundation, 278
Missouri Speleological Society, 59
Missouri State Chamber of Commerce, 7
Missouri State Fair, 291, 304
Missouri State Guard, 102, 104, 189, 249–
 53
Missouri State Highway Commission (De-
 partment), 13, 127, 136, 188, 204–7
Missouri State Museum, 189, 227, 231–32
Missouri State Park Board, x, 9–12, 15, 16,
 47, 177, 210
Missouri State Park Fund, 1, 4, 5
Missouri State Park Plan (1938), 10, 11
Missouri State Planning Board, 7, 10
Moccasin Springs, 188, 190, 193
Moniteau Creek, 212, 216, 217
Monroe, James, 220
Monroe Co., 301, 304–6 passim
Montauk SP, 5, 11, 28, 81–83

Montauk Spring, 82, 83
Montgomery Co., 116, 217
Montserrat Recreational Demonstration
 Area, 7, 287, 289
Mook, William, 57
Moore, David, 208, 210
Moore's Cave, 53
Moose, 128
Mormons, 326
Morrison, James and Jesse, 233, 235
Morschel Woods, 148
Morse, John Hathaway, 137
Mose, Carl, 316
Mount Vernon Church, 334
Mudlick Mountain, 46–50; tornado, 50;
 Wild Area, 50
Mudlick National Recreation Trail, 50
Muehl, Eduard, 223–24
Muench, Friedrich, 224
Mulligan, James A., 251–53
Munday, Horace, 13, 235

Nathan Boone Homestead SHS, 23, 28,
 70, 98–101
National Conference on State Parks, 4
National historic landmarks, 13, 158, 160,
 203, 241, 296, 316, 332
National Industrial Recovery Act, 75
National natural landmarks, 89, 177
National Park Service (national parks), 1,
 2, 4, 5, 7–10, 15–17, 58, 75, 81, 92, 102,
 152, 175, 287, 297, 304, 317
National Register of Historic Places, 15,
 17, 49, 78, 81, 131, 154, 217, 218, 222,
 283, 287, 299, 321
National 66 Association, 58
National Trails System Act, 214, 215
National Wild and Scenic Rivers Act, 15
National Youth Administration, 326
Natural areas, 17, 40, 50, 54, 70–72, 80,
 86, 94, 117, 124, 132, 155–56, 160, 177,
 190, 192, 210, 211, 248, 279, 289, 299–
 300
Natural bridges, 66, 67, 87, 89, 161–62
Natural divisions, vi, xi, 232, 340
Natural history (naturalist) program, 11,
 17, 54, 78, 92, 145, 154, 279, 300, 313
Nature Conservancy, 58, 66, 165, 278, 327
Nauvoo, Ill., 326
Nemastylis, 132
Neosho, 65, 92, 244, 258, 323
New Deal, 7, 9, 17, 47, 75, 152, 299
New Madrid, 13, 173, 183, 184
New Madrid Co., 184
New Madrid fault (earthquakes), 145, 181,
 183
New Madrid Floodway, 179
New Philadelphia, Mo., 237
New York, 83, 203, 258; parks, 1, 2, 5
Niangua River, 5, 28, 63, 65, 70
Nodaway Co., 261
Norfork Dam, 97
Norman, M. G., 89
North Fork River, 23
Northwoods Wild Area, 299
Novinger, 311
Nuderscher, Frank B., 231

Oak: blackjack, 71; bur, 132, 175, 176,
 310; northern red, 156, 248, 327; over-
 cup, 177; pin, 289; post, 37, 71, 107,
 131; scarlet, 119; shumard, 49, 177;
 southern cherry bark, 84, 183; swamp
 chestnut, 175; white, 50, 71, 82, 84,
 119, 155, 190, 310, 327, 328
Oberholtz, Lee, 335
O'Fallon, 17

Ogden, Derek, 136
Ohio, 325; parks, 2
Ohlson, Ralph and Mary, 80
Oklahoma, 65, 93, 94, 142, 179, 248, 280,
 282, 284; Indian Territory, 101, 188,
 190, 193, 284
Old Fort site, 247
Olmsted, Frederick Law, 1
Onondaga Cave SP, 4, 17, 28, 51, 55–59,
 79
Open Space Council of St. Louis, 149
Opossum, 72, 330
Orchid: coral root, 40, 83; grass pink, 124;
 green adder's mouth, 119; ladies'
 tresses, 40, 83; nodding pogonia, 40;
 putty root, 40; rattlesnake plantain,
 119; showy orchis, 40, 83, 119; tway-
 blade, 40; yellow lady's slipper, 54
Ordovician period, 27, 295
Ordway, Katharine, 278
Oregon Co., 87
Osage Beach, 109
Osage Indians. See Indians: Osage
Osage Plains, 107, 112
Osage River, 7, 105, 109, 112, 216, 218,
 229, 280, 282
Osage Trace, 237
Osage Village SHS, 17, 273, 280–83
Osceola, 111
Osprey, 54, 313
Otahki (Cherokee), 193
Otter, river, 54
Outdoor Recreation Resources Review
 Commission, 13, 22
Outstanding state resource water, 119,
 124, 279
Owen, Luella Agnes, 89
Owl: barred, 178, 313; great-horned, 313;
 screech, 72; short-eared, 274
Ozark Border, described, 155
Ozark Caverns, 79–80
Ozark Co., 95
Ozark dome, 27, 33, 115
Ozark National Scenic Riverways, 15, 28,
 81
Ozarks, definitions of, 27, 95

Paintbrush, Indian, 274
Paleozoic seas, 27, 55
Pape, Fred W., 11
Parks and soils sales tax, x–xi, 19, 20, 21,
 90, 93, 232
Parkways, 1, 7, 154–55
Parsons, Mosby Monroe, 252
Partridge berry, 119
Patterson, 47
Patterson Hollow Wild Area, 76, 79
Pawpaw, 132, 155, 177, 280
Pea, scurfy, 276
Peabody Coal Company, 168
Pecan, 177, 266
Peck, Charles and Ruluff, 219
Pelican, 274, 320
Pendergast, James and Tom, 285
Penn, George, 237, 240
Pennsylvania, 137, 315; parks, 2, 7
Pennsylvanian period, 168, 189, 273, 311
Pennywort, 190
Peoria, Ill., 197
Perche Creek, 137
Perry Co., 221
Perryville, 115, 143
Pershing, John J., 314–16, 317, 320, 322,
 323
Pershing Memorial Park Association, 12,
 316

About the Authors

Susan Flader is professor of United States western and environmental history at the University of Missouri–Columbia and has written or edited five books and numerous articles, including *Thinking Like a Mountain* (a biographical study of Aldo Leopold) and *The Great Lakes Forest*. She has served as president of the Missouri Parks Association (1982-1986) and as a director of the National Audubon Society and the American Forestry Association.

R. Roger Pryor, executive director of the Missouri Coalition for the Environment, has been active for more than two decades as a leader of several environmental organizations including the St. Louis Open Space Council and the Sierra Club, which he served as midwest regional vice-president. With degrees in geology and biology, he has conducted extensive natural area surveys of Missouri and has written over two hundred articles on environment and politics for newspapers and magazines.

John A. Karel, who has degrees in history and resource management, served during 1979–1985 as state park director, having joined the Missouri Department of Natural Resources as a resource planner in 1976. Founder of the Missouri Wilderness Coalition and active in the Sierra Club, he has also served as a director of several historic preser-

vation groups. Author of dozens of articles on resource issues, he is currently director of Tower Grove Park in St. Louis and president of the Missouri Parks Association.

Charles Callison, a 1937 graduate of the University of Missouri School of Journalism, has had a distinguished career as a conservation leader, serving as chief of information for the Missouri Department of Conservation, executive secretary of the Conservation Federation of Missouri, conservation director of the National Wildlife Federation, executive vice-president of the National Audubon Society, and president of the Public Lands Institute. He has written hundreds of articles and several books, including *Man and Wildlife in Missouri,* and for the past decade has edited the newsletter of the Missouri Parks Association.

Oliver Schuchard is professor of art at the University of Missouri–Columbia and a noted landscape photographer. Deeply influenced by his studies with Ansel Adams, he works with the large-format camera in both black and white and color and in both minute detail and panorama to render images of the landscape. His photographs have appeared in numerous books, magazines, and exhibitions, and he has produced two previous book-length photographic interpretations of his native state, *Missouri* and *Two Ozark Rivers.*